THE PROCESS GENRE

THE PROCESS GENRE

CINEMA AND THE AESTHETIC OF LABOR

SALOMÉ AGUILERA SKVIRSKY

DUKE UNIVERSITY PRESS
Durham and London 2020

Designed by Aimee C. Harrison
Typeset in Chaparral Pro, DIN
Neuzeit, and Neuzeit S LT Std by
Westchester Publishing Services

Library of Congress Cataloging-in-Publication Data
Names: Skvirsky, Salomé Aguilera, author.
Title: The process genre : cinema and the aesthetic of labor /
Salomé Aguilera Skvirsky.
Description: Durham : Duke University Press, 2020. |
Includes bibliographical references and index.
Identifiers: LCCN 2019032751 (print)
LCCN 2019032752 (ebook)
ISBN 9781478005407 (hardcover)
ISBN 9781478006442 (paperback)
ISBN 9781478007074 (ebook)
Subjects: LCSH: Work in motion pictures. | Process films—
History and criticism Classification: LCC PN1995.9.L28
S58 2020 (print) | LCC PN1995.9.L28 (ebook) |
DDC 791.436/552—DC23
LC record available at https://lccn.loc.gov/2019032751
LC ebook record available at https://lccn.loc.gov/2019032752

Cover art: Frame enlargements, "How People Make Crayons"
segment, "Competition (#1481): A Favorite Factory Visit:
Crayons!" *Mister Rogers' Neighborhood*, season 14, episode 81.

Duke University Press gratefully acknowledges the University
of Chicago Humanities Council, which provided funds toward
the publication of this book.

This book is dedicated
to Anton, Felix, and Rosa;
to my parents, Alan Skvirsky
and Anexora Aguilera Skvirsky;
and to my sister, Karina

CONTENTS

A NOTE
ON THE ART

THROUGHOUT THIS BOOK there are a series of grids composed of frame enlargements from single films—some are 1×3, some 2×3, some 3×3, some 4×3. The grids are not meant as adornment. I employ them to help the reader visualize what I am discussing. They should be read as Eadweard Muybridge's grids are read: from left to right, top to bottom, row by row. The grids are designed to approximate the processes under discussion. Two-dimensional representation is not ideal for conveying processes that unfold in time. Each image in the grids is intended to allude to a step in the process. Most of the grids are not complete (i.e., each and every step is not represented), though some are more complete than others. In some grids, each frame enlargement corresponds, simultaneously, to a step in the process *and* to a discrete shot of the film. In others, several steps (and thus several frame enlargements) come from a single shot.

ACKNOWLEDGMENTS

I WENT TO BRAZIL to do research for a dissertation on the representation of race in Brazilian cinema. With some luck, I managed to find the filmmaker of a twenty-minute documentary titled *Quilombo* (1975). Apart from what its title suggested—*quilombo* is the Portuguese word for maroon society—I knew nothing about the film. I could not find a description of it, and I did not know whether any copies survived. The filmmaker, Vladimir Carvalho, informed me that there was, in fact, a copy—but only one, he thought: a 16 mm print housed at the office of the state-run Centro Técnico Audiovisual in Rio de Janeiro. He generously agreed to arrange a private screening for me. But he did so with the warning that his film was probably not what I was looking for. I would not find much evidence of Afro-Brazilian culture in it, he said. The film was about a contemporary quilombo, not a historical one. And the people it was about—well, he said, they were devout Catholics, not practitioners of an Afro-Brazilian religion such as candomblé. Carvalho was right to suppose that, based on its title, I expected the film to be about African cultural survivals and that I would be totally unprepared for its actual subject matter. *Quilombo* is about the subsistence activities of a then contemporary community of peasants who were descendants of escaped slaves and lived in a small, rural village—Mesquita—an hour outside the nation's capital city, Brasília. The people of Mesquita had survived for generations by subsistence farming and the production of quince marmalade. The film

is structured around the community's production of saleable quince marmalade for the local market. With rigorous attention to the details of the process, the film displays two necessary activities in that production: the production of the marmalade itself and the fabrication of small, rectangular, wooden boxes to contain it. Intercutting back and forth between the two activities, the film presents the necessary steps in chronological order. The quince trees are planted; their flowers bloom; the rain comes; the fruit ripens. Then the quince is picked and tossed into metal buckets. The fruit is peeled, washed, boiled, pureed, reheated, and finally cooled. While the quince is being grown and harvested and conserved, four-by-six-inch, open-topped wooden boxes are made to hold the marmalade. A tree is cut down; its trunk is divided with a water-powered saw in a roofed outdoor workshop; the saw is cooled with water; planks are cut from the trunk; thin wood strips are nailed together to form the sides and bottoms of boxes; the boxes are sanded; and the carpenter checks his work.

As I watched Carvalho's film, I felt something familiar: a tingling in my toes and ears, a calm, a stillness, a lull. I was transfixed. I had experienced this before while watching film. Most recently, I had felt it watching Robert Flaherty's *Man of Aran* (1934) a few months earlier. Seeing the Aran islanders preparing an impossibly rocky plateau for the growing of potatoes by retrieving seaweed from the rocks' crevices and watching a young Aran man patch up a hole in a fishing boat with a rag, tar, and a flame had elicited the same sensation.

When I spoke with Carvalho after the screening, I hesitated to mention Flaherty. I imagined that he might be offended by the comparison to an Anglo-American filmmaker, that he might feel I was somehow suggesting his film was derivative. But when, eventually, I did bring up Flaherty, Carvalho grew animated. He said that it was seeing *Man of Aran* as a young man, at a Cine Club in the city of João Pessoa in Paraíba, Brazil, that had set him on his career path.

Well, it was seeing the similarities between his film and Flaherty's that set me on the path that led to the writing of this book. I began by wondering what accounted for the mesmerism of the two films. How was the effect achieved? Eventually I came to think that I had stumbled on a discrete genre, the process genre.

Because I came to the process genre through an encounter with Carvalho's work, I was attentive to certain of its features that otherwise would not have been salient. Although his work is understudied, Carvalho is an

important and interesting figure in Brazilian cinema. He was central in the Paraíban school of documentary, which overlapped with the Cinema Novo movement of the 1960s and '70s. For more than fifty years—impervious to all faddishness—he has pursued a single project: making democratic films about work and workers. In the first part of his career, he made several that, like *Quilombo*, were very beautiful and deceptively straightforward films depicting the ordered steps in a process of craft labor: the making of *rapadura* (raw brown sugar) in *A Bolandeira* (1968); the production of cotton in *O País de São Saruê* (1971); the mining of sheelite in *A Pedra da Riqueza* (1975); the art of weaving in *Mutirão* (1976). Later, Carvalho would turn to telling the story of the construction of the capital city, Brasília, which began in 1956—of how laborers, bused in from the distant northeast of the country, built an entire city, from scratch, in the middle of the country's central plateau, in four years; of how the workers had had few protections; of how several had died; of how they had suffered terrible indignities; of how this utopian city, designed to banish class differentiation, had no place for these *candangos*, as they were called, when it was completed; of how they were exiled from the city they had built and forced to live in improvised, poorly serviced satellite cities; of how their attempts to organize and demand a different future had been met with state violence and repression.

In his seventh decade of life, Carvalho described his artistic trajectory in an interview with the great Brazilian film critic Carlos Alberto Mattos. On three separate occasions, Carvalho's father, "a compulsive builder," built what would be for a time their family's home, using bricks and tiles that were produced on-site. "I do not doubt," Carvalho said,

> that my vocation documenting the land and labor was born as I watched the work of the men who extracted and piled the red clay, immediately adding river water that had been painfully brought on the backs of beasts of burden. Kneaded sensuously with their feet, the clay became easy to form and filled wood molds, ultimately to be transformed into bricks and tiles arranged into pyramids and later baked in a fire pit, on the festive night of the burning of the kiln. The dirty men of that generous soil were practically an extension of the land, much like those others, who, nearby, plowed the land. I learned that everyone was transforming the world into culture.[1]

Indeed, Carvalho's entire oeuvre exhibits an unwavering curiosity about and awe for people's capacity to make and remake the world. His stance

toward the considerable practical intelligence of those "dirty men of clay," as he calls them elsewhere, and the rigorous, uncompromising way he makes one feel the force of those capacities—without falling into a mawkish sentimentality—means that his early films about production processes exhibit not so much an "aesthetic of hunger," the term coined by Cinema Novo's foremost cineaste and theorist, Glauber Rocha, to mark an imperfect aesthetic matching a rough, immiserated human and geographic landscape, as an "aesthetic of labor." That is, they exhibit an aesthetic that makes palpable the awesome transformative potential of human labor.

Carvalho is the first person I thank in these acknowledgments—for his beautiful films; for his openness and generosity; for his internationalism; and for his example of a steady, unwavering political commitment to following this topic, wherever it might lead, even as it meanders in and out of intellectual fashion.

I HAVE UNDERTAKEN WORK on this project at three different institutions, in three disciplinarily distinct departments. In each institution I have encountered wonderful colleagues whose interest, feedback, and leads have helped shape this book's final form.

At the University of Chicago, I have been fortunate to find generous and committed colleagues who have devoted much time and energy to this project. Daniel Morgan read multiple drafts at multiple stages in the writing process, often volunteering to read yet another iteration at critical junctures. He is an ideal reader: giving the most charitable interpretation of my words while making useful suggestions for clearer exposition.

I convey my indebtedness to the participants in the manuscript workshop that the Department of Cinema and Media Studies organized for me. So much gratitude and warm feelings go to Allyson Nadia Field, Laura Gandolfi, Tom Gunning, Heather Keenleyside, Daniel Morgan, David Rodowick, and Jennifer Wild. The external participants in the workshop, Jonathan Kahana and Ana López, provided detailed, incisive commentary that helped me to transform the manuscript. I also thank Brodwyn Fischer and the Center for Latin American Studies for supporting the workshop financially and Traci Verleyen for making the event run so smoothly.

Thank you, as well, to Rochona Majumdar, who read and helpfully commented on the epilogue, and to Jim Chandler and Claudia Brittenham, who gave me excellent feedback on the introduction; to Dominique Bluher, who introduced me to several exemplary French process films, some of

which put pressure on the category and helped me refine my thinking; to Will Small, who raised critical but productive objections to early formulations of some of the book's claims; to Zack Samalin, Patrick Jagoda, Maria Anna Mariani, and Megan Sullivan for stimulating conversations and useful feedback during the revision phase. I was able to undertake the final revision thanks to a Faculty Fellowship at the Franke Institute for the Humanities. I am so grateful to the Franke and to the wonderful scholars in my 2017–18 cohort.

I thank the participants in my 2016 Cinema and Labor graduate seminar for their energy and engagement. Special acknowledgment must go to Pao-chen Tang, Finn Jubak, Gary Kafer, Hannah Frank, and Katerina Korola for feeding me with new examples and challenging me with counterexamples.

I began writing this book during a fellowship at the Institute for the Humanities at the University of Illinois, Chicago (UIC). Many thanks to Susan Levine and Linda Vavra, director and associate director, respectively, of the institute, and to the other 2014–15 fellows for their feedback on an early draft of the manuscript's introduction. At UIC, I spoke at length about the topic with Tatjana Gajic, Steve Marsh, and Javier Villa Flores, all of whom also read early drafts and provided characteristically insightful comments. At the University of Massachusetts, Boston, Emilio Sauri and Judy Smith were marvelous colleagues. They were enthusiastic and encouraging of the nascent idea at a critical moment when I was deciding to embark on a project distinct from my dissertation.

Although this book is a separate project from my dissertation, it would not have been possible without the nurturance, support, encouragement—and training—that I received from my graduate school teachers at the University of Pittsburgh. I will always be especially grateful to Adam Lowenstein, Joshua Lund, Shalini Puri, Neepa Majumdar, John Beverley, George Reid Andrews, and my director, Marcia Landy.

At various critical points in the writing process, colleagues, mentors, friends, and fellow travelers provided feedback, encouragement, and support. I am indebted to Joshua Lund, Molly Geidel, Sarah Ann Wells, Nell Gambian, Leslie Marsh, Gustavo Furtado, Takuya Tsunoda, Agnes Lugo-Ortiz, Richard Neer, Luc Vancheri, Julio Ramos, Carlos Alberto Mattos, Jonathan Buchsbaum, and Betsy Guenther.

I owe a debt of gratitude to Elizabeth Ault at Duke University Press, who made a few key interventions early on that account for the current

structure of the book and who has seen the project through from beginning to end. I particularly remember a two-hour (!) lunch at the 2016 Society for Cinema and Media Studies annual conference in Atlanta, where we talked through a different organization for the book from the one I had originally proposed. I am very grateful to the anonymous external reviewers who provided such detailed and constructive feedback on the first draft I submitted to Duke. Their insightful comments were instrumental in the final revision process, and their mode of engagement stands as a model of rigorous—yet charitable—criticism; it is a model to which I aspire. I thank Michael Phillips and Amanda Norton for their excellent help with copyediting at various stages in the process. And special thanks to Gary Kafer, who helped in the preparation of the images and in the securing of permissions. His care and conscientiousness saved me time and heartache. I am grateful to Andrés Zúñiga Mella, director of Outreach, and Michelle Ribaut Kompatzki, manager of the Audiovisual and Media Section of the Archivo Patrimonial, at the University of Santiago de Chile, for their help in securing permission to see and reproduce images from *Tejidos Chilenos* (Fernando Balmaceda, Chile, 1965).

It is not easy to find the right words to express love and gratitude to the most important people in one's life. This book would not have been completed if it had not been for the love, care, and support of Michelle Ford, Steve Ford, and Anna Marie Ford. They have spent the past six years feeding, napping, soothing, and delighting Felix, and now Rosa. They never once refused the craziest request or the most last-minute entreaty. Without them, this book would have been unthinkable.

I owe (almost) everything to my parents, Alan Skvirsky and Anexora Aguilera Skvirsky, an unlikely couple, from different worlds, religions, languages. They set very few rules and had two passions (to this day): movies and politics, probably in that order. To the horror of my teachers and of my friends' parents, my parents regularly took me to the movies—R movies, NC-17 movies, subtitled movies, any movie, every movie—even on school nights, beginning when I was a young child. They never left me at home, and they never cared about decorum. My sister and best friend, Karina Aguilera Skvirsky, was my first teacher on art matters, and I still run most things by her first. I am thankful for my keenly observant bundle of energy, Felix, and the charming and willful Rosa; they make every day and every dinner an exciting rumpus, and their sugar keeps me going. Finally, I thank Anton Ford, the love of my life, for everything—from reading drafts to taking care of babies; he has nurtured ambitions for me that I never

dared to entertain. Thank you all. I dedicate this book to you six, with love and gratitude.

EARLIER VERSIONS of parts of chapter 4 appeared as "Realism, Documentary, and the Process Genre in Early New Latin American Cinema," in *The Routledge Companion to Latin American Cinema*, edited by Marvin D'Lugo, Ana M. López, and Laura Podalsky (London: Routledge, 2018), and as "Quilombo and Utopia: The Aesthetic of Labor in Linduarte Noronha's *Aruanda* (1960)," *Journal of Latin American Cultural Studies* 20, no. 3 (2011): 233–60. Some of the concepts developed in chapter 5 appear in a different form in "Must the Subaltern Speak? On *Roma* and the Cinema of Domestic Service," *FORMA: Aesthetic Form and Politics in Latin American Culture and Theory* 1, no. 2 (2019).

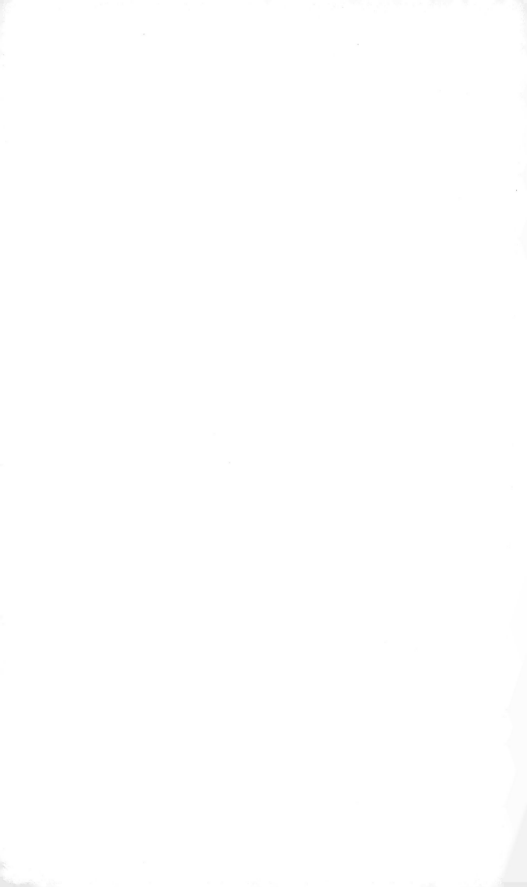

THE PROCESS GENRE

Here in the alcove of the wood and metal working rooms is a big vat of clay, a couple of potter's wheels, and a case of admirably modeled, glazed, and decorated pottery. Standing at the table is a clean old German kneading clay, his squat, bowed legs far apart, his body leaning forward, his long and powerful arms beating upon the clay like piston rods. He rolls it into a long cylinder and breaks it off with exactitude into a half dozen lumps. As he carries it across the room, walking with a side-wise straddle, one sees that he is bent and twisted by his trade, conformed to his wheel. Upon this he slaps his clay, and, thrusting out a short leg, sets it whirling. Above the rough lump he folds his hands, and, in a minute, from the prayerful seclusion, the clay emerges rounded, smoothed, and slightly hollowed. His hands open, his thumbs work in; one almost sees him think through his skilful thumbs and forefingers: the other fingers lie close together and he moves the four as one. Like some mystery of organic nature, the clay rises, bends, becomes a vase. "Look at that thing grow!" an excited boy exclaims, forgetting the crowd of onlookers. "See it, see it!" The old potter rises, lifts the vase in his mitten-like hands and, bending, straddling sideways, his face unmoved, carries it tenderly to its place.

Looking at him, I wonder. My heart aches. My flower-pots at home made by such as he, gain a new significance. They are no longer mere receptacles for holding earth and guarding the roots of my plants. The rough, red surface of them is written all over with the records of human patience, human cooperation with nature, human hopes and fears.

—Marion Foster Washburne, "A Labor Museum"

THIS BOOK is about a phenomenon with which we are all familiar but that does not have a name and that, consequently, has never been theorized: the sequentially ordered representation of someone making or doing something. Whether the action is performed before a live audience, is recorded and later projected on a screen, is drawn from imagination, or is narrated discursively; whether or not the action employs tools and machines; and whether the representation is received by children or adults, the sequential representation of people successfully making and doing things produces in the spectator a singular wonder and deep satisfaction.

The effect is powerfully captured by Marion Washburne in the epigraph. Writing for *The Craftsman* magazine, she describes a craft demonstration she observed in 1904 at the Labor Museum at Hull House in Chicago. The museum, founded by Jane Addams in 1902, was situated in the heart of a vibrant working-class immigrant community and was devoted to experiential learning. Addams hoped to mobilize the considerable know-how of the recently arrived migrants from Italy, Russia, and Germany to achieve educational and social ends. Craft demonstrations were an integral part of the museum's programming, because, as Addams put it, they tapped into the "fascination of the show." In her first report on the museum, Addams writes: "It may be easily observed that the spot which attracts most people at any exhibition, or fair, is the one where something is being done. So trivial a thing as a girl cleaning gloves, or a man polishing metal, will almost inevitably attract a crowd, who look on with absorbed interest."[1] Washburne's account of the vase-making scene confirms Addams's insight. Washburne is able to conjure both the complete linear arc of the process that transforms discrete coils of clay into a fully formed vase and its uncanny effect on a small crowd of spectators of different ages, spellbound by the element of the otherworldly in the demonstration.

Both the demonstration that Washburne describes and her discursive account of it belong to a distinct category of representation that I here call the "process genre." The process genre is characterized by the special way it organizes the representation of processes. The represented processes are typically, though not always, processes of production, and crucially, they are represented as having a sequentially ordered series of steps with a clearly identifiable beginning, middle, and end.

The process genre is not limited to early twentieth-century craft demonstrations in museums or at fairs. Our contemporary mediascape is awash with examples. Actually, the process genre is everywhere, present across history, media, and media platforms. On the internet, there are

YouTube instructional videos detailing how to make everything from crab cakes to video clips and "hands and pans" high-speed video recipe tutorials widely shared on social media.[2] On television, there are lifestyle, do-it-yourself, and educational programs such as the Food Network's 1990s cooking shows, Bravo's *Top Chef*, HGTV's *Fixer Upper* (about a couple in Waco, Texas, who renovate houses in the area), and Discovery Channel's *How It's Made* and *Some Assembly Required*.

In the sphere of cinema, the category includes educational, industrial, and ethnographic cinema since the early 1900s; observational documentaries from Frederick Wiseman's *Meat* (United States, 1976) to recent films such as *Leviathan* (Lucian Castaing-Taylor and Verena Paravel, United States, 2012) and *Raw Herring* (Hetty Naaijkens-Retel Helmrich and Leonard Retel Helmrich, Netherlands, 2013); art cinema such as Robert Bresson's *A Man Escaped* (France, 1956); slow cinema such as *La Libertad* (Lisandro Alonso, Argentina, 2001); and popular heist films such as *Ocean's Eleven* (United States, 2001). Also belonging to the process genre are the chronophotographic motion studies of Étienne-Jules Marey, Eadweard Muybridge, and Félix-Louis Regnault; craft demonstrations such as the one described by Washburne, as well as those that have taken place at international expositions, crafts fairs, and living, as well as traditional, museums; what E. H. Gombrich termed "pictorial instructions" including everything from airplane safety brochures and Ikea furniture assembly guides to the plates of Denis Diderot and Jean le Rond d'Alembert's *Encyclopédie, ou dictionnaire raisonné des sciences, des arts et des métiers*. In the domain of discursive media, recipes and instruction manuals also belong to the category. The enumeration could continue.

Despite its ubiquity, this phenomenon has gone unremarked on by scholars and critics. The present book undertakes the first study of this category of representation. In addition to naming it, my aim here is to define, historicize, and theorize this category of representation, accounting for its various fascinations. I come to focus on the process genre in film because, although the genre has a life in other media, as we have seen, I contend that it achieves its fullest expression in moving image media, not least because of the medium's constitutive capacity to visually and analytically decompose movement and to curate its recomposition. The process genre is, I argue, a ciné-genre.

The Process Genre pursues five questions in relation to the process genre. The first question is just how old the genre is. Film scholars may be tempted to subsume the process genre within the category of the industrial film, or

perhaps within educational cinema, and thus begin an account of its history starting in the last years of the nineteenth century. But in what follows I argue that pictorial instructions, exemplified by the how-to manuals of fifteenth-century Europe, ought to be included in the category. In that case, the process genre is considerably older than the moving image, and part of what a theory of the genre must account for is its transmedial character.

This leads directly to the second question, or set of questions: What is the relation of the process genre to medium—and, in particular, to cinema? Is it only an image-based genre? Is it only a durational genre? Is it a genre at all?

The third question concerns the effect of the genre on spectators. The lyricism of Washburne's description of the pottery demonstration is no accident, as the genre often elicits references to wonder and absorption; instances are frequently described as magical, spellbinding, mesmerizing, and so on. Why should this be so? What can be said about the *peculiar* attractions of the process genre?

After we have clarified what kind of category this is—that is, its age, its formal attributes, its effects—the process genre might still seem to be a neat curiosity, but little more. The fourth question of this study concerns its sociocultural and political significance. One striking feature of the catalogue of examples of the process genre listed earlier is that they are representations that straddle two distinct modes of organizing labor that are rarely treated together: artisanal and industrial production. Artisanal craft production and industrial mass production seem to belong to different worlds—the one "primitive" and hand-bound; the other capitalist and machinic. But the process genre brings them together in a single representational project. The process genre as a category of representation—and this we can also perceive in the ending of Washburne's description—is significant to the representation of labor and, by extension, to the representation of a society's mode of production.

Finally, given the fact, noted earlier, that our current media landscape is awash with examples of the process genre, a fifth question arises: Why now? The explosion has coincided with the resurgence of interest in craft and do-it-yourself culture that is evident in various subcultural trends, from the maker movement and "hacktivism" to the new ad-hocism and assorted slow-living movements. These trends have been accompanied by recent academic and crossover books (many of them self-help) about work and craftsmanship, including most prominently Robert Pirsig's *Zen and the Art of Motorcycle Maintenance: An Inquiry into Values* (reissued in 2006), Richard Sennett's *The Craftsman* (2008), Matthew Crawford's *Shop Class as*

Soulcraft: An Inquiry into the Value of Work (2010), Charles Jencks and Nathan Silver's *Adhocism: The Case for Improvisation* (expanded and updated in 2013), and James Livingston's *No More Work: Why Full Employment Is a Bad Idea* (2016).[3] These are all attempts to grapple with a new reality of work as the status and meaning of labor in the twenty-first century and across the globe is changing. The new landscape is defined by technological developments, advancing automation, and the dramatic growth of the immaterial labor sector. The recent examples of the process genre at once register these shifts, but they are also probably the reason that it is possible to now apprehend a category of representation that so far has gone nameless, that has yet to be recognized as a discrete phenomenon.

Exemplary Sequences

Cinematic expressions of the process genre appear very early in the history of the projected moving image. The films had titles such as *The Fan Industry in Japan* (Pathé-Frères, 1907), *How They Make Cheese in Holland* (Pathé-Frères, 1909), and *The Manufacture of Walking Sticks* (Heron, 1912).[4] Some of the films depicted processes of industrial production (e.g., *A Visit to Peek Frean and Co.'s Biscuit Works* [Cricks and Sharp, 1906]); others depicted artisanal production (e.g., *Making Bamboo Hats in Java* [Eclipse, 1911]). The films were made by operators from around the world, and examples abound in early French, Dutch, and American film catalogues and archives. Most film manufacturers even had a special category in their listings for these films. Pathé called them *scènes d'art et d'industrie*, while the American Mutoscope and Biograph Company called them "industrials."[5]

In the late 1990s, Tom Gunning coined the term "process film" to refer to this prominent group of multishot films, appearing between 1906 and 1917, that depicted a variety of production processes sequentially.[6] Gunning's coinage, which never gained much traction in cinema studies, is typically used specifically in reference to the predocumentary period. On the rare occasions it *is* mentioned, the "process film" has been generally treated as a self-evident category, as one of the genres of early cinema (alongside the travelogue, the scenic, and the nature film) that eventually would be absorbed by the more encompassing categories of "industrial film" and "educational film."[7]

Indeed, it is common to treat the "process film" (as Gunning understood it) as synonymous with the early industrial film. For example, in her entry "Industrial Films" in the *Encyclopedia of Early Cinema*, Jennifer Peterson

writes: "Industrial films tell the story of the birth of a consumer product. We see each product go through a series of processes, each one following from the previous in an inviolable order."[8] This description makes the industrial film sound a lot like Gunning's process film. In other words, Peterson found little use for a distinct appellation.

But the basic syntax and conventions of the process film were not invented by the industrial film; nor are they limited to it. Also, the process film as discussed by Gunning did not disappear in 1917 with the emergence of documentary filmmaking during World War I. In this book I use the term "process film" to refer to any *filmic* instance of the transmedial process genre. So understood, process films can be found throughout the history of cinema. The category certainly includes the production that Gunning and Peterson reference, but it encompasses much more. Process films are still being made today. And while the category intersects with the industrial film in interesting ways, it also interacts with other categories of filmmaking.

Since there are accomplished examples of process films made throughout film history, and all over the world, with much recent production made for the internet, it is not possible to produce an exhaustive filmography. Here is a partial inventory of especially significant process films whose processual character has gone largely unremarked:[9] Soviet montage works such as Dziga Vertov's *The Sixth Part of the World* (1926) and *The Eleventh Year* (1928); British documentaries such as *Drifters* (John Grierson, 1929), *Night Mail* (Harry Watt and Basil Wright, 1936), and *Steel* (Ronald Riley, 1945); most of Robert Flaherty's oeuvre, including *Nanook of the North* (1922), *The Pottery Maker* (1925), *Moana* (1926), *Industrial Britain* (1931), and *Man of Aran* (1934); New Deal films such as Joris Ivens's *Power and the Land* (1940); French works such as Georges Rouquier's *The Wheelwright* (1942) and *The Cooper* (1942), Georges Franju's *Blood of the Beasts* (1949), Jacques Demy's *The Clog Maker of the Loire Valley* (1955), Jean-Luc Godard's *Operation "Concrete"* (1958), and Jean Rouch's *The Lion Hunters* (1965); the New German Cinema of Peter Nestler, such as *How to Make Glass (Manually)* (1970) and *About the History of Paper* (1972–73); New Latin American Cinema landmarks such as *El Megano* (Julio García Espinosa, Cuba, 1955), *Araya* (Margot Benacerraf, Venezuela, 1959), *Trilla* (Threshing [Sergio Bravo, Chile, 1958]), *Aruanda* (Linduarte Noronha, Brazil, 1960), *Faena* (Work [Humberto Ríos, Argentina, 1960]), *Chircales* (Brickworks [Marta Rodriguez and Jorge Silva, Colombia, 1967–72]); Shinsuke Ogawa's Magino Village regional films, including *The Magino Village Story—Raising Silkworms* (Japan, 1977), *"Nippon": Furuyashiki Village* (Japan, 1982), *Magino*

Village—A Tale/The Sundial Carved with a Thousand Years of Notches (1986), and *Manzan benigaki* (Red Persimmons [with Peng Xiaolian, Japan, 2001]); Hollis Frampton's *Works and Days* (United States, 1969); Harun Farocki's installation film *Zum Vergleich* (In Comparison [Germany, 2009]); and Kevin Jerome Everson's eight-hour *Park Lanes* (United States, 2015).

But this is only a catalogue. To more precisely establish the defining marks of the process genre, it helps to recall a few iconic examples of the kind of representation that is characteristic of it. The following six exemplary sequences belong to well-loved films from across more than one hundred years of cinema history and from a wide field of geographic and of cultural space. They belong to different kinds of film—fiction as well as nonfiction, commercial as well as nontheatrical—that are not often discussed together. These sketches are meant to give a preliminary sense of what the process genre looks and feels like.

A VISIT TO PEEK FREAN AND CO.'S BISCUIT WORKS
(CRICKS AND SHARP, UNITED KINGDOM, 1906)

A Visit to Peek Frean and Co.'s Biscuit Works is an early corporate-sponsored film about biscuit, or cookie, production in Bermondsey, South London. With the help of intertitles, it depicts the steps in the process of mass producing Peek Frean biscuits—from steam powering the machines to the delivery of ingredients such as milk and flour; the rolling of dough; the cutting of the biscuits; their baking in ovens; and the washing, filling, weighing, labeling, soldering, and shipping of the filled tins. In one particularly striking two-minute sequence, introduced by the intertitle, "Biscuit machine with entrance to oven," two medium tracking shots present the trajectory of large sheets of thick dough as they are fed onto a giant conveyer belt—its dizzying wheels, gears, pulleys, and automated stampers plainly on display (figures I.1a–f). The dough is sprinkled with flour as it begins its advance through the machine; then it is flattened, smoothed, and evened by the machine's heavy rollers, which move it along. The dough is hand-cut into large, even rectangles, out of which automated stamping cylinders cut circular cookie shapes. At this point, suddenly, the conveyor belt splits into three parallel tracks: the uppermost track runs into a dead end, where the remainder of the dough is squished up into a heap (presumably to be reused in the making of more biscuits); the bottom track is attended by a child who puts empty metal baking sheets on the belt; and the middle track carries the prized biscuits, ultimately delivering them onto the empty metal baking

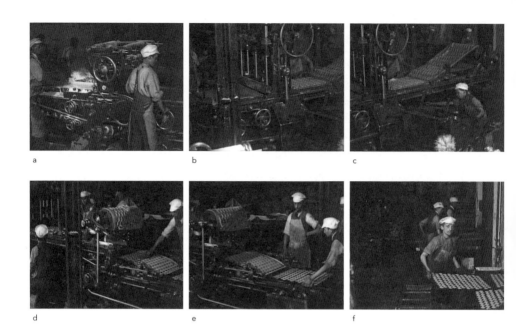

a b c

d e f

FIGS. I.1a–f "Biscuit machine with entrance to oven." Frame enlargements, *Peek Frean and Co.'s Biscuit Works* (Cricks and Sharp, United Kingdom, 1906). Each frame enlargement is intended to represent one step in the process. The grid should be read from left to right, row by row (as one reads text in English). The grid approximates the chronological unfolding of this part of the process of biscuit production.

sheets. Boys and men collect the baking sheets, each now with twelve rows of ten biscuits, and walk them, one at a time, to another moving belt, which conveys them into a giant oven.

NANOOK OF THE NORTH
(ROBERT FLAHERTY, UNITED STATES, 1922)

Nanook of the North features a series of production processes. One especially memorable three-and-a-half-minute sequence depicts the installation of a window for an igloo. The Inuit character, Nanook, has just completed the basic structure of an igloo for his family when, abruptly, he wades into the white expanse. Eventually he stops, cuts a square block of ice from the ground, and carries it back to his newly constructed dwelling. Nanook sets the ice block on the igloo and, with his long-bladed knife, traces the outline of the ice block on the igloo's roof. He then cuts a hole in the roof similar in shape to that of the ice block and puts the block into the hole to form a window. At this point the viewer's curiosity is satisfied; she has grasped the function of the ice block. But the shot does not cut away then. The sequence continues for another minute or so, in which Nanook is shown filling in the cracks around the perimeter of the ice window with soft snow, presumably to seal the window and secure it.

He fills in two edges of the window. Then a third, then the fourth, until all of them are carefully sealed and patted. When all four edges have been filled in, one can plainly see some flakes of snow on the surface of the window. Nanook wipes the snowflakes away and pats the structure fastidiously, presenting the viewer with a finished construction: a pristine ice window, well secured and glistening (figures I.2a–i).

RIFIFI (JULES DASSIN, FRANCE, 1955)

The classic heist film *Rififi* is perhaps best known for a thirty-three-minute sequence in which four thieves carry out the burglary of a jewelry store

FIGS. I.2a–i The Nanook character installs an ice window. Frame enlargements, *Nanook of the North* (Robert Flaherty, United States, 1922). Each frame enlargement is intended to represent one step in the process. The grid should be read from left to right, row by row (as one reads text in English). Although the grid approximates the chronological unfolding of the process from the first image on the top left to the last image on the bottom right, this series of nine images is not a complete visualization of the process as it is represented in the film; some steps are missing in this representation here.

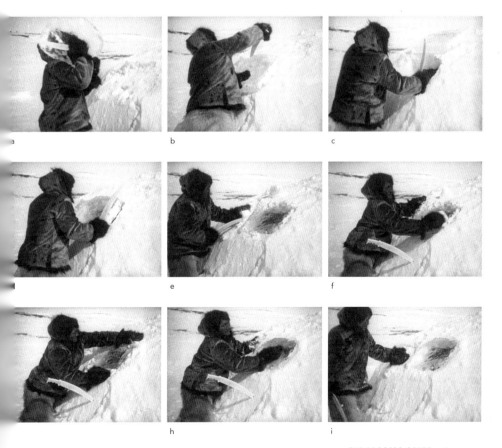

a b c

e f

h i

safe in the dead of night. The safe is held in a well-secured office, equipped with an elaborate alarm system triggered by noise. The thieves have determined that the only way to access the office space without activating the alarm is by "drilling" soundlessly through the floor of the apartment above it. The burglars make their way wordlessly through a series of steps that they have spent weeks planning and rehearsing. The steps are shown in order, with each step and each instrument clearly displayed. First, they neutralize the concierge and his wife; then they gain access to the apartment above the jewelry store office; they cover the window with a heavy blanket so the lights can be turned on without detection. Then they roll up the rug; loosen the wooden floor tiles in the living room with a long-handled chisel; remove the tiles with a pry bar; and wipe the underside of the tiles they have removed. Then they create a small hole in the floor with a bull point chisel and a socked mallet. Once the hole is large enough, they replace the bull point chisel with a larger one. They chisel away the floor until they break through the ceiling of the jeweler's office below, where the safe is kept; thread an umbrella through the small hole in the floor and ceiling; slip a rope around its handle so the umbrella does not fall through the hole into the room below; and contrive to open the umbrella using a metal rod. As they continue chiseling, the debris falls into the upside-down umbrella and thus does not trigger the alarm. They periodically remove the debris from the open umbrella so that the umbrella does not turn inside out from the weight of the gathering rubble. The hole in the floor-ceiling grows in diameter until it is large enough for a person to fit through, and so on (figures I.3a–l).

PICKPOCKET (ROBERT BRESSON, FRANCE, 1959)

In a one-minute sequence from *Pickpocket*, the protagonist, Michel, learns the craft of pickpocketing from a master pickpocket, Kassagi, played by an actual pickpocket who served as a technical adviser on the film.[10] In the lesson, Kassagi plays the pickpocket, and Michel plays his victim. The camera follows Kassagi's right hand in close-up as his four fingers delicately reach into the breast pocket of Michel's suit jacket, his thumb lightly resting on the outside fold of the jacket, steadying it to prevent the victim from feeling his clothing quiver. Kassagi grips the thin leather billfold with his fingertips just long enough to clear the pocket, then he releases the billfold down the interior of the suit jacket. The camera tilts down in time to capture Kassagi's left hand receiving the billfold before it falls to the ground, his thumb again steadying the jacket (figures I.4a–d). Kassagi's left hand passes the billfold

FIGS. I.3a–l A ten-minute part of the heist sequence in which the thieves enter the room with the safe by making a human-size hole in the floor of the apartment above. Frame enlargements, *Rififi* (Jules Dassin, France, 1955). Each frame enlargement is intended to represent one step in the process. The grid should be read from left to right, row by row (as one reads text in English). Although the grid approximates the chronological unfolding of the process from the first image on the top left to the last image on the bottom right, this series of twelve images is not a complete visualization of the process as it is represented in the film; some steps are missing in this representation here.

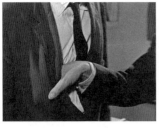
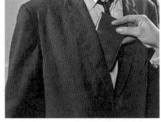

a b

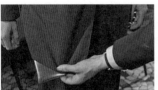
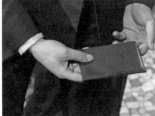

FIGS. I.4a–d A lesson in picking a suit breast pocket. Frame enlargements, *Pickpocket* (Robert Bresson, France, 1959). The rows should be read from left to right.

c d

back to his right hand and then to Michel's right hand, which returns the billfold to the breast pocket—the camera all the while attentively following the single cycle of the billfold's peregrination. The film dissolves to subsequent demonstrations of discrete actions: how to grasp the billfold in the breast pocket and clear the pocket; how to unbutton a jacket pocket with a quick snap of the thumb and index finger; how to dislodge a pen from the victim's pocket and slip it into one's jacket sleeve; how to drop the billfold down the inside of the jacket and catch it before it falls to the ground; and how to exercise one's fingers so that they are in good shape for the exertions of pickpocketing. Each demonstration is treated the same as the first as the camera trains its attention on the *pas de deux* of hand and object.

JEANNE DIELMAN, 23 QUAI DU COMMERCE, 1080 BRUXELLES
(CHANTAL AKERMAN, FRANCE/BELGIUM, 1975)

In the first bathing sequence of *Jeanne Dielman, 23 Quai du Commerce, 1080 Bruxelles*—a film about the quotidian routine of a housewife-prostitute who works out of her apartment—the spectator is presented with three shots, which together last about four-and-a-half minutes. Each shot corresponds to a different activity: to bathing, dressing, and cleaning the tub, respectively. The bathing part of the sequence begins with Jeanne turning on one faucet, the left one. She slides her right hand into a striped abrasive bath mitt and lathers the mitt with a bar of soap she has taken from the tub's built-in soap dish. Replacing the soap, Jeanne then begins her methodi-

cal bathing ritual, starting at the neck. She lifts her hair from the back of her neck with her left hand and soaps the area with her mitted hand (figures I.5a–f). Then the mitted hand moves to the left side of her neck; then to the right side; then to the right ear and to the left; then to the front of the neck; then down to her upper chest, to the left breast, to the left arm. She begins with the upper left arm, the brachium, its front; then she moves to the forearm, making her way to the wrist. She moves back up the arm from wrist to forearm to brachium to left breast to armpit, lathering the arm's underside. Having completed the soaping of the left side, Jeanne transfers the mitt from right hand to left. As her now mitted left hand is closest to her right wrist, she begins there, lathering the front side of her wrist, forearm, and brachium. Then she repeats the actions, but on the arm's underside, moving from wrist to forearm to brachium to right breast to armpit. She soaps her belly and the underside of her breasts, then her upper back. Jeanne transfers the mitt again, slipping it back into her right hand. Still focused on the right side, she lathers up her right thigh, her sex, her right breast. More soap. The left inner thigh and shin. The left outer thigh and calf. The left foot. The right foot. The genitals, one more time. Jeanne rinses the mitt thoroughly. Her cupped, mitted hand collects water and begins the rinsing process. First, the front of the neck. Then, the nape of the neck. The right ear. The left ear.

FIGS. I.5a–f Part of Jeanne Dielman's bathing ritual: turning on the water; preparing the mitt; soaping the nape of the neck; soaping the right ear; soaping the left ear; soaping the throat. Frame enlargements, *Jeanne Dielman, 23 Quai du Commerce, 1080 Bruxelles* (Chantal Akerman, France/Belgium, 1975). Each frame enlargement is intended to represent one step in the process. The grid should be read from left to right, row by row (as one reads text in English). The grid approximates the chronological unfolding of this subset of the process.

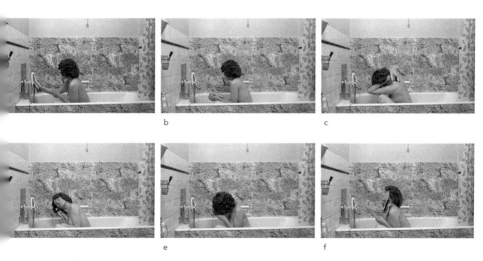

The left arm. She brings her left shoulder close to the running faucet. The left breast. The belly. She switches the mitt to the left hand. She moves her right shoulder in close to the running water, rinsing her entire arm. She takes her hand out of the mitt, grasping it with her right hand. Then the lower back. The right leg. The left leg. The feet. The genitals. Finally finished, she rinses the mitt, wrings it out, and sets it on the side of the tub.

EL VELADOR (NATALIA ALMADA, MEXICO, 2011)

The observational documentary *El Velador*, by the Mexican filmmaker and MacArthur Fellow Natalia Almada, is a "necropolitan" symphony film about five days in the life of a night watchman who guards the busy Jardin de Humaya cemetery in Culiacán, Sinaloa. The cemetery is favored by drug lords, who have built ornate mausoleums for themselves—mausoleums that, from a distance, make the cemetery look almost like a Moorish city on the sea. The final sequence of the film lasts five minutes and has become iconic.[11] It is one extreme long shot with a baroque mausoleum in the center of the frame. The shot depicts Martin, the night watchman, watering a dusty patch of road in front of the mausoleum (figures I.6a–f). The area he waters is a perfect square. With his fingers evenly distributing the flow of water from

FIGS. I.6a–f Watering the ground in the shape of a square. Frame enlargements, *El Velador* (Natalia Almada, Mexico, 2011). Each frame enlargement is intended to represent one step in the process. The grid should be read from left to right, row by row (as one reads text in English). Although the grid approximates the chronological unfolding of the process from the first image on the top left to the last image on the bottom right, this series of six images is not a complete visualization of the process as it is represented in the film; some steps are missing in this representation here.

a

b

c

d

e

f

the hose, he uses the water to outline the leftmost edge of the square, about five feet from where the mausoleum ends, and perpendicular to its stairs. Taking few steps, Martin aims the water at each spot long enough to darken the ground to the same hue before turning to the next patch. Once the leftmost column of ground is darkened, Martin waters two thinner columns before turning to outline the perimeter of the square that is parallel to the stairs of the mausoleum. He approaches this side of the square in much the same way he approached the left edge: he produces a thick row, perhaps four feet wide, of darkened ground. Now he shifts the hose's positioning, and, standing outside the intended square, he turns his attention to outlining the rightmost edge of the square, which extends about five feet beyond the mausoleum's rightmost edge. Before arriving at the slight incline on which the mausoleum's stairs rest, Martin (back inside the square) turns his hose on the still dry center of the square. All that is left now is the spotlight of dry ground where Martin is standing and the incline to the right of the mausoleum. Stepping outside the square again, Martin darkens the spotlight and then tackles the incline. The water edges up the incline, row after thin row, until the perfectly symmetrical mausoleum of arches, columns, turrets, and dome appears to rest perfectly—symmetrically—on a square, dark brown carpet of dampened dirt. His work done, Martin exits frame right.

Marks of the Genre

In spite of their differences, these six sequences clearly have much in common. The most important commonality is formal: all of the sequences are structured by a distinctive representational syntax that allows them to display the successive steps or phases of a process. In addition to this, and flowing from it, the sequences tend to produce a surprising degree of absorption in the spectator, as critics have often remarked. Furthermore, they all depict labor, capaciously understood, and they do so in such a way as to evoke something of the sensuous encounter of the human body, instruments, and materials. Finally, the sequences provide—or convey the impression of having provided—knowledge about the world.

These common characteristics should not be taken as hard-and-fast criteria of the process genre. Nor does this inventory pretend to be an exhaustive list of notable features. Throughout this study, I employ a scalar model in my treatment of the process genre, allowing that representations of a process can be more or less processual.[12] I marshal a variety of examples—

some more and some less paradigmatic, and some that put pressure on the category itself.

The definitive feature of the process genre is processual representation, in which the important steps in a process are shown in chronological order. Processual representation renders pro-filmic processes visible *as* processes. There are two aspects to processual representation: process and its representation.

A process, to put it crudely, is a continuous series of steps or actions that have a particular result and contain a definite order of steps. The exemplary sequences described earlier depict processes. Each involves making or altering something: making biscuits or ice windows; altering jewels or wallets (changing their location); altering the human body (changing it from dirty to clean); altering the dusty ground (changing it from dry to wet). Whereas some of the films, such as *Peek Frean*, present a single process (preparing biscuits for distribution), others, such as *Nanook of the North* and *Jeanne Dielman*, feature a series of discrete, unrelated processes (walrus hunting and igloo making in *Nanook* and cooking and bathing in *Jeanne*). Others still, including *Rififi*, *Pickpocket*, and *El Velador*, contain relatively few processes and a lot of screen time not devoted to processes. Even so, process—whether in terms of actual screen time or symbolically—is at the thematic center of all of these films.

But the sequences are processual in their form as well as in their content. They represent acts of making and altering *as* processes—that is, the steps that make up the process have been presented chronologically, and the process has a visibly identifiable beginning, middle, and end point. Thus, processual representation is a *formal achievement*. Not just any representation of process is a processual representation. In fact, most representations of processes are not processual: they convey (or often allude to) *what* is done, not *how* it is done. Imagine that one has been tasked with representing toothbrushing on film. Toothbrushing is a process: it unfolds in time; it has a beginning, a middle, and a moment when it is completed. But there are different ways to represent it. I could show a five-second shot of a child unscrewing the cap on a tube of toothpaste and, in the next three-second shot, show her leaving the bathroom. This would be a representation of a process but not a processual representation of toothbrushing. While the imagined scene suggests that the child brushed her teeth,

it gives no sense of toothbrushing as being composed of a series of steps with a beginning, middle, and end—it gives no sense of *how* to brush one's teeth.

So, *only* processes can be represented processually and *not all* representations of processes are processual. But it is also the case that *not all* processes are well suited to processual representation. Processual representation is especially appropriate for the treatment of certain subject matter, such as craft fabrication, and incompatible with other subject matter, such as art making. This owes to the difference in the social significance of craft as opposed to art; in craft, the how-to, protocol nature of skill is in play, while in art, singularity is paramount.

Processual representation often resembles a how-to.[13] Conversely, the standard form of the how-to—whether it is a recipe or a diagram illustrating how to activate the flotation device of a crashing airplane—is processual; it has a beginning and an end and a series of successive, linearly ordered actions in between. While not every processual representation is intended as a how-to, and while not many processual representations actually function as *effective* guides to action, one can often recognize processual representation by its prescriptive valence. If you search for the window installation sequence of *Nanook* on YouTube, you will find it under the title "How to build an igloo in the Arctic." Here, notably, a descriptive sequence (i.e., one that presents a singular event that took place in the past), in effect, doubles as a general and prescriptive one (i.e., one that could be repeated in the future). So what makes a how-to a how-to? What gives processual representation its prescriptive valence?

The Formal Conventions of Processual Representation

One might think that in order to make a process visible as a process, the process must be shown in its full duration. After all, is it not the case that every process is made up of an infinite number of subordinate processes? And is not each subordinate process made up of an infinite number of subordinate steps, each of which is infinitely divisible? Who is to say which steps are most important? Indeed, because a process is a series of steps that leads to a result, any process potentially involves an infinite number of steps. The infinitude of steps in a process follows from the infinitude of time: the steps in a process are infinitely divisible because time is infinitely divisible. As a consequence, it could seem that the long take is a privileged formal resource of the process genre. Indeed, most of my example

sequences do not make use of cuts as a means of temporal ellipses. Rather, they emphasize the duration of, for example, bathing or watering the dusty ground in the shape of a square. But from the earlier examples we can also appreciate that a representation can be processual, whether the process is presented in a long take or in short shots that condense the real-time process. For whereas *Nanook of the North, Jeanne Dielman*, and *El Velador* opt for long takes, presenting almost all of the actions in real time, *Rififi's* shots are relatively short, functioning mostly as what Ivone Margulies has called a "synecdochal tag"—where a part of the action stands in for the whole action.[14]

Making a process visible as a process requires curation. Representational decisions are made with a view to making a pro-filmic process *look* like a process on film. These decisions follow from the character of the process represented and from the medium of the representation; different kinds of processes (e.g., pickpocketing, bathing, house building) invite different formal strategies for achieving the relevant effect, and different media (e.g., film, photography, the written word) have available different toolkits of formal techniques. The selected formal strategies often reflect consideration of the temporal, spatial, and performative character of the pro-filmic process being represented.

In the medium of film, the most important resources for the representation of pro-filmic processes are *editing and fast motion* for long processes, and *slow motion and animation* for short processes. To shape the spatial representation of a pro-filmic process, *framing*—in particular, shot scale, camera angle and height, as well as point of view—becomes especially relevant. The selection and direction of the *performances* and operations of (social) actors and of machines, respectively, are also sites for curation. Let us consider these in turn.

Editing and Fast Motion: Long Processes. If it were true that processual representation is degraded when editing is used to elide time, then the fullest expression of the process genre would be the standard craft demonstration such as the one described by Washburne, in which the spectator observes a process live, from beginning to end, in real time. After all, even "filming in real time" is not free of temporal ellipses because of the apparatus's inability to reproduce the infinitude of time that belongs to the experience of lived time. The camera apparatus can give us sixteen or twenty-four or thirty or forty-eight, and so on, actions per second, but it can give us no more actions than the highest frame rate in existence.

Film is a privileged medium for processual representation not merely because of its durational character, but also because—unlike other durational forms (e.g., craft demonstrations)—it can easily elide time. With editing and fast motion, film can present long processes (such as the multi-hour safe-breaking episode in *Rififi*) that would not be easily presentable in the form of a live demonstration.[15] Think of television cooking shows, which often employ processual representation. Elliptical editing is a way to elide the dead time of tasks such as slow-cooking pulled pork or marinating tandoori chicken or finely chopping two cups of cilantro. The use of ellipsis in processual representation points to something important about the *representation* of process: not every step, not every action, is equally important from the point of view of representation, though it may be of utmost importance from the point of view of the process's result. There are steps, *and then there are steps*. Marinating chicken in yogurt for several hours is a crucial step in the process of making tandoori chicken. And that marination is itself a process whose end result is a thoroughly seasoned, tenderized chicken. But representing the stages in the process of a twenty-four-hour marination (from slightly marinated to thoroughly marinated) is not required and thus easily omitted from representation. Only select moments need to be shown.

In my written descriptions (which are themselves processual representations) of the processes depicted in the exemplary sequences described earlier, I enumerated a series of completed actions usually connected to an action verb. Step 1: Nanook "*cuts* a square block of ice from the ground." Step 2: he "*carries* it back to his newly constructed dwelling." Step 3: he "*sets* the ice block on the igloo." Step 4: "with his long-bladed knife, [he] *traces* the outline of the ice block on the igloo's roof." Such an enumeration of steps reflects my judgment about which are the consequential actions. In this case, the process is the installation of a window. I do not describe each footstep Nanook takes as his left leg follows his right on the way back to the igloo from the white expanse, nor do I mention the positions that Nanook's arm passes through as he raises it to trace the outline of the ice window. However, I could have omitted step 2 or step 3 from my description of *Nanook*, as those steps might seem less consequential than step 1. Every *representation* of process—whether discursive or image-based—has been "curated," and often the curation has involved editing.

Slow Motion and Animation: Short Processes. One might think that there are processes that are too short in duration for processual representation.

But in theory, even a very short pro-filmic process could be represented processually through the use of slow motion or by animating hand-drawn renderings of the steps in the process. The limit case for photographically capturing processes might be a process that, in duration, is equal to or shorter than the fraction of a second that may be recorded by the fastest camera in existence. Such a process could generate only a single frame, which would represent some fraction of a second. A single frame is basically a still photograph, and a still photograph (of a single action) cannot be a processual representation, for processual representation requires at least an approximation of duration. Without duration, there is no sense of a beginning, middle, and end. So Lewis Hine's photographic work portraits may be representations of labor—snapshots of a labor process—but they are not processual representations, because each image represents a single instance and gives no sense of duration. However, the intaglio engravings of commodity production in Diderot's *Encyclopédie*, despite their two-dimensionality, give the impression of a process that unfolds in time by including, in each single image, multiple figures at work, the clear separation between work stations (marking distinct steps in the process), the use of numbering, and a circular arrangement to suggest a process that unfolds in time with a definite beginning, middle, and end (figure I.7).[16]

In practice, because of standard projection speeds (twenty-four frames per second [fps] and up), a process of one second—say, a slow-moving human's single step—would, if it were projected at the same rate as its capture, be difficult to *apprehend* as a process on film because it goes by too quickly. But with the help of slow-motion effects, even such a short process could conceivably be elongated and thus apprehended as a process.

Consider the example of chronophotography in which a horse's gallop or a soldier's step or a single rowing cycle is a process decomposed into twelve or more sequentially ordered component parts and thus rendered visible to the beholder as a process with a definite beginning, middle, and end (figure I.8).[17] The resource at issue in this example is not slow motion, as chronophotography has used other techniques—that is, the placement of images on a page—to render processes visible as processes.[18]

Framing. To render a process visible as a process, shots must be framed in such a way that the viewer can assess the progress of the unfolding action. Depending on what the activity is, this may call for a medium shot, as in *Nanook*. If we had been given a close-up of Nanook's face or of his hands or an extreme long shot, we would not have been able to see the effect of his

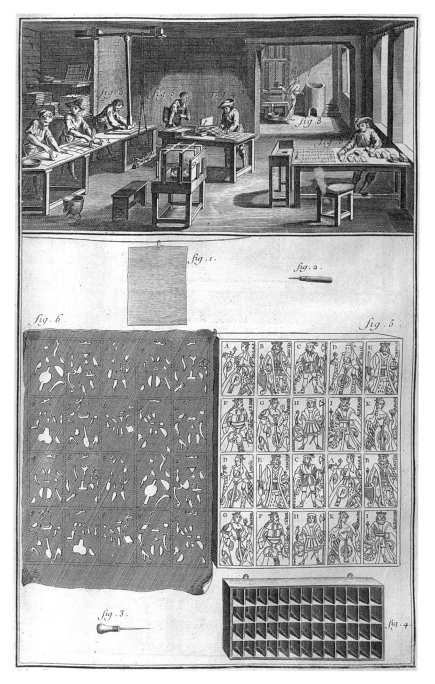

FIG. I.7 Cartier (card maker), *Encyclopédie ou Dictionnaire raisonné des sciences, des arts et des métiers*, vol. 2 (plates) (Paris, 1763). Courtesy of the ARTFL Encyclopédie Project, the University of Chicago.

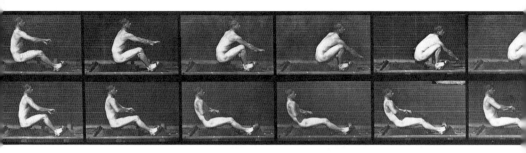

FIG. I.8 One rowing cycle. From Eadweard Muybridge, *Animal Locomotion: An Electro-Photographic Investigation of Consecutive Phases of Animal Movements, 1872–1885* (Philadelphia: University of Pennsylvania, 1887), plate 328.

activity on the ice window. In the case of *El Velador*, an extreme long shot is necessary for the viewer to see the night watchman watering the ground in the shape of a square. If his activity had been given to us in a medium shot, we would not have been able to tell what he was doing. The decision about shot scale is governed by the imperative to make the action visible as a process.

The same imperative governs decisions about camera angles, camera height, and point of view. Point of view is particularly interesting. While the processual representation need not take the precise point of view of the acting agent (e.g., *El Velador* does not), the representation cannot be from the perspective of the material being acted on. This is so because there is no way to assess the progress of the action unless one has the object of action in view. The point of view must be a point of view *on,* not the point of view *of,* that which is having something done to it (i.e., that which is being worked on).

To see why, we might consider the case of many intentional Autonomous Sensory Meridian Response (ASMR) videos. Autonomous Sensory Meridian Response is a recently identified sensory phenomenon associated with the physical sensation of tingling, particularly in the head and spine, that produces an associated feeling of relaxation and well-being.[19] The sensation is often experienced in response to audiovisual "triggers"; as a result, there are now several online communities devoted to sharing triggering videos, many of which have been produced for this very purpose. While several ASMR videos employ processual representation, the most paradigmatic do not; instead, they emphasize sound, in particular the whispering of a figure who appears on camera narrating and miming a sequence of quotidian actions (i.e., a process). I have in mind three example videos—of someone giving a haircut, of someone dressing another person's upper-body wound, and of someone applying makeup to someone

else.[20] In the videos, the image focuses on the face of the agent, while the sound amplifies the agent's manipulation of the tools and materials of the relevant trade. Although these pro-filmic actions are processes with identifiable beginnings, middles, and ends, in the ASMR renditions they are filmed from the perspective of the patient, not the agent; the image track tries to mimic the perceptual subjectivity of the figure *receiving* attention rather than the one doing the attending. The effect is that the processual character of the process is mysterious and largely unintelligible. Because the spectator has visual access not to the actions and their immediate effects but, rather, to the face of the agent at work, there is no way to assess progress visually from one step in the process to the next. Only the voice-over narration that accompanies the videos, narrating what is being done, provides any sense of a sequence with a beginning, middle, and end; it is much like a discursive recipe read aloud. But even this vaguely processual narration is of secondary significance as the words are mere vehicles for formal sound qualities such as the timbre and breathiness of the whisper and the clinking, clanking, and crinkling of instruments and matter.[21]

Performance. The curation of processual representation can also involve the performance of actors, social actors, and machines. In processual representation, the performance of people and machines is often presented as fluid and skilled; it rarely includes detours, diversions, or mistakes. Notice that in the long-take example sequences I begin with, the processes of window installation, pickpocketing, bathing, and watering the dusty ground in the shape of a square have been rendered continuously, without digressions or interruptions. The night watchman of *El Velador* does not pause midway through the watering process to get a cup of coffee; Jeanne Dielman does not step out of the bath mid-soaping to retrieve another bar of soap; Nanook does not go in search of his long-bladed knife before making the opening for the window in the igloo. Nor do the sequences include moments of equivocation or experimentation as the character decides which way to proceed or, having decided on a course of action, switches gears or tries to learn on the spot how to, for example, cut through ice. The eschewal of interruptions, digressions, or experimentation in the performances of actors and social actors alike is a feature of processual representation. The strategies for avoiding such detours vary, ranging from doing multiple takes (to get a smooth one) to deliberately selecting skilled social actors or rigorously training actors, as was the case with Delphine

Seyrig in the production of *Jeanne Dielman* and with Bresson's automatism method for directing actors.[22]

The inclusion of interruptions, digressions, or experimentations is as anathema to the process genre as it would be anathema to a recipe or to a how-to manual.[23] How-tos are necessarily repeatable protocols; they are the result of experience and tradition, sedimented knowledge, best practices—skill. Although film, by its nature, records the singular instance, processual representation displays its generic, universal aspirations by eschewing interruptions and digressions. Moreover, these interruptions and digressions (when they are present) arrest the absorption of processual representation.

Modern Times (Charlie Chaplin, United States, 1936) presents an instructive counterpoint to processual representation as it elevates the disruption of the industrial production process in the film's opening sequence to a formal conceit. The beginning of the film thus functions to halt a certain kind of absorption and to particularize and individualize the industrial worker that the film analogizes to sheep in one of its opening shots. A few minutes into *Modern Times*, Chaplin is working on a conveyer-belt assembly line tightening bolts with two wrenches. Suddenly he has an itch and scratches his armpit. This interrupts his work; he falls behind. Trying to catch up, he knocks into the worker next to him on the assembly line. This attracts the attention of the shop foreman, who berates him. Chaplin defends himself; he tries to explain what happened, gesturing with his arms. He falls behind again but manages to catch up by temporarily speeding up his own gestures. Then a fly starts buzzing in his face. He tries to swat it away with his wrench-wielding hands. Now he has fallen behind again, but this time he quickly recovers. The foreman comes over and whacks the fly on Chaplin's face, which sends Chaplin reeling, but he manages to resume his work. Then one of his wrenches gets caught on the metal plate whizzing by; in his attempt to release it, he knocks into his neighbor, who in turn knocks into *his* neighbor. Both respond angrily. The conveyer belt must be momentarily halted as the foreman intervenes. Later in the film, a similar conceit is used in the feeding machine segment in which an engineer is demonstrating a Rube Goldbergian invention designed to feed a worker lunch while he continues to work, uninterrupted, on the assembly line. The machine begins its smooth and efficient demonstration, only to spectacularly malfunction and break down, mauling Chaplin's face with a corncob and dumping soup on his chest.

Modern Times's representation of factory production is anti-processual, as the operations of workers and machines are subject to constant disruption.[24] In this case, the smooth and efficient functioning that one has come to expect in representations of factory production is thwarted by the "flawed" performance of the operator and of the feeding machine.[25]

Subject Matter for Processual Representation

So far we have seen various ways that filmmakers can use the resources of film to produce processual representations. But if processual representation is a formal achievement—a way to make a process in life look like a process in representation—some processes lend themselves more than others to this approach. The process genre favors visible movement. My exemplary sequences all represent actions involving visible physical movement, whether of the human body or of machines. It is largely because the actions are kinetic that they can be rendered sequentially on film.[26] Nonkinetic, mental processes such as adding together two plus two or remembering where I left my keys are not available for a similar kind of *photographic* deconstruction and recomposition.[27]

The centrality of movement and its subjection to a sequential structure in most of the sequences I describe demonstrate why they may be fruitfully compared with the late nineteenth-century photographic motion studies of animal and human locomotion (and of human labor) in the work of Étienne-Jules Marey, Eadweard Muybridge, and Félix-Louis Regnault. In a way analogous to Flaherty, Dassin, Bresson, Akerman, and Almada, these chronophotographers were interested in representing the successive phases of complete action and in an analysis of those actions that ordered, and then rendered, them sequentially—but also commonsensically. Marey abandoned the graphic method he had developed for analyzing processes such as the horse's gallop and the flight of birds precisely because Muybridge's photographically based example showed Marey that the visualization of movement is more convincing when the viewer can directly correlate the image with her own sense perception.[28]

Most instances of processual representation involve the representation of technique, skill, or artifact production. While it is not inconceivable that other kinds of kinetic processes, such as art-making processes or artistic performances, could be presented processually (and, indeed, such attempts exist), they strain the meaningfulness of processual representation and

thus highlight processual representation's special relation to subject matter that is general, repeatable, functional, and instrumental.

Part of the power of much processual representation comes from its double register as both a representation of a particular, specific instance of process (e.g., *this* bath, *this* burglary) and as a representation of a general kind of action (e.g., bathing, burgling). This double register is manifested in the way that Washburne seamlessly moves from a particular pot made by the German potter working—in a definite way, at a definite historical moment—right in front of her eyes at Hull House to her flowerpots at home via an association with the generic category: flowerpot. "My flowerpots," she writes, "made by such as he, gain a new significance. . . . The rough, red surface of them is written all over with the records of human patience, human cooperation with nature, human hopes and fears."[29]

While a processual representation of an instance of studio art making or an artistic performance could provide an after-the-fact description of an event that occurred in a definite way and in a definite historical moment, such a processual representation would likely not be simultaneously apprehended prescriptively, as a how-to. Each subject matter presents its distinct challenges for meaningful processual representation.

There are examples of processual representations of studio art making. In *The Mystery of Picasso* (Henri-Georges Clouzot, France, 1956) one can see Picasso's hand—in real time—producing several drawings and paintings. In the long sequences of Jacques Rivette's *La Belle Noiseuse* (France and Switzerland, 1991), the hands of an actual painter, Bernard Dufour—rather than of the actor playing the painter character—are filmed at work on a figurative drawing.

These are indeed processual representations, but they are quite unlike the more than four hundred episodes of *The Joy of Painting*, in which Bob Ross guides viewers through a series of techniques to create representational scenes (of recognizable woods, trees, bodies of water, mountains, sunsets, mist, fire, and so on.). For example, in the first episode of the first season, titled "A Walk in the Woods," Ross demonstrates how to make "cuts" through the layers of paint with a knife to produce the impression of sticks lying on the ground, which in turn helps to "create the illusion of distance in a painting," he explains. *The Mystery of Picasso*, by contrast, is not teaching techniques; it is not a how-to.

As a thought experiment, I can imagine renaming *The Mystery of Picasso* "How to Paint like Picasso," for in some literal sense one could copy Picasso's motions, his lines, his figures to produce replicas—just as one might

do watching a *Joy of Painting* episode. Yet the Picasso film renamed would be a wry misdirection, since it is intuitively clear that to paint like Picasso is a matter of something else entirely—not technical procedures, not the mimicry of his lines and figures, but something rather more unrepresentable. In *The Mystery of Picasso*, the processual representation quite misses its mark, because the *kind* of process represented is an artistic one and, although it may be conceivably repeated, the repetition would be meaningless from the perspective of art production. The processual representation of Picasso at work might be interesting for Picasso studies, but not for understanding something consequential about how to make *art*. Perhaps this merely confirms the common sense captured in the title of James Elkins's book *Why You Can't Teach Art* (2001).[30]

In the case of artistic performance, the difficulty is different. Consider the difference between trying to represent how to do a fouetté pirouette processually and trying to represent Alvin Ailey's *Revelations* processually. What would a processual representation of a fouetté look like? It could be rendered in the form of pictorial instructions: one could show a few different positions of the leg as it makes its way to a passé position and then show the body in different phases of the pirouette, leaving out innumerable intermediate positions. But a demonstration of a fouetté (which would show the pirouette in its entirety, leaving out nothing)—like the craft demonstration that Washburne describes—might also constitute a processual representation. While the first approach to the representation of a fouetté would be easily recognized as a how-to, the second approach leaches into a solely descriptive representation and thus exerts a certain pressure on the notion of processual representation. But still, the nature of the fouetté as a semantic unit in much dance choreography lends to it the kind of futurity characteristic of processual representation. Like the pot in Washburne's account, even a real-time demonstration of the fouetté must evoke its generic, useful, repeatable character.

The case of a processual representation of Ailey's *Revelations* is categorically distinct.[31] *Revelations* is above all choreography; as it happens, it is choreography that is performed by the Alvin Ailey dance company every season. In some sense, choreography is like a recipe, and some have attempted to use one dance notation or another to document dances for future performance. Conceivably, *Revelations* could be represented processually using dance notation, diagrams, and so on. Still, a cinematographic recording of a performance of *Revelations* in its entirety would be the most natural form of a processual representation. But notice: such

a representation could not contain any ellipses. Ailey's *Revelations* may have a beginning, middle, and an end; it may be a kind of process. But it is the kind of process in which every moment—every pirouette, every dégagé, every tendu—counts. The "result" of *Revelations is* the set of all its moments. (One could not understand how to perform *Revelations* if large portions of the piece were elided.) Such a representation, of the piece in its entirety, would amount to a filmed demonstration. But unlike with the filmed demonstration of a fouetté, a filmed "demonstration" of *Revelations* would look like a representation of an artistic performance—its prescriptive, how-to valance would be effaced. While perhaps technically a processual representation, its how-to character would be overwhelmed by the differential significance of a filmed performance. The fouetté was a recognizable semantic unit of dance, but a performance of *Revelations* is an artistic representation that mobilizes a distinct set of criteria for judgment. One judges art differently from a how-to. No matter the beauty, the grace, the extension of the demonstrator of a fouetté, if the demonstration is too quick or captured from an adverse angle and difficult to see, the processual representation would be a poor one. The point that I wish to emphasize is that one usually recognizes processual representation from the *kind of knowledge* it pretends to provide and from *the way* it absorbs the viewer. Certain subject matter can get in the way of this recognition and is therefore ill suited for a processual treatment.

ABSORPTION

The exemplary sequences described earlier are among the most widely praised and best loved in the history of global cinema. We have seen that they have a lot in common: they present processes of human form-giving activity in the style of a filmic how-to manual. But this is probably not what we remember about these sequences. What we remember is how they made us feel—absorbed, mesmerized, hypnotized, transfixed, fascinated. And we remember this because it somehow caught us off guard. Who would think of ice-window installation as high drama, replete with suspense and surprise? Who could imagine that thirty-three wordless minutes devoted to breaking into a safe could be so enthralling?

Critics testify to this effect. Of that *Rififi* sequence, Jamie Hook writes that it is "tingling, ecstatic," and Pauline Kael writes that it is "engrossing" and "absorbing."[32] "Hallucinatory," appealing to "our pure attentiveness," says the French theater scholar Jacques Guicharnaud.[33] Accounting for his

own response to the igloo window sequence in *Nanook*, the ethnographic filmmaker and scholar David MacDougall writes:

> Flaherty uses a technique of arousing curiosity and then satisfying it. . . . The technique might be thought to *distance* us from Nanook's world, since Nanook is manifestly always one jump ahead of us in understanding, but the effect is *curiously the opposite*. As the ice window slides into position, we have a moment of elation at this ingenuity, as though we had thought of it ourselves. We find ourselves placed within the communal resonance of a small but satisfying achievement as though we were present at the event, much as we might join in the satisfaction of changing a tire while actually doing no more than hold[ing] the tools.[34]

Nanook, Pickpocket, Rififi, Jeanne Dielman, and *El Velador* all depict handwork. Yet even when machines are doing the work, observers have been known to take great pleasure in witnessing it. In an 1894 interview with *McClure's Magazine*, Jules Verne reveals one of the abiding fascinations of his childhood:

> No, I cannot say that I was particularly taken with science. . . . But while I was quite a lad I used to adore watching machines at work. My father had a country-house at Chantenay, at the mouth of the Loire, and near there is the government machine factory of Indret. I never went to Chantenay without entering the factory, and standing for hours together watching the machines at work. This taste has remained with me all my life, and to-day I have still as much pleasure in watching a steam-engine or a fine locomotive at work as I have in contemplating a picture by Raphael or Correggio.[35]

A parenting guidebook published in 1954 with practical suggestions for children's activities recommends "watching machines and gadgets in action," noting, "The operations of machines and mechanical gadgets of all sorts fascinate youngsters. Some exert an almost hypnotic appeal. All bear investigation."[36] The philosopher of the history of technology Otto Mayr introduces his 1976 volume on philosophers and machines by highlighting the "intellectual, almost spiritual appeal of machinery." He continues, "Construction, operating, even watching machines provides satisfactions and delights that can be intense enough to become ends in themselves. Such delights are purely aesthetic. . . . It should be recognized . . . that the fascination and delights of machinery are a historical force, insufficiently appreciated perhaps because of a cultural bias, but nevertheless real, a

force that has affected not only technology but also philosophy, science, literature, or in short, our culture at large."[37]

Contemporary commentators on the staggering popularity (billions of views, tens of millions of fans) of BuzzFeed's Tasty "hands and pans" videos on Facebook strive to articulate the precise effect of the form on adult viewers.[38] Writing for *The Cut*, Dayna Evans describes not being able to look away when she encounters them on her feed:

> Inevitably, the Zen-like state that they put me in—who doesn't like to see a task go from start to finish in under one minute—caused me to seek them out myself in times of panic or desperation. They are the basic salve to all ills. I may never make chocolate galaxy bark, but it helped me not lose my mind on Monday. In fact, I've never made *any* of the dishes on Tasty's site, and I probably never will. To me, that's not the point.[39]

While exemplars of the process genre display this quality of absorption to a greater or lesser degree, I would maintain that at the heart of the process genre—its secret—is its capacity to absorb us in the drama and magic of labor.

I use the term "absorption" as shorthand for what I take to be a common experience of immersion when one is faced with processual representation. But whether we use the term "absorption" or another proximate term, such as "immersion" or "fascination" or "enchantment," there are two points I wish to emphasize about this spectatorial effect of processual representation.

First, it is a very familiar effect that has been attributed by different authors to particular works of art, to particular media, to particular everyday experiences. For example, in her treatment of enchantment, Rita Felski conjures this aesthetic experience as it pertains to certain works across media. Her phenomenological description incorporates several of the words the commentators cited earlier have used to approximate their experience of processual representation:

> Wrapped up in the details of a novel, a film, a painting, you feel yourself enclosed in a bubble of *absorbed attention* that is utterly distinct from the hit-and-miss qualities of everyday perception. . . . Descriptions of enchantment often pinpoint an arresting of motion, a sense of being *transfixed*, *spellbound*, unable to move, even as your mind is *transported* elsewhere. Time slows to a halt: you feel yourself caught in an eternal, unchanging present. Rather than having a sense of mastery over a text, you

are at its mercy. You are *sucked in, swept up, spirited away*, you feel yourself enfolded in a blissful embrace. You are *mesmerized, hypnotized, possessed*. You strain to reassert yourself, but finally you give in, you stop struggling, you yield without a murmur.[40]

If Felski asserts the transmedial character of this experience, Michael Fried has drawn distinctions across media. Whereas in the medium of painting Fried considers beholder absorption—that is, a "state or condition of rapt attention, of being completely occupied or engrossed"—historically contingent (i.e., the same works strike historically placed beholders as absorptive in one historical moment and as theatrical in another), he considers cinema constitutively absorptive.[41] Of course, the absorptive character of cinema is practically a cliché in popular as well as scholarly treatments of the medium's specificity. In the sphere of everyday life, John Dewey characterized "all those who are happily absorbed in their activities of mind and body," from the poet to the mechanic to the housewife tending her plants, as being involved in an aesthetic experience.[42] Meanwhile, the psychologist Mihaly Csikszentmihalyi has developed a self-help program for achieving happiness derived from his theory of "flow"—that is, "a state of optimal experience characterized by total absorption in the task at hand: a merging of action and awareness in which the individual loses track of both time and self."[43] From this abbreviated inventory it should be clear that the experience of absorption in art and in life is widespread. Moreover, watching a process or watching someone absorbed in a process and engaging in one oneself produces similar phenomenological effects on the observer and the doer. Still, what makes the absorption of processual representation a noteworthy effect rather than just par for the course?

Before addressing this question, there is a second point that bears emphasis. While absorption does not map precisely onto narrative, the two terms are closely correlated. It is not a coincidence that in "The Cinema of Attractions: Early Film, Its Spectator and the Avant-Garde," Gunning uses the phrase "diegetic absorption" as a contrast to the "exhibitionist confrontation" of early cinema.[44] The association of absorption with narrative is strong enough that narrative—which is not the sole province of fiction—is often taken for granted as the catalyst for absorption in all media. For example, only after discussing the phenomenon for a few pages in *A Feeling for Books* does Janice Radway gloss the novelist Reynolds Price's notion of "narrative hypnosis" as "a phrase that underscores the deep involvement of the body in the act of reading," leaving the modifier "narrative" unremarked.[45]

Victor Nell's *Lost in a Book* makes clear that getting lost in a book is a phenomenon that belongs as much to fiction as to narrative nonfiction, as much to the final entries of Captain Scott's journals as to a "newspaper account of tankcar derailment that sends poisonous fumes creeping toward a sleeping community."[46] What unifies these instances for Nell is what he calls the "witchery of a story" or "story magic."[47]

I propose that narrative is indeed useful for thinking about absorptive spectatorial effects in the process genre. But the sort of rudimentary narrative at play—what Peter Hühn calls "process narration"[48]—is one that does not rely on human characters or psychological identification, instead using structural conceits to generate interest. The surprise, the noteworthiness, of processual representation's absorptive effects thus owes to unacknowledged assumptions about what sort of subject matter and formal treatment can produce the quality of immersion described by Felski. And so, one *New York Times* writer endeavoring to pinpoint the source of people's fascination with "hands and pans" videos quotes a Facebook commenter smitten with the Tasty producer Scott Loitsch's very popular churro ice cream bowl video (over 183 million views): "'Call me a nut, but is it wrong that I can't take my eyes off the guy's hands? I want to know what the rest of this man looks like, and if he's single.'"[49] It is a funny line and one that notes the video's effect ("I can't take my eyes off the guy's hands") while trying to attribute the effect to something intelligible and familiar (often associated with narrative), such as the fascination with an attractive actor/character ("I want to know what the rest of this man looks like") rather than to the *unexpected* fascination of faceless process. The narrative dimension of the fascination with the characterless process is what bears investigation.

LABOR AND TECHNOLOGY

My exemplary sequences are all representations of labor, which is not to say that they are representations of wage labor. *Peek Frean* represents wage labor, but *Nanook, Rififi, Pickpocket,* and *Jeanne Dielman* do not. While it is common to think of labor as restricted to paid work, by labor—and following from the Hegelian and Marxian tradition—I mean form-giving activities, which include paid labor as well as unremunerated labor.[50] Moreover, form-giving activities encompass work in industry, craft, and agriculture, certainly, but also hunting, gathering, foraging (e.g., picking an apple from a tree); the labor of social reproduction, including cleaning and caring; affective labor; and the labor involved in manipulating sym-

bols, as in computer programming and teaching.[51] The activities pictured in my sequences are such form-giving activities: in *Peek Frean* and *Nanook of the North* they involve fabrication (of biscuits and ice windows); in *Rififi* and *Pickpocket* they involve a kind of foraging; in *Jeanne Dielman* they involve social reproduction; in *El Velador* they involve the transformation of matter (from dry to wet).

In the process genre, whether the form-giving activity depicted is waged or unwaged, whether it is *thought of* as skilled (as in *Nanook of the North*) or unskilled (as in *Rififi*, *Peek Frean*, *Pickpocket*, *Jeanne Dielman*, and *El Velador*), all form-giving activity is *treated* as skillful. Even when the process genre is depicting not labor but merely movement, such as walking, the movement itself is treated as an exercise of skill. Even when the movement depicted is that of machines, the machines are shown to be well designed; they operate smoothly and are effective. What concept can bring together the effectiveness of skilled human labor, human movement, and machine operations?

The process genre is a genre concerned fundamentally with technique, which Marcel Mauss defined as "action which is effective and traditional," which involves an "ensemble of movements or actions," that "work together towards the achievement of a goal known to be physical or chemical or organic."[52] Under the rubric of technique, I would include the technique involved in craftsmanship (where the process employs tools as well as machines); the technique on display in the design and operation of machines (even those designed for mass production under a Taylorized organization of the labor process); and what Mauss called "techniques of the body," such as walking, running, jumping, sleeping, resting, eating, swimming, washing, rubbing. The first two of these categories—craftsmanship and the design and operation of machines—I say more about later. In the meantime, a word about "techniques of the body" is in order.

Arguing that the human body should be apprehended as "the first and most natural instrument," Mauss uses the phrase "techniques of the body" to highlight the ways in which actions as seemingly natural and primordial as walking are actually techniques—that is, a way of doing something that is learned, transmitted, and variable across time and culture rather than inherited, spontaneous, and unchanging. Providing an example, Mauss claims that he can recognize a woman who grew up in a convent by the way she walks, with her fists closed: "I can still remember my third-form teacher shouting at me: 'Idiot! Why do you walk around the whole time with your hands flapping wide open?'" "Thus," Mauss concludes, "there

exists an education in walking, too."[53] Of course, to consider walking, running, jumping, sleeping, resting, eating, swimming, washing, rubbing, etc. all as *techniques* of the body is to understand human activity on a continuum of practical cultural knowledge.

Moreover, for my interests here, on Mauss's capacious understanding, all human action, then, from the walking captured by chronophotography to the labor of pot making (observed by Washburne), falls under the heading, technique. Through its concern with technique, the process genre brings together processual representations of basic movement with complex representations of labor.

While the categories of technique and labor are not identical as we saw earlier, the paradigm examples of the process genre represent the technique involved in craftsmanship and the technique relevant to industrial mass production—both of which require labor. At the heart of the process genre, then, is the representation of labor. But processual representation brings out the *skilled* character of technical processes. It is an *aesthetic of labor*. As such, the representation of craftsmanship is a natural subject matter for the process genre. Because technique implies tradition (to the extent that techniques are transmissible, or teachable, between people and across generations) and tradition implies training, and training is an "acquisition of efficiency" in Mauss's phrase, techniques are also defined by their efficiency, their effectiveness to their practical aims. Thus, built into the idea of a technique is the idea of skill, competence, dexterity, craft, or the Latin *habilis*—namely, a way of "designating those people with a sense of the adaptation of all their well-co-ordinated movements to a goal, who are practised, who 'know what they are up to.'"[54] Such people are generally called craftsmen, and Mauss is not alone in his emphasis on the competence of the craftsman. Craftsmanship is widely thought to designate, in the words of Richard Sennett, "an enduring, basic human impulse, the desire to do a job well for its own sake."[55]

This basic understanding of craftsmanship is echoed in the critic Jacques Guicharnaud's reading of *Rififi*'s processual representation of the actual heist:

> The question "Will they be copped?" yields precedence to the other question, "How do they go about it?" "Noble"—such is the epithet that some critics have applied to the film. For, in connection with activities regarded as socially harmful and inexcusable, Jules Dassin has managed to evoke a fundamental and fundamentally moral theme, namely, the greatness,

the dignity of man's intelligence and labor. . . . Everything that follows the burglary scene in *Rififi* (assaying the stolen jewels, selling them to the fence, stuffing the money in a suitcase) is much less exciting than the actual robbery. If there is any danger, as has been alleged, that this film may lead some youths to take up burglary, it will not be because of the profit motive. Those on whom its "evil influence" might take effect are not the slothful who dream of "making an easy buck," but the hard workers, the connoisseurs of the job well done, the perfectionists, all who have the vocation of a skilled craftsman or precision engineer.[56]

Here Guicharnaud proposes that despite first appearances, the subject matter of *Rififi*'s representation is labor—but the traditionally vaunted labor of the craftsman.

Let us consider the example of *Rififi* in more detail. What is it about its rendering of the burglary that lends it the *impression* that the thieves are skilled craftsmen? They are thieves, after all; they produce no tangible object; they actually introduce disarray into the scene. Three things stand out. First is the systematicity of the plan. But how does the spectator know that the plan is systematic? Partly because the plan unfolds with no interruptions, mishaps, false starts, or last-minute correctives. If the process were represented as inchoate or digressive or spontaneous, it would not seem like a result of experience, care, and skill—training and tradition in a certain sense. The second feature of the representation that stands out is the thieves' facility with the instruments and their dexterous employment. But, again, how? If the movements of the actors were hesitant and fumbling rather than smooth and knowing—the result of long experience—the impression of a job well done would not have been achieved. Third is the seeming absorption of the agents in their tasks. Had the thieves been represented as absentminded or haphazard, like Chaplin in *Modern Times*, rather than as concentrated on the particulars of each successive task, the effect would have been different. The point I am making is not that the pro-filmic reality is an instance of craftsmanship (maybe it is, maybe it is not), but that the representation—because of its formal elements—conveys the *impression* of craftsmanship.

If the thieves in *Rififi* can be apprehended as craftsman, surely the form givers in *Pickpocket*, *Nanook of the North*, *El Velador*, and even *Jeanne Dielman* can be also, for as in *Rififi*, they all are cast as perfectionists, "connoisseurs of the job well done." (It may seem odd to describe Dielman as a connoisseur of bathing, but if the task of bathing is to soap, scrub, and

rinse every part of the body, one could hardly conjure up a more systematic and thorough approach than hers.) But in all of these cases, the attribution of craftsmanship applies not merely because the activities appear to be skilled and the labor competent. Craftsmanship is relevant (and it comes up in various critical commentaries) because the labor process pictured is artisanal: the craftsmen are authors and masters of the entire process, from beginning to end. On display is the "personal know-how" Peter Dormer associates with craft, as opposed to the "distributed knowledge" associated with industry.[57] Moreover, perhaps the most stable and distinguishing element in the notoriously slippery and shifting concept of craft—more stable than the perfectionism of skilled work—is its "politics of work."[58] "It is not craft as 'handcraft' that defines contemporary craftsmanship," writes Dormer, "it is craft as knowledge that empowers a maker to take charge of technology."[59]

So far I have been emphasizing the association of the process genre with the representation of the technique involved in craftsmanship. This may seem counterintuitive, given that not all processual representations present artisanal production such as that depicted in several of my examples. Indeed, processual representation primarily has been associated with the depiction of industrial mass production (i.e., the assembly line fabrication of modern commodities such as cars, televisions, or textiles) and thus with industrial cinema. One might even think that the processual syntax *is* a formal syntactic correlate of Taylorist production schemes and thus that it is intrinsically tethered to the alienation of labor in industrial capitalism. While these are intelligible associations, I would maintain the inverse claim: processual representation—even when it visualizes industrial production—evinces the spirit of craftsmanship. This is precisely what has made the process genre a favored genre among corporations. Because industrial process films track the production process from beginning to end (even when the steps are presented out of order)—from raw material to finished commodity—the spectator, unlike the factory worker, occupies a position analogous to the artisan who has knowledge of every step in the production process. The spectator, like the artisan, gets what is denied the worker: a cognitive map of the process and the concomitant satisfaction of seeing it through to completion.

There is something else. Even when the processual representation of industrial processes concentrates on the operation of machines, as in the sequence from *Peek Frean*, the interest for the spectator, I would maintain, is less the repetition of a particular machinic operation (though that might

induce a pleasant stupor) than the ingenious design and effective functioning of the machine. Who, watching *Peek Frean*, is not momentarily distracted from the child laborer to marvel at the genius of the uppermost track of the conveyer belt that collects the dough remainder for reuse? Here, I suggest, is also the spirit of craftsmanship—both because a "precision engineer" (if we deploy Guicharnaud's phrase) has invented these machines and because the machines are effective, perfectionistic maybe; they do a good job, in imitation of the skilled craftsman.[60] In a striking articulation of this sentiment, Samuel Goodrich expressed his wonder in 1845 at the dexterous functioning of the cotton mill:

> The ponderous wheel that communicates life and activity to the whole establishment; the multitude of bands and cogs, which connect the machinery, story above story; the carding engines, which seem like things of life, toiling with steadfast energy; the whirring cylinders, like twirling spindles, the clanking looms—the whole spectacle seeming to present a magic scene in which wood and iron are endowed with the dexterity of the human hand—and where complicated machinery seems to be gifted with intelligence—is surely one of the marvels of the world.[61]

Rather than comparing the human being to the machine, Goodrich sees through the machine to the intelligence of the human being who labored to design it.[62]

While it is a Ruskinian commonplace to oppose the crafted to the machined, to exalt flawed human endeavor in the one and lament machinic perfection in the other, it is the craftsman (in an older tradition) that has long been identified with perfectionism and the job well done. Indeed, as Dormer has argued,

> The model of perfection that technology delivers is not set by machines but by humans. We set up machine technology to achieve more efficiently that which we can nevertheless and with great effort achieve without machine technology. The standards of "perfection" that are so often ascribed to the example of machine production were set first by human imagination and craft achievement. . . . There is a tendency . . . to see regularity, neatness and "perfection" as cold, and irregularity as "warm." But regularity is as much a human desire as irregularity and some people feel warmly emotional towards the precision of a motor vehicle, an aircraft component or a machine tool as others do towards carved stone or textured pots.[63]

The process genre in its representation of technical processes—whether craft or industrial—delivers the impression of regularity, neatness, perfection, and skill, as well as an artisanal organization of the labor process. This is the ethos of craftsmanship at whose core is the humanist and materialist insight expressed, without shame, by Roland Barthes in his discussion of the plates of Diderot's *Encyclopédie*. Referring to a plate depicting—processually—the activities undertaken in an artificial flower maker's workshop, Barthes writes, "Not only does nothing recall the flower, but even the operations which lead to it are constantly antipathetic to the idea of the flower: these are stampings, stencilings, hammer taps, punch-outs: what relation between such shows of strength and the anemone's fragile efflorescence? Precisely a human relation, the relation of the omnipotent praxis of man, which out of nothing can make everything."[64]

Of course, the aura of craftsmanship that attaches generally to processual representation has a different significance—and suggests a very different politics of work—depending on what sort of labor is being depicted. After all, representing artisanal labor as craft is one thing, but representing assembly line labor as craft-like is quite another. For the boy in *Peek Frean* whose job it was to continuously feed the conveyor belt with empty metal baking sheets, the difference is of central importance.

MATERIAL CONSCIOUSNESS

I said earlier that all the sequences I have described involve technique, whether techniques involving external instruments (as in the biscuit making and hosing sequences, where machines and tools are being used) or techniques of the body (as in the bathing sequence, where the primary instrument is the body). Technique implies not only instruments but also materials. After all, instruments work on matter. A person walks on sand, on concrete, on grass; she sits on wooden chairs, metal stools, overstuffed sofas, the tile floor. Her technique of walking or sitting is shaped by matter.

Instruments—whether the body or an external tool or machine—and material are central to the fascination of my example sequences, which, in scrutinizing technique, also reveal something about the transformative relations among force (labor), instrument, and material, as well as something about force, instrument, and material as things in themselves, each with its own distinctive properties.

The sequences, to a greater and lesser degree, impart a "material consciousness," to use Sennett's phrase—that is, they impart a palpable, syn-

esthetic sense of matter, both instruments and the material that resists their force.[65] The fascination and heightened awareness of tools and materials often depends on a gesture of defamiliarization. *Rififi* transforms an umbrella from a tool of deflection into a tool of collection; in *Pickpocket*, a man's hands become dainty, nimble, almost autonomous dancers; in *El Velador*, the hose acts as a kind of paintbrush. A similar defamiliarization is at work in relation to material: *Nanook* registers a distinctive quality of the material ice—namely, its translucence—that is surely one of its neglected use values for the Western spectator. In the *Jeanne Dielman* sequence— where the body acts as both instrument and material—the body, which is usually thought of in terms of its singularity, is suddenly apprehended for its symmetry and duality: every part on the left side has its counterpart on the right, every front face has its backside. In *El Velador*, water—both instrument and material—morphs from lifegiving substance into a means of petrifying unruly dirt.

Several of these sequences employ other formal resources besides narrative conceits in their efforts to heighten material consciousness. One resource is sound. The thirty-three-minute heist sequence in *Rififi* has no dialogue, but its use of sound is key. The soundscape is dominated by the heightened sound of the encounter of labor, instruments, and materials: the clacking of metal instruments as they are assembled; the prying apart, piece by piece, of a surprisingly thin veneer of wood floor tiles; the muted sound of a mallet buffered by a thick sock covering it as it pounds a chisel; the scratchiness of the matchbox Dassin opens to store his half-smoked cigarette. The soundscape synesthetically evokes the haptic quality of the materials: the hard coldness of metal, the graininess of wood, the woolliness of wool, the coarseness of the matchbox's striking surface. In *El Velador*, the final sequence amplifies the sound of water hitting the dirt, of the wind, and of Martin's shuffling footsteps on the dusty ground. We know that the ground is being *sprinkled* with water not so much because we see Martin's fingers redistributing the water from the hose, but because of the sound the water (seems) to make as it hits the ground and because the flat square shape could not have been achieved by a single, thick, water stream. The sound of Martin's footsteps on the ground conveys the dryness of the ground; the sound of wind suggests the dustiness of the air. This environment—marked by dry land and strong wind—makes the reason for Martin's activity almost comprehensible.

Another resource in the quest for material consciousness is duration. Without the length of Jeanne Dielman's bathing sequence we would not

have apprehended the relentless symmetry of the body. Other resources might include the use of the close-up or of light, as in the shot from *Rififi* in which almost buoyant debris catches the light cast by the hole in the floor as it floats to the ground.

But what does this material consciousness amount to? One paradoxical feature of this materialism that insists on the physical qualities of instruments and raw material (e.g., concavity, translucence, wooliness), on their presence as things in themselves, is that it deinstrumentalizes what are, at bottom, instrumental activities: bathing, burgling, pickpocketing, building. Thus, representationally, it lends (or perhaps restores) to practical activity an aesthetic dimension; art and technology reunite. Moreover, defamiliarized materials and instruments set the stage for invention and innovation. Attentiveness to the material qualities of objects makes possible learning and repurposing, which are manifestations of human intelligence and at the core of technological development.

As a consequence of the materially conscious approach that my examples take, they suggest a definite vision of skill that is ecological, on the one hand, and insider, on the other. In an ecological approach to skill, skill, according to Tim Ingold, is "a property not of the individual human body as a biophysical entity, a thing-in-itself, but of the total field of relations constituted by the presence of the organism-person, indivisibly body and mind, in a richly structured environment."[66] The anthropologist Gregory Bateson insisted in his account of a skilled woodsman felling a tree that the entire man-ax-tree system (i.e., labor, instrument, raw matter) demanded researchers' attention.[67] In my sequences, to a greater and lesser degree, the medium-specific resources of cinema (such as sound, editing, cinematography, etc.) underline, to a greater and lesser degree, an ecological approach by stressing the sensuousness of the environment.

Still, the perspective of the maker is central. The haptic character of the sequences helps to convey the importance of perception to learning a skill—even if the representations are not intended didactically; it brings watcher and doer into close proximity. Here haptic visuality—the mode of reception in which one perceives the figure with detailed textural intricacy—and kinesthetic empathy or sensorimotor identification come together.[68] Learning a skill, it has been argued, is not a matter of mere observation and mechanical imitation. Scholars of education in skill have pointed out that "through repeated practical trials, and guided by his observations, [the novice] gradually gets the 'feel' of things for himself—that is, he learns to fine-tune his own movement so as to achieve the rhythmic

fluency of the accomplished practitioner."[69] In the same way that cinema is not literally haptic, watching even a particularly haptic rendering of skilled bodies in motion is no substitute for experience and no shortcut to embodied knowledge. Still, some images are more haptic than others, and some renderings of skilled human action provide more information than others. The sequences I have discussed do not merely recapitulate a set of steps in a how-to process. Through their heightened, medium-specific attentiveness to the material dimensions of instruments and other matter, they in effect evoke the proprioception of a practitioner in action and thus invite the spectator's kinesthetic identification with the active practitioner.[70] The material consciousness of these sequences makes of them robust, sensuous how-tos—not merely cool, detached instruction manuals.

KNOWLEDGE

Although none of my example sequences were intentionally produced to be instructional, aiming to guide the action of others, commenters have often discussed them in such terms. Pauline Kael describes *Rififi* this way: "A quartet of thieves breaks into a jewelry store, and for a tense half-hour we watch as they work, silently. It is like a highly skilled documentary on how to disconnect a burglar alarm and open a safe."[71] Jacques Guicharnaud went even further in the describing the film: "What a marvelous object lesson it is, comparable to the shorts, dealing with locksmith's work or ceramics, that are used in schools, what an intensely practical demonstration! Movements of an hallucinatory objectivity make plain and 'explain' to us the art of piercing a ceiling, of putting a burglar alarm out of commission, of forcing a safe, with the admirable utensils of the burglar's trade."[72] It was rumored that *Rififi* was censored by the Paris police because they feared it would be used as a practical guide to burglary.[73] Roger Ebert describes a sequence from *Pickpocket* by writing: "Consider a sequence in which a gang of pickpockets, including Michel, works on a crowded train. The camera uses close-ups of hands, wallets, pockets and faces in a perfectly timed ballet of images that explain, like a documentary, how pickpockets work. How one distracts, the second takes the wallet and quickly passes it to the third, who moves away."[74] There is something hyperbolic in these commentators' assimilation of processual representation to practical, imitable instructions. Indeed, I take this hyperbole to be a shorthand way to indicate the rigorousness of the form of processual syntax rather

than an indication of the real-world applicability of these representations of practical activities.

The commonsense identification of the process genre with the how-to, with the instructional, with the educational film—in other words, with narrowly didactic ends—indicates the genre's close relation to knowledge. We might say that this is a genre trading on the pleasures of knowing. But, the epistephilia in question here is more expansive than the mere desire to *know how* to do something that is implied by a narrow conception of the how-to.[75] And this is why processual representations—across media—often are not intended and do not function as guides to action.

Diderot's *Encyclopédie* presents a striking example of this, for it was not bound to any narrowly didactic or pedagogical functions.[76] Unlike other technical literature of the period, the *Encyclopédie* was not intended for the craftspeople it depicts, for would-be apprentice artisans, for intermediaries distributing commodities on the market, or for the average man on the street. It was designed for a literate cultural elite.[77] The historian William Reddy contrasted Diderot's *Encyclopédie* with the well-used 1723 *Dictionnaire universel du commerce*, describing the former as a "luxurious coffee-table" book.[78] Indeed, the plates of the *Encyclopédie* offer a range of pleasures—aesthetic, to be sure, but epistemological, as well. The *Encyclopédie*, Barthes writes (and surely the insight applies to its readership, as well), was "fascinated, at reason's instance, by the wrong side of things," by the desire to "get *behind* nature"[79]—to cross-section it, to amputate it, to turn it inside out, to know it.

The *Encyclopédie*'s most potent method for "knowing nature" was processual syntax. What Barthes, in his essay, terms the "genetic" type of illustration depicts—within a single frame and often in a cutaway view that pulls back the outer layer of the workshop—a series of sequential steps, appropriately numbered, that, undertaken in order, follow the trajectory of the object from raw material to finished product (see figure I.7).[80] This paradoxical "trajectory of substance," which could yield a "delicate flowered carpet" from "an enormous mass of wood and cordage" is "nothing," Barthes writes, "but the progress of reason."[81] The "progress of reason" is evident in the genetic type of illustration, surely, but it is also evident in the bifurcated plates that present, in the top portion, either a tableau vivant—usually a long view, depicting people and instruments in a naturalistic context—or a genetic view like the one in the top portion of figure I.7; in the bottom portion they present an "anthological" illustration that depicts—in close-up and with striking detail—the relevant instrument(s)

or machine(s) or material(s) usually against a blank backdrop, isolated from any context (see figure I.7):

> The image is a kind of rational synopsis: it illustrates not only the object or its trajectory but also the very mind which conceives it; this double movement corresponds to a double reading: if you read the plate from bottom to top, you obtain in a sense an experiential reading, you relive the object's epic trajectory, its flowering in the complex world of consumers; you proceed from Nature to sociality; but if you read the image from top to bottom, starting from the vignette, it is the progress of the analytic mind that you are reproducing; the world gives you the usual, the evident (the scene); with the Encyclopedist, you descend gradually to causes, to substances, to primary elements, you proceed from the experiential to the causal, you intellectualize the object.[82]

The interesting point here is not merely the Aristotelian one that posits, "All men by nature desire to know." It is that a processual syntax—whether image-based or discursive—affords peculiar epistemological insights.

Processual representation might be thought of as the representational form of what Pamela Smith, writing on sixteenth-century natural philosophers such as Paracelsus, has termed "artisanal epistemology." Artisanal epistemology refers to the species of knowledge possessed by the artisan that is not reducible to the practical knowledge of how to do or make something.[83] For Paracelsus and others, this species of knowledge challenged the stark divide that existed, into the seventeenth century, between theory and practice, for it, too, claimed a wholly philosophical knowledge of nature, but one gleaned from experience rather than from contemplation, from the artisan's intimate bodily work with living nature. In artisanal epistemology, sense perception (especially observation) and imitation (of masters and nature) are paramount; however, they are conceived as forms of cognition.[84]

Thus, as I suggested earlier, processual syntax is the syntax of the artisan because it adopts her perspective (even if it does not adopt her literal point of view). Moreover, the employment of various medium-specific resources in processual representation to convey something of the materiality of instruments and matter suggests the centrality of the artisan's experience. But the genre's evocation of this perspective—which is resolutely empirical and materialist, grounded in sensuous experience and the faculties of human sense perception—promises to generate theoretical knowledge.

Summarizing, besides the kind of practical knowledge provided by instructionals that people actually consult and imitate, the process genre exhibits a range of different kinds of knowledge. There is the knowledge garnered from discovering hidden truths about everyday things such as flowerpots and cookies, about foreign and archaic processes such as traditional Italian weaving methods, about the functioning of machines, about difficult-to-achieve tasks such as breaking into a room holding a safe without making any noise, and so on. There is the knowledge of materials and instruments, of nature—the behavior of wood when wet and when dry; the translucence of ice; the lightness of dry dirt; the leverage of a chisel. There is knowledge about the relation of cause and effect, about reasoning.

The Process Genre as a Ciné-Genre

In the preceding discussion of the marks of the genre, I focus on image-based representation, particularly from cinema. However, the process genre includes text-based how-tos that include written recipes, instruction manuals, and some didactic literature. What, then, is the relationship of the process genre to image-based media? To moving-image-based media? If the definitive feature of the process genre is processual representation, some processual representation is in words, some in images; among the latter, some is in still images, and some is in moving images. The latter, I am arguing, is the core phenomenon.

IMAGE

The discursive representation of processes has a long history, and some researchers have suggested that recipes and how-to books emerged prior to pictorial instructions, as early as the 1400s.[85] Still, the development of pictorial instructions marked a watershed moment in this story of the process genre, for pictorial instructions could decode and supplement discursive how-tos. After all, language is a limited medium for conveying the relevant information. "Craftwork," Sennett has noted, "establishes a realm of skill and knowledge perhaps beyond human verbal capacities to explain; it taxes the powers of the most professional writer to describe precisely how to tie a slipknot. . . . Here is a, perhaps *the* fundamental human limit: language is not an adequate 'mirror-tool' for the physical movements of the human body."[86] Sennett proposes the image as a viable substitute.

To the extent that the how-to in most of its manifestations and regardless of its original purpose (whether pedagogical or not) is devoted to describing physical actions—which necessarily unfold in time—it is the province of the pictorial image, on the one hand, and it is time-based, on the other. The process genre is fundamentally an image-based and durational genre. Even when its exemplars evoke a sense of touch or the sensation that we occupy another body in motion, it is the versatility of the image that is at work. And because action unfolds in time, the genre is also time-based. Film is especially well equipped to represent time, as both duration and ellipsis. I say more about this later.

MOVING IMAGE

We have seen that as a category of representation, the process genre encompasses a variety of media and media platforms; it shares exemplars with distinct film genres such as the industrial, the educational, and the ethnographic film; and it spans a broad historical period, corresponding roughly with the advent of modernity. I have proposed "genre" as a category term to capture the process phenomenon. This term has its drawbacks.[87] It is rarely used to unify a single category across different media and across time. And there has been disagreement about deriving a genre category using a retrospective, critical-taxonomic approach rather than contemporaneous, circulating classificatory terms found in reviews from the relevant period or from industry-generated materials.[88] Still, "genre" is a flexible term, and I use it here in its loosest—and most basic—sense, to designate a kind. Of course, there are other category terms, many themselves quite contested, such as "mode" or "topos" or "subgenre" or "form" that might also conceivably apply. But each of these alternative category terms is ultimately unsatisfying, although "mode" presents the strongest case for an alternative.[89]

The sense of the term "mode" relevant here posits that mode is a kind of adjectival modification of a genre, as in the tragic, the comic, the pastoral, the melodramatic. Because of its modifying function, a mode can be present in different genres and across different forms. Where one finds a characteristic that is present in different media, in the same medium from different time periods, and in different media from different time periods, it is common to understand that feature as a mark of a modality rather than as a genre convention. This is perhaps why the process genre—given its manifestations in different media, time periods, and genres—may look at first like a mode.

The texts that make up a mode are often structurally, syntactically heterogeneous but thematically specific. That is, a mode, as David Duff puts it, is "non-specific as to [literary] form and mode of representation."[90] Given a mode's promiscuity across media, this formal variation is understandable. The thematic specificity of a mode has been understood as something deeper, more robust than merely shared semantic elements. A mode has been described as having something akin to a "world view," "vision," "sensibility," "spirit," "tone," "essence."[91] So, as Fredric Jameson put it (following Northrop Frye), a mode is defined by a "generalized existential experience behind the individual texts."[92]

The scholarly treatment of screen melodrama highlights a case in which the transmediality of melodrama generated a new critical framework that apprehended melodrama as a mode rather than as a genre. When Peter Brooks introduced the notion of the melodrama as fundamentally a modality rather than a genre, he in effect brought the study of melodrama across three media—theater, the novel, and cinema—closer together. The marks of the melodramatic mode became less a set of fixed stylistic conventions than a stylistically open-ended "theatrical substratum," "a semantic field of force," "a certain fictional system for making sense of experience" in a post-sacred era in which there is a need "to locate and make evident, legible, and operative those large choices of ways of being which we hold to be of overwhelming importance even though we cannot derive them from any transcendental system of belief."[93] In Linda Williams's adaptation and popularization of the modality approach to screen melodrama, the mode of melodrama admits considerable formal, stylistic, structural variation ("proteanism") across time, place, and medium because melodrama—to achieve its moving effects—must update and modify its representational choices.[94]

Modality is a broader, more encompassing classification schema than genre. Genres, considered critical categories rather than categories of reception, are widely regarded as both thematically and formally specific.[95] Genres, it is often said, are constituted by common semantic elements, as well as by their common syntactic structures.[96] The role of the syntactic—understood as a formal, structural feature of an individual text—in genre classification suggests to me that the process genre is best treated as a genre rather than as a mode. While the process genre encompasses different media and media from distinct geographical areas and historical periods, the syntactic, formal dimension is essential to its designation across space and time.[97] In other words, the process genre is formally specific in that its expressions use a definite structure (processual representation).

PLATES 1–2 Water-powered mill. Meunier, vignette view (plate 1 [*left*]); anthological view (plate 2 [*right*]). Images from *Encyclopédie, ou Dictionnaire raisonné des sciences, des arts et des métiers; Suite du recueil de planches sur les sciences, les arts libéraux, et les arts méchaniques, avec leur explication. Deux cens quarante-quatre planches* (Paris: chez Panckoucke: Stoupe: Brunet; Amsterdam: chez M. M. Rey, 1777). In-folio (pp. 466, 468). Courtesy of La Bibliothèque Mazarine.

PLATES 3a–l Twelve steps in the production of yellow crayons. Plate 3c in the series showcases the double-spout bucket; plate 3h, the crayon-labeling machine. Frame enlargements, "How People Make Crayons" segment, "Competition (#1481): A Favorite Factory Visit: Crayons!" *Mister Rogers' Neighborhood*, season episode 81. Each frame enlargement is intended to represent one step in the process. The grid should be read from left to right, row by row (as one reads text in English). Although the grid approximate the chronological unfolding of the process from the first image on the top left to the last image on the bo tom right, this series of twelve images is not a complete visualization of the process as it is represented in the film; some steps are missing in this representation here.

a b c

PLATES 4a–c Is it finished yet? These are not consecutive shots. Each might seem like the finished picture, but only the last frame enlargement is actually the finished picture. Frame enlargements, *The Mystery of Picasso* (Henri-Georges Clouzot, France, 1956).

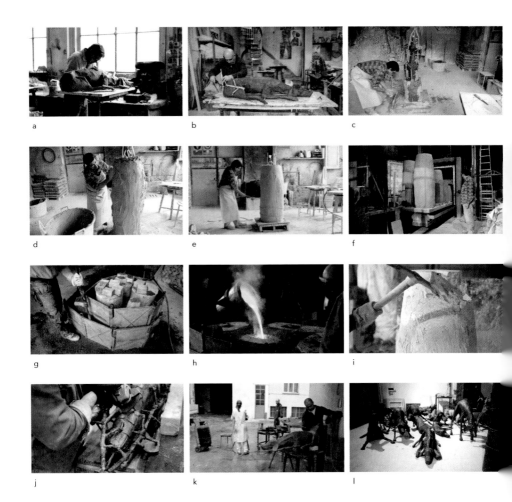

a

b

c

d

e

f

g

h

i

j

k

l

PLATES 5a–l Twelve steps in the lost-wax bronze casting process. The first step (5a) is Vitali putting the finishing touches on the wax mold. Frame enlargements, *Hand Gestures* (Francesco Clerici, Italy, 2015). Each frame enlargement is intended to represent one step in the process. The grid should be read from left to right, row by row (as one reads text in English). Although the grid approximates the chronological unfolding of the process from the first image on the top left to the last image on the bottom right, this series of twelve images is not a complete visualization of the process as it is represented in the film; several steps are missing in this representation here.

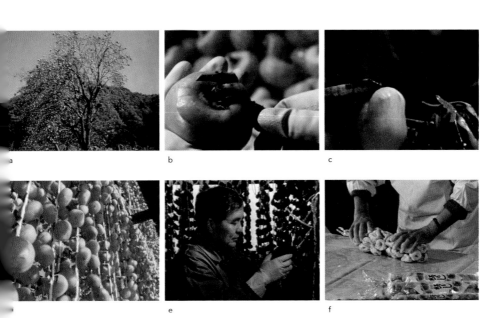

a

b

c

e

f

PLATES 6a–f Steps in the process of preparing dried red persimmons. Frame enlargements, *Red Persimmons* (Ogawa Shinsuke and Peng Xiaolian, Japan, 2001). The grid should be read from left to right, row by row (as one reads text in English). Although the grid approximates the chronological unfolding of the process from the first image on the top left to the last image on the bottom right, this series of six images is not a complete visualization of the process as it is represented in the film; several steps are missing in this representation here.

PLATES 7a–x Steps in the production process. Frame enlargements, *Dough* (Mika Rottenberg, United States, 2005–2006). Stills courtesy of Galerie Laurent Godin. The grid should be read from left to right, row by row (as one reads text in English). Although the grid approximates the chronological unfolding of the process from the first image on the top left to the last image on the bottom right, this series of twenty-four images is not a complete visualization of the process as it is represented in the film; several steps are not represented here. In addition, the grid does not correspond to the order of presentation in

the video. Instead, I am trying to reconstruct the chronological process from the disordered shots given in the video. The plates labeled a–j correspond to the first part of the process, in which the dough is kneaded and portioned. At the end of this process, the dough comes to rest (j). The images labeled k–x correspond to the second part of the process, in which the dough rises as a result of the steam produced by Raqui's tears and Tall Kat's pedaling. The 1.5 unit of dough is shown rejoining the original blob (t), and a single unit of proofed dough is pushed out, broken off from the blob, shrink-wrapped, and then piled (u–x).

PLATE 8 Preparatory drawing for *Dough*. Artist: Mika Rottenberg. Image courtesy of Galerie Laurent Godin. Compare this with plate 2.

The process genre is also thematically specific in the narrower sense that its exemplars often contain common semantic elements such as craftsmen, instruments, artifacts, workshops, workers, machines, factories, and so on. But the process genre is also thematically specific in the more robust sense that Jameson invokes to describe mode—that is, it expresses something akin to a worldview, an essence, a "generalized existential experience" related to human labor. I consider this robust thematic specificity to be the genre's "metaphysics of labor," its basic embrace of the existential, as well as the material, value of labor to human life.

The process phenomenon does not suggest an easy and obvious category designation. While its definite unity across media, time, and place indicates that it is indeed a category, the usual category terms prove inadequate. Indeed, I am drawn to the idea of genre precisely because of the fact that even other related but less usual categories, such as the "operational aesthetic," the "craftsmanship aesthetic," and "showing making," are manifestly different from the process genre.[98] Genre does not perfectly circumscribe the phenomenon, but I believe it is the best of the available category terms.

That said, while the process genre crosses media, it has a special relation to the medium of film that is manifest both in its affinity with the material substrate of the medium and in the history it shares with screen practice. The process genre's expression in cinema—the process film—is a privileged locus for studying this genre. Indeed, the process film can be profitably understood as a "ciné-genre." A ciné-genre is constituted primarily by medium-specific formal features and their concomitant visceral effects on spectators rather than by narrative elements that easily translate to other media.[99] Cinema, constitutively, has a special, medium-specific relation to process. Film is fundamentally processual: it treats time the way the process genre treats movement. If the process genre breaks visible processes (movement) down into sequentially-ordered component parts, film also breaks time down into sequentially-ordered component parts. Every second of projected film is, after all, standardly made up of twenty-four sequentially ordered instants: twenty-four still images when passed through a projector are rendered as one second of life. This basic principle holds even when the underlying technology is video or digital and when the rate of capture is thirty frames per second rather than twenty-four.[100] Moreover, like other ciné-genres, such as horror, the process film taps into a primal fascination inherent in cinematic form itself: its fascination with movement, its capacity to render processes, long and short, as sequential and linearly ordered. The index of that primal fascination is the absorption,

mesmerism, hypnotism that ubiquitously accompany both descriptions of process films and, often, of cinematic spectating itself.

Process and cinema are linked in another way. Screen practice, Charles Musser has argued, does not begin with the first public projection of photographic images in Paris in 1895 or with the invention of the magic lantern or with any other technological discovery. It begins in 1647 with the publication of a how-to manual, full of pictorial instructions displaying a process. Athanasius Kircher's *Ars magna lucis et umbrae* (*The Great Art of Light and Shadow*) was an illustrated manual that demystified the functioning of the "catoptric lamp." Kircher was not the inventor of the device, but through his manual he was its popularizer. With the publication of the *Ars magna*, the modern spectator was born, argues Musser. If the pre-screen era is defined by viewers' apprehension of reflected images in a darkened room as supernatural, magical phenomena, the screen era is defined by the spectator's apprehension of a man-made effect, a product of human labor, and the process by which that effect was achieved.[101] Cinema begins with processual representation. And the two have continued to mutually constitute their shared history.

OVER THE CHAPTERS TO COME, I present an account of the process genre. In chapter 1, "The Process Film in Context," I situate the process genre within two histories: the history of processual representation in related film genres such as industrial, educational, and ethnographic cinema, and the history of pre-cinematic expressions of processual representation, particularly craft demonstrations in international expositions and pictorial instructions.

In chapter 2, "On Being Absorbed in Work," I give an account of the special absorption produced by the genre. The chapter considers the genre in relation to narrative and to expositional structures such as curiosity, suspense, and surprise.

Chapter 3, "Aestheticizing Labor," argues that the category of labor is central to the process genre. In my account, the process genre is, in effect, always symptomatically reflecting on the interactions of human labor, technology (i.e., tools, instruments, machines), and nature. The chapter first examines the genre's relation to technique. Then it surveys the political implications of the ways in which labor is poeticized in the genre. In its most exalted examples, the process genre presents a striking paradox. On the one hand, it is the most instrumentalist of genres. After all, it is a genre constituted by the presentation of a sequential series of steps, all

aiming at a useful result; it is a genre that is usually associated with what scholars call "useful cinema."[102] On the other hand, it is a genre that has produced some of the most romantic, utopian depictions of labor in which labor figures not as that from which human beings seek relief in the form of listless leisure, but as the activity that gives human life meaning. The philosophical basis for the centrality of labor to life—what has been called the "metaphysics of labor"—finds expression in the process genre; thus, the genre stands in opposition to the politics of antiwork.

Chapter 4, "Nation Building," explores how the process genre has been mobilized for an array of racial or nationalist politics. While Fascist nation-states such as Italy under Benito Mussolini and Germany under the Nazis took a keen interest in processual representation in the development of propaganda materials, ethnographic process films have raised questions about the process genre, development, and the representation of non-Western "Others." Marxist filmmakers from Latin America have also adapted the process genre to their romantic anticapitalist political projects. The chapter surveys the implications of the process genre's frequent treatment of the relationship among nation, development, and civilization through an extended analysis of the early nonfiction process films of the New Latin American Cinema.

In chapter 5, "The Limits of the Genre," I take up the historical trajectory of the genre, inquiring into moments of exhaustion and renewal. What happens to the genre in postindustrial society? How does the genre grapple with nonkinetic forms of immaterial labor—in particular, affective labor? As its case study, the chapter focuses on *Parque vía* (Enrique Rivero, Mexico, 2008), winner of the 2008 Golden Leopard. *Parque vía* in some sense remakes Chantal Akerman's *Jeanne Dielman, 23 Quai du Commerce, 1080 Bruxelles*. The chapter explores the significance of *Parque vía*'s intertextual appropriation of *Jeanne Dielman*, which I read not as an attempt to capitalize on the prestige of Akerman's film but as a way to train spectatorial focus on the *work* of *affective* labor. The work of feeling has a different relation to time and a different potential for visualization from kinetic kinds of work—because of this, feeling, and affective labor more generally, are not easily adapted to processual treatments. *Parque vía* offers a meditation on the formal and historical limits of the process genre.

The epilogue, "The Spoof That Proves the Rule," reassesses the contemporary status of the process genre in light of a series of recent parodies or spoofs of its formal structures.

ONE

THE PROCESS FILM IN CONTEXT

THE PROCESS GENRE is defined in terms of its formal characteristics. In the introduction, I identified a slate of characteristic markers that were derived, inductively, from key film texts. While the exemplars were drawn from cinema, I emphasized that the process genre is a *transmedial* genre with a long and cosmopolitan past. One striking feature of its transmediality is its relative formal stability, which is what makes it possible to intuitively apprehend the commonalities between a film such as the 1922 *Nanook of the North* and an illustration such as the scene of card making in Diderot and d'Alembert's eighteenth-century *Encyclopédie* (see introduction, figure I.7). We can apprehend the unity of the phenomenon across time and medium as a consequence, precisely, of its formal consistency. This consistency across media and constancy over centuries invites a formalist approach to defining the genre like the one I took in the introduction, but it also raises a set of *historical* questions. When does processual syntax appear in the West? Why did it emerge when it did? And to what uses has it been put?

The aim of the present chapter is to historicize the process *film*. I do this in two ways: first, by situating the category in relation to categories such as the industrial, the educational, and the ethnographic film, all of which prominently include process films; and second, by exploring some of the genre's pre-cinematic expressions and pursuing its origins.[1]

For those who approach the process phenomenon from cinema and media studies, it may seem natural to locate the process film within the history of industrial or educational film. The disciplinary commonsense suggests that we treat the process film as a dominant subgenre of the industrial or of the educational film. But such a framework sets a certain, very limited agenda for any investigation of the process genre. In the case of the industrial film, it would privilege industrial process films and marginalize processual representations of artisanal production; it would link processual representation to Taylorism, prejudicing any serious consideration of its politics; and it would circumscribe the process film within the discourse of useful cinema, filtering out all the non- and, indeed, anti-instrumentalist instances of art process films. Most important, the framework suggested by the disciplinary commonsense would fail to explain why process films are so well represented within the genre of ethnographic film, which, after all, is a category distinct from both the industrial and educational. Treating the process film as a subgenre of the industrial or educational is a blind alley. What is required is a more expansive framework that pursues processual syntax into the past, into pre-cinematic forms.

The process genre is a genre of modernity, made necessary—I argue— by changes to the sphere of production in fifteenth-century Europe. While examples of the genre may seem to be innocent depictions of techniques of production or techniques of the body, they often have been implicitly understood to be plotting the societies they represent along a developmental trajectory from "primitive" to "advanced." Thus, in the process genre a method of production is not just a way of doing something or making something; it functions simultaneously as an index of a mode of production—and, by extension, of the status and character of a people or civilization.

As processual representation has persisted over centuries, migrating across media and across geographic space, it has served an array of different functions—it has supported nationalist and imperialist state projects; fulfilled corporate and commercial, as well as educational and research, ends; been repurposed in avant-garde and utopian aesthetic enterprises; and used as entertainment. The proteanism of its deployment has been undergirded by the stability of its form.

The Process Film

The term "industrial" first emerged around 1907 in the trade press and in the catalogues of film manufacturing companies (including Eclipse, Edison, Gaumont, Pathé, and Raleigh & Robert) as a marketing label.[2] Industrials were films depicting all variety of handicraft and industrial work processes.[3] The industrial was just one early nonfiction genre among others, including travel films, science films, nature films, scenics, and so on. In this film industry usage, the "industrial" is very close to Tom Gunning's critical genre category of the "process film": both are largely defined by their focus on a process of production, represented sequentially, and not by whether they were commissioned by industry to achieve commercially dictated objectives.

This early history of the industrial as a genre category makes intelligible the temptation to use the terms "industrial film" and "process film" interchangeably. But a problem arises because of the current usage of "industrial" as a genre designation. Contemporary scholars of industrial cinema designate the genre along other lines, displacing the criteria of inclusion in the category from formal (and thematic) conventions to the circumstances of production.[4] While acknowledging that the industrial is a "strategically weak and parasitic form," Vinzenz Hediger and Patrick Vonderau, editors of the first major collection in English devoted to industrial film, still locate its common trait "in its organizational purpose."[5] They identify three primary organizational purposes for the industrial film: "Not only have the countless number of industrial films in corporate archives all been commissioned . . . for a specific occasion . . . and a specific audience . . ., they also serve, or have served, one or more of the three purposes of record [corporate memory], rhetoric [to induce cooperation], and rationalization [practices aimed at improving performance]."[6] For Hediger and Vonderau—given that several sponsored industrial films exhibit the process films' governing structure—the process film is a subcategory, "one of the standard forms," of the industrial film.[7] Today's familiar association of industrial film with a particular institutional context—namely, being sponsored by industry itself—means that many process films (including some of those with which I begin this book), though they share similar generic markers such as sequential ordering, would not be included in the industrial genre because they were not commissioned by industry. Moreover,

the emphasis on "organizational purpose" in current accounts of the industrial film risks marginalizing process films that depict handicraft production rather than factory labor.

The problem here is that while the process film is defined by its formal, structural characteristics, the industrial film usually is not. The process film is not usefully thought of as a subgenre of the industrial. Although there is clearly overlap between the process film and the industrial film—many process films are also industrials and many industrials are also process films—not *all* industrial films are process films, and not *all* process films are commissioned by industry.

There is also a more interesting point to make in this context. Frank Kessler and Eef Masson, who have written one of the only treatments of early process films, note that many of the "generic markers" (such as sequential ordering) that the process film and the industrial share "originate outside the context of industrial organization, and, in some cases, predate the systematic use of film by industry by years, if not decades."[8] This suggests that the relevant, similar generic markers are antecedent to and not causally linked to a corporate institutional context. For Kessler and Masson, this is a reason to rethink Hediger and Vonderau's emphasis on "organizational functionality" in their definition of the industrial film. But it gives just as much reason to delink the process film from the industrial film.

While it does seem intuitive to associate process films with industrials and to imagine that these forms developed together—that the process film is the visual correlate of the Taylorized logic of the industrial production methods of the early 1900s—the history of the process genre makes it incumbent on us to read the industrial film as borrowing a syntax from preexistent, antecedent forms. Rather than assume a natural connection between the industrial and processual syntax, one should ask how they became connected. Why have commercial and corporate entities found processual syntax conducive to their organizational (and promotional) purposes?

EDUCATIONAL FILM

The process film is also represented in another, overlapping category of useful cinema: the educational film. The educational film was initially narrowly defined as film conceived and produced for classroom use, a conception associated with the production, in the U.S. context, of such entities as Eastman Classroom Films (established in 1928), Western Electric's Erpi

Classroom Films (established in 1929), and Encyclopedia Britannica Films, which acquired both of the former enterprises in 1943.

More recently, the category of educational film has been broadened to include "films that were used to teach, inform, instruct, or persuade viewers in a variety of ways and contexts."[9] This broader definition—which is a function of the *use* to which films were put rather than of their circumstances of production—has the category encompassing earlier, pre–World War I commercial films that entered the classroom circuit once their exhibition in theatrical venues declined. Elizabeth Wiatr has stressed that "the move from commercial theater to classroom signaled more a shift in emphasis and viewing context than a structural change at the level of the film."[10] So, for example, "Voyeurship of the colonial world came under the aegis of social science, while visualizing the steps of a manufacturing process became as legitimate an educational pursuit as studying the classics, if not more so."[11] In addition, educational films that were produced *expressly for classroom use* borrowed film rhetoric (including processual syntax) and even footage from commercial films, from government sources, and from corporate-sponsored industrial films.[12] Thus, process films that would have been labeled "industrials" in this period (those commissioned by industry, as well as those that were not) often also circulated as educational films.

In the United States, visual educators began using films in classrooms in the late 1910s and early 1920s. In this period, these educators turned primarily to travelogues and process films representing industrial processes. Indeed, more than half of the films in the Eastman Classroom Films collection depict industrial processes.[13] Even as early as 1907, Charles Urban, the United Kingdom–based film producer and distributor, claimed in "The Cinematograph in Science, Education, and Matters of State," his pamphlet on film and education, that educational films' natural subjects included three of five topics often treated processually in process films: agricultural cultivation, industrial knowledge, and demonstrations of trades and industries.[14] But why were process films so popular among visual educators? What did these educators see in processual syntax that they hoped to marshal toward their educational goals?

Visual educators conceived of film as a useful tool for, in Wiatr's terms, "suturing the gaps between experience and understanding."[15] In an increasingly complex, global, modern world whose underlying functional mechanisms were opaque and difficult to visualize, film could provide "vicarious experience" that would entertainingly bring the distant close and make

the recondite perceptible.[16] Film promised to transform a messy, chaotic, mystified modern world into a rational and conceptually masterable entity through training in visualization—that is, the "process of fashioning a coherent whole out of separate images, both those invented and those once seen and remembered."[17] Not only would visual instruction homogenize vision, forging modern perception for an ethnically diverse population;[18] it would stave off the growing alienation and listlessness of the future producer who understood little about the fabrication of the dizzying array of available commodities. It would also stabilize and strengthen her sense of national belonging in other ways.

Process films of industrial production were conducive to these aims. On the one hand, these films adapted to the medium of film the experiential, object-oriented approach that the Swiss pedagogue Johann Heinrich Pestalozzi had developed around the turn of the eighteenth century. The "object lesson," with which Pestalozzianism is commonly associated, involved students first observing for themselves the sense impressions made by often familiar, live three-dimensional objects.[19] That sensuous, first-person experience of the object would become the basis for an investigation that would lead progressively from the simple to the complex, from the concrete to the more abstract and general. From a certain point of view, industrial process films are like object lessons in which cinema's formal resources are marshaled to produce a sensuous (though vicarious) encounter with a commodity.

On the other hand, the process film's standard, evolutionary story that tracked the production process from raw material to finished commodity had an ideological dimension. According to Wiatr, it "tied the world together in one coherent vision of historical time, naturalizing exploitation of the land, and American hegemony."[20] But in the case of industrial process films, linking the steps in any process to the final result (i.e., abstracting from the particular) required the work of visualization, which visual educators were keen to teach. Often with the help of additional materials such as teachers' guides, maps, and diagrams, messy, complicated, multistep processes of production could be rendered (deceptively) complete, intelligible, and attractive, thus giving spectators an illusory feeling of comprehension (perhaps even ownership) and lending to the processes the impression of their excellent design and superior execution.[21]

It was not only classroom educators who saw pedagogic potential in industrial process films. Between 1914 and 1924, the Ford Motor Company's Motion Picture Department produced several process films that were ex-

hibited in a range of commercial and nontheatrical venues. They included titles such as *How Henry Ford Makes 1,000 Cars a Day* (1914), shown in the Palace of Education at the Panama-Pacific Exposition in San Francisco; *The Story of a Grain of Wheat* (ca. 1917); *Where and How Fords Are Made* (ca. 1919); and *Making Rubber Tires* (ca. 1922).[22] These process films—which circulated widely inside and outside the United States—reaching sixty million people, by one Ford company estimate[23]—were explicitly conceived by Ford as part of its strategy of educational outreach, which, according to Lee Grieveson, aimed at "shaping new modalities of 'useful' consciousness and conduct for working-class and immigrant groups who would form populations fitted to the new era of mass production."[24] In their celebratory tone, in their depictions of the time-saving feats of the assembly line, in their showcasing of efficient, new machines, these process films were, in Grieveson's words, "delineating both technological futures and the character types and positions necessary to construct those futures."[25] They were defining modern production methods against traditional ones: in comparison, the latter looked backward and inefficient. These process films were imbuing a Fordist method of production (and the workers who were cogs in its machinery) with an aura of world historical importance. While this pedagogic project served Ford's peculiar ends, it also dovetailed with the interests of a broader corporate sector that was seeking to implement new industrial labor practices and to socialize workers accordingly, and with the interests of the nation-state that was entangled with corporations, committed to the spread and success of mass production, and invested in strengthening the sense of national identity amongst a diverse and largely immigrant working class.[26]

In other national contexts, states took on a more direct role in the production and dissemination of educational cinema. Process films about industrial production were standard fare in the catalogues of state-directed entities, often serving an explicitly nationalist purpose. Here we might refer to the output of entities such as L'Unione Cinematografica Educativa and the International Educational Cinematograph Institute, both based in Mussolini's Italy; the Empire Marketing Board film unit in Britain; the National Film Board in Canada; and the Instituto Nacional de Cinema Educativo in Brazil.

In the extreme case of Nazi Germany, the National Socialists—who had taken a special interest in educational cinema, forming in 1934 the Reich Ministry for Pedagogy, Science and National Education—incorporated product advertising (among which process films are well represented) into

classroom film curricula.[27] Indeed, the Nazi "educational state" adopted an explicit policy toward advertising that, in Michael Cowan's words, "demanded not only that private advertising toe Nazism's ideological line, but also that it subordinate individual pleasure and company profits to the task of 'educating' consumers in their duties as 'Volksgenossen' [national comrades] of the new state."[28] Thus, a process film such as Walter Ruttmann's *Mannesmann* (1937), which was commissioned by a private German company of the same name that was known for its production of seamless steel tubes, circulated as an educational film to be screened in German classrooms. Cowan has argued that *Mannesmann* appealed precisely because, in its depictions of the factory fabrication of cylinders and metal plates, it suggested a useful analogy that turned on the surprising malleability of steel as a raw material. "The motif of steel production and steel usage," writes Cowan, "points toward the unexpected qualities of mass bodies—of workers and children—in Nazism's disciplinary regime: like the school children in the film taking down dictation, steel was meant to *conform* to the dictates of the new and thoroughly planned society."[29] Not only does the film advance the Nazi pedagogic project through its work with the trope of molding and forming, but, like other industrial films used in the classroom, it underscores the modern and vital character of German industry, thus promoting a sense of German technical superiority with which a national collective could identify and in which it could take pride.

In this German example we confront a stark case of the nexus among industry-commissioned film, educational film, and nationalist objectives. While this entanglement between industry and state educational entities took different forms in different national contexts, process films often have been part of the picture. They have straddled the categories of industrial and educational film, often serving multiple, sometimes overlapping, agendas. What bears further consideration is the more general relationship between the process genre and nation, for while state entities and private corporations may have deployed processual representation to achieve *nationalist* ends, anthropologists have also made frequent use of processual syntax in research—to study cultural groupings.

ETHNOGRAPHIC FILM

From its inception, ethnographic film has had a special investment not only in documenting processes of production, but also in capturing and analyzing their processual, sequential aspects. Although it may be gener-

ally true that anthropology in the first half of the twentieth century shied away from incorporating film into its methodologies because of film's close association with a nonscientific, popular, commercial endeavor, the ethnographic filmmakers who did turn to film—with varying degrees of enthusiasm and urgency—made films of "native" industry and movement.[30] And so among the films widely considered to be ethnographic there are many process films.[31]

In early ethnographic filmmaking, processual representation posited a link between a society and its mode of production and implicitly sought to plot "native" peoples along an evolutionary trajectory. This investment follows, as we will see, from the disciplinary commitments of anthropology to cultural evolutionism, as well as to the cultural significance of material culture and the material significance of bodily movement.[32]

Most accounts of ethnographic film begin with Étienne-Jules Marey's student Félix-Louis Regnault, who in the 1890s produced his own chronophotographic films of human movement.[33] Renault had been trained as a physician but is remembered for his work in the areas of "prehistory" and anthropology. In the mid-1890s, interested in a comparative, racialized taxonomy of human movement, Regnault filmed the movements of West African and Malagasy performers at the Exposition Ethnographique de l'Afrique Occidentale in Paris. The movements he captured ranged from walking, running, and jumping to grain pounding, tree climbing, cooking, and pot making.[34]

For Regnault, the processual character of chronophotography offered unrivaled research advantages over other kinds of representation. It was superior to demonstrations or "cinematoscope" projection because it allowed the researcher multiple re-viewings, as well as the possibility of slowing actions down, "decomposing" them, to analyze their component parts.[35] And unlike museum displays of material culture, chronophotography introduced the temporal dimension. Encouraging the incorporation of chronophotography in museum exhibition, Regnault wrote, "Museums of ethnology should add time-sequence photographs to their collections. It is not enough to have a loom, a lathe, or a javelin; one must also know how these things are used; and, we cannot know this precisely without using time-sequence photography."[36]

Regnault's film of a Wolof performer making a pot at the 1895 Exposition Ethnographique is standardly identified as the first ethnographic film. It is also a process film, and its processual character was an explicit part of Regnault's own discourse about it. The film was accompanied by a

short text Regnault published with Dominique Lajard in the *Bulletins de la Société d'Anthropologie de Paris* titled, "Unfired Pottery and the Origin of the Wheel." In that text, Regnault and Lajard claim that the technique employed by the performer (which involves the use of a bowl as a centering and stabilizing instrument) had not been documented before and that it "illustrates the transition from pottery made without the wheel to that made with the wheel."[37] The evidence for this claim is based on the combined research of Lajard and the chronophotography of Regnault. The article describes the "phases" in the Wolof potter's process and even includes a sequenced, lettered drawing (with two images labeled "A" and "B") as a visual aid. The description is striking for the way it follows the structure of a how-to manual or a recipe, listing the requisite materials and the steps in order: "To make the vases, [the potter] possesses: 1. A hollow drinking bowl of 25 cm . . . 2. Some powder of black sand," and "this is how she proceeds: She moulds the clay between her two hands. She hollows the ball of clay with her hands before placing it on the bowl."[38]

It is perhaps no coincidence that the story of ethnographic film begins with a pottery demonstration, as pottery has been central to the disciplinary history of anthropology. This history was shaped in no small part by the nineteenth-century evolutionism associated with figures such as Henry Lewis Morgan and Edward Burnett Tylor, both of whom developed anthropological correlates of the theories of Charles Darwin and Herbert Spencer.[39] For his part, Morgan, in *Ancient Society* (1877), proposed a theory of "ethnical periods," according to which human societies universally and unilinearly pass through a series of seven developmental stages from savagery to barbarism to civilization. The boundaries between stages were drawn on the basis of "the successive arts of subsistence," which, according to Morgan, "must have exercised [great influence] upon the condition of mankind."[40] Morgan relied on material culture—what he referred to as "inventions or discoveries"—to demarcate distinct modes of subsistence, and thereby distinct stages, so that, for example, the invention of the bow and arrow marks the end of the "middle status of savagery" stage and the beginning of the "upper status of savagery." Pottery was the most controversial of Morgan's technological indices of human progress and the "invention" he spends most time defending.[41] In his schema, the art of pottery marks the boundary between savagery and barbarism, inaugurating, for him, village life and "a new epoch in human progress."[42]

Morgan's materialism, his theoretical dependence on subsistence, made him an important figure for Friedrich Engels, who used Morgan's work as the

foundation of *The Origin of the Family, Private Property, and the State* (1884), as well as for twentieth-century Marxist anthropologists such as Eleanor Leacock.[43] But that materialism also influences the theoretical centrality of material culture to the early anthropological project more broadly. The fabrication of use objects and their deep relation to a society's mode of subsistence—in other words, the relation between technology and mode of production—was an abiding commitment of anthropology, manifest not only in the early ethnographic films of Regnault and Pliny Goddard but also in the "life group" museum displays associated with one of Morgan's staunchest critics, Franz Boas.[44] Moreover, that Regnault's chronophotographs of the Wolof potter—more than his films of human movement and other subsistence activities, such as cooking and pounding grain—should be remembered as the early paradigm of ethnographic filmmaking surely follows from the materialist and evolutionist beginnings of the discipline of anthropology and from the privileged role of pottery in adjudicating the stage to which a given society belonged.

Regnault's orientation is perhaps most strongly echoed in the work of Pliny Goddard in the 1910s and in the archive amassed by the German Institut für den Wissenschaftlichen Film (IWF) in the early 1950s. Goddard, an anthropologist trained at the University of California, Berkeley, produced—with the assistance of the artist Howard McCormack—anthropological films of the Apache in the American Southwest for the American Museum of Natural History. In his 1914 recordings, Goddard showed a marked preference for filming material culture.[45] In his prescriptive account from 1918 of the proper subject of ethnological knowledge, he contends—prefiguring Marcel Mauss—that ethnology's "true subject matter" is "made up of the habitual movements and activities of a people."[46] The point, he claims, is less to see an Apache man and a White man sitting on a horse than to know from which side each mounts. "Such habits [i.e., as the way of mounting a horse]," Goddard writes, "are the most important means of making comparative and historical studies in ethnology, for they are generally learned from one's neighbors or ancestors."[47] Goddard goes on to proudly describe—almost getting carried away by his own litany of processes—the films he made of

> such industries as basket-making, the boiling and application of pitch to make a basket watertight, the gathering of mesquite beans, the grinding of corn, the preparation and cooking of the century-plant stump. Men were photographed flaking arrowheads, feathering arrows, and putting sinew on the bow. The rather simple process of discharging an arrow from

a bow, taken on twenty-five feet of film, illustrates the position of holding the bow and the arrow release practised by the Apache, two points of considerable comparative interest.[48]

Like Regnault, Goddard defends the research advantages of recording movement and activities on film, which allows for frequent re-viewings and, more important, for the observation and recording of "every significant movement involved in the work of a single individual engaged in such a simple task as making a flint arrowhead."[49]

It was German anthropology that most energetically used film to document the technical processes of cultural Others.[50] This was evident in the mission of the IWF, which produced its Encyclopaedia Cinematographica (EC) in 1952. The EC is a multidisciplinary film archive that includes a large number of 16 mm ethnographic films focused on movement and material culture.[51] As Martin Taureg has noted, "It has always been easier to film manufacturing processes than to search for the visual expressions of social and political structures."[52] The EC's founder, Gotthard Wolf, a comparative ethnologist, believed film could enhance human perception; it could arrest movement by allowing for multiple re-viewings and systematic analysis of discrete units of action.[53] Influenced by the positivism (and evolutionism) of the Kulturkreis school of anthropology, the EC established strict criteria for the inclusion of ethnographic film documentation that emphasized the systematic filming of activities as unified, complete actions.[54] The rules included proclamations that affirmed film's special vocation for filming kinetic activities—especially production processes and economic activities, on the one hand, and dance and musical performances, on the other hand—as well as prescriptions for documenting all representative aspects of a given activity.[55] The aim was to produce an archive of short films of "single thematic units" for comparative analyses of the varied "activities" of varied groups. To explain this notion of the "single thematic unit," Peter Fuchs, professor and coeditor of the EC in the late 1980s, turns, predictably, to the example of pottery:

> The activities that can be best treated as a single thematic unit appear to be skilled manual operations such as a potter making a mug. However . . . , the film should not restrict itself to the pottery operations alone. In order to achieve the "completeness" desired, the film must show all stages of the mug's production: (1) how the potter obtains his clay, (2) what he does with it before throwing (kneading, etc.), (3) after throwing, (4) the trimming, (5) painting, (6) firing of the earthenware vessel and finally, a shot of

the mug in use. Even when a film of this sort is limited to the purely technical aspects of the event, it still comprises a total of six "smallest thematic units" and is likely to be about 300 meters in length.[56]

The basic approach described here by Fuchs has a theoretical foundation that was developed within French anthropology in the second half of the twentieth century. Introduced by André Leroi-Gourhan (a student of Mauss) in 1943 as an analytic tool for archaeological research (an alternative to the prevailing preoccupation with artifact morphology), the *chaîne opératoire* (operational sequence) is a method for analyzing technical processes. The operational sequence—which can take the form of written descriptions, diagrams, pictures, photographs, or film—materializes or codifies the observation of process by breaking it down into a series of sequential, step-by-step actions: "a series of operations which brings a raw material from a natural state to a manufactured state."[57] It was an important methodological innovation because technical processes are largely invisible—not only because those who performed the processes are no longer alive, in the case of prehistoric societies, but also because simply watching someone doing something does not necessarily yield a firm understanding of the steps involved. Techniques cannot be "seen" even if the people who are doing something can be seen doing it.[58] Seeing a technique *as a technique* implies that codification—or a deliberate identification and re-description of constituent steps—has already taken place.

In addition to allowing anthropologists to rigorously describe technical activities and to understand something about materials, gestural actions, and spatial configurations, the operational sequence as an interpretive methodology also enables them, according to Marcia-Anne Dobres, "to infer something of the abstract cognitive processes and underlying normative logic systems structuring those acts," as well as to infer something about "dynamic interpersonal social relations of production."[59]

Is the operational sequence a form of processual representation? Well, yes. Consider the case of Geoffrey Gowlland, a researcher working on an exhibition for the Cambridge Museum of Archaeology and Anthropology who recently described his experimentation with photography and film to study the making of a *zisha* pot by the Chinese artisan Ge Taozhong. Gowlland made two edited films from the complete six-hour process he captured on video: one twenty minutes long, and the other forty minutes long. The former was included in the exhibition. While he describes the films as documenting a *chaine opératoire* (in his words, "all the procedures

that are necessary to complete a technical object"), their length relative to the entire six-hour process indicates condensation.[60]

To account for the temporal ellipses, Gowlland describes his editing process—the way he tried to make principled decisions about what movements or repetitions of particular movements to cut out and *when* to cut from one step in the process to a successive operation in the process.[61] So while each step in Ge Taozhong's process might require several repetitions of a particular movement, a future spectator could grasp the step without needing to sit through all the repetitions of the action required before the material was ready for the artisan to move to the next step. Thus, many repetitions could be cut out. Similarly, deciding when one step in the process ended and another began was a matter for Gowlland's judgment and discernment, as transitions between steps do not spontaneously announce themselves. One step often bleeds into the next.

Thus, what Gowlland in fact describes in his written essay about his research is the process by which he produced process films from the footage he took of Ge Taozhong at work. Rendering the artisan's operational sequence on film turns out to be a lot like making a process film. Gowlland (much like Wiatr writing on industrial process films used in classrooms) expresses some skepticism about the knowledge of technical processes produced by the filmed operational sequence. The resulting films, he claims, are not quite adequate to convey "the richness of the embodied experience of work of the artisan." They "mystif[y]" the work of the artisan by condensing or "miniaturizing" the material.[62] Nevertheless, he concedes that the processual/operational approach will continue to be deployed, as it makes "complex techniques intellectually accessible," allowing one "to understand the techniques of the craft and how the elements integrate."[63] Indeed, as in the case of the educational process film, the ethnographic process film cannot be reduced to a mere instrument of deception, for even when operations in the operational sequence are missing—that is, when the operational sequence is imperfectly documented—the method itself still holds out the promise of a certain knowledge of the world.

When the ceramicist Ge Taozhong was asked his opinion of Gowlland's shorter film, which had been made available for viewing on the internet, he had two responses. Underscoring the usefulness of the operational sequence for research, he noted that Gowlland had left out a crucial step in the process. Gowlland's judgment had faltered in one place: he had not "seen" a technical step as a step. But this confirms how much of the process Gowlland was able to adequately represent. The second response suggests

the advertising potential of the process film: Ge Taozhong noted how glad he was to have a video to which he could refer potential and current customers. His reaction crystallizes the ambiguous and multifaceted usefulness of the process genre that I have been describing. Even in the context of ethnographic film made for research and teaching purposes, the process genre's significance to commerce and industry lurks in the background.[64]

The Process Genre in Other Media

If the process film is prominently represented among categories as diverse as industrial, educational, and ethnographic cinema, this is because processual syntax is antecedent to the advent of cinema. It was not invented within any one of these film genres; nor is it tethered to any one of them. Processual syntax was already available to be adapted by the film medium. In the second part of this chapter I examine pre-cinematic expressions of processual representation in other media. My intention is not to provide a comprehensive, teleological, or linear history of the process genre from its emergence to its flowering in film. Instead, I hope to probe the sources and meanings of processual representation in other media. The two media on which I focus are live demonstrations of crafts and machines, such as those common in the international exhibitions of the nineteenth century and early twentieth century, and pictorial instructions exemplified by Diderot and d'Alembert's mid-eighteenth century encyclopedia of crafts and industry. While processual syntax was present in a variety of other forms and media prior to its appearance in early cinema (including in discursive how-to manuals, educational lantern slides and stereographs, and serial photography), live demonstrations and pictorial instructions are particularly significant pre–moving image processual forms.[65] While the craft and machine demonstrations of international expositions of the mid-nineteenth century display a materialist and evolutionary logic to which the genre often remains tethered, the pictorial instructions that developed in the early modern period as a means of communication for a nascent capitalist mode of production likely mark the genre's earliest appearance.

DEMONSTRATIONS OF MACHINES AND CRAFTS

If the craft demonstration is a paradigm of the process genre, the machine demonstration is more ambiguously related. Both emerge as entertainment spectacles with the international expositions of the nineteenth

century, though the craft demonstration is a later development historically that, already from its first appearance, conveyed a powerful feeling of nostalgia.

The machine demonstrations of the Great Exhibition of 1851 were not the first such demonstrations, but they placed the spectacle of machines at work on an appreciably grander scale.[66] Many contemporary writers commented on the unrivaled popularity of the exhibition's "Machinery Court," emphasizing that the displayed machines were "machines in motion."[67] The court was quite unlike the other sections of the exhibition, such as "Manufactures," where commodities "were at a standstill . . . just sitting there, mute and solid."[68] Among the machines in operation were McCormick's reaping machine, Taylor and Son's jacquard loom, Applegath's vertical printing machine, and J. N. Adorno's cigarette machine (which could make eighty to one hundred cigarettes a minute). There was De La Rue's envelope machine, which could fold, by one estimate, three thousand envelopes per hour; it was singled out for the way its intricate motions, as the *Illustrated London News* put it, "closely followed several actual movements of the human form divine."[69] There was also Hibbert, Platt and Son's fifteen cotton machines (in operation behind an iron railing), which demonstrated the cotton-spinning process from opening, carding, and doubling to spinning, warping, and weaving.[70] In a satirical treatment of a family's visit to the Great Exhibition, Henry Mayhew, a well-known journalist of the period, brought to life the spectacular and broad appeal of the machine demonstrations:

> But if the other parts of the Great Exhibition are curious and instructive, the machinery, which has been from the first the grand focus of attraction is, on the "shilling days," the most peculiar sight of the whole. . . . [R]ound every object more wonderful than the rest, the people press two and three deep, with their heads stretched out, watching intently the operations of the moving mechanism. You see the farmers, their dusty hats telling of the distance they have come, with their mouths wide agape, leaning over the bars to see the *self-acting* mills at work, and smiling as they behold the frame spontaneously draw itself out, and then spontaneously run back again. . . . Round the electro-plating and the model diving-bell are crowds jostling one another for a foremost place. At the steam brewery, crowds of men and women are continually ascending and descending the stairs; youths are watching the model carriages moving along the new pneumatic railway; young girls are waiting to see the hemispherical

lamp-shades made out of a flat sheet of paper; indeed, whether it be the most noisy flax-crushing machine, or the splashing centrifugal pump, or the clatter of the Jacquard lace machine, or the bewildering whirling of the cylindrical steam-press—round each and all these are anxious, intelligent, and simple-minded artisans, and farmers, and servants, and youths, and children clustered, endeavoring to *solve the mystery of its complex operations.*[71]

The picture Mayhew paints here of a diverse group of visitors to the exhibition fascinated by the workings of machines, "endeavoring to solve the mystery of [their] complex operations"—such as how they transform a flat sheet of paper into a lampshade or how they fold and gum so many envelopes so quickly—reveals the close affinity these machine demonstrations have to processual representation. The demonstrations unfold in time; the machines visibly transform something—either raw material such as cotton or the position of a carriage. The process of transformation follows a definite sequence and is successful because it achieves its set function: some recognizable useful object or action caps the process. And it is efficient, time- and labor-saving—so much so that its complex operations are, to the layperson, a mystery *worth* contemplating. Of course, the machine demonstration's processual character is largely a consequence of the design of Victorian machines. Herbert Sussman has argued that the transparency and visibility of the mechanical operations of the exhibitions' machines—in contrast, for example, to the opacity of contemporary technology design, with its diminutive scale, its electronic or digital basis, and its chrome encasements—rendered the mere observation of their operations both educational and fascinating. A spectator could grasp the sequence of operations, for in the machines in motion the relation of cause to effect was an *open* secret: "Rotating rods turned leather belts. Moving cylinders carded the raw cotton. Shuttles flew through the loom. Gears meshed and finished, patterned cloth emerged."[72]

But even as the "Machinery Court" displayed machine processes, the *full circuit* of production from raw material to finished, saleable commodity was spread across the exhibition's four discrete sectors, each segregated from the other. It was precisely this physical separation of "Raw Material" from "Machinery" and of "Machinery" from "Manufactures" and "Fine Arts" that made a visit to the exhibition unlike later phenomena such as factory tours and "work displays" (which were popular with tourists at turn of the twentieth century) and unlike industrial process films.[73] It

was this separation that made it possible for visitors to perceive the machines as "self-acting" (as Mayhew describes them) and the commodities as miraculous wonders, and thus to forget the role of human labor in the transformation of raw material into commodities.[74] While the Great Exhibition of 1851 included machine demonstrations in which people played little role, it did *not* include craft demonstrations in which people played a more prominent role. Indeed, Jeffrey Auerbach has observed that colonial handicrafts in general were systematically downplayed in favor of raw materials from colonial territories that could be exploited by metropolitan manufacturers.[75]

The craft demonstration (and colonial handicrafts) would come later, in the international expositions of the last quarter of the nineteenth century. Its story has two parts. The first is how people—rather than merely machines, manufactures, and raw material—became an important part of the displays.[76] The second is the story of how and why interest turned by the 1880s to *processes* of fabrication and to the artisans *doing* the fabricating.[77] Both parts of the story entail a colonial dimension, as early craft demonstrations were usually performed by non-European people displaying so-called preindustrial methods of production.

The inclusion of what Paul Greenhalgh dubbed "human showcases" in international exhibitions has been traced to the rise of the discipline of anthropology and to the sponsored exhibitions at the Jardin d'Acclimatation in Paris.[78] The Jardin was opened in 1859 as a center for the study of botany and zoology. But beginning around 1877—inspired perhaps by the Paris Exposition Universelle of 1867, which employed foreigners as workers in themed exhibitions that included an Egyptian bazaar and a Tunisian barbershop—exhibitions at the Jardin included human displays among the displays of plants and animals. Among the people displayed were "Gauchos," Mapuche, "Fuegians," Sami, "Ceylonese," and Kalmyk.[79] By the time of the Exposition Universelle of 1889, colonial peoples were present at international exhibitions not merely as workers but—for the first time at an international fair—as zoological specimens occupying "native villages" and going about quotidian activities on the fairgrounds.[80] While the human displays took different forms, one standard category of display featured "people as craftsmen."[81] These displays of artisanal production were part of the official exposition—in which colonial subjects performed in "native villages" as part of a menu of quotidian activities that included religious rituals as well as various arts and crafts demonstrations—but they were also a feature of the expositions' unofficial amusement zones,

where the demonstrations often served to stimulate the purchase of handicrafts.[82]

Although the "human showcases" were touted by organizers for their educational and scientific contributions to the international expositions, it was the entertainment value of artisans at work that especially stood out to contemporary commentators. For example, the Colonial and Indian Exhibition in London in 1886 featured forty-five artisans from different regions of the Indian subcontinent practicing crafts such as silversmithing and carpet weaving in full view of an enthralled public.[83] The executive commissioner of the exhibition, Sir Francis Philip Cunliffe-Owen, wrote that the "body of native artizans" constituted "undoubtedly the most attractive feature of the whole Exhibition."[84]

Whereas the craft demonstration in particular owes its emergence to the more general phenomenon that transformed human beings into zoological spectacles, there are other relevant factors in the specific shift in interest from artifacts and raw materials to artisans and their methods of production.[85] First, the imperial age's encyclopedic drive demanded, as Paul Greenhalgh puts it, "complete knowledge," a "total world view" that could not be achieved without accounting for *all* human endeavor.[86] Second, to rule effectively the colonial powers needed more precise knowledge of local groups, their customs, and their lifeways. The period thus saw the birth of what Nicholas Dirks called an "ethnographic state."[87] The growing demands of administering the colonies produced a new preoccupation with the particulars of daily life, including processes of material, social, and cultural production and reproduction, as well as a new concern over the impediments to adopting more "advanced" forms of technology.[88] Third, as a result of the influence of the Arts and Crafts Movement in the 1880s, there was a global shift in thought about craft. As Abigail McGowan puts it, "Now crafts were not just a form of industry, but a way of life; handcraftsmanship was not just a means to an end, but itself a key source of value."[89] Within this ascendant hierarchy of value, the medieval craftsman of the European past and the "primitive" craftsman of the colonial present occupied a privileged place in the European imaginary. With this new valorization came an interest in the *how* of artisanal production, broadly construed.

For the most part, craft demonstrations at international expositions were performed by colonial subjects of color, but there were also white settler colonial craftspeople on display, such as Irish lacemakers and Shaker furniture makers, as well as romantic national displays featuring *historical*

artisanal crafts demonstrations.[90] The architectural historian Edward Kaufman has observed that at fairs in the late nineteenth century, "the increasingly elaborate presentation of foreign culture was paralleled by an ever more loving exaltation of national tradition."[91] For example, for the Manchester Royal Jubilee Exhibition of 1887, designers built an idealized historical theme village called "Old Manchester and Salford."[92] This composite village combined the spectacular, such as a cathedral tower, with the quotidian. The lower floors of most buildings operated as shops where visitors could watch costumed national types involved in handicraft demonstrations and then purchase a souvenir to take home. The contemporary commentator Walter Tomlinson describes a scene:

> There were jewellers, glass engravers, printers, bookbinders, pipe-makers, electro-gilders, umbrella makers, *all at work*, busy as bees, and dressed in the most charming old-world costumes. Lloyd, Payne, and Amiel were *showing the actual manufacture* of costly jewellery, their shop, full of resplendent gold and silver articles and fancy goods. . . . *The cutting, engraving, and polishing of stones for jewellery* were being shown by Messrs. Joseph and Co. of London. . . . Glass engraving, and *the process of making small fancy articles in glass*, were being practiced by Burtles, Tate, and Co., of Manchester.[93]

These national exhibition displays, which became more standard as the nineteenth century wore on, fixed national identity in a romantic medieval past. They gave rise to what is referred to today, variously, as the "living museum" or the "outdoor museum," of which Hazelius's Skansen museum in Stockholm and Plymouth Plantation in Massachusetts are well-known examples.[94]

The trends of national and colonial imperial exhibition display share much of the same ethnographic character. This confluence is explained by the structuring apparatus of the colonial enterprise. With the emergence of the national pavilion phenomenon at the Exposition Universelle of 1867, a spatiotemporal logic prevailed.[95] The spatial axis distinguished between the nucleus of organizer nations—the exemplars of Western civilization—such as France, Britain, and Prussia, which were modern and represented "progress," and the foreign nations, which included the colonies (southern and eastern), the so-called Orient, and northern countries with traditional societies (Russia, Norway, Sweden, and Austria). The temporal axis demarcated 1800 as the threshold separating the traditional European societies from modern European societies. Whereas the

ethnographic European theme villages of the exhibitions belonged to a clearly marked historical past, the "native villages" of colonial territories belonged to the spatially distant present.[96] The former represented travel (back) in time and an act of historical reconstruction, and the latter represented contemporary travel over land. But both the "foreign" villages and the historical villages functioned as symbols of difference—either a difference in space or a difference in time. Both differences were measured by their distance from a Euro-American modern present inhabited by the fairs' organizer nations and the fairs' visitors. In the evolutionary schema that prevailed in the period, the European past and the colonial present could be comfortably mapped onto anthropology's teleological account of the evolution of human societies through stages, advancing progressively from traditional to modern.

Even in the case of Hull House's Labor Museum of the early 1900s, the craftsmen involved in demonstrations importantly belonged to immigrant groups, and their craft knowledge—in the official discourse of the settlement—was placed within the context of industrial evolution.[97] They were the guardians of Old World knowledge that was being lost in the modern United States but, thankfully, salvaged and historicized by Hull House. Jane Addams writes, for example,

> In the Italian colony immediately west of Hull House . . . may be found peasant women, who in Italy spun, wove and dyed and made the clothing for their families. Some of the older women still use the primitive form of distaff. It will be possible by their help to *illustrate the history of textile manufacture*, to reveal the long human effort which it represents, *to put into sequence and historic order* the skill which the Italian colony contains, which is now lost or despised.[98]

Built into the craft demonstration from its emergence in the sphere of international expositions to its deployment in museums, traditional and living, is the element of nostalgia, the poignant sense that something important has been lost, superseded by modernity's inexorable march.

While the machine demonstrations of the mid-nineteenth century showcased *novelty*—displayed the latest feats of industrial engineering; symbolized "man's industrial progress"; touted national ingenuity and manufacturing promise; introduced a large swath of the population to the emergent restructuring of the national economy ushered in by a new reality of industrialization and mechanization—by the time craft demonstrations became popular attractions, industrialization was no longer incipient.

It was a fait accompli. As a consequence, something like an "imperialist nostalgia"—that is, a nostalgia for what imperialism destroys—took hold.[99] And the perception of the "charm" and "virtue" of handicraft production came to be epitomized by the world's "backward" Others, who were still occupying an evolutionary stage that had been passed through, superseded by Europe and United States. Craft demonstrations manifested the felt anachronism and the tinge of regret that accompanied the demise of craft production.

PICTORIAL INSTRUCTIONS

World exhibitions have often been compared to encyclopedias. For example, Frederick Skiff, director of exhibitions for the St. Louis World's Fair of 1904, assimilated the exposition to "an encyclopedia of society . . . a classified, compact, indexed compendium available for ready reference—of the achievements and ideas of society in all phases of its activity, extending to the most material as well as the most refined."[100] This comparison establishes a direct lineage that leads us back to the most famous encyclopedia ever to have been produced: Diderot and d'Alembert's monumental *Encyclopédie, ou dictionnaire raisonné des sciences, des arts et des métiers* (Encyclopedia, or a Systematic Dictionary of the Sciences, Arts, and Crafts [1751–72]). The thirty-two-volume encyclopedia includes eleven volumes of plates containing more than three thousand engraved images. Referring to those plates, Roland Barthes commented, "We consult the plates of the *Encyclopédie* as we would visit today's World's Fair in Brussels or New York."[101] What exactly did he mean? It is not out of place to wonder how the *Encyclopédie*'s processual illustrations of processes of production and the inner workings of machines are reminiscent of the live craft and machine demonstrations at world expositions.

The *Encyclopédie*'s two-dimensional processual representations belong to the category Ernst Gombrich dubbed "pictorial instructions." The plates of the *Encyclopédie*, in Gombrich's estimation, were "the greatest enterprise in pictorial instruction" ever produced.[102] What Gombrich surely had in mind in the *Encyclopédie* were two types of illustration: one that Barthes would usefully classify as a "genetic" image, and the other that he would refer to as an "anthological" image. The genetic image depicts—within a single frame and often in a cutaway view that pulls back the outer layer of the workshop—a series of sequential steps, appropriately numbered (or lettered), that, undertaken in order, follow the trajectory of the ob-

ject from raw material to finished product.[103] The anthological image depicts the relevant instrument(s) or machine(s), shown in an exploded view (or in a cutaway view in the case of a mill), with its parts—pulleys and hoists—appropriately numbered (or sometimes lettered [see figure I.7]).

The genetic image is the one that is most straightforwardly processual, but certain anthological images of machines can be said to be processual, as well. The genetic image stages a scene of production in depth, arranging a series of steps of a given process in a kind of circle (with figures in the background, middle ground, and foreground). Each discrete station is numbered and shows a nondescript human figure (wielding an instrument) arrested in mid-action. Although the image is often of a single workshop space featuring multiple figures at work, the clear separation between stations, the use of numbers, and the circular arrangement of stations suggests a sequential process that unfolds in time with a definite beginning, middle, and end.

The anthological images, specifically of machines, also make use of numbers (and letters), which often suggests a sequential process. The numerical or alphabetical labeling system is employed in such illustrations precisely to indicate the chronologically ordered trajectory of material through the machine—in other words, to give a sense of how one part of the machine activates another part that activates another in a chain of cause-effect relationships. This is clear in the illustration of a water-powered flourmill (see plates 1–2).

Diderot and d'Alembert's *Encyclopédie* may have had the most extensive compendium of pictorial instructions, but this kind of processual drawing had been around for centuries. Indeed, it is within this category of pictorial instruction that we can find the earliest instances of the process genre. Gombrich argues that the "incunabula" of this type of pictorial instruction (i.e., the subset of illustration he refers to as "sequential narrative") can be found in pattern books.[104] One of the earliest exemplars he highlights is the Göttingen Model Book from the mid-fifteenth century, which explains, through text and image, how to draw and paint the decorative foliage scrolls and the patterned backgrounds that adorned the earliest printed manuscripts.[105]

While pattern books were among the earliest manuscripts that incorporated pictorial instructions, early sixteenth-century manuals on various forms of combat, particularly fencing—such as Andre Pauernfeindt's *Ergrundung Ritterlicher Kunst der Fechterey* (1516)—depicted segmented movement pictorially.[106] According to Janina Wellmann, it was around

1600 that the number of printed books devoted to teaching bodily movement through numbered pictures proliferated. The largest category of these "instructional graphics," as Wellmann refers to them, was devoted to the military drill.[107]

In the case of combat books (and pattern books), these texts were actually intended to be used for instruction in, for example, how to use arms such as the pike and the musket. Changes in the practices of war in the early sixteenth century necessitated a new disciplinary regime founded on the military drill. There were new weapons that soldiers needed to be trained to handle, as well as movements of individual soldiers that needed to be standardized across a corps of soldiers, whose morphing formations increasingly would constitute the choreography of modern warfare. But to learn these movements, whose uniformity was essential, soldiers needed to have the motions broken down into their constitutive poses so they could be easily comprehended and then fully assimilated. Indeed, printed series were shown to soldiers on the field during drills to aid in training.[108]

Wellmann has shown that the iconographic conventions established by the Dutch engraver Jacques de Gheyn in the early 1600s in his manual for the exercise of arms, *Wapenhandelinghe van Roers Musquetten Ende Spiessen* (1607), would define standard practice for centuries: "All the plates have the same format, showing the same frame from the same perspective; the background is reduced to a simple floor line, the soldier placed centrally upon it. Alongside these constant elements are the variable ones, such as the positions of the limbs. The engravings thus represent the changing poses in the form of repetition with variation" (figures 1.1–1.3).[109] Each page presents one pose. The individual poses or variable elements have been selected deliberately; they reflect an assessment of the *key elements* of the action rather than a depiction of the action's steady, *even* unfolding in time.[110] After Gheyn, the emphasis on serialization intensified as the individual images came to be displayed by later engravers such as Johann Jacobi von Wallhausen as a series on the same page rather than as successive images on different pages, as Gheyn had done. Meanwhile, the emphasis on individuated figures diminished.

Still, the conventions of instructional graphics for teaching the military drill remained remarkably stable for centuries.[111] Moreover, we can discern a clear resemblance between these combat pictorial instructions and the late nineteenth-century chronophotography of Marey and Eadweard Muybridge: the simple background, the single perspective, the abstracted figures, all of which make it possible to clearly discern the micro-variations in pose from one serial image to the next.[112]

1　　　　　　　　　　　2　　　　　　　　　　　3

FIGS. 1.1–1.3 A series of three consecutive poses from the pike exercises. Images from Jacob de Gheyn and J. B. Kist, *Wapenhandelinghe Van Roers Musquetten Ende Spiessen* . . . (Lochem: N. V. Uitgeversmaatschappij de Tijdstroom, 1971). Courtesy of the University of Chicago.

While the earliest processual representations *taught* manual and bodily skills, machine drawings—which emerged around the same time—and processual illustrations of technical processes served more multifaceted functions. Wolfgang Lefèvre has argued that machine drawings appeared in the West in the beginning of the early modern period as a consequence of new developments in the realm of production. The developments Lefèvre points to include new forms of division of labor—particularly at the construction sites of Gothic cathedrals and in mining and shipbuilding—that replaced the relatively flat hierarchy of the craft workshop;[113] new technologies that could not be taught in the old ways (e.g., new kinds of weapons of war); new contexts for learning, such as technical schools that were supplementing the once dominant system of apprenticeship; the rise of the engineer, a figure with training in the sciences; and an incipient public interest in technology.

In the case of early modern how-to manuals detailing technical production processes, the situation is similar.[114] Pamela Smith has stressed the changing political, economic, and social landscape, which included a growing urban culture; rulers who required the expertise of artisans for the development of technologies of war; and the growing importance of distributors who acted as intermediaries between producers and markets, as well as of connoisseurs and investors—all of whom required greater knowledge of production processes.[115]

All of these developments necessitated new means of communication among different sectors—among different craft specialists; between engineers and craftsman; between commanders and soldiers; among craftspeople and merchants, nobleman, the literate public—that in an earlier period had little need of efficient communication. Pictorial instructions served these new needs by codifying and, at the same time, often standardizing the best practices in the rapidly changing areas of combat, craft, and machine design.

THE EFFECTIVENESS of pictorial instructions as a form of communication must have depended on their *intelligibility* to a diverse constituency. That requirement goes some way toward explaining the conventions, especially linear perspective (or, at least, the adoption of a single viewpoint and realistic appearance), that would develop for the representation of bodily skills (e.g., Gheyn's engravings of military drills), as well as for the representation of machines and production processes.[116] These conventions of representation are consistent enough that it is possible to trace processual syntax from the pictorial instructions of the early modern period through the international expositions of the nineteenth century and into the process films of the twentieth and twenty-first centuries.

Despite this consistency, the uses to which processual representation was put were remarkably diverse. In the early modern period, processual representation was a useful aid for growing, urbanizing, modernizing societies that needed to codify and standardize practical knowledge. Later, in the context of international expositions and living museums, processual representation in the form of demonstrations of particular artisanal and machine processes acquired other functions, such as advertisement, nation building, the rationalization of conquest, and consolations for the alienation of modern life. Not to be underestimated, it served these functions while reliably offering the pleasure and entertainment associated with the spectacle.

The process film must be seen in this historical context. By the time processual syntax was employed by camera operators at the turn of the twentieth century, it was a well-developed, ready-to-hand, versatile formula with a proven track record of providing entertainment to heterogeneous audiences. Over the course of the twentieth century and into the present, filmmakers working within diverse cinematic genres and with a range of objectives have continued to turn to processual syntax—with results both inspired and pedestrian.

ON BEING ABSORBED IN WORK

WHEN I DESCRIBE THE PROCESS FILM to generational contemporaries, I have often turned to an example from the archive of educational film. *Mister Rogers' Neighborhood* on the Public Broadcasting Service (PBS) was staple television of many childhoods. One of the most memorable segments from its thirty-three years of programming is a six-minute film tour of a Crayola crayon factory.[1] The film follows the trajectory of yellow crayons, beginning with a railroad tank car carrying hot wax to the factory where the crayons will be made and ending with the packing of shipping boxes containing cartons of crayons (plates 3a–l). There is hardly a single human face, as the short film instead showcases wonders such as the double-spout bucket and the crayon-labeling machine. The segment aired on June 1, 1981, and today has a remarkable life on the internet. What is particularly striking is the language used by writers, bloggers, and fans to characterize their experience of the segment. One commentator writes:

> Funnily enough, people who didn't grow up with his show see [Mister Rogers] as a weird old guy with a boring monotone voice. But there's a *magic* to Mister Rogers that lives on, and it's not just nostalgia keeping it alive. In this old clip from his show, Mister Rogers shows how crayons are made in a factory. As the video shows footage of mass produced crayons rolling down conveyor belts and passing through box makers, there's this *hypnotic, almost*

zen-like quality that takes over. For five minutes today forget about your bills, your student loans, your stressful job, and just *get lost* in the relaxing mundanity of watching crayons get made.[2]

Another anonymous writer on a different site reminisces,

Of course, once Mr. Rogers is in your head, it's hard to get him out. I couldn't resist looking for the Video That Started It All. Since I'm guessing there is a very good chance that you too have fond memories of that eternally soothing voice calmly guiding you through the crayon-making process, while you stared *transfixed* at the tick-tick-ticking of the Crayolas down the assembly line to their awaiting boxes, so *mesmerized* that you temporarily took a break from begging your mom to PLEASE get you those upside-down-cup-stompy-stilt things from Romper Room, well then, here you go.[3]

Hearing a description of films about the production of crayons or biscuits or cars or steel, a listener might find it difficult to conjure any film so dull. Yet spectatorial absorption has been a recurring trope in professional as well as amateur commentaries on a range of durational processual representations, from live craft and machine demonstrations to process films. The language used in phenomenological descriptions of processual representation—across durational media—is strikingly consistent, featuring descriptors such as "absorbing," "enthralling," "transfixing," "fascinating," "mesmerizing," "hypnotizing," "spellbinding," "entrancing," and "magical."[4] What exactly is the appeal of the process film? And how can we account for its surprisingly immersive spectatorial effects? These are the questions this chapter aims to explore.

The sense of surprise in the face of certain subject matter has been registered in a range of commentaries on different process films. Writing about *A Man Escaped* (Robert Bresson, France, 1956), a film about a man's painstaking preparation for his prison escape, Roger Ebert, in the spirit of meta-commentary, digresses mid-review: "This has been an unusual movie review, mostly describing what *doesn't* happen. Is the film therefore a static bore? Few films have seemed more *absorbing* to me."[5] In a review of a recent Fédération Internationale de la Presse Cinématographique (FIPRESCI) award winner, *Hand Gestures* (Francesco Clerici, Italy, 2015), a film about lost-wax bronze casting in an illustrious Milan foundry, the writer—who is incredulous—comments: "While in theory this should make for a somewhat academic film experience, the result is genuinely

and *unexpectedly mesmerising*."[6] In a recent *New York Times* review of the YouTube channel Primitive Technology, which stars an Australian man in more than forty-four short process videos that show him—shirtless, in "the Bush"—making rudimentary shelters and rustic tools using natural materials from the surrounding landscape, Jennifer Kahn, a professor of journalism at the University of California, Berkeley, marvels at the unlikely fascination of the series:

> By the time I started watching, my husband, Nick, had been talking about it for weeks. The videos were simple, he said, but *strangely captivating*, almost beautiful. Still, I never quite found time to take a look. One video, Nick told me, was entirely about making charcoal. Charcoal! How could I possibly want to watch that? *Amazingly*, it turned out that I did want to watch it. And so did a lot of people. (As of this writing, the charcoal segment has been viewed more than nine million times.)[7]

The idea that process films are "strangely captivating" or "unexpectedly mesmerizing" registers taken-for-granted intuitions about the nature of fascination and its usual sources. After all, who would say about *The Silence of the Lambs* or *The Godfather* that they are "strangely captivating" rather than just "captivating"?

I can imagine two explanations that immediately present themselves for the spectatorial effects of processual representation. First, one might be tempted to turn to Neil Harris's concept of the "operational aesthetic"— that is, the instinctive, natural pleasure people take in "uncovering process," in understanding how things work.[8] This was the term Harris coined to explain the paradoxical appeal of P. T. Barnum's 1830s–40s "oddities," such as the "Feejee Mermaid" or the one hundred and sixty-one-year-old woman. Barnum's shows presented, simultaneously, seemingly impossible, wondrous "specimens" (e.g., the mermaid), but they also promised to expose "the processes of action" by which mysteries (or trickeries) were devised.[9] Show attendees wanted to know whether these incredible entities were *real*, and, if they were not, how they could seem so. In other words, for Harris, Barnum's paying attendees were less dupes or bumpkins than Moderns characteristically fascinated by *how* the deception had been carried out, by how things work.

Second, one might think that the fascination of processual representation owes to a basic fascination with movement—whether live or on-screen, whether of people or machines—and especially with repetitive movement. In trying to account for the way films "release a mechanism

of affective and perceptual *participation* in the spectator (one is almost never totally bored by a movie)," Christian Metz turns to movement— movement, which in its suggestion of volume and corporeality, evokes life; movement (at least the movement of others) that for Metz is perceived *visually* rather than materially and whether seen on the street or seen on a screen is apprehended in the same way—as a key to film's power to absorb.[10] The "reality of motion" for Metz is part of the "secret" of cinema.

Both of these explanations shed some light on the appeal of processual representation, but I think they are ultimately unsatisfying. Neither is specific to processual syntax, and neither accounts for the experience of surprise or strangeness reported by spectators. On the one hand, an explanation of the absorption of processual representation that turns to the "operational aesthetic" would suggest a broad, amorphous, formally unspecific epistemological drive toward knowledge. Do all formal approaches to laying bare process generate the same impression of mesmerism and fascination? There are other conceivable procedures besides processual syntax for, in Harris's terms, "uncovering process," and indeed Harris says nothing of such a syntax in his book. On the other hand, the explanation that turns to the fascination of movement is also unspecific; it cannot not distinguish between the trancelike state produced by the observation of the rhythmic, repetitive movement of bodies and machines and the *peculiar* mesmerism produced by watching processual representation. After all, the unending repetition of single actions is inimical to processual syntax, which is marked by a succession of causally linked steps leading to a clearly identifiable result. This is not to say that processual representation does not often include some rhythmic repetition of steps, but generally it does so as a way to give a clearer sense of how the action/machine works (i.e., sometimes the workings of the mechanism cannot be grasped immediately). Thus, repetition alone cannot explain the peculiar draw of processual representations in which steps move ineluctably toward a result.

In this chapter I argue that the widely noted absorption of durational processual representation is largely due to overarching narrative structures. But while it has been traditional to associate the sort of absorption described earlier with narrative, this association might seem surprising in the case of the process genre, given that narrative is often tied to psychological identification with human figures and to particular rather than repeatable events. Processual representation, by contrast, generally eschews psychological identification and depicts repeatable protocols. Thus, while the lay and professional commentators turn (in surprise) to the language

of absorption and magic to describe their experiences with processual representation, they do not appeal to the discourse of what Victor Nell called "story magic" as they might if what was being described did not seem to them so antithetical to narrative.[11] On the face of it, narrative does not seem as if it could provide a promising framework for understanding the surprising absorptiveness of processual representation. But actually I think it does. What alternative notion of narrative, then, could be usefully applied to the process genre, given that psychological identification is not at play?

My discussion turns to the idea of "process narration"—typified by the recipe and applicable to processual representation—and the challenges to and possibilities for fascination that this kind of narration presents. The generic, protocol character of process narration and the importance of a strong sense of closure to this kind of narration are a central part of the story. But the chapter comes to focus on the ways in which expositional narrative structures of curiosity, suspense, and surprise—perhaps counterintuitively—exploit precisely the repeatable, protocol character of processual representation that makes narrative seem inapt to its analysis. These expositional structures, each in its way, orchestrate a compelling—often unexpected or unpredictable—interplay between the spectator's knowledge and her ignorance about the protocols depicted.

Narrative and the Recipe

Scholars writing about image-based processual representations (which, of course, they do not describe as such) have resisted the association of processual representation with narrative. In cases where narrative has entered the account, the narrative elements invoked are not structural but extra-structural features, as if narrative does not itself belong to processual representation but is merely an addition to it. For example, Marta Braun, in *Picturing Time*, proposes that Eadweard Muybridge's processual motion studies are concerned more with narration—with "narrative representation"—than with movement. However, the evidence Braun marshals to support her claim does not come from the processual syntax itself:

> The space stimulates more than just an interest in the rhythms of gesture and posture. Each sequence and each single image within the sequence invites us to *transform the models into dramatis personae* frozen into unaccustomed poses of beguiling attraction. We are not limited to a purely formal consideration of the contours of the body or the shape of any action but

are impelled beyond, into the world of *dramatic narrative and biography*. Light and perceived depth, strong modeling and vigorous foreshortening call our attention to the *stories being played out*. The faces demand scrutiny; the concentration with which they go about their tasks and the sheer individuality of each cajole us into *psychological identification* with them. We are compelled by the subjects' fascination with their own performance before the camera and by Muybridge's fascination with them.[12]

Striking in this passage is the sense in which "dramatic narrative and biography" and the "stories being played out" are ultimately references not to the narratives of *actions* but to the stories of individual lives. This implication is cemented by the reference to the "faces" of the performers, to their "sheer individuality," and to the spectatorial "psychological identification" these faces invite. The narrative qualities of Muybridge's motion studies are here associated with character and psychology, not with sequential action. Maybe Braun's analysis of Muybridge's motion studies is right, but what is striking in this argument is the implicit view that what is meant by narrative is something other than the narrative of action. Such a view of narrative—and perhaps also the prejudice against narrative—threatens to impede a satisfying account of the process genre's absorbing effects.

It has been a common expectation for narratives to entail human experience, and this is implicit in Braun's comments. As Jerome Bruner puts it in his frequently cited primer on narrative, "Narratives are about people acting in a setting and the happenings that befall them must be relevant to their intentional states while so engaged—to their beliefs, desires, theories, values, and so on. When animals or nonagentive objects are cast as narrative protagonists, they must be endowed with intentional states for the purpose, like the Little Red Engine in the children's story."[13] Because the process genre is commonly focused on objects, machines, the body, the hand—and often eschews the face and the individual as such—it is not surprising that its narrative character could go unregistered or even be implicitly resisted.[14]

But there is perhaps an even deeper difficulty in thinking about processual representation and narrative together: the generic character of most process genre examples. The process genre is a paradigmatic instance of a generic narrative. A generic narrative is meant as the story of a *kind*, of an archetype, of a broader *class* of object or action such as *the* crayon or *the* ball rather than *this particular* crayon or *this particular* ball. I argue that, paradoxically, it is precisely the generic character of processual representations that holds the key to their absorptiveness. In making this case, it

is useful to bring to bear on the question the debate in narrative theory about the questionable narrative character of the recipe.

The narratologist Peter Hühn, writing about discursive narrative, has identified two basic types of narration: a general type that he calls "process narration" and a more specific type that requires a surprising turn—or some "eventfulness," as he puts it—in the action. In Hühn's schema, "informative genres" such as recipes, instruction manuals, and itineraries belong to process narration and can be considered "proto-narratives."[15] Although these proto-narratives exhibit the temporal and causal organization that is fundamental to narrative form, they lack the unexpected departure from an invoked norm or script that has become so closely identified with narrative. A script, according to Roger Schank and Robert Abelson, is "a predetermined, stereotyped sequence of actions that defines a well-known situation."[16] The departure from an invoked norm or script—the violation of the status quo, in other words—has been variously termed "eventfulness" (Hühn's term), "tellability" (William Labov's term), and "canonicity and breach" (Bruner's phrase).[17]

The recipe has emerged as a favorite limit case for narrative theorists because of its questionable eventfulness. While some narrative theorists such as Hühn and Algirdas Julien Greimas include the recipe in the category of narrative (it is a "proto-narrative"), others are not so sure.[18] David Herman opposes narrative to recipes, using the recipe to help him draw the boundaries of "narrativehood."[19] In a playful piece titled "Forty-One Questions on the Nature of Narrative," the narrative theorist Gerald Prince asks, "Does a recipe or user's manual constitute a story?"[20]

The problem with the recipe from the standpoint of narrative theory is that it lacks particularity, which has been treated as important for a sense of eventfulness. In his list of the ten features of narrative, Bruner includes "particularity" as the second: "Narratives take as their ostensive reference particular happenings. . . . [A] narrative cannot be realized save through particular embodiment."[21] Marie-Laure Ryan implicitly agrees. In her treatment of the recipe, she argues that in order to turn a recipe for fruit custard, for example, into a story, "it would be necessary to imagine individuated participants, for instance a chef as agent and patrons of his restaurant as beneficiary, give the agent a particular goal (acquire a third Michelin star), and assume that the events happened only once, instead of being *endlessly repeated*."[22]

However, to de-narrativize the episode in Book V of *The Odyssey* in which Odysseus, with Calypso's help, constructs a raft ("He cut down

twenty trees in total, trimming them with the axe: then he smoothed them dextrously, and made their edges true"), Ryan argues that "you would have to ignore Odysseus and his goal (return to Ithaca), and extract from the description of particular events *a protocol that can be performed over and over again*, with you or me or anybody else in the role of agent."[23] Ryan summarizes: "You cannot read a text that tells you how to cook a dish as being about an evolving network of human relations—the preferred subject matter of narrative."[24] But it is apparent that the reason the recipe fails to be about an evolving network of human relations is that it lacks particularity. Rather than being an event that happened once to a particular agent, the recipe presents a set of events that can be "endlessly repeated," that represent a general "protocol that can be performed over and over again" and to which agential individuality is beside the point. Implicitly, while the recipe has sequence and causality, its necessarily generic character suggests that it is the story not of a single, unique entity (a single batch of pistou soup or a particular fruit custard) but of a *kind*—pistou soup or fruit custard. In other words, the problem is not merely that the recipe or user's manual is about a nonhuman entity, an object; the problem is that it is about an abstract *kind*. This fact jeopardizes the recipe's inclusion in the category of story at all.[25]

The process film bears comparison to the recipe. Like discursive recipes, innumerable visual instructionals on YouTube guide the unpracticed through the step-by-step process of doing almost anything, from making crab cakes to making video clips. While many examples of processual representation were neither intended to, nor do they actually, function as visual instructional guides, they take the form of a how-to and are usually *intended* to give an account of a generic process. For example, the crayon film on *Mister Rogers' Neighborhood* with which I began this chapter is titled "How People Make Crayons," not "How Yellow Crayon No. 1,356 Was Made." In the process genre, it is suggested that that which is being depicted—walking, constructing an ice window, making crayons— belongs to a recognizably generic, repeatable category of action and *not* to something unique and singular, such as an improvised musical number or a spontaneously invented dance move.

One relevant difference between discursive recipes and process films has to do with medium. What is the case for the discursive recipe or instructional guide—that it has a generic rather than particular character— is not, in strict terms, the case for the process film, or, for that matter, the craft demonstration or the chronophotographic motion study or

even pictorial instructions.[26] Unlike with the recipe, the generic character of filmic processual representation is largely a convention of interpretation, a convention that tends toward allegorization—treating a singular instance as a stand-in for a kind. Even when a process film was intended and functions as a how-to, it remains at the same time a unique, particular instance of doing or making. Indeed, its appeal owes to this tension between the generic and the singular. Because of the medium's arguable indexicality—the image's ontological relation to a pro-filmic scene—the resulting recording belongs to an unrepeatable past moment.[27] The camera has recorded a fait accompli, and one that is unique. The hand that corrals the crayons in the *Mister Rogers* film, that removes defective specimens and makes sure that the crayons are evenly and perfectly stacked, is singular, and in some absolute sense, the action is unrepeatable. That hand repeating that gesture again five minutes after the film was recorded is not the same hand: it is five minutes older; it is more tired and certainly more experienced, and so on. Nor is the gesture the same gesture: the hand interacts with different crayons and adjusts itself to a different material world in an ongoing process of "sensory corrections."[28] This is one of the insights of the anthropology of skill.[29] And it must account for at least some of the fascination of processual representations of familiar, quotidian actions such as cleaning the dishes or bathing (as in *Jeanne Dielman*). What looks like endless repetition is not; different people do it different ways, and the same person may do it different ways on different days.

Even if process films, in strict terms, are always representing particular and singular events that have taken place in the past—rather than prospective events—still I would argue that much of their absorptive power comes from the suggestion that what is being produced or done belongs to a general category (e.g., the crayon, the hat, charcoal, walking, rowing) and that what is being represented can be repeated, that it is a protocol or a programming discourse.

Generality and Closure

For the absorptive power of the process film to be engaged, often two interrelated factors are at play: first, the pro-filmic action or object itself is actually a recognizable *kind of something* (e.g., a crayon, a biscuit, charcoal, etc.); and second, the representation has closure—or, put differently, the spectator comes to recognize the *kind* in the depiction. A sense that the representation does not have closure can result when the representation

has ended midway through the process or when the action or object is not recognized as a *kind of something*, either because it is not or because of a spectator's missing contextual knowledge. In other words, one's recognition of a kind depends in part on the pro-filmic character of the action or object (i.e., that it actually belongs to a kind) and on one's contextual knowledge (i.e., that she is familiar with the kind), as well as on the process reaching completion.

Imagine three scenarios. In the first, the action or object being performed or produced in the processual representation does not belong to a *kind of something*. It is particular, as in the case of a spontaneously invented dance move. Because the spectator has no way to recognize the dance move (she has never seen such a move before), she will not know when it is complete, and she will not have other versions in mind with which to compare it.

Now consider Kathryn Morgan's YouTube instructional breaking down the sequential steps and body positions of the fouetté turn.[30] The fouetté turn is a generic, familiar dance move. I have seen it many times, though too quickly to make out the distinct positions of the body that constitute it. Because I am familiar with the fouetté as a *kind* of ballet move—a building block of standard choreography—I know when the fouetté has been performed; I am able to compare the finished fouetté of the video with all of the other fouettés I have seen; I understand things about the fouetté that I had never understood before (e.g., I never realized that the leg that jetés to the side produces the momentum that allows for the pirouette). These reference points help hook me into the video, but they would not function in this way if I was unfamiliar with the action because of missing contextual knowledge (i.e., if I did not know anything about ballet) or if the action being performed in the processual representation was singular, particular, or nongeneric, as in the first scenario.

In the third scenario, imagine that the crayon film on *Mister Rogers' Neighborhood* ends mid-process. In other words, imagine that the film ends at the point at which the double-spout bucket full of hot wax is poured into the crayon mold. Intuitively, it must be clear that much of the satisfaction of processual representation is the strong sense of closure—the *apprehension* of a complete process of production or a complete cycle of action so that the representation takes us to the threshold between one cycle and the next (i.e., the point at which one process gives way to the next) or to the threshold between production and consumption (the packaged product that I immediately recognize from my encounter with it on a store shelf marks that moment). But to recognize that moment, the beholder

must recognize the kind of thing that is being produced—"Ah, yes, there is a yellow crayon," a recognition that will depend on whether the object is indeed a kind of something and whether one has the contextual knowledge to be familiar with it. If the action is not recognizable as an action (e.g., taking a step, bringing the hammer down on the anvil, rowing for one cycle) or if the object is not recognizable as a generic object, perhaps for cultural reasons (e.g., in the case of an object unknown in one's native land), the sense of recognition when the action has been completed will be compromised. Moreover, it is largely because we are familiar with the conventions of the process genre that we develop a set of expectations when confronted with processual representations. These expectations of satisfaction heighten the spectator's involvement. While it is certainly possible to depict generic actions and objects without a strong sense of closure by ending the representation mid-process, a strong sense of closure is difficult to achieve in the depiction of singular, unique, idiosyncratic actions and objects where closure depends not on one's own recognition of a familiar object or action but on an external indicator (e.g., narration or text indicating that the process is complete).

The Mystery of Picasso (Henri-Georges Clouzot, France, 1956) is a film that dramatizes this point. While it seems to be a process film about Picasso's painting process, what it represents is not generic but singular. For this reason, the film lacks the closure that accounts for much of the fascination of the genre. In the case of Clouzot's film, it is not that the representation ends midway through the completion of a painting so much as that one does not realize each drawing/painting is complete until the image cuts to the next blank canvas; the cut to a blank canvas is the external indicator of completion.

The Mystery of Picasso follows Picasso's painting process across a series of pictures, some drawn with pens and some painted with oils. Clouzot devised a special method that allowed him to film, from a fixed position, Picasso's pen strokes without also filming Picasso's body and his hand at work (figures 2.1a–c). The stationary camera is set up at a distance from a piece of paper that is vertically suspended from the ceiling. On the other side of the paper is Picasso drawing with special pens that soak through paper and so become visible on the side of the paper that faces the camera. The camera films, without cuts, the seemingly autonomous appearance of ink on paper; the resulting picture is the reverse of what the painter has painted. Partway through the film, Picasso turns to oil painting. Clouzot's approach changes: now he films the canvas, again without the human

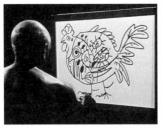

a b c

FIGS. 2.1a–c The setup: Picasso on one side drawing (2.1a); the positioning of the camera vis-à-vis the painter (2.1b); the close-up, unframed perspective of the camera (i.e., what the viewer mostly sees [2.1c]). Frame enlargements, *The Mystery of Picasso* (Henri-Georges Clouzot, France, 1956).

figure, but at intervals since oil paint does not soak through the canvas. This method is a variation on stop-motion animation: the painter fills in a red sky, the camera shoots the result of the effort; the painter adds two figures in an embrace, the camera shoots the addition of the figures; the painter erases the figures, the camera shoots the subtractions, and so on. Colors and figures appear and disappear as the canvases evolve and as Picasso deliberates and experiments, meandering his way through the process.

The film, in some sense, tracks the process of drawing/painting as each episode begins with a blank white paper or canvas and ends with a completed drawing or painting. In the interval between Picasso beginning to paint the picture and the picture's final form, the spectator sees a series of sequential, chronological additions and subtractions as Picasso feels his way to the end of each picture. And yet this is not straightforwardly a process film. Although each episode of *The Mystery of Picasso* ends with a finished picture, the point at which the picture is finished comes as a total surprise to the spectator.[31] The most striking feature of the film is the status of closure.

Closure, according to Noël Carroll, "is the impression that exactly the point where the work does end is just the *right* point. To have gone beyond that point would have been an error. It would have been to have gone too far. But to have stopped before that point would also be to have committed a mistake. It would be too abrupt. . . . Closure yields a feeling of completeness."[32] This sense of completeness "transpires when all of the questions that have been saliently posed by the narrative get answered."[33] Although all narratives end or stop, not all narratives have closure.

The sense of closure so common to the process genre is absent in *The Mystery of Picasso* because the ending of each picture is wholly idiosyn-

cratic and impossible to anticipate. Each picture episode prompts, at some point as it unfolds, the following questions: "How will the picture look when it is finished?" and "Why is the picture not finished now? Or now? Or now?" In other words, the episodes provide no sense of closure because the pictures are finished only when Picasso decides they are—this, despite the fact that each shot of the time-lapse paintings could itself conceivably have been a finished painting. In his review of the film, André Bazin goes even further, arguing that unlike in a didactic film about painting (e.g., Bob Ross's PBS show, *The Joy of Painting*), *The Mystery of Picasso* renders a truer (but under-recognized) conception of painting as a durational art: "The intermediate stages are not subordinate and inferior realities, parts of a process that will result in a final product: they are already the work itself, but a work that is destined to devour itself, or rather to metamorphose until the painter wants to stop."[34] Each layer of the series is a picture in its own right—just one whose very evanescence facilitates the next picture. This means that every layer is, potentially, the last—a possible endpoint (plates 4a–c).

These pre-finale steps could be finished pictures in a way that a well-kneaded lump of clay could not plausibly be a bowl. Because of the *kind* of thing being produced—a painting rather than a bowl—it is what it is when the artist says so and not when it plausibly fulfills a basic bowl function. One requirement for the satisfying sense of closure, as Carroll puts it, is not only for all the questions to be answered, but also for the spectator to *realize* that the questions raised in the narrative have been answered.[35] In most process films, the spectator comes to this realization when she recognizes the object or action to be complete. She recognizes this finality because she recognizes the object or action.

What emerges from *The Mystery of Picasso* is a different kind of experience. What the film documents is not technique or skill, which belongs to the generic, the repeatable, the imitable. Rather, these episodes (which are processes with sequence and causality) and the pictures they produce are wholly singular, particular, unique, unrepeatable. The film is not teaching *how* something is done. Moreover, without the closure afforded by usual process genre artifacts and action, Picasso's picture-making process *ends* rather than *concludes*. The effect of the process is not so much curiosity as surprise: "Ah, so now he thinks it done!" And if there is suspense in the film (as the commentator on the Milestone DVD edition insists), it is generated largely by the anticipation of the answer to the question "Is it finished?" and not by the more usual process genre question "How is such a

feat accomplished?"[36] The achievement of the Picasso pictures is not in the "how" (i.e., how they were done) but in the "what" (i.e., what was done). No quotient of training in paintbrush strokes and no accuracy of imitation could produce similar achievements. It is just not that kind of thing.

Unlike in most examples of the process genre, a certain kind of involvement or absorption is precluded in *The Mystery of Picasso*. While the pen strokes and brushstrokes are the actual causes of the picture we perceive on the screen (without them, the image would not appear as it does to us), this brand of causality is constitutively different from the one that prevails in paradigms of the process genre. As Bazin has observed, "Each of Picasso's strokes is a creation that leads to further creation, not as a cause leads to an effect, but as one living thing engenders another."[37] The true "causes" of the pen and brushstrokes are in Picasso's head and wholly inaccessible and impossible to anticipate. In the process genre, the steps in the process are accessible to an alien intelligence; the beholder can identify with the rationality on display. Perhaps a certain step in the formation of crayons from wax, for example, strikes her as surprising or unexpected; she may ask herself why such a step was undertaken—what was its function—to which there *is*, in processual representation, an account that is rational rather than mystical. In the process genre, in general terms, each action has its reason(s) because all actions are subsumed by a pursued and desired result. Part of the pleasure in processual representation is surely the identification with a human rationality that the spectator shares. *The Mystery of Picasso*, by contrast, explores the irrationality and illogic of Picasso's process. The beholder is in a position totally external to the process; she is at its mercy. In this case it is not human intelligence and ingenuity that one admires but something else: the mysterious workings of artistic genius. This is perhaps why Bazin begins his essay on the film with the declaration that—notwithstanding the filmmaker's claims to the contrary—the film "doesn't explain anything." Rather, "it shows [Picasso], and the lesson to be learned, if there is one, is that watching an artist at work cannot give us the key to his art, not to mention to his genius."[38] Indeed, the title suggests a misdirection. Unlike in most mystery films, in this film "the mystery" is never revealed. Rather, the "mystery" is metaphysical.

Compare this with the seemingly similar case of *Hand Gestures*. The film, briefly mentioned earlier, is a 2015 observational process documentary about the lost-wax bronze casting of one of Velasco Vitali's famous dog sculptures at Milan's Fonderia Artistica Battalgia—a place where the lost-wax casting process has been practiced, roughly unchanged, for one

hundred years. Widely heralded as "enthralling," "fascinating," "hypnotic," and producing a "strange thrill," *Hand Gestures* follows the crafting of a life-sized bronze sculpture of a floppy-eared dog at rest.[39] The film is seventy-seven minutes, without narration; it moves chronologically through the steps in the process, from Vitali's initial wax sculpture through the various stages of spruing and investment casting, to the high-pressure cooking of the ceramic shell, the pouring of the bronze to the "breaking out" of the bronze sculpture from its ceramic shell, the metal chasing and welding to the patinization process, and, finally, the piece's installation in a gallery space (plates 5a–l).

Although Vitali is a famous artist (though not quite as famous as Picasso), and although the sculpture is a singular work of art, what is striking in this case is how little screen time the film devotes to Vitali's role in the artistic process. This decision contrasts starkly with *The Mystery of Picasso*. When we are first introduced to Vitali in a studio of the foundry, just three minutes into the film, rather than encountering a "blank canvas" and observing Vitali create the dog sculpture from nothing, we watch him putting the finishing touches on the almost fully formed wax dog. This segment—tracking these finishing touches—will take up a little more than five minutes of screen time. It feels like only enough time to get a sense of the chemical behavior of the red wax and the means by which Vitali shapes it using everyday tools such as knives, files, and a plug-in double burner. One might think that in fact *Hand Gestures* has begun in medias res, that it should have started with Vitali's empty sculpting table (as *The Mystery of Picasso* began with the blank canvas), but this view would reflect a misunderstanding of the subject of the film. Indeed, the drama of the film does not inhere in Vitali's idiosyncratic, mysterious process—his seemingly spontaneous and whimsical decision to add a cut here, an additional patch of wax there. Rather, the real interest of the film is in the circuitous means by which the foundry's artisans get from Vitali's positive wax mold of the floppy-eared dog to the final bronze sculpture. The drama comes from the puzzle of *how* to manipulate with such precision material as natively nonmalleable as bronze.

There are two aspects of this setup that I want to highlight. First, although the film is ostensibly about the production of a singular, unique fine art object (as was the Clouzot film), its real subject is the genius of the lost-wax casting process—a generic, repeatable process. And second, the film's early introduction of the finished wax sculpture, as well as the fact that the sculpture is realistic and representational, is largely responsible

a b c

FIGS. 2.2a–c Three moments in the trajectory of the dog from wax to bronze. The first frame enlargement is taken approximately eight minutes into the film (2.2a); the second is taken approximately thirty-eight minutes into the film (2.2b); and the third is taken approximately sixty minutes into the film (2.2c). Frame enlargements, *Hand Gestures* (Francesco Clerici, Italy, 2015).

for the film's absorptiveness. Eight minutes into *Hand Gestures*, Vitali has completed the final touches, and the spectator now has some notion of what the finished bronze sculpture will look like, for the red wax mold is the positive of the bronze dog. As the film moves into successive stages of the process, it follows an arc in which the sculpture will look less and less like the wax mold as the artisans alternate between spruing, where a treelike network of wax tubes is added around the wax sculpture, and investment casting, where layers of wet clay are applied to the wax sculpture and to the network of wax tubes that extends out of it. This alternating process, which occupies close to thirty minutes of screen time, encases the wax dog in a solid, smooth ceramic cylinder—all traces of the dog are effaced. This is the film's perplexing climax: the viewer may wonder, what is the function of the elaborate spruing and investment casting steps? How will the molten bronze penetrate the cylinder? How will the ceramic cylinder be broken? How and when will the dog look again like a dog? Indeed, the dog will only again come to resemble the resting animal of Vitali's wax mold sixty minutes into the film (figures 2.2a–c). But notice that the viewer's knowledge of roughly what the sculpture is meant to look like generates considerable mystery.

Imagine that the five minutes of Vitali forming the wax sculpture (i.e., from minute three to minute eight) had been cut out. In that case, as the film turned to the spruing and ceramic casting processes, the viewer would have no idea what was being cast. How different would the nature of the viewer's involvement be? Perhaps she would watch on, hoping to see what was being cast. But would she be asking herself about the function of the sprues or would she be wondering whether the sprues were part of the final object or not?

Now imagine that the initial wax sculpture (introduced at three minutes) was abstract and unfamiliar (i.e., not the form of a floppy-eared ca-

nine), hard to take in over the five minutes the viewer spends with it and hard to remember more than thirty minutes later. How different would the moment of recognition (at sixty minutes) be in that case? Would we be as elated? I am proposing that the key to the fascination of the film is the recognition of the resemblance between Vitali's finished wax dog at rest (see figure 2.2a) and the bronze dog revealed at sixty minutes (see figure 2.2c), just after the removal of the last sprues; this recognition has been facilitated by the choice of a representational subject matter. Once the dog starts to look like itself—once the ceramic cast has been broken, once the bronze object has been washed, once the treelike scaffolding surrounding it (which, after the pouring of the molten bronze, had become bronze sprues) has been ground off, once the dog's leg has been welded back on—the main drama has passed. The major questions are answered. The wondrous secret genius of the lost-wax process is revealed: the red wax that formed the dog and the treelike wax scaffolding melted in the oven (see plate 5c), creating a cavity for the molten bronze to fill; the scaffolding, it turns out, provided the molten bronze with a pathway to Vitali's dog. Without that network of wax tubing so expertly constructed, how would the bronze have reached every nook, every line, every indentation Vitali had made in the surface of the wax?

All that is left in the fifteen minutes that follow (the last minutes of the film) are the finishing touches: the traces of the process must be removed, the bronze must be treated, the patina added, and the finished sculpture transported to a gallery, where it will take its place among Vitali's other canines. A more definite and satisfying closure for the film I can hardly imagine.

I have been arguing that paradigmatic examples of processual representation elicit a generic, allegorical reading of the actions and objects they depict and that they exhibit a strong degree of closure. Generic, repeatable subject matter and a strong sense of closure are central to the process genre. And while this protocol character has generated arguments against the "eventfulness" of "process narration" in general debates about narrative, we have seen that it is precisely the generic (and familiar) character of the subjects of processual representation that generates much of the genre's fascination. In other words, the process genre exploits to considerable effect its recipe-like narrative character.

But we can go deeper. The recognition of a generic subject matter by a spectator depends, in part, on cultural and historical factors—that is, on the spatial and temporal situatedness of *actual* spectators. Moreover,

different process films organize the revelation of information about process and subject matter in different ways that take account of the situatedness, or context, of actual spectators.

Eventfulness and Audience Context

Eventfulness or tellability—the quality that lends a feeling of "so what?" to the story by violating a status quo—is thought of as a quality that belongs both to prediscursive narrative (e.g., as in the common sentence "Have I got a story to tell you," in which the speaker foretells the narrative character of the events before she has even narrated them) as well as to already discursivized stories.[40] It is a quality that is at once inherent to stories and can be amplified or diminished by the formal expression of a story. This means that a badly discursivized story can compromise the discourse-independent tellability of the material, whereas a well-told story about low-tellability events (i.e., perhaps not inherently very interesting ones) can absorb an audience.[41] But the discourse-independent eventfulness of events in a story can be subject to contextual factors, as well, whether they are historical, cultural, or based in genre expectations. What is eminently tellable in one cultural context and in one historical moment may be only mildly tellable in another. Meanwhile, the tension between an invoked norm or script and its violation, which is part of a story's eventfulness, is also affected by genre conventions and the expectations they generate. In other words, eventfulness can be achieved by thwarting prevalent genre conventions. Contextual factors come into play in the act of interpretation, and they depend on the extratextual sociohistorical context of the audience and on the audience member's familiarity with literary/filmic phenomena and conventions outside the text.[42]

In relation to the process genre, one might say that the popularity of processual representation at certain historical moments is due in part to fluctuations in the level of anxiety in advanced capitalist consumer societies toward a general state of ignorance about industrial production. In the case of industrial process films that depict the process of production of a commodity such as biscuits or Chevrolet cars, as well as in the case of most ethnographic process films that depict artisanal methods of producing use values, these films often present a notional idea of the object being produced early on in the diegesis or in the film's title. This familiarity with the object sets up a mystery about the object's genesis. The puzzle surrounding the object arises in large part from the spectator's ignorance,

which may have different causes. To be sure, the dazzling commodities of our modern consumer society—from packaged meat to seaweed chips, Stetson hats, iPhones, and external hard drives—are shrouded in mystery. Most people have no idea where these items come from, how they are made, what they are made of, and who made them in what conditions and where. Elizabeth Cain has argued that this "alienation from the production of goods," the way in which "even commonplace objects . . . could seem marvelous" because of the obscurity of their origins, gave rise between 1910 and 1945 to what she calls the "craftsmanship aesthetic"— that is, the interest in "contemplating the accomplished making of things, by artisans, artists, or other skilled workers."[43] (We might add that the "alienation from the production of goods" did not end in 1945 and persists today, perhaps intensified by the compounded mysteries of the Information Age.) But it is not only the most technologically complex objects that seem marvelous. We could say much the same for handmade or "exotic" (though still recognizable) objects that no one makes by hand anymore. This was the driving conceit of the craft demonstrations performed mainly by recent immigrants at Jane Addams's Hull House in the early 1900s. It is in the context of an advanced capitalist consumer society in which production is ever more distanced in space and time from consumption that the interest and eventfulness of processual representation is heightened and amplified. I would argue that the recent resurgence of process films as a prominent trend in observational documentaries devoted mostly to artisanal and traditional industrial production is surely related to the attendant anxieties and disorientations of the eclipse of the machine age and dawn of the digital age.

There are other ways in which contextual factors can be relevant to understanding the appeal of processual representation. Consider again the case of the *Mister Rogers' Neighborhood* crayon film, which is part of the series "How People Make Things." These process films depicted other processes, such as "How People Make Bread," "How People Make Guitars," and "How People Make Fortune Cookies." But why is it that among all of these the crayon episode is the most iconic? Surely, the answer must have something to do with the status of the crayon in the lives of the series' intended audience: American children, for whom crayons are ubiquitous, almost exclusively their domain (unlike guitars, bread, and fortune cookies), and typically left behind with childhood. The story of the mystery of the yellow crayon derives its eventfulness at least in part from the status of the crayon in a standard American childhood. This status is echoed in

the many internet commentaries that cite the crayon episode as a particularly memorable *childhood* viewing experience. Vis-à-vis the crayon, the American child spectator occupies a position of knowledge and ignorance. On the one hand, the child recognizes the yellow crayon from the Crayola box. She has probably used one before: she has picked it out of a similarly labeled box; she has held it in her hand; she has a sense of its weight, its girth, the brilliance of its color on white copy paper versus on pink construction paper; she knows how hard one must press when it is new and its point is pointy versus when it is old and its point is dull. On the other hand, it is likely she has no idea how to make such an object from which she has derived such pleasure; nor does she know what the crayon is made out of or who makes such objects, in what spaces, and under what conditions. Whatever *form* the processual revelation of the mystery of the yellow crayon takes, the autobiography of the crayon—in a certain context—has a priori, discourse-independent tellability.[44]

It stands to reason that the viewer's relation to a process film would be quite different if the object being constructed or the action being undertaken were less exciting than, say, the crayon is to the child or if the object or action were overly familiar or banal. And yet, process films about quotidian activities or simple objects can also potentially—as a result of their formal structure—generate their own brand of fascination. Consider the case of *Jeanne Dielman, 23 Quai du Commerce, 1080 Bruxelles* (Chantal Akerman, France/Belgium, 1975) from the introduction. Unlike the crayons in the crayon film, the labor of the everyday that takes up most of the film's screen time—food preparation, cleaning and tidying up, mending, bathing, and so on—is usually devalued, routinized work. In contrast to the relative mystery behind how a crayon is made, the average Western spectator has some familiarity with how food is prepared, how dishes get washed, how a bed is made, and how one bathes oneself. In other words, the discourse-independent material of the film has low tellability. But the film itself, as a whole, achieves remarkable tellability by first invoking a canonical cultural script prevalent in Euro-American societies. The relevant script in this context is a domestic one that denies the skill involved in this kind of labor. *Jeanne Dielman* invokes this script and then thwarts it (and the viewer's expectations) by presenting each process of domestic labor as ostentatiously skilled and efficient—a ballet of mundane gesture. As the *Jeanne Dielman* bathing example from the introduction suggests, it is difficult to imagine a more systematic approach to bathing. Moreover, because many of the processes—which are repeated over the three-day pe-

riod of the film's diegesis—begin to break down with each new iteration, the film again thwarts the very expectations it has trained the spectator to anticipate. There is nothing that makes the viewer more aware of the skill of domestic labor than the frustration we experience when Jeanne neglects to replace the top on the tureen in the dining room where she stores her money or when she leaves soapsuds on the dishes she is washing.[45] My reading here gives a certain slant to Akerman's admission that she "made this film to give all these actions that are typically devalued a life on film."[46]

Another example of an elevation of quotidian actions may be seen in the final five-minute sequence of *El Velador* (Natalia Almada, Mexico, 2011) in which Martin, the night watchman of a cemetery in Sinaloa, systematically waters the ground in front of a baroque mausoleum in the shape of a perfect square. Almada effectively transforms the night watchman from menial laborer to abstract expressionist painter. Not only does the film thereby breach the script surrounding the labor of the watchman, but it also underlines the paradox of having Martin's human skill wasted on the doubly futile enterprise of keeping dwellings for the dead dust-free in a dry, dusty landscape.

These last two examples highlight at once the significance of contextual factors in eventfulness and the significance of formal mechanisms in shaping the eventfulness of discourse-independent material. Not all processual representations are equally absorbing. Absorption is an achievement. It is in part a function of the contextual, discourse-independent tellability of the process represented. But absorption is also achieved by formal means. Formal strategies can enhance the eventfulness of material that seems ordinary or even inherently boring. The strategies that I have in mind include the manipulation of narrative structures to heighten surprise, suspense, or curiosity.[47]

Expositional Structures

The expositional structures that engender surprise, suspense, and curiosity vary in the means by which they shape spectatorial knowledge and ignorance.[48] In a surprise discourse structure, important story information has been withheld from the plot. But it is not only the case that the information is missing; it is also the case that there is no indication in the plot that this important information has been withheld.[49] In other words, the viewer is not aware of her own ignorance vis-à-vis the story events. When

the spectator is confronted with this important, missing information, she experiences surprise and then sets about the task of reevaluating her previous understanding of the events of the plot. Surprise, as Meir Sternberg writes, "is an index of false understanding and a call for realignment."[50] Surprise reflects not so much uncertainty as disorientation.

Suspense is characterized by uncertainty about an important future outcome. A suspense discourse structure often contains an important story event early on in the plot structure. But the consequences of that "initiating event" will not be known until the end of the narrative. The viewer is then cast into a state of suspense as she anticipates the outcome of an event she knows to be significant and unresolved.[51] Here is Alfred Hitchcock's famous account of the difference between surprise and suspense, which he gave to François Truffaut in an interview in 1962:

> We are now having a very innocent little chat. Let us suppose that there is a bomb underneath this table between us. Nothing happens, and then all of a sudden, "Boom!" There is an explosion. The public is surprised, but prior to this surprise, it has seen an absolutely ordinary scene, of no special consequence. Now, let us take a suspense situation. The bomb is underneath the table and the public knows it, probably because they have seen the anarchist place it there. The public is aware that the bomb is going to explode at one o'clock, and there is a clock in the decor. The public can see that it is a quarter to one. In these conditions this innocuous conversation becomes fascinating because the public is participating in the scene. The audience is longing to warn the characters on the screen: "You shouldn't be talking about such trivial matters. There's a bomb beneath you and it's about to explode!" In the first case we have given the public fifteen seconds of surprise at the moment of the explosion. In the second case we have provided them with fifteen minutes of suspense.[52]

In a curiosity discourse structure, as in the surprise structure, significant information has been withheld, but in this case the viewer knows that information is missing. The mystery surrounding the missing information elicits curiosity in the spectator—curiosity that is generally satisfied by the end of the narrative.[53] Because the missing information usually pertains to past events rather than future outcomes (as in the suspense structure), the viewer experiences less a sense of uncertainty about the future than "an interest in the information for its own sake."[54] The curiosity structure is most common in whodunit detective stories in which a crime has already taken place, perhaps even before the first plot event.[55]

The narrative, then, sets about unraveling the mystery of who did it, how, why, and so on.

Perhaps the most common structure in the process genre is a curiosity structure similar to the structure used in many detective stories.[56] *Hand Gestures* has such a structure. In the case of that film, the spectator knows that by some means a wax mold will be transformed into a bronze sculpture; the missing information is *how* precisely the process will work. Because the spectator is familiar with processual syntax as a representational convention, she forms the expectation not very long into the film that, indeed, *Hand Gestures* will deliver the image of the completed bronze dog sculpture. She is not so much uncertain about the outcome of the process as her curiosity is piqued by the puzzle of it; she has "an interest in the information for its own sake."[57] She may wonder, how does the lost-wax casting process work? How do artisans shape so hard a material as bronze? Moreover, although she has a notional idea of what the sculpture will look like eight minutes into the film (i.e., she has an idea from the red wax mold [see figure 2.2a]), a view of the finished bronze sculpture is withheld until the end.

The telos of almost every process film is an object (almost always a commodity) or a completed action. As in a detective story where a crucial event is known early on, in process films the viewer often knows early on what commodity, use value, or action is being produced. Sometimes this fact is established by the film's title, as in *A Visit to Peek Frean and Co.'s Biscuit Works* (Cricks and Sharp, United Kingdom, 1906) or *A Man Escaped*; sometimes it is established in the film's voice-over narration; sometimes it is established in the plot itself, as in the *Mister Rogers' Neighborhood* crayon episode, which begins with Mister Rogers drawing a rainbow on a flip pad with different colored crayons, or as in *Hand Gestures* where the viewer sees, within the first minutes of the film, the wax mold that will be cast in bronze by the end. This discourse structure in which the spectator knows the object but is ignorant of how it is made primes a viewer from the start, setting up a curiosity structure that is ultimately satisfied by a processual representation that answers the opening question.

Let us look again more closely at "How People Make Crayons" (plates 3a–l). The first image of the film is a railway tank car arriving into a rural station in a bare, wintery landscape (plate 3a). It is carrying the hot wax to the factory, Mister Rogers's voice-over tells us. The white steam from the train fills the frame and dissolves into a close-up shot (that will gradually track out) of the white, hot wax filling a giant kettle that has an automatic

stirring device. These are the first two shots of the six-minute film, and they correspond to two early steps in the process being presented. Of course, between these shots and between these steps, there are several steps in the pro-filmic process that are missing from the representation. After all, how was the hot wax transported from the train station to the factory? How did it make its way into the factory, and then into the machine that releases a certain quantity into the giant kettle? These steps are elided in the representation but relatively easy to fill in and unlikely to feature any surprises. The actual depiction, instead, begins with two shots that already, by themselves, present an obvious puzzle: the crayon that I have held in my hand is solid and slim; it has a definite shape, and it is yellow. But the wax that I see—apparently the material substrate of the crayon—is white, liquid, and amorphous. How does something white, wet, and liquid become something yellow, dry, and solid? To find the answer, I must keep watching.

The next few shots show the addition of a special powder for hardening the wax and a special powder for coloring the wax yellow. This begins to answer some questions, but still the gap between what I know the crayon to be and what I am seeing on the screen seems an unbridgeable abyss. A few shots later, the hot yellow wax—now with its hardener—is poured, using a double-spout bucket (plate 3c), into two long metal rectangular trays with evenly distributed holes the diameter of a standard crayon. The trays contain molds, and as the hot wax is poured over the trays, it disappears into the holes, as gravity sucks the liquid down into the molds. A dissolve suggests the passage of time, and in the next shot the now excess dried yellow wax that has formed an almost solid layer over the tray is scraped off (plate 3d), revealing two metal trays dotted with hundreds of yellow circles. Two seemingly identical metal trays are placed on top of the two scraped trays; these are crayon collectors. I may be asking at this point, are the crayons in those collectors? They look a lot like the receptacles for the hot wax. The film cuts to an eye-level close-up of the crayon collectors, and with a magic chime sound effect, the yellow crayons are simultaneously pushed up into the crayon collectors, which are shorter than the length of the crayon, thus revealing a bed of yellow crayons, an upper inch of crayon visible above the metal mold (plate 3e).

This is one of the most striking moments of the film. Certainly the magic chime helps, but it really just accents what has become apparent. Ultimately, the power of the moment arises from the diminishing gap between the crayon that I know—that I have held, that I have used—and the proto-crayon that I see before me. As the film proceeds in unraveling

the puzzle that it first generated, the crayon I see has started to look like the crayon that I know. But understanding the success of this most crucial moment requires several steps in my reasoning. The addition of hardening powder accounts for how pouring a liquid concoction into molds could yield a solid crayon form. The laws of gravity account for how pouring the wax over the metal trays is such a perfect way to fill the molds. The metal crayon collectors make sense because without them, what would happen to the crayons when they were pushed out of the mold? They would spill out, with crayons falling every which way. Some could be damaged, and they would all then have to be collected by hand and painstakingly piled and faced in the same direction, which is surely a crucial step for the labeling process.

Of course, the film has not been explicit about these hows and whys, but one plausible way to engage with the film is by reconstructing a chain of causes and effects on the way to the final outcome (i.e., the crayon) that I seek. Over the next four minutes, several of the remaining questions that are propelling me forward, maintaining the film's grip on me, will be answered, including, "How do the labels that save me from having to feel the greasiness of the wax get affixed?" (plate 3h); "How do the differently hued crayons get sorted so that every box guarantees the very same pleasing array of colors?" (plate 3j); and "How are the boxes prepared for shipping?"

Much of the spectatorial involvement that I have attempted to describe here has depended on my familiarity with the object—the crayon—and my efforts to connect *what I see* to *what (I think) I know*. This organizational structure is a curiosity structure: the drive to know how matter and labor metamorphose to become a familiar, recognized object is what grips me and spurs me forward.

Of course, there are other expositional structures that can generate eventfulness besides curiosity structures. Imagine that the crayon film is called "Wax." Imagine that this film begins with the tank car carrying hot wax and proceeds in the same way as the original, but without the mention of crayons. Would I be trying to anticipate *how what I see* would become *what I know*? Or would I be preoccupied with trying to guess what is being made and forming hypotheses about it ("Oh, they're making candles" or "They're making Chapstick")? A change in the film's title or the omission of reference to the object being constructed could have a profound impact on the character of my engagement. A structure in which a spectator is gripped by anxious anticipation as she waits to learn *what* is being produced is more likely to generate feelings of suspense than one in which a spectator is rapt with curiosity about *how* a familiar object is made.

Park Lanes (Kevin Jerome Everson, United States, 2015) is a recent example of a process film with a suspense structure. This eight-hour film represents one working day in a factory that makes parts for bowling alleys. The film moves between different work stations depicting different kinds of activities—from screwing parts together and painting the metal sheet that forms the underside of the mechanism that automatically removes fallen pins so that the bowler can roll another ball to bending metal and fabricating wooden bowling floors, and so on. Yet from the title of the film it is not possible for a general audience to know what sort of factory is being represented. Nor is it clear within the first six hours of the film what sort of object(s) this factory manufactures. The film does not present its steps in order, as would often be the case with a film on craft production. Instead, it shows a variety of activities seemingly being performed simultaneously for the entirety of the working day. Although the steps of the processes are not presented sequentially (they, too, are out of order), the film moves roughly from simple actions on small parts to more complex actions on larger machine parts. All the while, over the course of the eight hours of spectating, the viewer is constantly involved in the internal activity of ordering the steps in the various processes and puzzling out what is being fabricated and how large machines are constructed from smaller machines. Only in the last two hours of the film is it possible to see how the parts that are assembled early on combine with other parts to form recognizable objects that make up bowling alleys. Thus, *Park Lanes* exploits a suspense structure—and, to a lesser extent, surprise mechanisms—to create its effects and power.

THE UNSTABLE OBJECT
(DANIEL EISENBERG, UNITED STATES, 2011)

The Unstable Object is an especially compelling case because it employs, across a single film, different expositional structures and process genre conventions precisely to meditate on the process genre as such. *The Unstable Object* is a process film with three episodes that depict, respectively, the assembly and sale of Volkswagen cars in Dresden, the fabrication of wall clocks for federal buildings by visually impaired workers in Chicago, and the making of cymbals in Istanbul. The first two episodes are loosely processual, the third is more robustly so. Each episode corresponds roughly to different expositional structures—respectively, surprise, curiosity, and suspense.

The opening shots of the first episode are exterior long shots of the so-called Transparent Factory, a factory for the assembly of the Volks-

wagen Phaeton luxury sedan (figure 2.3a). The building is an architecturally impressive structure made of glass and metal designed by the architect Gunter Henn. As a series of opening shots move in closer to the factory, it becomes apparent that the building is housing cars. Is it a car showroom? In a series of six vignettes, each fading to black at the end, the viewer is, first, introduced to a gleaming and bright architectural space that functions simultaneously as showroom, work display, tourist attraction, and assembly plant.[58] The second vignette introduces a method of production *sans* assembly line as workers dressed in white and wearing white gloves move around the factory floor visiting individual cars in production and using hand tools to hammer, screw, and staple parts of the cars' shells (figure 2.3b). In the third vignette, the factory floor is dominated by seemingly self-propelled robot machines carrying vehicle undersides, moving this way and that—in arcs and squiggles rather than at right angles—with nary a human in sight. In the fourth vignette, the viewer sees an amazing sight: a robot delivers a tire bed to the shell of a car, eventually sandwiching them together and tightening the bolts. In the fifth, a couple is presented, in a private showroom, with the Phaeton they have purchased; frosted, curved glass sliding doors part to reveal the car. They get in while workers in executive attire put the couple's belongings in the trunk, then doors to the outside grounds open, and the couple drive right off the premises. In the sixth vignette, a kind of coda, the workers leave the factory.

This first episode recounts a stylized process of production from the assembly of the shell to the addition of a motorized base to the moment of consumption. But the twenty-minute episode's discourse structure is

b

S. 2.3a–b The Transparent Factory, Dresden: third
ot of the first episode (2.3a) and gloved peripatetic
rkers (2.3b). Frame enlargements, *The Unstable*
ject (Daniel Eisenberg, United States, 2011).

not one marked by suspense, for we know from the first minute of the film what is being produced (the Phaeton). In a suspense structure, we would likely not know until much later what the factory produces. Nor does the episode satisfy one's curiosity, for even though we know early on what is being produced (as is the case in a curiosity structure), we also realize that the film will not provide enough visual information to give much of a sense of what the workers are doing (what they are stapling, screwing, hammering) or anything but the most rudimentary idea of the progression of the process.

Instead, the episode delivers a series of shocks that strike us as surprising by virtue of their departure from familiar car manufacturing and factory scripts and iconic representations. From these scripts and iconic representations we think we know that factories are dark, dingy, dirty, windowless spaces; sites of production and sites of distribution are spatially separate; factories consist of a series of conveyer belt assembly lines that move parts while workers remain largely stationary and repeat the same basic gestures over and over again. Workers' clothes are dirty and stained, and their hands are calloused and smeared with grease. The conceit, then, of this first episode of *The Unstable Object* is to invoke a set of normative representational conventions and then thwart them by presenting a series of visual surprises: a bright, pristine factory made of glass; a single site for production and distribution; workstations peopled by peripatetic technicians rather than assembly lines; workers in white (figures 2.3a–b). These surprises are the source of the episode's eventfulness, and taken together they invite—as surprise discourse structures do—the spectator to reevaluate what she thought she knew about car manufacturing. In effect, by virtue of its processual structure the episode has invoked a set of absent representational norms associated with industrial process films and then systematically subverted those representational expectations. These subversions or surprises, as I am calling them, function like events and generate mounting interest as we are introduced—via a step-by-step comparison between the industrial manufacturing script we carry in our heads and the postindustrial manufacturing that we are seeing on the screen—to a new phenomenon: "artisanal" mass production.

The second episode of *The Unstable Object* is set at the Chicago Lighthouse, a nonprofit organization dedicated to serving the blind and visually impaired with a range of social services, but also with employment opportunities in the organization's clock factory that, since 1977, has had a federal contract to provide government buildings with wall clocks. Like the

film's first episode, this one is not primarily marked by suspense: it is clear from the first shot what object is being manufactured in the space. Surprise is not much at play, either, because it is apparent within two minutes of the start of the episode that the workers in this clock factory are visually impaired; we see them navigate the factory space using canes for the blind. Thus, within the first few minutes of this second episode, we know the basics, and as the episode progresses, it will not reveal shocks comparable to the revelation (in vignette four of episode one) that the Phaeton building is a site of production and distribution simultaneously. So how, then, does episode two generate its own interest? The discourse structure of this episode is largely shaped by curiosity, as the opening prompts the question, "How *do* people who are visually impaired make clocks?" Notice that this question has a different emphasis from a more standard question that one might expect to be structuring an industrial process film about the production of wall clock—namely, "How are clocks made?"

Another notable feature of this second episode is that, rather than depicting the production process of a single wall clock through an ordered sequence of steps, beginning with the printing of the clock face on cardboard and ending with the fully assembled wall clock being placed in cardboard boxes for shipping (which would be a standard processual account), the episode employs parallel editing among the full array of workstations. Each station is staffed by one person and represents one step in the process of wall clock production. But the depicted steps are presented out of order; the shots are relatively short; and the film returns to each station a few times at random intervals over the episode's twenty minutes (figures 2.4a–f). For example, the step in which clocks are boxed is represented more than once, spread a few times over the entire episode. This use of parallel editing suggests that each task is being performed simultaneously by different people over the course of the workday. Despite this shuffling (somewhat like that in *Park Lanes*), we do get a complete sense by the end of the episode of the distinct steps in the process, from the printing and cutting of the clock faces to the attachment of the clock faces and plastic molds, the addition of hour and minute hands, the dusting of the clock faces, the addition of the second hand, the placement of the transparent plastic covers, the hanging of the assembled clocks, and, finally, the preparation of cardboard boxes for shipping. We have a sense of the steps in the process because we have likely reordered them in our mind's eye. The real emphasis of the episode, though, is on how each task or step is accomplished. Largely because of the use of close-ups, the spectator gets

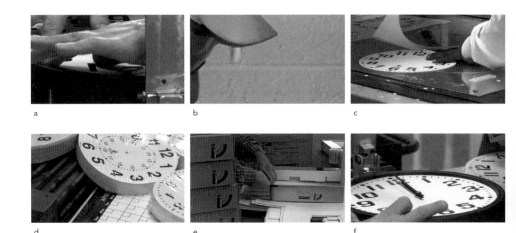

a　　　　　　　　　　　b　　　　　　　　　　　c

d　　　　　　　　　　　e　　　　　　　　　　　f

FIGS. 2.4a–f The Chicago Lighthouse, Chicago. These are the first six *actions* (not shots) in the order presented by the film. They do not correspond to the sequence of production of a single clock. Clockwise from the top left, they depict attaching a clock face to a base; hanging a fully assembled clock; cutting clock faces; moving packaged clock faces; assembling boxes for clocks; attaching the hour and minute hands. Frame enlargements, *The Unstable Object* (Daniel Eisenberg, United States, 2011).

an acute sense of how visually impaired workers carry out such work with limited sight, of how the hand becomes a surrogate for the eyes.

The episode returns us to the familiar dingy factory space and to the familiar assembly line method of production, but it has two sources of eventfulness. First, it presents a paradox: visually impaired workers produce clocks whose time they cannot tell by looking. In other words, because the technology of the clock generally requires the faculty of sight, it is surprising to see clocks produced by workers with limited sight. Second, it destabilizes the familiar exploitation-of-labor script and the alienation-of-assembly-line-production script. These factory jobs offer to the visually impaired—workers who otherwise would have few prospects for employment—the opportunity for the sociability (emphasized by the audio track, which picks up banter and conversation among the workers) and purpose, as well as money, that work also implies.

The third episode of *The Unstable Object* is the most processual, and the most absorbing, representation of the three. It depicts, sequentially, the steps in the production of handmade cymbals at Bosphorus Cymbals in Istanbul. Rather than using parallel editing (as episode two does) to represent the various steps in the process of cymbal production—steps that must be occurring simultaneously at the cymbal factory—episode three conforms to more standard process film conventions in that it follows the steps in order, as if it were tracking the coming into being of a single cymbal. Unlike in the first episode, the third episode is rigorous in its depiction of the

a b c

d e f

g h i

steps, lingering on each for long periods and es-
tablishing a tighter, and more intelligible, causal
relation among steps. The segment begins in a
dark, dingy, rustic shed-like space—neither in-
side nor exactly outside—where a copper-based
alloy is being smelted in holes in the ground that
workers are constantly feeding with coal, wood,
and straw (figure 2.5a). It then proceeds through
the steps in the cymbal-formation process (fig-
ures 2.5b–i): casting discus-like blanks the shape
of pancakes; sharpening hand tools; heating the
blanks; rolling them in a roller that flattens them;
reheating the flattened blanks; rerolling them;
shaping them; cold hammering the cymbals; lathing them; shaving the
edges; and branding them.[59]

FIGS. 2.5a–i Bosphorus Cymbals
Workshop, Istanbul: nine steps
in the production of cymbals.
Frame enlargements, *The Unstable
Object* (Daniel Eisenberg, United
States, 2011). Although the grid
approximates the chronological
unfolding of the process from the
first image on the top left to the
last image on the bottom right,
this series of nine images is not a
complete visualization of the pro-
cess as it is represented in the film;
several steps are not represented
here.

But unlike in episodes one and two, and in many other process films,
that this workshop is producing handmade cymbals will not be known by
most spectators until the last few minutes of the eighteen-minute episode.
The expositional structure of the episode, then, is a suspense structure
as the question "What are they making?" generates considerable antici-
pation and as the rendering of the steps in the process delays acquiring

the knowledge we most desire—knowledge that our familiarity with the conventions of process films has primed us to expect. Unlike in a surprise discourse structure in which the event information that is withheld from the plot is not missed, in this suspense structure the spectator is aware that information is being withheld and watches closely to learn the outcome. When we have finally recognized—probably close to the end of the episode—that the objects being produced are cymbals, we experience a certain satisfaction, as if an itch has finally been scratched, as well as surprise as the film triggers a reassessment of the various hypotheses and prejudices the unfamiliar spectator has been forming and revising for the almost eighteen-minute duration of the episode.[60]

As in episodes one and two, episode three has conjured a set of conventional scripts, mostly related to the so-called developing world and primitive modes of production. From the look of the workshop space, an unfamiliar spectator might expect (1) the work being performed to be unskilled and repetitive; (2) the method of production to be "primitive" as a result of a low level of technological development; and (3) the object being produced to be either folkloric or crude (perhaps a part for a complex machine). On all three counts, such a spectator would be mistaken: (1) the most repetitive and seemingly unskilled labor performed in the segment—cold hammering—is actually the highly skilled work of the cymbalsmith (see figure 2.5f); (2) the handmade method of production is not a default but a choice that signals the high quality of the object being produced; and (3) although the cymbal is an important instrument in Turkish vernacular musical traditions, it is also a common percussion instrument used regularly in orchestral choreography across the globe (i.e., the object is not folkloric).

The three episodes of *The Unstable Object* are marked, respectively, by the structures of surprise, curiosity, and suspense. They surely generate different degrees of engagement and absorption that owe, on the one hand, to the spectator's contextual knowledge (e.g., Do I know anything about the Phaeton factory or not? Do I know anything about the production of cymbals?), and, on the other hand, to the episode's dominant expositional structure. Contextual knowledge and expositional structure combine into a different calculus of knowledge/familiarity and ignorance depending on the individual spectator. And yet the conceit of *The Unstable Object* is surely that for most spectators, "artisanal" mass production; visually impaired, factory-employed clockmakers; and the skilled hammering of the cymbalsmith are all novelties.

There can be more to a process film's expositional structure than the curiosity, suspense, and surprise that I have discussed. *A Man Escaped* offers a challenging and particularly complex example. Although the film has a loose overarching curiosity structure, that gets us only so far in understanding its absorptive effects. Still, I think processual syntax and expositional structure—across the film and within its many microprocessual episodes—interact in intricate ways to produce the film's perhaps surprising fascination.

The film is a fictionalized staging of an action: a prison escape. The title of the film strongly suggests that the film's protagonist, the captured French Resistance fighter Fontaine, will escape from the prison he is taken to by German occupation forces at the beginning of the film. Unlike some prison break films, in which the success of escape is an open question that leaves the viewer in a state of suspense, the outcome of the escape in this film is known from the outset.[61] As in "How People Make Crayons" and *Hand Gestures*, confidence in success, which is established by the title *A Man Escaped*, makes the escape generic and repeatable. Brian Price points out that "because we know the techniques on display work, the film offers itself as a blueprint for prison escape."[62] We might add that unlike the opening sequence of the film, in which we see Fontaine rehearsing and in effect planning his escape from the vehicle delivering him to the prison, in the rest of the film the work of planning and strategizing and settling on a course of action occurs offscreen. When we see Fontaine in action, he is executing a preformulated plan, not fumbling around to make a plan. Blueprints are not improvisations; they are the achievements of prior fumblings. Because the film offers itself as a blueprint from the start, one is curious to understand how and why the action works. The spectator's task is different when there is a question about *whether* something will work; then, one's stance is likely anticipatory: Is that right? Will that succeed?

While the eventfulness of "How People Make Crayons" and *Hand Gestures* arose from a puzzle around the manipulation of materials (e.g., how to transform liquid wax into crayons or how to mold hard bronze), in *A Man Escaped* the tension comes less from the literal task (i.e., how to move one's person one hundred meters from one location inside the prison to another outside of it) than from all of the constraints placed on its achievement. The cell is on the second floor of the prison; the cell door is locked; the cell block and the grounds are well guarded; there are

no available tools such as hammers or chisels or rope or rappelling hooks or weapons; Fontaine has a cellmate. The puzzle, then, is for this more or less regular person to escape from the prison, given all the constraints. Getting around the constraints requires devising workarounds; it is these workarounds that generate much of the film's fascination. They are mostly repurposings of ordinary objects (figures 2.6a–f): the stone shelf intended for the prisoners' effects is used as a perch to communicate with prisoners outside; a handkerchief to wipe away blood becomes a carrying device that allows Fontaine to pass material back and forth to the prisoners outside the cell; a safety pin doubles as a key to unlock Fontaine's handcuffs; a slop pail becomes a means of disposing of incriminating material refuse; a spoon acts as a chisel; a shoe acts as a hammer; the crisscross wire netting holding up Fontaine's mattress functions as the basis for a rope, and so on.

One might suppose that the film's instructional approach to repurposing—which eschews close-ups of the face and focuses instead on the activities of Fontaine's hands—pushes the spectator toward a kind of motor, rather than psychological, identification—a kinesthetic empathy. "We are meant to see these hands as if they were our own," Price writes.[63] *A Man Escaped*, he goes on, relies on "a conscious solicitation of the spectator to imitate the actions that appear on screen."[64] While I think it is

FIGS. 2.6a–f Surveying the shelf and repurposing it (2.6a–b); handkerchief repurposing (2.6c); how-to instructions for handcuff removal with a safety pin: "Put pressure on spring in keyhole" (2.6d); safety pin repurposing (2.6e–f). Frame enlargements, *A Man Escaped* (Robert Bresson, France, 1956).

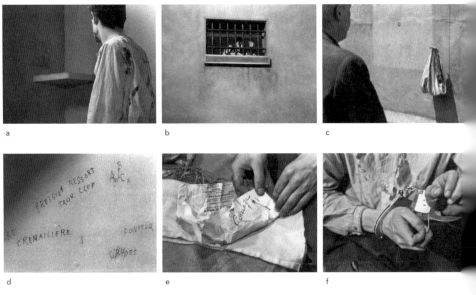

a

b

c

d

e

f

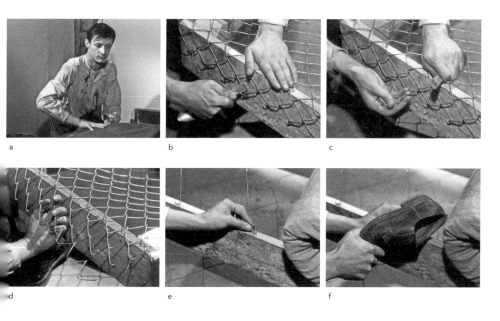

FIGS. 2.7a–f Culling wire from the bedframe to make rope. Frame enlargements, *A Man Escaped* (Robert Bresson, France, 1956). Each frame enlargement corresponds to a discrete step, though not to a distinct shot. The sequence has four shots in total. All of the steps represented in the film are also alluded to here.

certainly true that many process films—especially those that home in on manual dexterity—elicit just this kinesthetic empathy, in *A Man Escaped* Fontaine's dexterity is secondary. For example, the shots that depict the process by which Fontaine strips his bedframe of wire netting to be repurposed as the basis for the rope he intends to make are relatively short—just long enough to get a visual idea of the steps (figures 2.7a–f). The interest is not in his manual skill; it is in his conception, in the idea he arrives at to resolve his practical problem.

The interest in his conception is partly triggered by a structure of curiosity the film sets up in its juxtaposition of voice-over narration and visual demonstration. Price has claimed that at various points in the film, the voice-over narration previews the action in store "much like a television chef announcing the next step of a recipe"; the action then "repeats the information provided in voice-over," thus creating an "instructional redundancy."[65] But, I do not think that it does because the narration is actually often quite unspecific. Returning to the example of Fontaine's repurposing of the bedframe's wire netting for rope, the voice-over narration provides this preview: "Forty feet of rope strong enough to hold a man is what I needed. The netting from the bedframe supplied 120 feet of flexible and sturdy wire." But the narration does not indicate, as the visual track does, how Fontaine separates one chain in the netting at a time (see

figure 2.7d); how he redistributes the wire diagonally across the bedframe to hold up the mattress (see figure 2.7e); or how he uses his shoe as an improvised hammer to pound in the nails that will keep the reduced netting in place (see figure 2.7f). The narration on its own accounts for *what is done* (i.e., the bedframe providing the basis for the rope) but gives no sense of *how* the task was accomplished (i.e., how the bedframe supplies the basis for the rope while also supporting the mattress). The visual demonstration does the latter. The curiosity (and involvement) generated by the relation between the voice-over narration and the subsequent visual demonstration surely has little to do with Fontaine's motions as one hand holds the nail in place while the other uses the shoe to hammer it into the bedframe. Rather, the interest has more to do with the visually specified, ordered series of steps that had to be undertaken to accomplish the task. The same gap that opened up between the near-certainty of Fontaine's escape and the means of his success also applies in these mini-episodes as the voice-over narration produces a curiosity that ultimately will be satisfied by informative visual demonstrations.

Because Price is focused not on an unfolding series of steps to achieve a desired result but on hand movements closely observed, he brings Richard Serra's 1968 hand films to bear on Bresson's work. Those films depict the repeated actions described in their titles *Hands Catching Lead, Hands Scraping, Hands Tied*. Part of the point for Price is Benjamin Buchloh's point that Serra's "sequence of actions" is devoid of "any narrative or dramatic quality."[66] In a similar vein, Donald Skoller has written, "It is the consistency, the tenacity with which Bresson develops each action from this core principle [i.e., the "direct apprehension of the visual details and elements" independent of how they fit into the story] that makes the films more accessible through attention to processes presented, rather than through attention to a story or narrative line."[67] But I would argue that "attention to processes presented" *is* "attention to . . . a narrative line," if we acknowledge that processes *are* narratives, that actions have narrative arcs. What is striking in *A Man Escaped* is that each action, each act of repurposing, has instrumental value. It gets Fontaine one step closer to freedom; it is part of a tight, unfolding series of causes and their effects (e.g., he needs the wire from the bed netting to strengthen the shreds of pillowcase that will form the rope).

The point I am making is that our fascination is with Fontaine's conception, with his instrumental rationality. His conception has two aspects. First, there is the sequence of tasks, which demonstrate a tight, methodical causality. After all, he must find a way to open the cell door before he can

begin to construct the tools that he needs, for he will not know whether he needs ropes until he decides on his path out of the prison. But along the way there are the big steps, such as finding a way to get into and out of the cell without being detected, and a series of subordinate steps, such as fashioning a tool to work on the door's wood frame, removing enough wood boards so he can fit through the bottom part of the door, and removing the wood shavings from outside the cell door so as not to raise suspicions. Each subordinate step comes with its own tensions and eventfulness: how to fashion a chisel from the sparse metal objects the prisoners come into contact with, how to remove the cell door's planks quietly and without proper tools, how to remove them in such a way that they can be put back into their original places without the door coming apart each time it is opened.

Second, the film's repurposings are triumphs in conception as Fontaine sees in an ordinary object the possibility for a new use. Each of these repurposings is a source of elation, leading viewers to marvel at Fontaine's ingenuity. And unlike the ingenuity of the designer of the crayon collector device in "How People Make Crayons" (plate 3e) or the ingenuity of spruing in *Hand Gestures*, Fontaine's cleverness has required no specialized knowledge (since the materials he has to work with are common and familiar); it has required only a certain cultivated cast of mind. While each of these surprise repurposings is a thrill, I do not think that each one taken by itself could produce the sustained absorption generated by watching Fontaine's entire process. These repurposings, in other words, have a cumulative effect. They are not merely punctuations. They provide a kind of instruction, a training—not only training in how to escape from prison, but training in *how to see as Fontaine sees*. And just how does Fontaine see? In the world as it is given to him, he sees nascent possibilities and potentialities. He sees, in Price's words, "how matter can be altered . . . and thus how one's fortune can be altered."[68]

This is clearly a revolutionary and democratic sensibility: to imagine that another world is possible, one must be able to break out of the metaphoric frame to which one has become habituated. To see in a shelf a ledge to stand on or in a handkerchief a sack or in a spoon a chisel or in a shoe a hammer or in a bedframe a rope is to be persistently breaking out of one's pre-given framework. These acts of repurposing are conceptual—expressions of a habit of mind—rather than achievements of the body's muscle memory. This habit of mind is a characteristic of revolutionary thought.

But it is also a habit that is surely—and perhaps paradoxically—facilitated by a formalist mode of seeing that abstracts from immediate function. The metal spoon can double as a chisel because of its shape, length, and hardness; the shoe can double as a hammer because its heel is dense and flat and its long body gives one something like a handle to hold on to. When I can separate the form and material basis of objects from their current function, I make it possible to apprehend a new use for them. The soundtrack for *A Man Escaped*, with its amplification of the regular sounds of prison life and of quotidian objects and makeshift instruments, surely contributes to the spectator's apprehension of the formal qualities of repurposed objects. Moreover, even the film's credit sequence, with its focused attention on the texture and cracks of the prison's wall, suggests this investment in haptic perception, which is often defamiliarizing. Notice here that *de*instrumentalization can act as a step in a process of *re*instrumentalization.

Through Fontaine's repetitive repurposing of objects, we as spectators are learning to see, and this capacity to see—unlike the capacities on display in *Hand Gestures* or the capacities of the machine designers responsible for the clever crayon collectors—is as available to an average nonspecialist viewer as it is Fontaine. In "How People Make Crayons" and *Hand Gestures*, so much escapes the nonspecialist spectator: How exactly do the machines work? Why don't the crayons that are pushed into the crayon collector slip back into the mold? In *A Man Escapes*, every step can potentially be understood and reconstructed by the nonspecialist; nothing is beyond her. If *A Man Escaped* generates a sense of intimacy, of identification, it is not with Fontaine's psychology (that much is clear) but nor is it with the kinesthetic movement of his hands; it is with a rationality that requires no special training, only a cultivated attention. The rationality of the crayon-making process and of the centuries-old practice of lost-wax casting is admirable and absorbing, but the rationality of the democratic practice of ad hocism that Fontaine's ingenuity suggests touches me where I live. It is wholly addressed to me and absorbs me by virtue of both its unexpectedness and its didactic character.

Repurposing is a common, though not universal, source of eventfulness and fascination in process films. We could think about the use of ice for a window in *Nanook of the North* (Robert Flaherty, United States, 1922) or the use of the umbrella as a tool of collection rather than deflection in *Rififi* (Jules Dassin, France, 1955). Not only are these repurposings events, in the sense that they are departures from the status quo uses associated

with the objects in question, but they represent the democratic end of the technological innovation continuum. Repurposing is ingenuity for the uninitiated, for the masses.

I BEGAN THIS CHAPTER with a puzzle about the often surprising effect of absorption in processual representation. I argued that processual representation is a narrative form that derives much of its fascination from expositional structures that elicit different combinations of curiosity, suspense, and surprise and that contain a strong degree of closure. The intensity of the effect follows from the interplay of familiarity and ignorance. The familiarity at issue is familiarity with the class of object or action being produced or performed; the ignorance at issue is ignorance of the techniques that bring the object or action into being. If the object or action is not perceived to belong to a class (if it is not generic) but is, rather, particular, singular, idiosyncratic, or unrepeatable, the effect will be different. The generic character of the object or action is often what furnishes the sense of closure in processual representation. The fact that the generic character of processual representation—its recipe-like character even when it is not intended as instruction—adds to its fascination rather than detracting from it puts the arguments of narratologists about the compromised eventfulness of what is often called "process narration" in a new light. Moreover, the process genre's generic character makes it especially well suited to the representation of technique. The relationship between the process genre and the representation of skilled labor is the subject of the next chapter.

AESTHETICIZING LABOR

PROCESSUAL REPRESENTATION is a formal narrative syntax that presents its object *as* technical. Whether it is treating the work of human hands or that of colossal machines, the artisanal labor of ethnographic films or the commodity production of industrial cinema, the walking and rowing of motion studies or the bathing and bedmaking of art films, processual representation reveals activity as a display of technique, skill, care, or systematic intelligence. Because of the process genre's relation to technique, processual representation in effect makes the labor it represents "look good" rather than toilsome.[1] It aestheticizes labor—or, put differently, it represents the labor it depicts as *approaching* the magic standard of zero labor.

We saw in chapter 2 that commentators often describe their experience of processual representation as absorptive, mesmerizing, or fascinating. But there is another related term that, as we have seen, commentators also regularly use in their descriptive accounts. The term is "magical" or "magic," and its use is striking from the perspective of the representation of labor. In a *New York Times* review (mentioned in chapter 2) of the Primitive Technology channel on YouTube, which features several processual videos of a man fabricating useful things (e.g., tools, shelters, charcoal) in the Australian Outback without the help of modern technology, the journalism professor Jennifer Kahn marvels, "Watching the Man head into the forest to yank up some kind of tough, fibrous plant, you wonder: What's

he going to do with that? Later, when the plant has been stripped and woven into a cord that powers a surprisingly effective drill, the moment feels gratifying, like a small *magic*."[2]

This reference to magic is suggestive. Magic is commonly associated with the power to summon, to vanish—to make objects appear and disappear suddenly—as in "abracadabra." Meanwhile, as one writer recently quipped, "disenchantment"—or the evacuation of magic from the world—is "the confidence in the existence of somebody able to explain how a tram works."[3] The process genre delivers such explanations. In processual representation, nothing—no object or action—appears suddenly, out of thin air. Process films are not trick films. They provide detailed visual accounts that go behind the scenes of artifact fabrication and action how-tos, even when temporal ellipses may leave out steps in the process. Although process films may not themselves expose their own means of representation (i.e., the booms and mics and rehearsals that went into their production), they are largely concerned with the "baring of devices" in an analogous realm of commodity production and bodily performance. From a certain point of view, they involve a *gesture* of revelation and demystification (even if partial) rather than the concealment and falsification associated with absorptive media. How is it that a genre so closely associated with giving a technical account of how artifacts came to be, and thus how they work, so often evokes a sense not of disenchantment but of enchantment, of magic? Why does the observation of process—which is, in effect, its demystification—engender "an air of" magic?

I think the answer has to do with the relation between magic and labor. "Magic," writes the anthropologist of technology Alfred Gell, "haunts technical activity like a shadow."[4] It "is the negative contour of work, just as, in Saussurean linguistics, the value of a concept (say 'dog') is a function of the negative contour of the surrounding concepts ('cat,' 'wolf,' 'master')."[5] If common wisdom opposes magic to technology—the former, a symbol of premodern superstition; the latter, of modern science—Gell has put magic and technology in a single frame, arguing that magic should be understood as an ideal *technology*. It is ideal because it requires zero work. To make something appear as if out of nowhere, to bring it into existence with the wave of a wand, requires zero time, zero effort—zero work. It is in relation to magic that labor acquires its meaning. Gell goes on: "All productive activities are measured against the magic-standard, the possibility that the same product might be produced effortlessly, and the relative efficacy of techniques is a function of the extent to which they converge

towards the magic-standard of zero-work for the same product."[6] Thus, when the beholder of a processual representation marvels at the magic of a process that is not concealed but (seemingly) revealed, I propose that she marvels at the look of ease and efficacy, at the ingenious design, of a process (whether of a machine or a person) that approaches the ideal technology, the magic standard of zero labor. The sense of wonder must increase in relation to the beholder's perception of the difficulty of the feat, which surely must follow from her assessment of her own capabilities. If the feat does not seem like a feat, its accomplishment will not strike her as so magical. The feat might not seem difficult because of the beholder's comparable capacities or because the feat does not seem particularly valuable. In a disenchanted world, one in which we know that magic does not exist, production seems wondrous to the extent that it *approaches* the magic standard of zero work without being itself magical (i.e., accomplished by a supernatural power). The attribution of magic to processual representation is no accident. It is a consequence of the process genre's relation to skillful labor; it is a sign that the beholder has perceived that something valuable and difficult has been accomplished with relative ease and grace as a consequence of skill.[7]

The process genre's constitutive aestheticism, its effacement of toil, suggests why processual representation has been oddly neglected in the growing body of research on art and labor.[8] It is standard in the literature on cinema and labor, for example, to decry the invisibility of labor in representation.[9] "Where is the work and where are the workers?" commentators ask. Harun Farocki, for example, laments, "The first camera in the history of cinema was pointed at a factory, but a century later it can be said that film is hardly drawn to the factory and is even repelled by it. Films about work or workers have not become one of the main genres, and the space in front of the factory has remained on the sidelines. Most narrative films take place in that part of life where work has been left behind."[10] Farocki is attracted by the content of representation. Here he gives voice to the unspoken assumption of so many publications about work and cinema—namely, that the paradigm of work is factory work.[11]

For Jean-Louis Comolli, in his reprise of the topic, labor has been largely invisible in cinema not so much because work as a subject matter is absent but because cinema spectacularizes work. Comolli has argued that film either "unrealistically" transforms the machine into an ideal embodiment of work or, alternatively, when it does train its lens on the human body, "the gestures of work" once they "pass through the turnstile of the

cinemachine" are transformed into gestures of play.[12] Work is de-realized, aestheticized, as the worker metamorphoses into "an athlete, a dancer, an acrobat."[13] "The undeniable arduousness of work in the steel mill is thus imbued, through cinema's magic, with lightness and grace."[14] Of course, that metamorphosis is nowhere more paradigmatic than in the perceived magic of processual representations. Because Comolli assumes that an adequate representation of work would be a representation of its arduousness, only by "filming against the cinema" can a filmmaker film work.[15] In other words, for Comolli, as for other commenters on the relation of work to cinema, the truth of work is toil; adequate representation would not aestheticize labor.

But is the truth of work really toil? In this common way of framing the problem of representing work, "work" has been restricted to wage labor, its paradigmatic expression stultifying factory labor. Unpaid work does not fit within the category of work, and paid work is necessarily neither enjoyable nor fulfilling. In other words, satisfying unpaid work— gardening, for example—is considered not work but its opposite: leisure. But there was a time, Raymond Williams has argued in a philological vein, that the word "work" was understood as "our most general word for doing something, and for something done," a way to indicate "activity and effort or achievement."[16] That usage gave way to its predominant current usage to refer to regular paid employment. In other words, there has been a shift from a term for "productive effort" to a term that describes a "social relationship" (e.g., wage labor).[17] For certain sectors, that social relationship carries a set of negative connotations that align "work"—understood as wage labor—with the toil and pain once associated with the word "labor." What Williams in effect describes is the loss of a capacious understanding of work, paid or unpaid, as form-giving activity. The character of work (and labor) within a definite (capitalist) mode of production has come to stand in for the nature of work (and labor) *tout court*; a historical state of affairs has been naturalized.

The standard identification of both work and labor with the toil of the Taylorist factory in capitalist society goes some way toward accounting for *how* much processual representation has been treated or ignored in the scholarly literature and for *why* it has been implicitly associated with the political right. If the truth of work is toil, then making work "look good"— as processual representation does—understandably raises concerns. One might think that only totalitarian nationalists and unapologetic capitalists could make the toil of labor in an exploitative economic system look

like play, and only romantic ethnocentrists could unselfconsciously celebrate the arduousness of labor in so-called primitive economies. After all, nationalists from the National Socialists in Germany, the Fascists in Italy, and the Stalinists in the Soviet Union have made propagandistic use of processual representation to glorify both the elbow grease and the engineering prowess of national subjects in a bid to construct a unified national identity and to promote productivism. Meanwhile, corporations in capitalist societies have availed themselves of processual representation in advertising campaigns aimed at selling commodities. And there is a well-documented record of anthropological films employing processual representation within a salvage paradigm that adjudicates the degree of civilization of faraway peoples according to the manner and kind of their production methods.

The process genre has indeed often served nefarious political purposes. But does the process genre *as such* have a regressive politics of labor? That is the question I ultimately explore in this chapter. My discussion focuses on two kinds of worries about the process genre and its constitutive aestheticization. The first, to which I have already alluded, is that the syntax of processual representation is inherently Taylorist and thus belongs, at its inception, to industrial capitalism. The idea is that processual representation is the formal syntactic expression of the rarefied division of labor that is the hallmark of a Taylorist organization of the labor process. Thus, its clean and orderly aesthetic manifests something akin to a political "original sin." The second worry is that by idealizing work, processual representation conceals—and falsifies—the true nature of labor, which is implicitly understood to be toil. Moreover, aestheticization either results in dehumanization because the human being is assimilated (in representation) to the machine, the messiness and imperfection of human life obscured in the treatment, or it engenders spectatorial pleasure in the face of painful labor that has made of the human being a beast of burden.

While I think it is right to say that the process genre aestheticizes labor, I do not think that the process genre *as such* thereby implies a reactionary politics of labor. The politics of the genre vary as processual representation is mobilized for an array of genuinely progressive as well as reactionary political projects. Thus, what it means to aestheticize labor requires a more nuanced treatment.

But although the process genre betrays a certain political agnosticism, it *is* fundamentally committed to (what might be thought of as) a kind of politics that straddles left and right: the metaphysics of labor. The "meta-

physics of labor" is a shorthand phrase used to characterize the view that a flourishing human life has labor—capaciously understood—at its center. In other words, the metaphysics of labor opposes the idea that (transhistorically) the truth of labor is toil.

The metaphysics of labor is defended by sectors of the political right (e.g., totalitarians and capitalists) that embrace productivism or some variation of the Protestant work ethic, as well as sectors of the political left (e.g., classical Marxists and utopian socialists), for overlapping and other reasons. But there are also adherents of the political right (e.g., restorationists and monarchists), as well as adherents of the political left (e.g., autonomists and some anarchists), who on principle reject a metaphysics of labor, whether because they consider working a servile pursuit or the unfortunate consequence of a sinful human nature (as in the biblical account of Adam and Eve's ejection from the Garden of Eden) or because they have a different account of what makes human life meaningful. The process genre's basic commitment to a metaphysics of labor accounts for its resurgence in the contemporary art film landscape, as labor—material and immaterial—has become a key locus of the structural reorganization of society in the present.

Representing Technique

What exactly does it mean to say that processual representation reveals activity as a display of technique? How does it accomplish this?

Techniques, according to Marcel Mauss, are actions that are effective and traditional: effective in the sense that they achieve a goal that is physical or chemical or organic (though not immaterial, as in the case of religious or artistic goals), and traditional in the sense that they are "tried and tested" (they have been taught, learned, transmitted; they have been "assembled for the individual not by himself alone but by all his education, by the whole society to which he belongs, in the place he occupies it").[18] Techniques—whether those involving instruments or those using the body as an instrument—thus have a social character.

Gell proposes a not dissimilar account of technique, adding some details.[19] "What distinguishes 'technique' from non-technique," Gell writes,

> is a certain degree of *circuitousness* in the achievement of any given objective. It is not so much that technique has to be learned, as that technique has to be ingenious. Techniques form a bridge, sometimes only a simple

one, sometimes a very complicated one, between a set of "given" elements (the body, some raw materials, some environmental features) and a goal-state which is to be realized making use of those givens. The given elements are rearranged in an intelligent way so that their causal properties are exploited to bring about a result which is improbable except in light of this particular intervention.[20]

As for Mauss, for Gell the effectiveness of technique is part of the account (because who would describe something unsuccessful as "ingenious"?). The circuitousness that Gell refers to could correspond—despite his disavowal—to tradition (Mauss's term) or practice or training, for the example he gives in this section is one in which the technique of hitting a ball with a baseball bat requires a "prolonged [i.e., circuitous] learning-process."[21] Moreover, Gell emphasizes the role of causality and efficiency (i.e., the result would be "improbable except in light of this particular intervention").

With this working definition of technique, I now want to give two examples of representations that purposefully depict labor as lacking all technique. These counterexamples of the process genre put into stark relief the difference between the representation of labor and the representation of labor *as technical*—that is, as an expression of technique. The first example comes from a WunderTütenFabrik (Grab Bag Factory) video recently posted on Deadspin by its managing editor, Tom Ley. The six-minute video, which was suggestively titled "The Most Unsatisfying Video in the World Ever Made," is a parody of processual representation.[22] It compiles twenty very short, closely shot videos of quotidian actions, most of which are processes, including partitioning a cake, slicing a tomato, peeling a hardboiled egg, folding an 8.5×11-inch sheet of paper in quarters, and shuffling a deck of cards. Each is filmed without cuts, and several segments follow the process from beginning to end rather than interrupting the action before it reaches completion. Ley introduces the video with the following explanation:

> You know how when you're scrolling through Facebook, and you happen upon one of those top-down videos that shows a pair of hands creating some sort of delicious food or craft, and then you get stuck watching it for three or four minutes, not because you are especially interested in how to make pineapple upside down cake or whatever, but because there is something calming about witnessing a clean, precise act of creation?
> This is like that, but the exact opposite.[23]

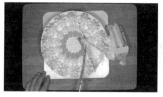
a
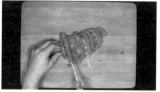
b
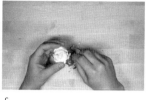
c

Indeed, the processes filmed in the WunderTütenFabrik video are neither clean nor precise. In the partitioning of the round cake—which is filmed from above—the knife strokes are random, with not a single one originating from the center point of the cake (figure 3.1a). The result of the haphazard method is that each piece of cake is a different size and shape. In the slicing of the tomato, the use of a dull knife and poor technique conspire to squish the tomato; by the end of the video, the uneven slices of tomato have become an unappetizing pile of red goop (figure 3.1b). In the peeling of the egg, the shell is so well attached to the egg and the person peeling so impatient that, while he finally manages to separate shell from egg white, he has so badly pockmarked the egg that it hardly resembles itself (figure 3.1c). In each of these cases, the spectator almost surely knows what is supposed to happen (i.e., uniform slicing of cake and tomato, and easy separation of shell and egg to reveal a smooth, shell-less surface), but her expectations are thwarted at every turn by each incompetent action.

FIGS. 3.1a–c A parody of technique. Frame enlargements, *The Most Unsatisfying Video in the World Ever Made* (Sandro De Lorenzo Gardinal and Charlotte Hübsch). Courtesy of WunderTütenFabrik.

These three examples from the WunderTütenFabrik video are all instances of form-giving activities, of labor. They all get the job done: the cake is cut into pieces; the tomato is sliced; the egg is peeled. But the examples in the video are all ostentatious displays of technical failure, at the level of both conception and execution. These are representations whose conceit turns on parodying the representation of technique; thereby they accomplish "the exact opposite" (Ley's words) of processual representation. The dissatisfaction and hilarity of watching the video results from the simultaneous invocation of the pleasures of the process genre and the eventual denial of those pleasures. Getting the joke depends on having internalized the process genre's special treatment of technique.

A second example brings out the *difference* between a representation of technique that is processual and one that is not. Chantal Akerman's *Saute ma ville* (Blow Up My Town [1968]) is a twelve-minute film that depicts a harried young woman arriving at an apartment; she locks herself in the kitchen, where she makes pasta, eats some of it, throws the bowl with

the rest on the floor for the cat; tapes the doorway while eating a pear; throws pots and cans and food items on the floor; mops the floor with all these items on it by throwing soapy water at the mess; polishes her black shoes (and her legs); tapes the window; turns on the gas; lights a match; and . . . *poof.* The film alludes to several processes: cooking, eating, taping the doorway, mopping the floor, polishing shoes, and so on. But every action is conspicuously lacking technique in the sense elaborated by Gell and Mauss. The processes the protagonist engages in are circuitous but in a different way from the way Gell means: they do not reflect a learning process, for they seem as if they have never been performed or even observed before. They are not ingenious because their steps or elements are not causally related. On the contrary, they are irrational and resolutely idiosyncratic.

Although the film presents a series of mostly form-giving actions, the representation is not processual because the sequence does not establish a tight causality. It *looks* neither analytic nor, therefore, generalizable and generic. Although the processes have ends that in some sense are ultimately achieved—food is consumed; the doorway is taped; the floor is mopped—the *means* of achievement is the opposite of orderly, systematic, economical, rational, and satisfying (figures 3.2a–b).

Contrast this approach with the one in Akerman's *Jeanne Dielman, 23 Quai du Commerce, 1080 Bruxelles* (France/Belgium, 1975), in which domestic labor exhibits the hallmarks of technique—both its effectiveness and its codification in tradition. Thus, Ivone Margulies has referred to *Saute*

a

b

FIGS. 3.2a–b Mopping the floor is accomplished but without what might be called skill. Frame enlargements, *Saute ma ville* (Chantal Akerman, Belgium, 1968).

ma ville as *"Jeanne Dielman . . .* run amok." But, as Margulies points out, the important contrast is not so much that *Saute ma ville* is an inversion of *Jeanne Dielman*. In a diametrical inversion of the later film, the ends of the processes would be different: mess and chaos would be *aims* rather than inadvertent *means*.[24] The protagonist in *Saute ma ville* is unquestionably performing (domestic) labor, but she lacks technique, with its generic character and its link to the training, repetition, and transmission implied by tradition. Without repetition, there is no tradition, either personal or cultural. Explicitly linking technique to tradition, Akerman, in her own comments on the later *Jeanne Dielman*, described her wish to reproduce the ritualized actions of the extended Jewish family who surrounded her in childhood, actions that she understood to have taken the place of Jewish ritual.[25] Thus, the implicit relation between skill and tradition allows us to make sense of the 1968 film's title—"blow up my town"—which suggests a severed link between the individual and the collective or the community.

I want to emphasize three points. First, *not all* labor involves technique. Second, *only* labor that involves technique *can be* represented processually. Third, labor involving technique can be represented processually or not; indeed, it is often represented non-processually. The process genre homes in on a certain species of labor: labor that exhibits technique. Its conventions then bring out the technical character of the labor represented. In other words, the technique that is at the heart of processual representation is a function of the mobilization of the process genre's conventions, which make technique visible *as* technique.

Five closely interconnected conventions of the process genre bring out the technique involved in skilled labor: allegorization; the effectiveness of the pro-filmic process; tight causality that eschews digression or on-the-spot problem solving; the displacement of the labor of design or conception to a prior temporal frame; and the display of motor fluency and dexterity.

Allegorization and effective pro-filmic processes. Processual representation— whether a process film, pictorial instructions, craft demonstrations, or motion studies—puts itself forward as a successful instance of a generic act of doing or making: walking, rowing, hammering, hat making, pot making, car making. Processual representations are codifications of effective practices. They propose, "This is an effective way to do X." They claim a certain universality, functioning allegorically even in the case of a live-action film where the representation refers to a singular, actual event that

took place in the past. The titles of many process films signal this: *Raw Herring, Red Persimmons, Wicker, Threshing, How They Make Cheese in Holland, Making Christmas Crackers, Bricks, Charcoal, Copper, The Cooper, The Wheelwright*. One instance and one way of producing raw herring or dried red persimmons or bricks or charcoal stands in for a universally applicable approach, for a generalizable *method*.

Moreover, the approach could not rise to the level of generalizable method if it did not work. The success of the process in processual representation is assumed; it is a feature of the process genre. As we saw earlier in the "The Most Unsatisfying Video in the World Ever Made," a sequential, step-by-step representation of a process that is ineffective, that does not achieve its intended result, subverts the form.

Causality and offscreen planning. In addition to the work of titles and completed recognizable objects/actions, process films often make use of a tight causality and an analytic approach that eschews digressions. Writing about *A Man Escaped* (Robert Bresson, France, 1956), Donald Skoller refers to its "purity," to its "rigor," to the "sense that it has been cleansed of all inessentials," to the way Bresson "reduces his field of concern to an action, the action of escape."[26] I take this reference to rigor and inessentials to follow from the film's tight causality. In contrast to Bresson's film, other prison escape films, Skoller observes, take "the edge off the concentration on the process itself." In them he notes a "short-circuiting or detour" that "tends to dissipate the perceptual action taking place."[27] While Skoller argues that *A Man Escaped* eschews narrative, that the film is "accessible through attention to processes presented, rather than through attention to a story or narrative line," as we saw in chapter 2, the sequential steps in the process of escape themselves make up a narrative of action. Moreover, tight causality would not be possible if the representations were *investigations of* effective practices—that is, if they were digressive—rather than representations of practices that were already tried and tested achievements of prior tradition or prior experimentations. For example, the digressive, noncausal relation between actions in *Saute ma ville* marks them as nontechnical; it is not possible to link the step of throwing items from the cupboard onto the kitchen floor causally with the step of mopping the floor (see figures 3.2a–b)

One might think that the instances of repurposing in *Nanook of the North* (Robert Flaherty, United States, 1922), in which ice is used to create a window, or in *Rififi* (Jules Dassin, France, 1955), in which an umbrella

is used as an instrument for collecting debris rather than deflecting rain, or in *A Man Escaped*, in which a handkerchief is used as a sack, are all moments of experimentation or spontaneous digressions. While they surely suggest the ingenious use of common materials, the thought behind these innovations—the actual working out of these ad hoc solutions—has taken place offscreen prior to what we see onscreen. In other words, the solutions are not being thought of and worked out before our eyes. We are seeing the result of an Inuit tradition in the case of *Nanook* and of presumably tried and tested experimentation in the case of *Rififi* and *A Man Escaped*—the deployments of the umbrella and the sack are *executions* of *previously devised* plans.

Motor fluency and dexterity. The process genre selects fluent (or skilled) movement, whether of machines or of people. The creators of process films find formal means to bring out the fluency of pro-filmic material. As I discussed earlier, those formal means include the selection of material (e.g., subjects), rehearsals and training (e.g., Bresson's automatism approach), framing, camera distance (e.g., the use of close-ups), duration (e.g., long takes), and so on. And in turn, the effective representation of dexterity and skill achieves certain spectatorial effects. One of these is the impression of effortlessness or magic (as we saw earlier), an effect captured in the phrase "She made it look easy," which registers a special feature of skill in which something difficult does not appear to be so from the outside.

Giving the impression of skill where skill is absent is no easy feat in cinema. In Robert Altman's *The Company* (2003), the actress Neve Campbell is cast in the title role as a dancer with the Joffrey Ballet. Although Campbell had some prior experience with ballet, she never attained the skill level of the professional dancer she is playing. The film features several heavily edited dance sequences with Campbell, who does her best. Despite the attempt to obscure Campbell's rough mastery of ballet, her inexperience is evident in the way she points her toes, in her extensions, in her posture. The film cannot fake skill (though it must be the case that for those with little exposure to ballet, the amateurishness of Campbell's toe point is missed).

It has long been common wisdom that observing skilled performance elicits feelings of pleasure in the observer. Recent research by cognitive psychologists in the area of kinesthetic empathy has demonstrated the positive affects produced by both the performance of goal-oriented fluent action and the observation of another person performing goal-oriented

fluent actions.[28] Fluent action is generally understood as action that requires less effort and that demonstrates an efficient and direct movement trajectory.[29] Fluent action—which encompasses what is usually thought of as skilled action, as well as more mundane, everyday actions such as reaching for a coffee mug—has been shown to generate positive feelings both in the performer of those fluent actions and in those who observe the actions, usually on a screen.[30] Researchers have explained this second finding by proposing that observers simulate the observed actions in their own motor system in an expression of motor (rather than emotional) empathy.[31]

This recent experimental research has its correlates in philosophical insights on grace in the work of writers such as Herbert Spencer and Henri Bergson.[32] In their respective treatments of grace, Spencer and Bergson tie the recognition of grace in another to a perception of ease (or an economy of force) and skill.[33] Spencer, for example, poses the hypothetical example of the skater who first acquires the skill of figure skating:

> They will remember that all early attempts, and especially the first timid experiments in figure skating, are alike awkward and fatiguing; and that the acquirement of skill is also the acquirement of ease. The requisite confidence and a due command of the feet having been obtained, those twistings of the trunk and gyrations of the arms, previously used to maintain the balance, are found needless. The body is allowed to follow without control the impulse given to it; the arms to swing where they will; and it is clearly felt that the graceful way of performing any evolution is the way that costs least effort. Spectators can scarcely fail to see the same fact, if they look for it.[34]

For Spencer, when one exhibits ease in the execution of a skill, one also exhibits economical motion—that is, motion in which all the moving parts play a particular role, and each is necessary and well calibrated. To speak, then, of the grace of inanimate objects such as machines is, according to Spencer, to anthropomorphize them; they can be graceful to the extent that they can be analogized to human and animal forms that exhibit this economy of force.[35] For Bergson, effortless movement is pleasant because it predicts and thus prefigures future movement; it "passes over into the pleasure in mastering the flow of time and of holding the future in the present."[36] This pleasure in prefiguration and prediction perhaps also explains the often noted enchantments of the rhythmic repetition of actions that establish certain predictable patterns and then satisfy expectations.[37]

Both Spencer and Bergson arrive at the view—ultimately echoed by the experiments of contemporary cognitive psychologists—that the perception of grace in another has its basis in motor sympathy. Spencer writes,

> The same faculty which makes us shudder on seeing another in danger—which sometimes causes motions of our own limbs on seeing another struggle or fall, gives us a vague participation in all the muscular sensations which those around us are experiencing. When their motions are violent or awkward, we feel in a slight degree the disagreeable sensations that we should have were they our own. When they are easy, we sympathize with the pleasant sensations they imply in those exhibiting them.[38]

If the observation of fluent action elicits a motor simulation of the same actions in the observer, it is not surprising that the pleasurable feelings that accompany the performance of fluent action would also be present in its observation (whether the observation is mediated by a screen or direct). These insights are relevant to processual representation because if processual representation brings out the skill in technical activities (i.e., activities that generally involve fluent action), it is no wonder that the pleasurable evaluative feelings that accrue to the observation of skilled action would also be at play in watching processual representation. This pleasure, though, is distinct from the narrative pleasure I discussed in chapter 2, for it could be present whether or not the representation has a beginning, middle, and end and regardless of whether it has closure. In other words, it is a pleasure that is not exclusive to processual representation, though it may be characteristic of it.

Taylorism

The five conventions of the process genre enumerated earlier conspire to present a pleasant, aestheticized image of labor. Indeed, even when processual representation turns to the depiction of (often maligned) industrial production, it makes the labor process look clean, orderly, fluid, dexterous. It makes it look precise and efficient. Precision and efficiency were primary goals of scientific management. To the extent that processual syntax makes production processes (industrial as well as artisanal) look precise and efficient, one might suspect that it is constitutively tethered to industrial capitalism's drive to divide labor into ever more specialized units.

Processual representation as a formal syntax could look Taylorist even when the process being represented is an artisanal or a craft process. After all, processual representation breaks up a process into a set of discrete, identifiable, sequential units or "chunks," to the use the term Ernst Gombrich borrowed from engineering.[39] It might seem that with processual representation we are encountering what Jonathan Crary called—referring to the late nineteenth- and early twentieth-century stereoscopic entertainment device called the *Kaiserpanorama*—the "'industrialization' of visual consumption."[40] That is, the segmentation of steps in processual representation is uncoincidentally analogous to the segmentation of the labor process in industrial production, which is in turn uncoincidentally analogous to the camera's sequential segmentation of action (manifested in the form of the filmstrip) and to the projector's sequential operation in its animation of the frames. In other words, one might think that processual representation is the formal correlate, the expression, of an industrial way of organizing labor, just as some have argued that the camera and projection apparatuses are technological correlates of industrial production.[41] Along these lines, Lee Grieveson notes that two contemporary observers on Ford Motor Company's production of Model T cars in the 1910s compared the production line to "the successive negatives on a motion picture film."[42] So in this view, the industrial division of labor, cinema, and processual representation are all of a piece. There is no question that a formal analogy indeed applies. The question is, "What is the significance of this?"

DEHUMANIZATION

In his analysis of the eighteenth-century plates of Diderot's *Encyclopédie*, William Sewell made a case for the close entanglement of processual representation (although he did not call it that) and Taylorism, despite the former's significantly earlier provenance. Sewell concluded that "the twentieth century factory, with its assembly lines and time-and-motion studies, is the legitimate heir of the vision of labor elaborated in the *Encyclopédie*."[43] Thus, for him, the *Encyclopédie* prefigures Taylorism; it is proto-Taylorist.[44] Sewell's treatment of the issue is instructive.

In a good text–bad text structure, Sewell compares the *Encyclopédie* plates unfavorably with similar processual illustrations of production processes from the sixteenth and nineteenth centuries. All of the illustrations under discussion are analytic and processual, but the plates of

the *Encyclopédie* are singled out for their abstraction: workshop spaces are depicted as vast and barren; human figures are anonymous, their faces unspecific; each task is represented by separated figures, each oblivious to his or her neighbor. Meanwhile, the "good texts"—including Jan van der Straet's "Sugar" (1600), Abraham Bosse's illustration of the engraving process from the mid-seventeenth century, and two 1840s prints from the series "Notions industrielles" found in the Cabinet des Estampes at the Bibliothèque Nacionale—mitigate the abstraction that inherently belongs to processual representation by featuring workshop clutter and chaos, human faces, sociability. For Sewell, these features act as counterweights to the analytical character of processual representation. In other words, the *Enclyclopédie*'s distillation of processual representation to its essential form is the problem. Sewell writes of the *Enclyclopédie*'s plates,

> The barrenness and lifelessness of the workshops also represent a world ordered by scientific precision rather than by human skill. Diderot's "scientific" vision helps to explain the isolation of the workers from each other. Eighteenth-century scientific thought was profoundly analytical. To understand a phenomenon scientifically was to break it down into its elements. This is precisely what has happened to the workers in the plates. Each represents a discrete and separable step in the process of production, and the process as a whole consists of a simple adding up of these discrete steps—not, as in the sixteenth- and seventeenth-century prints, a unified whole that is clearly greater than the sum of its parts. . . . In summary, the plates of the *Encyclopédie* represent a scientized, individualized, utopian projection of the world of work as imagined by the philosophes. It is not an attractive vision. It repudiated that more human, cluttered, and communal world represented in the sixteenth- and seventeenth-century prints. It is cold, analytical, and deadly serious. The robotic workers of the *Encyclopédie* lack the playfulness and wit we can discern in the faces portrayed by van der Straet or Bosse. Van der Straet's and Bosse's workers seem to have lives and personalities of their own, unconquered by the artist's pen; one can imagine them arguing about politics, playing a trick on the boss, or planning a strike. The workers in the plates of the *Encyclopédie* are docile automatons who carry out their scientifically determined tasks with the efficiency—and the joylessness—of machines. . . . [T]he plates of the *Encyclopédie* might reasonably be characterized as an early capitalist utopian vision.[45]

Here we can see that for Sewell, the analytical character of the plates is troubling because it signals dehumanization. The argument takes for granted that the human is evinced by the individuated face, by the presence of clutter and chaos, by signifiers of cultural and historical particularity. Sewell's conception of what makes a representation more and less "human" is fairly conventional. Treatments of Taylorism in art often strike the same note. For example, Sharon Corwin notes that

> the Gilbreths' [motion] studies . . . exist in an idealized, illusory realm that sought to create its own visual vocabulary of efficiency—one in which labor is finally made fully alienated and therefore manageable through and through. Thus while the Gilbreths' project is fundamentally about visualizing the act of labor (to be distinguished from the subject of labor)—the messiness of that work is necessarily cleaned up, abstracted, standardized, and alienated. Precisionism also represents a certain kind of labor—one marked by an obsessive, even cultic adherence to a formal language of standardization and exactitude.[46]

In her treatment of Ford Motor Co.'s *Rhapsody in Steel* (F. Lyle Goldman and Bob Roberts, United States, 1934), Corwin argues that the propaganda film "dramatizes the dream of autogenic production by depicting the V-8 automobile in the process of self-assembly."[47] The workers appear as "disembodied hands and legs"; they "are seen not as individuals but as anonymous bodies."[48] Similarly, in his treatment of *Master Hands* (1936), Jam Handy's sponsored industrial process film about the fabrication of Chevrolet cars, Max Fraser has argued that the subjects of the film are "faceless, always anonymous men, whose identities had been reduced to a point beyond their status as mere workers to the very mechanical operations of their hands."[49]

The process genre's analytic structure, with its eschewal of the face and its accompanying devotion to order and systematicity, might seem to make the genre more generally susceptible to the critique that Sewell levels at Diderot's *Encyclopédie* and that Corwin and Fraser level at the Gilbreths, Ford, and Jam Handy. In other words, according to their implicit criteria, the process genre as such is Taylorist. If the process genre finds its earliest expression in pictorial instructions whose distinguishing feature is its analytic character, and this analytic character evinces a proto-Taylorism, then the process genre might be said to come with its own "original sin."

Yet although it may be true that the process genre has an analytic character, one may object that this does not by itself constitute proto-

Taylorism. As Harry Braverman points out, while the division of labor in production "begins with the *analysis* of the labor process—that is to say, the separation of the work of production into its constituent elements," this analytic segmentation "in itself is not what brings into being the detail worker."[50] Braverman goes on, "Such an analysis or separation, in fact, is characteristic in every labor process organized by workers to suit their own needs."[51] Moreover, does the analytic character of processual representation really conceal labor? And is messiness and clutter in representation really a virtue, a sign of the human?

In relation to the first question: what is it, *really*, to conceal labor; and what is it, *really*, to reveal labor? The grave political misstep of "concealing labor" is conceived of rather literally in Sewell and Corwin and others: labor is concealed where the laborer's face is missing. Hands without a face or nonindividuated faces function as automatic indices of labor's shameful concealment. But another reading is possible.

Consider Roland Barthes's reading of the *Encyclopedie*'s plates. Barthes and Sewell largely agree that the plates are analytic. Where their accounts diverge is in their value judgment of this feature. For Barthes, the analytic character of the plates signals the epic of the human mind, the "progress of reason" itself. The human is evinced by the magic of production and the role of reason—the calculation of causes and effects—in its success.[52] That calculation is indicated by the analytic character of the plates. For Barthes, there is nothing more revelatory of the truth of labor than the processual images of the *Encyclopédie*, which establish the human relation between unformed matter and useful objects: "the relation," as he says, "of the omnipotent praxis of man, which out of nothing can make everything."[53]

In relation to the second question: are messiness, inexactitude, wasted motion, carelessness—or, in Sewell's terms, "clutter"—really quintessentially human values diametrically opposed to the values of precision and the job well done? Is the striving for perfection and for bodily efficiency really a product of a capitalist mode of production and the mark of dehumanization? There is a literature on skill and dexterity that chafes against the Ruskinian idea that there is "never reason to be proud of anything that may be accomplished by patience and sandpaper," that "men were not intended to work with the accuracy of tools, to be precise and perfect in their actions. If you will have that precision out of them you must unhumanize them."[54] David Pye and Harold Osborne contest the view, inherited from the Arts and Crafts Movement, that the important cleavage is between the precision of machines and the imprecision of workmanship. For Pye,

while perhaps precision does belong to machines, it also constitutes one source of pleasure in craftsmanship: "What Ruskin was inveighing against was not hard labor, but patient work. . . . He did not realize that there is great pleasure in doing highly regulated work"—that is, work where precision and exactitude are called for in the realization of design.[55] Thus, for Pye slavery in labor does not directly correlate to a particular aesthetic. Osborne put the point more starkly: "The modern glorification of handwork for its own sake, however inexpert or crude it may be, has little to recommend it. It is not the precision or accuracy of the machine that we should resent. There is an aesthetic satisfaction in a precision job done to a high degree of tolerance."[56] Moreover, for Osborne, the cult of excellence is at the heart of craftsmanship and is "one of the most ancient and deeply rooted of human drives":

> [Craftsmanship] involves a genuine pride in the process of production itself, a pride which drives a man to make whatever things he makes as well as they can be made, even beyond economic considerations of reward. This impulse, which lies at the roots of fine craftsmanship, is now recognized by anthropologists to have existed from the earliest stages of human activity. . . . It is this impulse, this cult of excellence, which through the centuries of prehistory and history led to the perpetuation of traditions of craftsmanship, the rich storehouses of know-how and skill.[57]

Indeed, recent attempts—such as Richard Sennett's *The Craftsman*—that try to rescue craftsmanship from the charge of anachronism and usher it into the twenty-first century also distill craftsmanship into a transhistorical human impulse to do a job well for its own sake.[58]

I do not wish to deny that industrial capitalism is dehumanizing or that assembly line work mortifies body and soul. Nor do I aim to recuperate the Taylorist organization of labor under capitalism. I only want to think carefully about what, exactly, is politically objectionable in Taylorist production by zeroing in on the Ruskinian critique of perfectionism. The Ruskinian aversion to the job well done—perhaps inadvertently—undergirds much thought about the representation of labor and the dangers of its aestheticization. I propose that the smoothness and precision built into processual syntax—the way processual representation transforms action into technique—should not be treated as a symptom of the genre's original political sin. I believe there are precedents for considering this faceless, abstract, and analytic approach to the representation of labor as something other than a representational correlate to capitalist or proto-

capitalist forms of organizing labor. Inspired by Barthes and Pye and Osborne, we might think of it as a representational expression of something older and more transhistorical—the celebration of the rationality at the heart of skill and technique—even if processual syntax makes its appearance (in the West, at least) only in the fifteenth century. Still, even if this is true—even if processual syntax is not inherently Taylorist—it does not settle the question of when and why the process genre is used *strategically* to conceal the nature of labor under industrial capitalism.

APPROXIMATING THE ARTISAN'S VIEW

There can be little doubt that most industrial process films picture a Taylorist labor process. What is surprising is how processual representation makes a rarified division of labor *look like* an artisanal one. How is this effect accomplished?

The first thing to notice in this respect is that most industrial process films do not use parallel editing. As we saw in *The Unstable Object,* parallel editing represents more than one step in the process of production as occurring simultaneously, with each performed by different people or groups of people for the duration of the working day (see figures 2.4a–f). Person X cuts clock faces while person Y puts the assembled clocks in boxes for shipping while person Z adds the second hand. The viewer sees the three activities performed in the first five minutes of the episode and then sees person X cutting clock faces nine minutes into the episode and then again sixteen minutes in, while we see person Y boxing up clocks eight minutes in and sixteen minutes in and person Z attaching second hands seven minutes in and thirteen minutes in. Editing in this case establishes the simultaneity of the activities across the length of the working day. This approach to process gives the strong impression of a Taylorist division of labor as the spectator is confronted with the reality of work on an assembly line. You might say that in this case, the film takes the point of view of the worker who repeats the same actions for several hours each working day.[59]

But now consider the more standard industrial process film, which generally proceeds from raw material to finished commodity. The standard approach uses editing to suggest the necessarily chronological trajectory of a particular, singular proto-object from nothing to something, from formless matter to recognizable commodity. Yellow crayon number 1,356 began in *this* batch of hot wax; subsequently, it was molded and cooled; then it was labeled; and after it was labeled it was boxed. The standard industrial

process film—such as "How People Make Crayons"—gives the impression that the camera is following a particular proto-object through all of its sequential stages as it becomes itself. While yellow crayon number 1,356 is making its way from station to station at the Crayola factory, the reality of factory production is such that molding, cooling, labeling, boxing is happening simultaneously to different crayons throughout the entire workday.

Although in the standard industrial process film the spectator does not see the same person boxing and labeling as one would if the process were artisanal, there is a way in which the organization of the epic of crayon fabrication mimics an artisanal process—one without a division of labor, one in which a single person or group is involved in every stage of the production process. After all, in some sense the spectator *is* "involved" in every stage of the process. Thus, in the case of the standard industrial process film the spectator is not nudged into contemplating the production process from the perspective of an assembly line worker who spends the workday at a single station repeating a single gesture. On the contrary, the spectator of paradigmatic industrial process films enjoys what the worker is denied: the satisfactions of the whole, of completion, of being involved in all the steps of the production process. So what is in reality a Taylorist organization of the production process comes to *look* like an artisanal organization of the production process. This is a form of concealment: the basic procedure of industrial process films conceals the toil, repetition, and monotony of factory labor. But the same processual approach applied to artisanal production implies a different set of politics as an analogy between the artisanal character of the pro-filmic process and its artisanal depiction would apply in such a case and would have a different ideological implication.

Commodity Fetishism and the Concealment of Labor

While one of the standard strategies of conventional sponsored industrial process films is to transform what is in reality a Taylorist production process into one that looks artisanal in order to tap into the affective satisfactions of craft, another promotional strategy involves enhancing the allure of commodities by valorizing the labor embodied in them. The first strategy capitalizes on the charms of craftsmanship; the second reflects a basic faith in the labor theory of value.

Processual syntax has long been used in advertising. The practice goes back to the displays in the Crystal Palace at the Great Exhibition of 1851 in which, according to Thomas Richards, "the exhibited commodity became,

for the first time in history, the focal point of a commodity culture."[60] The Great Exhibition "helped to shape the way advertisers represented commodities for the rest of the century."[61] And how were commodities presented at the exhibition? At Prince Albert's insistence, commodities were organized in a sequence that mirrored the steps in a production process, running from raw materials to machinery and mechanical inventions to finished manufactures.[62] This display logic amounts basically to a processual display that is not so different from an enactment of Diderot's *Encyclopédie* plates or from contemporary promotional videos, such as "The Story of a Pioneering Sock," a commercial produced in 2014 by Shoot-Media for Levi Strauss & Co. that pretends to follow the production of a single pair of long socks from the threading of a traditional circular knitting machine to the packaging of the socks in an individually numbered box.[63]

Why has processual syntax been treated as a good advertising strategy for selling commodities? This might seem surprising, given the general association of advertising with mystification and processual representation with demystification (even if the elaborated process has little correspondence to reality).[64] But rather than diminishing the aura surrounding the commodity, the "demystifying" approach characteristic of the process genre, paradoxically, heightens the status of the commodity.

Let us consider the example of the advertising film *Birth of a Hat: The Art and Mystery of Making Fur Felt Hats* (J. B. Stetson Hat Co., United States, ca. 1920).[65] This is a sponsored industrial process film paid for by the Stetson Hat Company to sell its products. It presents the steps in the manufacture of Stetson hats at a large plant in Philadelphia that employs more than five thousand workers and produces more than three million hats per year.[66] The film tracks the steps in the process from shots of (1) raw material in the form of swimming beavers, scurrying nutria, and trapped rabbits; to (2) the chemical treatment of the pelts; to (3) the drying of the treated pelts in ovens; to (4) the brushing and cleaning of the pelts in machines; to (5) the cutting of the pelt fur; to (6) the sorting of fur for color and quality; to (7) the picking and blowing of the sorted fur; to (8) the blending and cleaning of the blown fur; to (9) the separation of enough fur for a single hat; to (10) the forming of the structure for a single hat from a three-foot, perforated copper cone spinning in a machine; to (11) the dipping of the hat body into hot water in a shrinking process; to (12) the hand-rolling process intended to make the felt firmer; to (13) the two-hour shrinking process; to (14) the pulling out of the crown and the brim; to (15) the blocking to shape and size; to (16) the smoothing with

a b c

d e f

g h i

FIGS. 3.3a–i Coda: "The Evolution of a Hat." Frame enlargements, *Birth of a Hat: The Art and Mystery of Making Fur Felt Hats* (John B. Stetson Co., ca. 1920). The grid should be read from left to right, row by row (as one reads text in English). Each frame enlargement represents one shot. The sequence is composed of nine shots; it is introduced by a dissolve, followed by seven more dissolves and then a cut between the eighth shot (3.3h) and the ninth (3.3i).

emery paper; to (17) the more refined softening (with a subseries of steps); to (18) the bending of the brim; to (19) the cutting of leather bands; to (20) the trimming and sewing. But this last shot of women trimming and sewing on the leather bands is followed by a striking coda announced with a final intertitle, "The Evolution of a Hat." Following the intertitle are a series of eight dissolves and one final cut recapitulating part of the process we have just seen, but without reference to the workers (figures 3.3a–i). The dissolves show the lone proto-hat in the center of a black frame morphing from three-foot conical mold (step 10) to finished, banded Stetson (step 20).

This final coda contains not a single trace of a human agent. The hat's "evolution" looks like autogenesis; the semi-animated hat seems to form itself, as if by magic. This coda could be a visual illustration of Marx's

theory of commodity fetishism.[67] Here we have the magical hat enveloped in mystery—a little god reigning over us. Look how it moves itself! Where did this fetish come from?

Well, we know exactly where it came from. The film has a double discourse. On the one hand, we have sat through thirteen minutes of workers, with the help of machines, fabricating Stetsons, so we know what magical force has produced the hats. On the other hand, the coda suggests the Stetson made itself. Made by people, made by magic. This advertising film, in a Gellian gesture, has analogized production by human labor to production by magic, revealing—inadvertently perhaps—the true cause of the fetish's seemingly magical transformation.

In this surprising juxtaposition, the film's implicit valuation of labor is striking. Imagine for a moment that the film has consisted only in the final coda—which by itself is a dramatic effacement of every trace of human labor—without the prior thirteen minutes of processual representation. It would not have been nearly as effective as advertising. Why does showing the labor process prove an effective strategy? The calculation of the Stetson company is implicitly one in which the secret of the value of the commodity is labor.[68] I am using value in the sense in which Karl Marx understood it. "Value," he wrote in the first chapter of *Capital, Volume 1*,

> therefore, does not stalk about with a label describing what it is. It is value, rather, that converts every product into a social hieroglyphic. Later on, we try to decipher the hieroglyphic, to get behind the secret of our own social products; for to stamp an object of utility as a value, is just as much a social product as language. The recent scientific discovery, that the products of labour, so far as they are values, are but material expressions of the human labour spent in their production, marks, indeed, an epoch in the history of the development of the human race, but, by no means, dissipates the mist through which the social character of labour appears to us to be an objective character of the products themselves.[69]

In effect, industrial process films are undergirded by their accession to the labor theory of value—in other words, the view that the (exchange) value of the commodity is basically determined by the amount of socially necessary labor time congealed in it. While the films actually depict particular instances of concrete labor, they *pretend* to represent the average amount of time (and steps) necessary to produce the referenced commodity. Just as process films expect the spectator to generalize and abstract

from the particular and singular instance pictured (i.e., we are expected to understand that we are seeing a representation of the making of *the* yellow crayon rather than a representation of the making of yellow crayon number 1,356), so, too, are we, in effect, expected to treat concrete labor as if it were socially necessary abstract labor. Even though most industrial process films condense and distort—often through elliptical editing—the average amount of labor time it took to produce the pictured commodity, the time spent watching the production process must make palpable to the spectator something of the *quantity* of labor congealed in the commodity, thereby enhancing her perception of its value and, thus, of its desirability.[70] The duration of a representation of the labor process must approximate (though on a much reduced scale) the labor time congealed in the finished product. Surely, the more complex the representation of the labor process is—the more skill involved or the longer the buildup to the finished commodity (i.e., the more that has gone into the commodity by way of time, of skill, of material)—the more amazing and valuable (and perhaps even underappreciated) the commodity must seem. A processual representation that incorporates some images of painstakingness or difficulty or—in Gell's terms—"resistance" would surely enhance rather than undermine the spectator's sense of the value of the commodity being produced. Though, at the same time, too much emphasis on pain or toil must also diminish the delight and sense of magic in observing effective processes, as the technology would seem less than ideal—more distant from the magic standard of zero work. In some general sense, the industrial process film capitalizes on the secret of the commodity (the socially necessary labor time congealed in it) to generate the commodity's aura of value in the representation. By approximating the (socially necessary) labor-time that went into the production of the commodity in the currency of screen time, the spectator must feel the commodity accumulating value—even when the representation includes sequences of autogenesis and even when it does not individualize the workers involved (e.g., by not showing their faces). In the latter case, labor as such is not being concealed, even if its particular authors are.

Process films depicting the industrialized slaughter of animals present an interesting counterpoint. I have in mind Frederick Wiseman's *Meat* (United States, 1976). Of course, there are many others, such as Georges Franju's *Blood of the Beast* (France, 1949) and *Faena* (Humberto Ríos, Argentina, 1961), and recent films such as *Our Daily Bread* (Nikolaus Geyrhalter, Germany, 2005). It is striking that in the case of industrialized

slaughter, processual representation is generally wielded by independent filmmakers and is used not as a stimulus to consumption but as its deterrent. Corporations do not produce process films depicting meatpacking because they would not be effective advertising vehicles. The processual approach in the case of slaughter films does what baring the device is meant to do—namely, force a critical confrontation with the work of commodification. Even for the unrepentant carnivore, which Wiseman himself was, declaring irreverently in an interview about *Meat* that while he was filming it he ate steak every day, the confrontation with factory meat production strikes a discordant note. There is something too irreverent, too instrumentalist about the treatment of the animals. One is struck by the ways in which animals are *unlike* raw material such as cotton or wicker. Here, the considerable labor congealed in the packaged meat products (which the spectator has been forced to contemplate in detail) devalues the commodity, which becomes less desirable. By the end, the packaged meat is missing the aura of the Stetson hat or the glass marvels of Peter and Zsóka Nestler's *How to Make Glass (Manually)* (Sweden, 1970). Instead, it functions as a synecdoche for the perversity of industrial slaughter and the misuse of labor power. But these slaughter films are exceptions that prove the rule; they use processual syntax against itself and reveal the syntax's basic adherence to the labor theory of value.

The Metaphysics of Labor

The process genre is a genre that, by virtue of its processual syntax, is deeply committed to skill and technique, on the one hand, and to labor as a source of value, on the other hand. I think it is to this basic glorification of labor—whether factory or craft, alienated or unalienated—that we can attribute the diversity of political projects that turn to processual representation. While it is certainly the case that sectors of both the traditional left and the traditional right have embraced a metaphysics of labor, the metaphysics of labor has lately received renewed scrutiny with the growing popularity in leftist circles of the politics of antiwork.[71] Moreover, read through the lens of antiwork politics, the process genre finds itself at the center of a contemporary debate about the status of work in human life. It is a debate that is redrawing the boundary between left and right along the lines of antiwork/work politics.

Believing in a metaphysics of labor can mean being committed not merely to the idea that labor is the source of value in commodity exchange

but also to the idea that it is the transhistorical source of meaningfulness in human life—"life's prime want," as Marx famously wrote in *The Critique of the Gotha Programme*.[72] Recent critiques of the metaphysics of labor have come from the Autonomist-inspired left and are, for the most part, targeting classical Marxism—both socialist modernization and socialist humanism.[73]

In the classical Marxist account, the realization of communist society depends on radically reducing the socially necessary labor time (and thus reducing the length of the working day) so that people have more free time for other pursuits. The achievement of such a radical reduction depends on the development of the forces of production. The modernization of technology and the reorganization of work routines (e.g., Taylorism) were considered steps toward that development, and it was for that reason that Lenin was notoriously fascinated by Taylorism. Modernization was treated by many as a means to an end, as progress—enabling a shortened working day for everyone. Within this schema, work, though toilsome and monotonous, is treated as a good; workers work within an industrial mode for the sake of the nation and for the sake of its communist future. This is "socialist modernization"; it is grounded in an embrace of labor, even if the embrace is understood to be instrumentalist.

"Socialist humanism" refers to the view articulated in *The Economic and Philosophical Manuscripts* in which labor is at the core of human species-being. "For labor, *life activity, productive life* itself," Marx writes, "appears to man in the first place merely as a means of satisfying a need—the need to maintain physical existence. Yet the productive life is the life of the species. It is life-engendering life. The whole character of a species, its species-character, is contained in the character of its life activity; and free, conscious activity is man's species-character."[74] Erich Fromm put the idea more starkly when he wrote, "Labor is the self-expression of man, an expression of his individual and mental powers. In this process of genuine activity man develops himself, becomes himself; work is not only a means to an end—the product—but an end in itself, the meaningful expression of human energy; hence work is enjoyable."[75] The travesty of capitalist society, then, is that it deforms human life and mystifies the true source of human flourishing: "Man (the worker) only feels himself freely active in his animal functions—eating, drinking, procreating, or at most in his dwelling and in dressing-up, etc.; and in his human functions [i.e., labor] he no longer feels himself to be anything but an animal. What is animal becomes human and what is human becomes animal."[76] Communist so-

ciety, then, offers the promise of a life of unalienated labor or "free, conscious activity" organized and directed by the laborers themselves.

Antiwork politics takes special aim at this often forgotten variant of the metaphysics of labor.[77] There are three main critiques: the historical (and postcolonial) critique of humanism, the critique of romanticism, and the critique of the moralism of productivism.[78] First, the metaphysics of labor presupposes a transhistorical account of human nature and the human subject (through which we distinguish ourselves from animals by our way of laboring) whereas in reality—argue Jean Baudrillard, Moishe Postone, Dipesh Chakrabarty, Kathi Weeks, and others—this account is based on the notion of "abstract labor" (the assimilation of all instances of working, whether at smithing or at sewing, under a single sign), which not only *arises within* a capitalist mode of production but is its invention. In other words, labor is a category internal to capitalism rather than a category that transcends it or opposes it.[79] A true alternative to capitalism, then, cannot be couched in one of capitalism's pillars and inventions—labor—even if that labor is genuinely unalienated. In the second critique, "free, conscious activity" can sound a lot like artisanal and craft work, which is also redolent of a historically circumscribed, individualist, petty bourgeois ideal rather than a properly collectivist one.[80] As much as Marx may have tried to distinguish his view from the one he attributed to Pierre-Joseph Proudhon and termed "craft-idiocy" in *The Poverty of Philosophy*, antiwork critics are in effect rejecting the distinction he tried to make.

The third critique is clearly articulated in Weeks's recent book *The Problem with Work: Feminism, Marxism, Antiwork Politics, and Postwork Imaginaries*. Weeks—inspired by the anarchist Paul Lafargue's tract *The Right to be Lazy* (1883)—argues that this metaphysics of labor betrays a certain (again historically and culturally circumscribed) moralist asceticism, a prejudicial horror of laziness (what's wrong with it, anyway?), and an unfounded suspicion of "carefree consumption" (Lafargue's phrase).[81] Encapsulating the critique, Lafargue issued the following hyperbolic, tongue-in-cheek corrective in *The Right to be Lazy*: "But to arrive at the realization of its strength the proletariat must trample under foot the prejudices of Christian ethics, economic ethics and free-thought ethics. It must return to its natural instincts, it must proclaim the Rights of Laziness, a thousand times more noble and more sacred than the anaemic Rights of Man concocted by the metaphysical lawyers of the bourgeois revolution. It must accustom itself to working but three hours a day, reserving the rest of the day and night for leisure and feasting."[82]

In a similar vein, the historian James Livingston traces the genealogy of the celebratory metaphysics of labor back to Martin Luther and the Protestant work ethic, which tied labor to religious salvation, redefined the aristocracy as a parasitic element, and put work in the place of politics and reason as the source of human self-discovery and self-determination. Livingston thereby draws a straight line from Luther and the Protestant work ethic to Hegel to Marx, who said of Hegel, "He grasps labor as the essence of Man."[83] Thus, in addition to tracing its original sin back to capitalism, the embrace of a metaphysics of labor can be traced back to Christianity. Livingston, Weeks, and others attempt to historicize to death the belief in a metaphysics of labor. If the view that labor is life's prime want is reduced from a philosophical claim about a transhistorical human nature to a view with a definite history in the West, then labor loses its significance to human life as well as its explanatory value.

Against the faith invested in work *as* liberation, the antiwork contingent prescribes a liberation *from* work. Weeks writes:

> Let me be clear: to call these traditional work values into question is not to claim that work is without value. It is not to deny the necessity of productive activity or to dismiss the likelihood that, as William Morris describes it, there might be for all living things "a pleasure in the exercise of their energies." It is, rather, to insist that there are other ways to organize and distribute that activity and to remind us that it is also possible to be creative outside the boundaries of work. It is to suggest that there might be a variety of ways to experience the pleasure that we may now find in work, as well as other pleasures that we may wish to discover, cultivate, and enjoy. And it is to remind us that the willingness to live for and through work renders subjects supremely functional for capitalist purposes.[84]

What is unavoidable in the metaphysics of labor is a certain utopianism. Whether the content of that utopia is endless productivity, progress, and abundance or whether it is a human life made meaningful by unalienated, skilled making and doing (which is possible only after a consolidated revolution), the metaphysics of labor offers right and left a future-oriented vision of the good life in which humans could be freed from necessity and the toil of labor, in which our condition would be governed as if by magic. Without work to fill the void, we would need another source of meaningfulness in human life.

Whatever position one takes toward the metaphysics of labor (whether one defends a principled refusal of work or clings to a view of work as life's

prime want), the process genre is grounded in its logic. The recent resurgence of art cinema process films should be understood against this background: these are films made in a utopian key, feeling around—though often ambivalently—for the texture of a meaningful human life and finding it in craft labor.[85] If the process film has an aura of the antiquated and excites a twinge of nostalgia, it must be in part because, today, the promise of labor as liberation *feels* like an anachronism, a historical relic out of sync with the latest transformations of capitalism.

NATION BUILDING

IF THE PARADIGMATIC PROCESS of the process genre is a work process, there are two main kinds of work processes: industrial and artisanal. Each process has in turn been associated with corresponding categories of filmmaking—sponsored industrial and educational cinema, on the one hand, and ethnographic cinema, on the other. This division has created two areas of research, useful cinema and visual anthropology, which have largely proceeded in parallel, without much reference to each other. On the surface, this segregation makes sense. After all, industrial processes and artisanal processes seem to belong to separate worlds—the one is associated with the city, the other with the countryside; the one with the machine, the other with the hand; the one with the modern and progressive, the other with the ancient and arrested; the one with mass industrial society, the other with so-called primitive society.

The process genre reaches across this divide. While the process film has usually been associated with industrial and educational cinema, where it has been treated as a dominant subgenre, processual representation has also been a favorite structuring principle in ethnographic filmmaking. Examples range from Félix-Louis Regnault's early film of a Wolof potter made at the 1895 Exposition Ethnographique de l'Afrique Occidentale in Paris to the films Pliny Goddard made of Apache material culture for the American Museum of Natural History in the early twentieth century, as well as most of Robert Flaherty's film corpus to the Encyclopaedia Cinematographica

produced by the Institut für den Wissenschaftlichen Film (IWF). The use of processual syntax across the representation of industry and craft and across the industrial-ethnographic film divide allows us to think of these two categories of work and filmmaking together, in a single frame. And it prompts the question: why has processual syntax been a useful organizing principle for *both* of these representational endeavors? The answer, I argue, lies in the relationship between the process genre and nationality. If the process genre must be examined in relation to work, it also should be examined in relation to nationality.

Processual representation has often been mobilized in industrial, educational, and ethnographic filmmaking to address "nationality," not primarily in terms of cultural identity, but in terms of a people's capacity or level of development. Industrial, educational, and ethnographic process cinema—for different reasons—have all historically been invested in the civilizational attainments of different national formations. The civilizational attainment of national formations is extrapolated from the data provided by the objects being produced and by the methods of production. There is a basic materialism at work here. First, to the extent that the process genre paradigmatically represents the coming into being of material objects, the question of technology is paramount. It is paramount not merely because the objects themselves are technologies, but because the developmentalist syntax of the genre requires the depiction of the tools, instruments, and machines used in the process of fabrication, even if the only tool is the human hand. Second, technologies have long been treated—by a range of thinkers—as indices of the stage of development of a particular society. Thus, thinking about processual representation also requires one to think about cultural evolutionism—that is, the constellation of theories positing that societies pass, unidirectionally, through a series of stages that lead from less complex to more complex configurations.[1]

In industrial/educational and ethnographic process films, artifacts and processes are not just artifacts and processes; they have a symbolic valence. They speak of and for the nation or state or community or society that produced them. The salted herring of *Drifters* (John Grierson, United Kingdom, 1929 [Empire Marketing Board]), the automobiles of *Master Hands* (Jam Handy, United States, 1936 [Chevrolet]), or the steel pipes of *Mannesmann* (Walter Ruttmann, Germany, 1937 [Mannesmann Steel Works]) are intended as indices of the civilizational superiority of imperial Britain, the prewar United States, and Nazi Germany, respectively. Similarly, Regnault's film of the Wolof potter making a pot without a wheel—

commonly considered the first ethnographic film—aimed to locate the Wolof people along an evolutionary path, somewhere between middle and upper barbarism.

If the process genre is often associated with nationalist imperial projects, it is because nation-states have used industrial/educational process films to make the case for national technological modernity and what that implicitly is thought to signify: national superiority. Ethnographic process films may not be nationalist in this sense, but they have often also plotted nations or peoples or the societies they depict along an evolutionary timeline of human history that supposedly leads from a "primitive" past to a modern present. While in industrial process films the degree of cultural evolution along a linear path toward increasing technological sophistication is usually an object of celebration, in ethnographic process films the tone is often dominated by a romantic "imperialist nostalgia"—that is, nostalgia for a simpler way of life prior to the irreversible destruction imperialist globalization has wrought for so-called primitive peoples and nonindustrialized ways of life.[2] In these films, the trajectory of modernity is usually the object of not only critique and discomfort but also resignation. Still, whether cultural evolutionism (and development) is looked on as a triumph or as a catastrophe, it is understood to be inevitable, and it belongs to the basic terrain the process genre navigates in much the way that a metaphysics of labor does.

Latin America provides an especially auspicious context in which to explore the connections between the process genre and nationality and development. There, the tradition of industrial nonfiction filmmaking gave rise to the processual representation of a mixed-race folk national subject engaged in artisanal work. Process films that include, paradigmatically, *Aruanda* (Linduarte Noronha, Brazil, 1960) were the inaugural gesture of the New Latin American Cinema (NLAC), the continental film movement responsible for one of the most sophisticated bodies of leftist political filmmaking in the twentieth century. The opening gambit of the nationalist cinema movements held together under the umbrella of the NLAC was, on the one hand, to interrupt the narratives of national technological achievement that were standard in the industrial/educational films that dominated nonfiction film production in many nation-states. But, on the other hand, these early NLAC process films often also shook up the usual temporal logic applied to the non-White "Other" by ethnographic filmmaking practices of the time. While these films might look like ethnographic process films in that they depict the supposedly "primitive" lifeways of

indigenous and African-descended peasants, they thwart the spatiotemporal logic of much ethnographic filmmaking—what Johannes Fabian described as "allochronism"—by insisting on the dynamism and innovation of the depicted craft production.[3] Likewise, while they seem to reject the technological modernity of their nationalist industrial film counterparts by focusing on an artisanal mode of production, they are ultimately also nationalist and pro-development. The cycle of Latin American process films that I focus on in this chapter is an exceptional case, both for the way the films' particularities shed light on the interactions of processual representation and nationalist film projects and because the process genre shaped so significantly a major movement in Latin America cinema. The process genre, in effect, offers a lens for rethinking the historiography of Latin American cinema.

The Process Film and the Historiography of the New Latin American Cinema

The historiography of the New Latin American Cinema standardly begins in the late 1950s with mostly short documentaries about the difficult lives of mixed-race peasants living in rural areas. The movement achieves its height in the late 1960s with such masterworks as *Black God, White Devil* (Glauber Rocha, Brazil, 1964), *The Hour of the Furnaces* (Fernando Solanas and Octavio Getino, Argentina, 1968), *Memories of Underdevelopment* (Tomás Gutiérrez Alea, Cuba, 1968), *The Jackal of Nahueltoro* (Miguel Littín, Chile, 1969), and *The Battle of Chile* (Patricio Guzmán, Chile, 1975). New Latin American Cinema begins to fracture and dissolve in the late 1970s as the revolutionary fervor of the end of the previous decade is met with violence in Argentina, Chile, and Brazil and as revolution gives way to state capitalism in Cuba.

The standard scholarly account of the inception of the NLAC has emphasized three aspects of this production: the representation of "underdevelopment"; the influence of Italian Neorealism and Griersonian documentary; and the extent to which these early works were a developmental "stage" along the path toward a militant, autochthonous (rather than derivative) production that would be emblematized by the masterworks of the late 1960s.[4] It is certainly true that several of these films fix—for the first time in this region—a new visual lexicon to accompany the emergent discourse of "underdevelopment." That lexicon includes isolated, harsh, often barren rural landscapes; "primitive" methods and instruments

of production; rustic dwellings constructed from natural materials such as mud and sticks; mestizo peasants with well-lined, weathered faces; and naked, barefoot, unkempt children. It is also undeniable that Neorealism and Griersonian documentary were important references for the cosmopolitan filmmakers involved in the NLAC. This is especially true for the Argentine Fernando Birri and the Cubans Tomás Gutiérrez Alea and Julio García Espinosa, who all studied filmmaking in Italy in the early 1950s at the Centro Sperimentale di Cinematografía in Rome. A scholarly focus on the depiction of poverty and "underdevelopment" and on the works' European antecedents thus made sense in the historical moment in which these films were produced. After all, before these films, the cinematic representation of poverty in this region had a different, sanitized look.[5] But what this orientation toward the representation of "underdevelopment" has obscured—and what stands out today in the midst of a resurgence of processual representation—is a striking commonality of several of the most emblematic and canonical early works of the NLAC and their difference from later production: they are mostly process films. The processual character of these films has never been examined in the scholarly literature. It is, as I show, crucial to their place in the NLAC.

Process genre films of the NLAC include *Arraial do Cabo* (Paulo Saraceni, Brazil, 1959), about traditional fishing and fish salting in a small municipality on the coast of the state of Rio de Janeiro; *Aruanda* (mentioned earlier), about the fabrication of ceramic housewares in a remote part of Paraíba, Brazil; *El mégano* (The Charcoal Worker [Tómas Alea and Julio García Espinosa, Cuba, 1954]), about charcoal burning in the Zapata swamps of Cuba; *Araya* (Margot Benacerraf, Venezuela, 1958), about the process of salt mining on the Arayan peninsula in Venezuela; *Mimbre* (Wicker [Sergio Bravo, Chile, 1957]), *Trilla* (Threshing [Sergio Bravo, Chile, 1959]), *Día de organillos* (The Day of the Barrel Organ [Sergio Bravo, Chile, 1959]) about, respectively, craft in wicker, traditional wheat threshing, and organ making in Chile; *Faena* (Work [Humberto Ríos, Argentina, 1960]) and *Cerami-queros de Traslasierra* (The Ceramicists of Traslasierra [Raymundo Gleyzer, Argentina,1965]) about, respectively, industrial slaughter and the production of ceramic figurines in Argentina; and *Chircales* (Brickworks [Marta Rodríguez and Jorge Silva, Colombia, 1967]) about brickmaking in Colombia. Although these films are more and less rigorous in their deployment of processual representation, they all are organized around processes of production that have a cyclical character; the processes are repeatable protocols. At the same time that a process of production is being presented,

a process of reproduction is being implied. In every case, the process of (re)production is cast as the basis of a way of life. The films, thus, are largely allegories of a parallel national community with a distinct mode of production—that is, parallel to the official nation-state. Thus, it is little wonder that many of the titles—*Aruanda, Arraial do Cabo, Araya, Ceramiqueros de Traslasierra*—refer to geographic places.

While the process films of the NLAC signaled a break from previous sanitized representations of iconic national spaces, they also displayed a certain continuity with the history of national cinematic representation. The films had clear antecedents in the local nonfiction, useful filmmaking scene. They emerged in a context in which nonfiction filmmaking was dominated by state and corporate institutions and initiatives and in which processual representation was a standard structuring convention. At the same time, NLAC cineastes were newly confronted with the achievements of international cinema in the university cine-clubs that had taken root in the mid-1950s. It is against this background that several NLAC filmmakers adopted processual syntax in their early films. But in their experimentations, processual syntax is not an incidental feature of the films' style. It is central to their aims and to their power.

Of course, each national context had its own, particular characteristics. In Chile and Brazil, the nonfiction filmmaking scene through the 1950s was dominated by sponsored films (educational as well as industrial films). In Argentina, there was a broader spectrum of production contexts and an independent sector. I focus here on two cases—Chile and Brazil—because of the importance of industrial/educational filmmaking to the story and because these two countries produced some of the most compelling process films to emerge from the first phase of the NLAC.

The Chilean Case

In Chile, it was the prominence of industrial filmmaking that provided the relevant backdrop for the emergence of the NLAC process films. Chile's tradition of mostly industrial—corporate and institutional—filmmaking began with *Cemento Melón* (Melón Cement [Carlos Eckardt Zúñiga, 1917]), about the newly constructed cement factory in Valparaíso, and with the film scholars consider the first Chilean documentary, *El Mineral "El Teniente"* (The Mineral of the "El Teniente" Mine [1919]), by the Italian Argentinian Salvador Giambastiani, about copper mining activities at the U.S.-owned Braden Copper company. While *El Mineral "El Teniente,"* the only one of the

two that survives in some form, is better read as an "album film," featuring a collection of discrete views of the geography of the mining town and some disparate mining activities, than as a process film, by the early 1940s process films were becoming the dominant mode of nonfiction filmmaking in Chile. Between 1941 and 1957 (the year Bravo's *Mimbre* was made), of the approximately fifty-seven documentaries produced nationally, at least twenty-four could be considered process films, and several others incorporated processes into an album film format.[6] The remainder are mostly travelogues. The process films featured titles such as *La pesca en alta mar* (Fishing on the High Seas [Armando Rojas Castro, 1941]), *Central de Leche* (Milk Station [Guillermo Yánquez, 1944]); *Carbon Chileno* (Chilean Coal [Pablo Petrowitsch, 1944]), *Salitre* (Salt Mine [Pablo Petrowitsch, 1946]), *Cobre* (Copper [Pablo Petrowitsch, 1950]), *Acero* (Iron [Patricio Kaulen, 1950]), *Chile y su explotación ovina* (Chile and Its Sheep Industry [Vinicio Valdivia, 1951]), *Petroleo chileno* (Chilean Oil [Armando Parot and Fernando Balmaceda, 1955]), and *Pãnos de Tomé* [Cloth of Tomé [Boris Hardy, Alejandro Wehner, and Jorge Di Lauro, 1955]). Most of these films focus on industrial processes and factory production and, in one form or another, tout Chilean modernization and industrialization. A few of the album documentaries, such as *Tarapacá, un pasado y un porvenir* (Tarapacá, a Past and a Future [Egidio Heiss, 1943]), made for the local provincial government, depict nonindustrial production. Almost all of these films—the process films and the album films—were supported by private companies such as Braden Copper, Carbonífera Lota-Schwager, and Nestlé or by public entities such as the University of Chile's Instituto de Cinematografía Educativa and the Ministry of Agriculture, and many were produced by private publicity companies such as Cinep, founded by Fernando Balmaceda and Armando Parot, and the Argentinian company Emelco. The films were all produced by the same cast of filmmakers, which included the cinematographer Egidio Heiss and the directors Guillermo Yánquez, Armando Rojas Castro, Pablo Petrowitsch, Naúm Kramarenco, Patricio Kaulen, and Fernando Balmaceda. Between 1957 and 1969, process films continued to account for a large proportion of nonfiction production—approximately twenty-five process films of eighty-three exhibited.[7]

Against this backdrop, Sergio Bravo's films from 1957–62, which are among the inaugural films of the NLAC, stand out *not* because they are the first process films. Bravo used familiar genre conventions, but he transformed them.

Sergio Bravo was the founder, with Pedro Chaskel, of the Centro de Cine Experimental in 1957. The Centro de Cine Experimental, which in 1961 would be incorporated into the Audiovisual Department of the University of Chile, and the Instituto Fílmico de la Universidad Católica revolutionized Chilean national cinema, constituting a break with previous production both in fiction and nonfiction.[8] In the first phase of its existence, from 1957 to 1963, the Centro produced ten short films, the most outstanding of which are five process documentaries directed by Bravo—*Mimbre*, *Día de organillos*, *Trilla*, *Láminas de Almahue* (Scenes from Almahue [1961]), *Parkinsonismo y cirugía* (Parkinson's and Surgery [1962])—and the city symphony film *A Valparaíso* (1963), directed by Joris Ivens, who spent several months at the University of Chile in 1962–63. In the late 1950s, Bravo understood his work as opposed to that of his contemporaries—filmmakers such as Fernando Balmaceda, for whom he worked as a cameraman in 1957 and 1958; Pablo Petrowitsch; and Jorge Di Lauro.[9] They were filmmakers making publicity process films for industry. While their films were almost universally nationalist celebrations of machine-driven extractive industries such as copper, coal, and limestone, Bravo's films were celebrations of artisanal, manual labor: the craft in wicker in *Mimbre*; wheat threshing by hand in *Trilla*; barrel organ fabrication in *Día de organillos*; traditional wheelwright craftsmanship in *Láminas de Almahue*; and the surgeon's craft in *Parkinsonismo y cirugía*.

Bravo's difference from his contemporaries should not be sought only in the fact that these contemporaries were producing films for paying patrons—whether corporate or governmental—with directly useful objectives. After all, several of these sponsored films circulated nationally and internationally as works of cinematic art, some winning awards (e.g., *Salitre*, which in 1947 won an award from the Chilean film and theater magazine *Ecran* for best short film of the year). Balmaceda, perhaps the most prolific process filmmaker of the late 1950s and '60s, viewed the reception of his films with surprise, especially, he noted, "if one considers that all of them were commissioned films that were either public service announcements or publicity films."[10] Yet Balmaceda's documentaries were exhibited in theaters and written up in the local newspapers. He also won an annual prize from the Critics of the Art, and his work circulated in international film festivals. He received honorable mentions in Montevideo and Karlovy-Vary; a gold medal in Moscow; a Golden Dove in Leipzig's documentary festival; and the medal for best short national film at the IV Festival de Cine de Viña del Mar for the sponsored film *Carbón* (Coal

[1965]). Television stations in Poland, the Soviet Union, Switzerland, and France acquired the rights to exhibit some of Balmaceda's films, including *Tejidos Chilenos* (Chilean Fabrics [1965]).[11]

Nor are the differences between these industrials and Bravo's films to be sought in their nationalist orientation: they are all—at least ostensibly—paeans to the intelligence of the Chilean worker. For example, in *La metalurgia del cobre* (The Metallurgy of Copper [Patricio Kaulen, 1960]), sponsored by Braden Copper, the voice-of-god narrator ends his step-by-step account of the process of copper refining with a crystallization of the explicit message peddled by the film: "The cycle is complete. The blind furies of nature were dominated by man. His intelligence made possible the exploitation of her riches, and in a process that appears unreal, fantastic, hallucinatory. Here what began as a simple rock became a refined product of an indefatigable labor and an irrefutable illustration of what man is capable of making with what nature proffers."[12] The sophistication of the design of the process and machinery of copper refining is displaced from the American engineers of an American-owned copper mine to the Chilean workers employed by the company.

Nor are the differences between industrial process films of this period and Bravo's process films to be found in the former's neglect of artisanal production. Some of Balmaceda's best-received films, *Manos creadoras* (Creator Hands [1961]) and *Tejidos Chilenos*, centrally involve craft production. *Manos creadoras* is a short film depicting crafts (including work in wood, textiles, ceramics, engraving, tapestry) practiced at the School of Applied Arts at the University of Chile. *Tejidos Chilenos*, commissioned by the Bellavista-Tomé Cloth Factory, one of the major textile companies in Latin America, to celebrate its one hundredth anniversary and produced by Balmaceda's publicity company, Cinep, proudly traces the history of Chilean textiles from the pre-Columbian practices of the Mapuche people that survive into the present, through the practices of the Chilean cowboy (*el huaso*), to the machine production of the Bellavista-Tomé factory. It is a particularly instructive example. The film's final voice-over narration declares:

> The Chilean textile tradition saw itself incorporated into the movement of progress and its slow and patient flow became an agile and powerful industrial impulse. Chilean textiles since then have achieved a new dimension that may be traced back to their traditional beauty and quality. The art of textiles—whether it is the kind that sprouts spontaneously near

a dry stone wall in Atacama or in the smoky, warm interior of a hut in Temuco or beneath a tile roof on some patio in Doñihue—is an art with one single origin and one single destiny, to which the industrialized art is not foreign. The same love of material binds them since they have in common the spinning and the dyeing and the warping and the knitting. One, the craft, sprouts pleasantly and lovingly like the quiet flowering of nature. The industrial art is, on the other hand, man-made machine and power, ingenious and rhythmic, unlimited in its reach, as if it returns to itself for the delight and satisfaction of men. This is what Bellavista-Tomé has accomplished in its 100 years and what it will continue doing: evolving in a textile tradition that is also its own tradition.[13]

The argument of *Tejidos Chilenos*'s narration is unmistakable: the industrial production of cloth borrows everything that is good and natural from the artisanal production of the autochthonous craftsman and develops and improves on it. While the world "evolves new techniques and designs," the narration continues, "here [in the countryside among artisans] . . . these silent centers of creative activity flower in their own eternity." The dichotomy between city and country, factory and artisanal workshop, creole machine operator and indigenous craftsperson mobilizes familiar scripts: the city, the factory, and the industrial worker are dynamic, always evolving and innovating; the countryside, the small-scale workshop, and the Indian are eternal, traditional, natural. Yet in Balmaceda's narration, both the dynamic factory and the enduring autochthonous craftsman have their place in the story of Chilean textiles. The latter gives rise to the former before branching off into a dead end.

This approach to Bellavista-Tomé's one hundredth anniversary, which devotes half its screen time to a positive assessment of artisanal production, was initially of concern to the company's executives—until they saw the final film.[14] Despite the glowing review of traditional, autochthonous Chilean textile practices, in which, according to the narration, these folk practitioners "appear limitless in their creative imagination, in the good taste of their designs, in their weaving practice which is pure mastery," the film's visual treatment of machines and industrial production has quite a different character from its treatment of artisanal practices. The portion of the film devoted to artisanal production features several postcard-perfect landscapes shots, what one might expect from a tourist brochure or a travelogue: of alpacas at sunrise; of misty virgin forests; of manicured meadows; of pre-Columbian totems at dusk (figures 4.1a–b). When the

 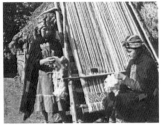

FIGS. 4.1a–b Idyllic scenes of national particularity from the opening. Frame enlargements, *Tejidos Chilenos* (Fernando Balmaceda, Chile, 1965). Courtesy of Archivo Patrímonial Universidad de Santiago de Chile.

a b

camera does turn to Mapuche and huaso weaving processes, the images are accompanied almost continuously by voice-over narration, except for a one-minute interlude in which a Mapuche woman works on a handmade wooden loom. Several of the shots that make up this section are artfully framed and photographed. Still, the particulars of her labor and the sequence of her work are difficult to make out.

By contrast, in the portion of the film devoted to industrial production, Balmaceda constructs a particularly striking two-minute-and-twenty-second, narrationless processual sequence in which machines spin and ply and then pick and gill and dye and dry and card and comb and warp and weave. One contemporary critic for the Chilean magazine *Ercilla* praised the sequence for illustrating the industrial process processually—"in a precise way, without the habitual excesses of narration. The cinematography ably takes advantage of the color and texture of the different elements, while the music of Sergio Ortega lends an important auditory complement to the visual rhythm of this sequence."[15] The stars of this lyrical sequence are unquestionably the dazzling automated machines—filmed in dramatic close-up—that spin and roll and twist and transform shorn wool into colorful, patterned fabric (figures 4.2a–c). While the narration gives both industrial and artisanal production a favorable treatment, the image track and the score tell another story about the unlikely technological modernity of the Chilean textile industry.

This divergent approach in the representation of indigenous craft production and industrial mass production is not atypical in colonial—or, we might say, internal colonial—contexts. As Rianne Siebenga has shown in the case of the representation of Indian crafts in early British films, processual representation was reserved for the depiction of industrial production, while the album film format was employed in the representation of traditional Indian crafts. Siebenga concludes that in the Indian case, an album approach to craft was consonant with colonial discourse in that it,

a b c

FIGS. 4.2a–c Three images from the two-minute-and-twenty-second, narrationless processual sequence. Frame enlargements, *Tejidos Chilenos* (Fernando Balmaceda, Chile, 1965). Courtesy of Archivo Patrimonial Universidad de Santiago de Chile.

too, underscored a lack of modernity.[16] The point could be extended: processual representation as a structuring principle in itself suggests modernity. Balmaceda thus forgoes a processual approach in his representation of the Mapuche and the huaso precisely to underscore the lack of modernity. In the Latin American context, in which it was ideologically paramount that the indigenous element's "backwardness" be folded into and overcome in a dialectical *synthesis* emblematized by the mestizo (mixed-race) national subject, any suggestion of the modernity and dynamism of the indigenous national subject poses a problem for a state's project of acculturation (and whitening).

The ideology of *mestizaje* in which the indigenous national element is not expelled from the nation (as in U.S. national ideology) but incorporated—swallowed and absorbed—maps easily onto the ideology of reactionary modernism in which the nation's nonindustrial, rural, "primitive," folk past could be harmoniously combined with an industrial, urban, technological, modern present.[17] In an adaptation of reactionary modernism to the Latin American context, *Tejidos Chilenos*'s solution to the rurality, indigeneity, "archaicism," and "underdevelopment" of the Chilean countryside is to propose a triumphalist cultural evolutionism that passes linearly from tradition to modernity, from country to city, from artisanal labor to machine automation, from Indian peasant to mestizo worker on the march toward Progress. A processual approach to the textile production of the countryside would have undermined this narrative.

Returning to the peculiarity of Sergio Bravo's films, what sets Bravo's films apart from Balmaceda's best exemplars, then, is not that the former employs poetic photographic and editing strategies. After all, *Tejidos Chilenos* uses those very resources in its treatment of machines—their rollers, their axles, their gears. The major difference is in their respective treatments of artisanal craft and the artisan. While *Tejidos Chilenos* reserves

processual syntax for industrial production, Bravo's films deploy it in the representation of artisanal production performed by peasant artisans and, in so doing, upsets the progressive, linear narrative of development that underpins the reactionary state.

Mimbre was Bravo's first process film, which he would have begun during the time he was working as a cameraperson for Balmaceda on Cinep publicity projects. *Mimbre* is a ten-minute film that depicts the work of Manzanito, a master wicker craftsman, living in the Quinta Normal commune of the metropolitan city of Santiago. The film opens on a medium-long shot of Manzanito seated outside, concentrating on the task of splitting and preparing wicker fibers for weaving (see figure 4.7a). The figure absorbed in work, facing the camera, shares the frame with a leaning tree trunk in a composition that borrows the conventions of the picturesque. Manzanito labors to a guitar score composed especially for the film by the Chilean musician and folklorist Violeta Parra. The film depicts—in a loose process structure—the steps in Manzanito's production of a wicker sea animal beginning with the preparation of the wicker fibers and moving to the weaving of fibers around vibrating upright stakes; then to the manipulation of fibers to create the animal's body cavity; then to the construction of the fish head. The sequences of Manzanito laboring are interrupted twice, marked each time by a distinct musical thread that introduces a visual interlude in which the meandering camera surveys, from near and far, the marvels of Manzanito's completed wicker animals: the simulation of the undulating wing of a dove in flight; the approximation of bird feathers; the open mouth of a fish as if gasping for water in a fisherman's net; the contrast of the fish's tail fin with the scales effect created by the wicker weave; the plasticity of a horse's wicker mane; cow eyes and pointy, curving wicker horns; arched chicken beaks and wicker wattles and combs, and so on (figures 4.3a–c). These shots highlight, at once, the versatility of the wicker material that can approximate fish scales just as well as horses' manes and chicken wattles and the ingenuity and flourish of the craftsman who has vivified his birds by his crafting of the feather wing in flight and who has enlivened his fish, paradoxically, by freezing them in a last, open-mouthed gasp for water. The displayed wicker animals are further animated by the breeze that stirs a dove hanging from a string and by the children in the film who commandeer the life-size wicker animals, putting them to use as masks and play costumes.

a b c

IGS. 4.3a–c Finished creations.
rame enlargements, *Mimbre*
>ergio Bravo, Chile, 1957).

The animation of inanimate matter extends to raw materials when the camera films vibrating wicker stakes (figure 4.4). In one shot, the upright vibrating stakes occupy the foreground, Manzanito's face obscured behind them and his working hands—the cause of their vibration—out of the frame entirely. In another shot, the fiber stakes extend horizontally out of the leftmost edge of the frame, the cause of their movement wholly hidden from view. Matter—wicker animals and wicker fibers—seemingly moving itself is not so different from Balmaceda's automated machines that miraculously card and comb and weave seemingly without the aid of a human agent. But whereas Balmaceda reserved this dynamism for industrial textile production and relegated huaso and Mapuche artisanal textile production to the realm of an inert, unchanging, eternal (though aesthetically pleasing) Tradition, Bravo's craftsman, the craftsman's workshop, the craftsman's materials, and the craftsman's artifacts teem with life, dynamism, movement, and an evolving creative ferment.

Each of the two interludes I mentioned earlier presents a mystery about how Manzanito was able to manipulate wicker in such a way as to approximate a flowing mane or a tapered horn or a fish's tail fin. Because the interludes punctuate the processual representation, each time we are thrown back to observing Manzanito at work, manipulating his materials, our apprehension of the craftsman's dexterity at the level of execution and his ingenuity at the level of conception (after all, how did he think to solve the problem of the chicken's wattle with wicker loops rather than something else?) is enhanced. It is this sense of dexterity and ingenuity that is missing from Balmaceda's Mapuche and huaso weavers, whose labors *look* restless and unsystematic.

Mimbre's primary aesthetic strategy achieves an acute sense of the craftsman as a technologist. Defamiliarization is the governing aesthetic conceit of the film, evidenced most clearly in the enlivening of wicker animals and wicker fibers, but also manifest in the proliferation of visual and aural analogies. For example, the self-moving, dry fibers catch the light in such a

FIG. 4.4 Vibrating fibers. Frame enlargement, *Mimbre* (Sergio Bravo, Chile, 1957).

way that their reality is uncertain—are they tangible matter, fibers, or the illusion of matter created by light rays? Is it a light show that we are seeing? Or are the fibers the liberated strings of Parra's guitar that plays over the images? The discarded fiber curlicues produced by Manzanito's wicker fiber shredding process look like discarded celluloid film reels (figure 4.5).

In another example, the body cavity of Manzanito's wicker whale is filmed from an aerial perspective (see figure 4.8a), then visually analogized, through associative montage, to a daisy, to a field of daisies, and to a spider spinning its web (see figure 4.6a). In this segment of the film, we are presented with four shots: (in order) a field of daisies, differentially illuminated by natural light; the wicker animal's body cavity, filmed from above (see figure 4.8a); a close shot of a spider, washed out, spinning a web (see figure 4.6a); and a close image of Manzanito working on a dramatic wicker hourglass shape (see figure 4.6b). The first two shot transitions are form dissolves: the high angle shot of the bunch of daisies melts into the shot of the hollow center of the whale's body, the round darkness of the daisy field in the left third of the frame is replaced by the round darkness of the hollow center of the animal (see figure 4.8a). For ten seconds, the camera records the changing play of light inside the animal's body cavity as the dark round center shrinks and throbs with the sun's inconstant illumination. The shot suggests two other visual analogies: to a single daisy, with its dark disk looking like the hollow center and its light-colored petals looking like the wicker weave, and to the eye of a living creature whose pupils dance with the reflection of light. In the next transition, a quick form dissolve superimposes a round, washed-out, white spider on the dark center of the whale cavity—thus juxtaposing two images at once similar (in shape) and distinct (in color) (see figure 4.6a). The spider's pat-

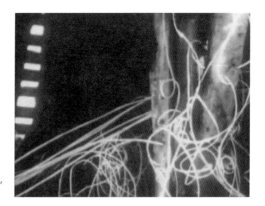

FIG. 4.5 Film strip—two ways. Frame enlargement, *Mimbre* (Sergio Bravo, Chile, 1957).

terned silk threads are like the wicker fibers, which, once woven, are solid enough to hold together but permeable enough to allow air and light to pass. The spider shot cuts to a close-up of Manzanito at work—the round white spider in the top left of the frame is displaced by a round, dark hollow cavity and Manzanito's hand at work weaving through splayed wicker stakes (figures 4.6a–b). The spider's labor, thus, is explicitly likened to the craftsman's labor.

Bravo's films produce an acute material consciousness as one is confronted by a comparison of forms: the wicker dying fish is like and unlike the real dying fish; the vibrating wicker fibers are like and unlike the strings of the guitar, light rays, reels of (discarded) celluloid; the wicker weave is like and unlike the cobweb; the spider is like and unlike the artisan; the wicker cavity is like and unlike a daisy or an eye. The sequence of poetic cinematography that defamiliarizes and abstracts the work of the machines in *Tejidos Chilenos* functions similarly, but the formal comparisons are to nonrepresentational, abstract, modernist shapes and patterns. Still, in both cases these analogies of forms seem to deinstrumentalize the steps in an instrumental process with a determinate, useful end.

Surely, in the case of *Mimbre* one might think that Bravo's defamiliarization of the materials of wicker craftsmanship deinstrumentalizes them as it emphasizes their physical properties—treating those properties as ends in themselves—rather than emphasizing their function in the creation of use objects (e.g., wicker animals). Such a reading would suggest that *Mimbre* just inverts the industrial process film's instrumentalism: means displace ends as the isolable beauty of each step in the process of wicker animal production risks rendering the final object superfluous. On this

view, *Mimbre* just extends what, in *Tejidos Chilenos*, is a flourish—making it the governing principle of Bravo's film as a whole.

But consider the *usefulness* of defamiliarization to technological innovation. Does not innovation often sprout from a fresh perception of the possibilities of matter—a fresh perception that then leads to repurposing? Where does wicker come from? How did wicker first become the basis for basket making? One source of wicker is tree branches. When the branches are attached to trees, growing leaves, shading the ground, it is difficult to imagine that those very same branches could be "repurposed," used for basketmaking or—as in the case of Manzanito's work—for life-size wicker animals. To acquire such an insight, one would have to know something about those branches, the character of their fibers—when wet, when dry, when living, when dead. The possibility of using those branches to make wicker must have depended at some point on defamiliarizing their usual use, which requires acquaintance with their properties. "Making strange" is a phase in much technological innovation; thus, deliberate defamiliarization could be a strategy for inventing.[18]

In the case of *Mimbre*, it is not trivial that the film is bookended by an image of a tree (figures 4.7a–b). While the first shot of the film juxtaposes the tree's trunk with long wicker fibers, culled and piled on the ground awaiting Manzanito's treatment, the film ends with a more explicit survey of the tree. An aerial medium shot looks down on a dark bucket of water

a b

FIGS. 4.6a–b The last two shots of the four-shot sequence: the spider and the craftsman, graphically matched. Frame enlargements, *Mimbre* (Sergio Bravo, Chile, 1957).

that Manzanito uses to make the wicker fibers more pliable; the water in the bucket catches the dancing light presumably from the moving clouds overhead in such a way that for a moment it seems that an animal—a rabbit, perhaps, as in a magician's trick—is stirring in the bucket, about to emerge (see figure 4.8b). The bucket is surrounded by long strands of wicker fiber hugging its rounded contours; the image is an allusion to the visual metaphor of the daisy, with its round, dark center, and of the dark cavity of the wicker animal, and of the spider in the eye of its web, and of the eye with its reflective pupil (figures 4.8a–b). The image cuts to a slightly longer shot of the same scene, but now the camera tilts and tracks upward to reveal the tree of the opening shot, with all its diverging branches and its fluttering leaves (see figure 4.7b). This final moment of the film—as it lingers over a view of leaves quivering in a gentle zephyr— recalls the Lumière brothers' early film *Baby's Meal* (1895), in which the wind in the trees came to signify, for contemporary audiences, the miracle of cinema. From the tree Manzanito has derived wicker fibers and from wicker fibers, wicker animals. Manzanito's craft labor has repurposed the stuff of nature, and the film suggests the miracle was achieved not despite an investigation of form(s) but because of it. Moreover, the kinesis that permeates every shot and all matter in the film underscores the dynamism of life where nothing stands still, where everything is subject to constant change and development.

a b

FIGS. 4.7a–b A tree: the first shot of the film (4.7a) and the last (4.7b). Frame enlargements, *Mimbre* (Sergio Bravo, Chile, 1957).

The human capacity for technological development gains a political significance in this context, for just as the human being can repurpose nature and make some useful object from mere matter, surely she is also capable of transforming the world, of organizing it according to a different set of principles. In *Mimbre*, the agent of world making and remaking is neither the industrialist of Balmaceda's *Tejidos Chilenos* nor the figure of the Indian. Rather, he is a hybrid national subject—the Chilean *volk*—constituted by the realities and ideology of racial and cultural mixing. Unlike Balmaceda's artisans in *Tejidos Chilenos*, Bravo's artisans—across his process films—are cast as men of action, makers of worlds; they are not analogized to an inert nature, resigned to an unchanging, eternal biological life. The processes that Bravo poeticizes—from the wicker work in *Mimbre* to wheelwrighting in *Láminas de Almahue*, barrel organ construction in *Día de organillos*, and threshing in *Trilla*—are not autochthonous in the sense that they are unique to Chile, invented there (i.e., processes originating with its native peoples). They are "autochthonous" only in the sense that they were processes practiced there at the time Bravo filmed them.

The important point for Bravo is not that Chile has a unique, singular culture (featuring indigenous Mapuche and homegrown cowboys) that

a b

FIGS. 4.8a–b Compare the eye metaphor of the earlier moment (4.8a) with the eye of the penultimate shot of the film (4.8b), an aerial view of the outdoor workspace. In both, the metaphoric pupil uses light (from the bottom of the cavity in the first case and from the reflection of the sky in the second) to suggest life. Frame enlargements, *Mimbre* (Sergio Bravo, Chile, 1957).

can be traced back into the historical past. It is, rather, that Chile's symbolic national mestizo subject is dynamic and inventive. He has skill, capacity, intelligence, and agency—in the present. Bravo's achievement was to marshal processual representation to convey, viscerally and bodily, not merely intellectually, the significance of the practical, living intelligence of the mixed, folk subject.

The Brazilian Case

While Bravo adapted the conventions of the already prevalent industrial process film to a rural, artisanal context, the Brazilian Paraíban filmmakers responsible for *Aruanda* (1960), the inaugural film of the Cinema Novo movement, were innovating within their own documentary scene. Brazilian nonfiction film emerged not out of a tradition of sponsored corporate films but within the state's first film institution, the Instituto Nacional de Cinema Educativo (National Institute of Educational Cinema [INCE]).

The institute was established in 1936, under the auspices of the Ministry of Education and Health, and was intended as much as an organ of censorship as of production, a way to guide and rein in the potentially disruptive medium. Directed by the anthropologist Eduardo Roquette-Pinto, INCE's mandate—in accordance with the positivist intellectual climate of the day and inspired by the state-directed educational film initiatives of the Nazis in Germany and the Fascists in Italy—was to use cinema as a pedagogical tool for the unification, education, and "racial improvement" of the Brazilian people. The head of the Ministry of Education and Health, Gustavo Capanema, famously declared that "national culture" was the objective of his ministry:

> Wherever man does not dominate nature; where he does not resist her temptations and her bitterness, but rather succumbs to them; where he is sick and fragile; where he lacks density, hardness, vigor; where he is missing the providential resources of science and technology and the noble inspirations of the soul—there, there is no culture. There, man is primitive, barbarous, backward.... Culture is present where man dominates the elements, where his body emerges and projects itself—wholesome, solid and beautiful—where—because of his sensitivity, his intelligence, his disciplining of the Will, he becomes the creator of material and spiritual values.[19]

From this positivist standpoint, Sheila Schvarzman has observed, the Brazilian was not only ignorant of Culture with a capital "C." He was also ignorant of Brazilian culture in particular, and really, he did not even know himself.[20] INCE would be a favored instrument of his enlightenment. Cinema would, as one contemporary commentator said, "achieve the miracle of showing Brazil to all the Brazilians—from the man of the coast to the man living in the western extremes of the country to the man of the pampas [of the south] to the man of the Amazon."[21] The institute had a double function: it would help *forge* a national identity at home—one based on an ideology of progress and racial improvement through education—and it would showcase Brazil abroad in film festivals and world's fairs not as the land of an exuberant, tropical, free-range nature, but as a land that was modernizing, where man was succeeding in taming nature.[22]

From 1936 until it was dissolved in 1967, INCE produced 358 films. Most were made by Humberto Mauro, INCE's in-house filmmaker. The history of INCE can be divided into two periods: 1936–46, which ended with Roquette-Pinto's retirement, and 1947–67, which ended with INCE's declining importance to the consolidation of a strong state and with a slowing rate of production.[23] The first period saw the production of 244 films, about ninety-five of which emphasized scientific and technical subjects. While the ideological thrust of the productions of the first period cast Brazil as a *modernizing* country, with its share of brilliant men—scientists, inventors, statesmen—who would lead the way out of the cave, the second period turned to the ordinary and the everyday.[24] While the first period was forward-looking, underlining the state's modernizing mission, the second period—which has been most closely associated with Mauro—was backward-looking and romantic, showing signs of an incipient disenchantment with the modernizing project. While cities and centers of political power (such as the state of Rio de Janeiro, where the country's capital was situated) were the focus of the first period, the rural, the countryside—and, in particular, Mauro's home state of Minas Gerais—were at the imaginative center of the production of the second period. While only 114 films were produced during this second period, the number of films having to do with rural themes more than doubled, and the number of films devoted to scientific research, machines, preventive health fell to about thirty-one. Moreover, of all of the films produced by INCE, the institute is probably best known for the *Brasiliana* series, made by Mauro between 1945 and 1964, about Brazilian folk music.[25]

Among the films produced by INCE across its history, a significant proportion—especially in the early years—were process films. Indeed, it can be argued that processual representation was Mauro's preferred filmic syntax. In this he was confirmed and strengthened by a 1938 trip to the Venice Film Festival, where he encountered Walter Ruttmann's prizewinning *Mannesmann* (1937), a process film that depicts a special method for producing particularly resistant steel pipes.[26] Although *Mannesmann* was an advertising film commissioned by the Mannesmann Steel Works, it was used in German classrooms during the period in the implementation of the Nazi regime's policy of incorporating sponsored industrial films in the curriculum as a means of educating students in National Socialist principles.[27] *Mannesmann* reflects an unmistakably nationalist ideology and participates in the National Socialists' embrace of steel as the key industry for "restoring" Germany to its former stature. In Ruttmann's film, Mauro saw the new global tendency to elevate documentary to the status of art "by studying man and things as products of an environment that has been *meticulously* described—that is, materially, spiritually, socially, and philosophically," Mauro said in an interview.[28] *Mannesmann* was "an encyclopedia devoted to the process of steel formation and to the lives of the workers employed in that necessary enterprise, with a dose of love to enliven the description."[29] Brazil did not lack for worthy topics such as this one. This was the path, Mauro asserted, that the Brazilian producer should follow. He added, "It is evident [that this kind of film] is a propaganda vehicle; but who cares if the public appreciates it and is enlightened by it?"[30]

Upon his return from Europe, Mauro operationalized what he had learned abroad. INCE made process films about industrial production such as *Refining Gold* (Mauro, 1938), *Fabrication of Steel Plates* (Oscar Motta Vianna da Silva, 1938), *Graphite* (Mauro, 1943), *Fabrication of Bulbs* (Mauro, 1946), and *Ophthalmic Lenses Industry* (Mauro, 1953); process films about technical processes such as *A Screw* (Mauro, 1936) and *The Telegraph in Brazil* (Mauro, 1936); and process films about scientific processes such as *The Preparation of Rabies Vaccine* (Mauro, 1936), *A Lesson in Taxidermy* (Mauro, 1936), and *The Sterilization Method of Dr. Gudin II* (Mauro, 1938).

Given the preponderance of process films in INCE's catalogue, it is striking that the films for which Mauro is most famous—the films that are most often cited as precursors of the political cinema of the late 1950s and '60s—are not process films. The *Brasilianas* series is composed of nine films ostensibly about Brazilian folk music. Despite having work as one of their key themes, the films of the series largely eschew a processual approach

to work. Perhaps the most emblematic example from the series is *Cantos de Trabalho* (Songs of Work [1956]). The first part of the film, the pestle song, depicts the repetitive, rhythmic task of pounding cassava, coffee, pepper, soil. This section of the film is unified not by a process that has an identifiable beginning, middle, and end, but by a single action, operative in several processes and whose nature is such that its transformative character is difficult to identify precisely. After innumerable repetitions of the action of pounding, what was whole coffee beans eventually becomes ground coffee, and what was cassava becomes *farofa,* a flour made from cassava. Still, pounding suggests not so much transformation and progression (i.e., the magic of making something from nothing) as unending repetition. The pounding serves as an expedient metaphor for one of Mauro's favorite themes in the series: the circularity—the permanence and ritualism—of rural life, which, for Mauro (here he is decidedly like Balmaceda), was one of life's principal virtues. Pounding, in this case, also gives the cinematographer, José Mauro—who was deeply influenced by the work of Gabriel Figueroa, the inventor of the Mexican Golden Age's photographic look—the chance to compose attractive, static shots of dark, bare, glistening bodies in athletic poses (now flexing, now releasing) against a big, open, cloud-filled sky (figure 4.9).[31] The focal point in the pestle song is not human skill as much as beautiful, muscular bodies—bodies worthy of Greek statuary—posing against an attractive, natural Brazilian backdrop. Humberto Mauro's *Brasilianas* films are suffused with nostalgia. They make use of the conventions of the picturesque to depict a bucolic countryside—usually the Volta Grande, the region of Minas Gerais where Mauro grew up—where man and nature share an easy rapport, where they coexist in effortless harmony and equilibrium, yet where both are implicitly under threat from modernization.

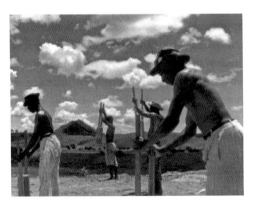

FIG. 4.9 Workers against a big, open sky. Frame enlargement, *Cantos de Trabalho* (Humberto Mauro, Brazil, 1956).

Compared with the Chilean case, what is noteworthy in the Brazilian case is that by the late 1950s there was already a precedent for filming in rural and peripheral settings. In Chile, one of the innovations of Bravo's first films was to shift the focus from industrial production to the artisanal production of craftspeople and peasants in the countryside or in satellite towns. In Brazil, the rural landscape had already taken on an iconic visibility, thanks largely to Mauro's work. If in Chile Balmaceda's corporate advertising process films were the foil for Bravo's artisanal process films, in Brazil the first political process films, beginning with *Aruanda*, were distinguishing themselves as much from the nostalgia of Mauro's filmography in the second half of INCE's history as from the films of "meticulously described" scientific and technical processes from the first half of INCE's existence. Those political process films, as in the Chilean case, were an important departure from what had come before.

Between 1959 and 1979, a group of filmmakers from Paraíba would produce a formidable body of process films, including *Aruanda*; *A cabra na região semi-árida* (Rucker Vieira, 1966); *A Bolandeira* (Vladimir Carvalho, 1968); *Os homens do caranguejo* (Ipojuca Pontes, 1968); *O País de São Saruê* (Vladimir Carvalho, 1971), which was banned for nine years; *Quilombo* (Vladimir Carvalho, 1975); *A Pedra da Riqueza* (Vladimir Carvalho, 1975); and *Mutirão* (Vladimir Carvalho, 1976). While *Aruanda* and some of the other Paraíban films were materially supported by INCE, they are distinguished by two features missing from Mauro's *Brasilianas* films: (1) the visual treatment of the *sertão*—the arid northeastern region of Brazil—and other rural regions as sites of poverty and "underdevelopment"; and (2) the rigorous application of processual representation to the quotidian activities, the craft practices, and the small industries of poor peasants.

If Mauro's scenes of the Volta Grande of Minas Gerais were idyllic, pastoral, and picturesque, the Paraíban filmmakers depicting the impoverished northeastern sertão treated the place as an extreme landscape where man battled rather than harmonized with nature. The documentary scholar Amir Labaki sums up the difference this way: "[Mauro's mature films] seek to preserve and celebrate popular culture. Mauro eternalizes a lost paradise; Noronha [the director of *Aruanda*] historicizes an open air purgatory."[32] Until *Aruanda*, the films INCE produced had, for the most part, eschewed visible signs of "underdevelopment." After all, one of INCE's mandates from its early history had been to project a positive image of Brazil abroad: Brazil was to be presented as a modernizing nation rather than as

an exotic, impoverished backwater. Moreover, in the contemporary reception of *Aruanda*, spectators were most taken with the film's stark, visceral representation of "underdevelopment." Glauber Rocha, the Cinema Novo auteur, wrote,

> The montage . . . gives an impression of *Paisá* in the Northeast. Noronha and Vieira [the cinematographer] are close to the fantastic Rossellini; the miserable realism of material misery, in the dirty treatment of the surface of the land and the hungry faces of men. We can be certain that *Aruanda* wanted to be truthful more than it wanted to be a narrative: [a cinema] language as [medium-specific] language is born of the real, it is the real. . . . That is why *Aruanda* inaugurates Brazilian documentary.[33]

In other words, while watching *Aruanda* one encounters not merely a particular subject matter (poverty). One encounters a subject matter treated in such a way, in cinematographic terms, as to give the spectator sensorial access to the extremity of that poverty. There are pretty pictures of misery (well composed, well framed, well lit) and there are ugly pictures of misery (overexposed, technically imperfect). *Aruanda*'s ugly images of misery were new in Brazilian film. Vladimir Carvalho, the assistant director on the project, recently commented that *Aruanda* definitively broke with an old style and "inaugurated a [new] style of filming the northeast."[34] In other words, with the film a now familiar and abiding iconography of the region was born, an iconography that Cinema Novo films such as *Black God, White Devil* would make resonant all over the world.

The Paraíban documentary filmmakers' association with the representation of "underdevelopment" is part of what has led to the widespread reading of their films, as one recent treatment put it, as emphasizing "backwardness, passivity, and a lack of agency," as reinforcing entrenched stereotypes of Nordestinos (people from the northeast) as "nonmodern, animal-like, or slavelike"—in other words, as depictions of "the Other."[35] But seen against the background of INCE's production, another reading emerges. Like Bravo's films in Chile, these films exploit the magic of processual representation to guard against a prior dominant representational strategy and, in so doing, open up space for a new kind of image to emerge. But while Mauro reserved processual representation for scientific processes, industrial production, and—in an interesting case—bird-nest building in his two versions of *João de Barro* (1938, 1956), the Paraíban filmmakers applied processual representation systematically to a variety

of peasant labor, from agricultural production to craft production; local, small-scale industry; and activities of quotidian life such as house building.

Aruanda, which is (as I said earlier) usually considered the film that "sparked" the Cinema Novo movement and an inaugural film of the NLAC, is a revealing example of the ambiguities of representing artisanal peasant craft.[36] Funded meagerly by government cultural entities including INCE, *Aruanda* depicts the subsistence activities of a small, isolated community of Afro-Brazilian descendants of escaped slaves (in Portuguese, a *quilombo*) in an arid, rugged pocket of northeastern Brazil. Carvalho, the assistant director and co-screenwriter on the project and arguably the figure most responsible for its aesthetic, would later go on to become one of the most prolific makers of Latin American process films.[37] Vladimir Carvalho, named after Vladimir Ilyich Ulyanov (a.k.a. Lenin), was the son of a "fervent socialist" and himself a member of the youth league of the Brazilian Communist Party around the time *Aruanda* was written.[38] In his self-mythology, he identifies two experiences in his youth that would determine his artistic development; both have processual representation at their center. The first occurs when he is a young boy growing up in the town of Itabaiana in the Brazilian state of Paraíba. "If I were to excavate my first fascination with ideas of sequential narrative and movement," Carvalho has said,

> I would find myself spellbound by reflections in stained glass, the sound of a kind of harpsichord, the bas-reliefs of the stations of the cross in the main church of Itabaiana. In the city market, a miniature simulacrum of a flourmill called my attention. It was exhibited inside a large box, with the help of small lenses. As the operator turned the crank, we saw puppets reproducing in detail the activities of the mill worker, the feeding of the oven, etc. It was a kind of barrel organ, or a rustic kinetic art.[39]

The second experience occurred later, when he was in his teens. In 1958, while he was studying philosophy in the northeastern Brazilian city of Recife, the cine-club to which he belonged hosted a screening of *Man of Aran* (Robert Flaherty, United Kingdom, 1934). "It was an epiphany," Carvalho later said. "The images of *Man of Aran* sparkled on the cinema screen in Recife and, in a little more than an hour, I came to see cinema in a completely

different way. The unfolding of the film had produced a seductive astonishment, a kind of ecstasy that I couldn't identify at the time."[40] Flaherty's film was "a revelation" for Carvalho—a cinema of nonprofessional actors that was not spectacular in the Hollywood sense; a cinema of the camera in search of reality.[41] The reference to Flaherty makes good sense, given that most of Flaherty's corpus—from *Nanook of the North* (1922) to *Moana* (1926), *Industrial Britain* (1931), and *Man of Aran* (1934)—consists of process films.

Aruanda, one of the first films Carvalho worked on, only a year after seeing *Man of Aran*, could look a lot like an adaptation of Flaherty to the Brazilian backlands. In other words, it looks like it could be an ethnographic film from the first decades of the twentieth century. After all, it depicts a rural black community using "primitive" tools and struggling for survival in an inhospitable environment. Glauber Rocha suggested as much in a newspaper review in 1960 praising *Aruanda* as a film that established Brazilian documentary. Rocha echoes the standard evolutionary discourse that frequently accompanied these kinds of ethnographic representations. About the Quilombo da Talhado (the maroon community that is the subject of the film) as it was represented in *Aruanda* Rocha wrote, "It is a civilization in the age of clay, 1,000 years behind in development."[42] All of the ingredients are here for a nostalgic celebration of "primitive" economy in the face of the onslaught of modernity.

But *Aruanda* is deceptively straightforward. It holds together—in a tense unity—both a celebration of craft and a critique of "underdevelopment." This makes it a rich case study of the left's mobilization of processual representation. *Aruanda* is divided into two parts, corresponding to two distinct historical periods (the mid-nineteenth century and the mid-twentieth century), two film forms (fiction and documentary), two thematic threads (migration and subsistence), and two musical motifs. The first part of the film is a fictionalized reenactment of the mid-nineteenth-century journey made by the former slave Zé Bento (Paulino Carneiro) and his family from a slave plantation to Serra do Talhado, in the arid region of the state of Paraíba, where they establish a homestead (figure 4.10). This first part is deliberately staged. It casts the actual inhabitants of present-day Serra do Talhado as a nineteenth-century nuclear family—father (Zé Bento), mother, son, and daughter—loading their few possessions onto a donkey and traveling day and night deep into the dry interior. The omniscient narration explains that the family is fleeing slavery and setting off in search of a "land that belongs to no one." This part constitutes a kind of origin story: Zé Bento, whose pioneering spirit and unquenchable desire

FIG. 4.10 Reenacting the nineteenth-century flight from slavery. Frame enlargement, *Aruanda* (Linduarte Noronha, Brazil, 1960).

for de facto freedom from slavery leads him to Serra do Talhado, is the founding father of the contemporary quilombo, Olho d'Água.

The music that dominates this first part is a well-known folk song of uncertain provenance, "Ó, mana, deixa eu ir" [O, Sister, Let Me Go]. The song became famous when the composer Heitor Villa-Lobos used its melody in the third movement—the "Aria/Cantiga"—of his Bachianas Brasileiras No. 4. In the film, it is sung by a local man, Othamar Ribeiro. The text of the song is a story told from the point of view of a brother addressing his sister, begging her to allow him to go alone to the backlands of Caíco: "O, sister, let me go. O, sister, I am going by myself. O, sister, let me go— to the city of Caíco." The second and third verses are curious, combining seemingly unrelated details: "I sing as I go along / with my engagement ring on my finger / Here I am only afraid of Master Zé Mariano / Mariazinha placed flowers / on the window sill / as she thought of a white dress / a veil / and flowers in the chapel." The speaker's desire for freedom is displaced onto his intended (Mariazinha), who dreams of a church wedding. But why should the addressee—the sister—care about her brother's fiancée's frustrated fairytale fantasy? The hopes of all three—the sister's hope for family futurity, Mariazinha's hope for a white wedding, and the speaker's hope for freedom from fear—are all bundled together and invested in the success of the brother's journey. The song captures the fugitive slave's yearning for a better future, his resistance to an impossible present, and an uncommonly powerful backward glance that is tinged with a sense of loss and loneliness.

The second part of the film is dominated by long processual sequences depicting the present-day (mid-twentieth-century) subsistence activities performed by the inhabitants of Serra do Talhado, who are descendants

of slaves who followed Zé Bento to Olho d'Água after emancipation. These present-day inhabitants survive by harvesting cotton and making ceramic housewares that they sell at the local marketplace.

The dominant musical theme of this second part of the film is an upbeat, repetitive, hypnotic tune, "Piauí," played on a fife. It was performed by Manuel Pombal, a ninety-three-year-old member of a local black religious association, as part of a yearly celebration of the Catholic saint Rosário, the patron saint of Afro-Brazilians. Noronha, the film's official director, describes having chosen this piece of music even before the film was shot. It was the music he heard during his initial visit to the community in 1958 when he was writing an article for the newspaper *A União*. According to Noronha, that article, titled "As Oleiras de Olho Dágua do Talhado" (The Potters of Olho Dágua do Talhado), despite its title, was a report on the "religious syncretism" of the "festa do Rosário." The music from the yearly celebration had made such an impression on him that he insisted on including it in *Aruanda*, over the objections of technicians and advisers who were dissatisfied with the quality of the recording and with the "primitive" (their word) character of the music.[43]

Despite the fact that the film has been described as an adaptation of Noronha's article, the script for *Aruanda* departed radically from the article: religious syncretism had dropped out almost entirely, leaving its only trace in the film's score.[44] In the film, Pombal's fife exclusively accompanies sequences showing people involved in productive activity (ceramics, farming, house building). In fact, the film makes no visual reference to the "festa do Rosário." But Noronha retrospectively justified the new fit between sound and image. After all, the fife was "repetition without end! Pa-ra-ra-ra, pa-ra-ra-ra, pa-ra-ra-ra, only that."[45] For Noronha, this "pré-logical," "exhausting" fife that "reflected the anguish of survival for these people . . . who were caught in an unending economic cycle" was a perfect metaphor for the closed cycle of subsistence the film depicts.[46]

With this in mind, *Aruanda*'s bifurcated structure—neatly indicated by explanatory opening intertitles and an authoritative voice-over narration— is not as straightforward as it appears, for the two halves of the film, despite their temporal separation, *look* the same: both depict a dry, harsh landscape. As a consequence of the film's consistent use of location shooting, nonprofessional actors, and an unwavering camera style, the visual track paradoxically suggests a strong temporal continuity between the two halves: the past and the present collapse into one another; the historical quilombo and the contemporary quilombo seem unproblematically to

form a single entity, whose look and feel anchor it to the contemporary context. Suggesting that one hundred years has made little difference to the level of development, this structure casts the quilombo as a static entity, caught in a continuous present. Here we can see the taxidermic trope of ethnographic filmmaking that Fatimah Tobing Rony has highlighted.[47] Moreover, the longing for freedom of the first part, made palpable by the song "Ó, mana, deixa eu ir," is disappointed by the precarity of the subsistence cycle of the second part, making Olho d'Água's present all the more tragic; the fugitive slave's intrepid desire for freedom and autonomy seems to find no outlet.

But this negative reading, which echoes Noronha's own comments on the fife music, is complicated by the film's utopian title. "Aruanda" is a word derived from Bantu that roughly means "paradise" or "promised land." The word comes from "A Luanda," the capital of Angola (named so in the sixteenth century). For the descendants of slaves in Brazil it came to stand in for all of Africa and was thought of as a utopia of well-being and freedom.[48] Indeed, the film's title has long raised questions.[49] *Aruanda's* early title, *Talhado, a cidadela do barro* (Talhado, Citadel of Clay), bore a closer resemblance to the title of Noronha's article for *A União*.[50] While Noronha admits that he was familiar with the word "Aruanda" from the 1940 book *O Negro Brasileiro* (by Arthur Ramos, although Noronha misattributes the book to the anthropologist Nina Rodrigues), it was the poet Vanildo Brito who first mentioned Aruanda in relation to the film.[51] He was the one who explicitly made the comparison between the argument of the film and the promised land of Brazil's Angolan slaves.[52] Of course, this association of the quilombo community with a utopian space is in direct tension with Noronha's sense of the community as stuck in a tragic, "unending economic cycle." It is also significant that Brito made the connection only *after seeing* a rough cut of the film. Brito's idea could not have come directly from the work of either Arthur Ramos or Nina Rodrigues, or even of Edison Carneiro, a writer and folklorist who is most commonly cited as the source for the etymology of "Aruanda," for in the works by these men, the utopian space of "Aruanda" has nothing to do with Brazil's quilombos. At that time, neither historical nor contemporary quilombos were treated as utopian promised lands. In other words, in the late 1950s it would have seemed odd to idealize the present-day quilombo of Olho d'Água in this way. The quilombo had not yet acquired its now taken-for-granted utopian aura. Indeed, *Aruanda* may be the first major cultural production to make this connection.

What did Brito *see* in the rough cut of the film that could have evoked the idea of a "promised land"? And to what does the film's title really refer? Is the quilombo of Olho d'Água a kind of promised land? How could it be? The voice-of-god narration, which was written exclusively by Noronha, tells us that Olho d'Água is in fact no paradise, that its inhabitants live a life of servitude, isolation, and scarcity. The film's opening titles report that after emancipation Olho d'Água "was transformed into a peaceful quilombo, isolated from the country's institutions, lost in the hills of the Northeast's plateau, with a small population caught in a tragic, dead-end economic cycle, alternating between cotton harvesting and ceramic production." This might lead one to think that the title is ironic, that although Zé Bento left the plantation in search of "Aruanda"—the promised land— he found only more misery and hardship. This is the solution suggested by the strangeness of the film's bifurcated structure. But the problem with this solution is that what we *see* of Olho d'Água, and what Brito saw of Olho d'Água, is not primarily misery. The film focuses not on poverty, hunger, and so on, but on a *process of production*, which it transforms into something magical.

Indeed, to my mind, the film's greatest accomplishment is the detailed visual account of the artisanal mode of producing ceramic housewares—in other words, its mobilization of processual representation. Although the film depicts other kinds of making and working—Zé Bento's construction of his home from mud and sticks, the couple's planting of cotton in desiccated soil—it is the pottery sequence that is most complete. Of the film's twenty-two minutes, a full eight are devoted to showing how the members of Olho d'Água make giant clay vessels. The film depicts the necessary steps in order: the gathering of dry clay pebbles; the pounding of the hard, clumpy soil into a more refined form; the fetching of water from the well; the mixing of the water and the dry soil; the kneading of the mud into clay; the hollowing of the clay; the smoothing of the jug's outer edge; the construction of the lip from coils of clay; the decorative pinches in the lip; the patient trimming and smoothing; the baking; the loading (onto donkeys); the walk to market. As a paradigm of the process genre, the film's attentiveness to the process distinguishes it from just any depiction of work. The sequence says not so much "Look, *they* work. They make pottery" as "Look *how* pottery is made." And the effect produced by the film evinces the absorption that is a hallmark of the genre. Carvalho, in his writings on how *Aruanda* changed his professional trajectory, often mentions the

"hypnotizing" effect of the film, even titling one essay, "I Still Live under the Hypnosis of *Aruanda*."[53]

A fragment of the sequence made to look like a lesson in the construction of a single jug from the gathering of water from the well to the completion of the jug before firing is perhaps most illustrative of this spellbinding effect. In the middle of the two-and-a-half-minute sequence the shots are high-angle medium shots, and because they are joined by a series of form cuts, the jug is consistently on the left side of the frame, allowing the viewer to easily assess progress from the previous shot (figures 4.11a–x). In each shot, the camera focuses on the resolute activity of autonomous and nimble hands as they work methodically and systematically across the surface of the clay—patting, trimming, pinching. The beams of natural sunlight unevenly illuminate the object being formed, as the precise hands in motion cast dancing shadows on the jug. The camera does not ignore the workers' faces and clothes, but the real object of its fascination is the relation among the artisan's hands, the tools she uses, and the matter that is being (trans)formed. *Aruanda*'s visual account of the making of pottery is beautiful and magical, not miserable.

This approach to the representation of an impoverished mixed-race national subject contrasts suggestively with other kinds of contemporaneous nonprocessual representations. Perhaps the best-known of such counterexamples is Fernando Birri's 1960 short, *Tire dié* (Throw a Dime; Argentina). A touchstone of the NLAC, it depicts the desperate and precarious lives of a community of people living on the outskirts of the city of Santa Fe, in Argentina. The children of this peripheral encampment play a dangerous game to contribute to their family's income: they run parallel to the trains that pass through the empty landscape (on their way to coastal cities) begging for dimes from the passengers. The passengers sometimes throw the dimes and sometimes hand them off to the ragged children, who are shown running along a narrow, uneven platform—arms outstretched, barefoot, struggling to keep up with the moving train. The film ends with a thirty-second shot that has become iconic: a boy of about five, captured in close-up, his dirty face flanked by his mother's still hands holding each of his shoulders. The boy stares straight ahead—out of the frame—at the viewer; he wears an expression of pathetic abandon (figure 4.12). The camera jiggles, a diegetic tango plays from beyond the frame. The face is the symbol of humanity in *Tire dié*; it is the privileged visual trope of the film. The boy's face pleads for action, something to lift up the national subject. But there is no processual representation here.

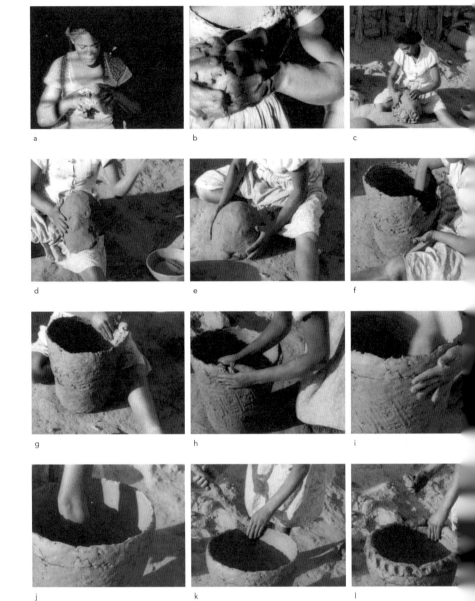

a

b

c

d

e

f

g

h

i

j

k

l

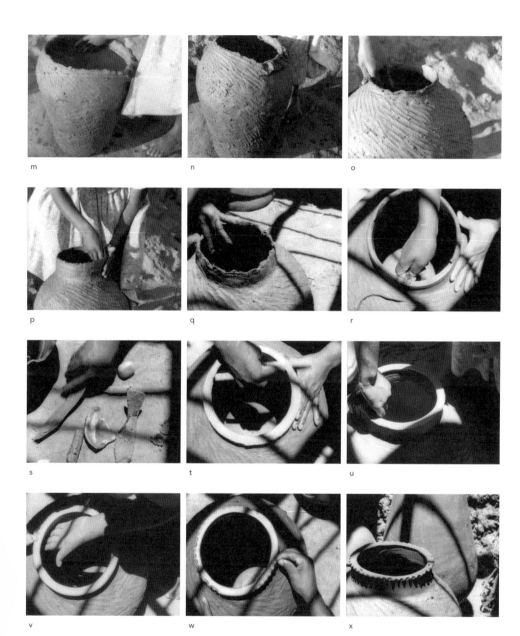

FIGS. 4.11a–x Fragment of the ceramic sequence ending with a shot of the completed jug. Frame enlargements, *Aruanda* (Linduarte Noronha, Brazil, 1960). The grid should be read from left to right, row by row (as one reads text in English). Unlike most of the process grids in this book, in this one each frame enlargement corresponds to a single shot. The sequence has twenty-nine shots; the first five of the sequence have been excluded from this figure set.

FIG. 4.12 The last shot of the film. Frame enlargement, *Tire dié* (Fernando Birri, Argentina, 1960).

By contrast, *Aruanda* and *Mimbre* have little use for facial close-ups. In both, it is the hand engaged in action—bending, flexing, pressing, grasping—that establishes the humanity of the film's social actors. If *Tire dié*'s final image casts the dirty-faced boy as an object of sympathy and solicits perhaps some institutional version of charitable redress, *Aruanda* and *Mimbre*'s craftsmen—like *Mannesmann*'s workers—are cast as a molders of matter, shapers of worlds, or, we might say, agents of change.

Does this emphasis on craftspeople mark *Aruanda* and *Mimbre* as exercises in nostalgic idealization? After all, an emphasis on molding matter—on making and fabricating—is as important in Flaherty's romantic treatments of nonindustrialized societies as it is in nationalist industrial process films. But if the application of a molding thematic to non-White artisans distinguishes a film such as *Aruanda* from typical nationalist industrial process films, what distinguishes *Aruanda* from its romantic Flahertian intertexts? *Aruanda* largely seems to succumb to the romanticism of artisanal labor on display in Flaherty's process films; these latter are films that idealize a low level of material development, implicitly cast industrialization as an unwelcome opponent, and suggest that whereas development is catastrophe, tradition and stasis are well-being.

The key difference between Flaherty's work and *Aruanda* lies in the use of "development" as a critical category. *Aruanda* avoids the political pitfalls of Flaherty's approach by ultimately insisting (despite the utopian treatment of craft labor) that the kind of society it depicts is not ideal. And it does so at the level of image and narration by foregrounding the precarity of life in Olho d'Água. This is how the first part of the film, which emphasizes the sterility and the dryness of the land, and the film's narration,

which emphasizes the tragedy of this dead-end economic cycle, may be reconciled with the second part, which emphasizes production processes. The film's final voice-of-god narration issues a stark denunciation of government neglect: "The prolonged droughts, the illiteracy, the hunger, the isolation force them [the inhabitants of Olho d'Agua] into a primitive lifestyle, into an unproductive economic system. They form a vicious circle. From scorched stones to the open market and from there to the isolated and poverty-stricken lifestyle of the region, to ceramic crafts. Talhado is a social sector that is separate from the country. It exists physically. It doesn't exist in the realm of institutions." Moreover, as many commentators have argued, *Aruanda* gives a palpable sense of the dryness of the land and the inhospitality of the environment that underscores the narration's point (see figure 4.10). Zé Bento picks up a handful of dirt, presumably testing its suitability for planting; no sooner has it left the earth than it is blown away in a cloud of dust. At planting time, the land looks like a sea of dirt pebbles. Zé Bento and the other residents of the quilombo are in a struggle with nature. As in Flaherty's *Nanook of the North* and *Man of Aran*, *Aruanda* suggests that the residents of Olho d'Água have not brought nature under their control. But unlike in Flaherty's films, in *Aruanda* the negative consequences of the minimal development of the forces of production are treated as tragic. They are a product not of nature's malice but of the state's neglect. If for Flaherty development is a calamity, in *Aruanda* it is a necessity.

We are back to the central puzzle of the film: is Olho d'Água an "aruanda"—a utopia—or is it a dystopia characterized by scarcity? To be sure, it is both. On the one hand, the film deplores the quilombo's isolation from state institutions, maintaining a clear position on the irredeemable character of poverty. On the other hand, it valorizes the quilombo's production process for its human dimensions. While the film may be generally *for* development, its loving treatment of unalienated artisanal labor memorializes the "artisanal mode of production" that industrialization renders obsolete and projects it into a utopian future. It does this by using the resources of cinema to approximate phenomenologically for the spectator the subjective experience of craft labor. *Aruanda* teeters on the edge of what Michael Löwy and Robert Sayre called "Marxist romantic anticapitalism": it tries to recuperate the centrality of unalienated human activity—of a work process that resembles an artistic process—but without succumbing to noble savage romanticism. It is a difficult balance to achieve.

The many strains of romantic anticapitalism—of which Marxist romantic anticapitalism is only one among the revolutionary strains—deplore

"the decline and disappearance of the old pre-capitalist handicraft—a kind of work in which *creativity* and *imagination* were essential components of labor" and "they describe and analyze the absolute predominance of mere *quantitative* production [in industrial society], the domination of dead machinism over living people, the stultifying effects of the division of labor, the 'repulsive' (Fourier's term) character of mechanical and lifeless toil, the degradation and de-humanization of the worker."[54] In the case of Marxist romantic anticapitalism, the embrace of precapitalist handicraft is animated not by a reactionary project aimed at feudal restoration or by an anarchist rejection of a centralized state, or by a populist desire to see the formation of a federation of semiautonomous, small-scale artisanal communities. Rather, Marxist romantic anticapitalism is utopian in that it imagines that the socialist utopia of the future will embrace the qualitative values identified with precapitalist handicraft, but this utopianism is hostile neither to a centralized state nor to technological development as such.[55] The future "Association of Free Men" will embrace automation, machinery, and technological innovation as long as the division of labor implied by this technical progress is a not the *old* division of labor in which tasks are broken up into smaller tasks, each performed by a different individual who is mortified by this single-sided work, organized by others without his participation, and stretching out for a lifetime.[56]

Marxist romantic anticapitalism was an intellectual current that had some purchase in the so-called Third World, particularly in Latin America, beginning in the 1920s with the work of the Peruvian José Mariategui. *Aruanda*, for its part, exhibits its commitments. On the one hand, the discourse of development suggests a commitment to a more effective centralized state whose institutions *would* reach into the forgotten backlands of its territory and bring development and modernity, thus ending the region's vulnerability to the vagaries of nature. On the other hand, artisanal production is imagined as the core of a utopian national formation of the future, as the quilombo of Olho d'Agua functions as a kind of parallel nation. This utopianism is suggested by the film's deinstrumentalization of craft. Although the pots made by the Olho d'Agua artisans are ultimately destined for the market, the screen time devoted to the processual representation of their production and the presentation of the absorption of their artisan craftspeople transforms the process into an enchanted one. Here in *Aruanda*, as in the most paradigmatic process films, we encounter—to use Alfred Gell's formulation—an enchanted technology and a technology of enchantment (i.e., art).

The film's linking of craft with fine art is explicitly suggested by a shot of upside-down drying ceramic jugs and bowls—smooth and of various sizes. They have been placed in such a way that they cease to look like what they are and instead look like an abstract arrangement of the eggshells of strange prehistoric birds. Löwy has expressed this delicate stance in the Marxist tradition elegantly: "The Romantic dimension has also to a large extent shaped its [the Marxist] vision of the socialist future, presented by the more radical and imaginative Marxist thinkers not only as an economic system where the property of the means of production will be collective, but also as a *new way of life*, where labor would become (again) like art—that is, *the free expression of human creativity*."[57]

While the audience to which romantic anticapitalist art is directed is broadly distributed among the social classes, its creators come largely from the traditional intelligentsia, the sector that "inhabits a mental universe governed by qualitative values, by ethical, esthetic, religious, cultural or political values" and whose "spiritual production" is shaped by those values.[58] *Aruanda*'s filmmakers certainly belong to this group. Moreover, the film establishes an unmistakable parallel between the mode of production of the Olho d'Água potters and the mode of production that produced the film *Aruanda*: both are artisanal. After all, like the represented practice of the Olho d'Agua potters, an "artisanal mode of filmic production" is one marked by a nonhierarchical, collaborative, undifferentiated division of labor.[59] (This was an explicit objective of the NLAC and of Cinema Novo.) *Aruanda*, in effect, analogizes the work of its subjects to the work of its cineastes. By treating the labor of the Olho d'Água potters as art, *Aruanda*'s filmmakers make it possible to apprehend the cineaste's artistic activity as labor. The film suggests the unity between the artistic labor of the filmmakers and the subsistence labor of the potters; they exist on a continuum of creative human activity. In positing this affinity, the film thereby undermines the familiar opposition between manual and intellectual labor.

That *Aruanda* puts the figure of the maroon at the center of this universal humanist utopian vision is of paramount significance. The first part of the film—which (as we have seen) consists of a fictionalized reenactment of Zé Bento's tortuous journey to "a land that belongs to no one" (according to the narration)—imbues, largely through its music, the fugitive slave's desire for freedom with affect and urgency. This affect is carried into the second part, where it heightens our perception of the potters' practical intelligence and relative autonomy and of the aspiration for freedom that led

Zé Bento to Olho d'Água—an aspiration that remains, as yet, incompletely realized. Moreover, the film universalizes the fugitive slave. It presents *his* aspirations as the prototype for every kind of utopian longing; it baptizes every "promised land" with the name "Aruanda," the name *he* has given it; and it casts *him* as the unrivaled agent of history, propelling humanity forward by *his* resolute desire for freedom and by *his* capacity to mold raw material, to make a new world.

Of the process films of the first phase of the NLAC, some, such as *Aruanda*, place the emphasis on the dexterity of the artisan. Others, such as *Mimbre*, place the emphasis on the ingenuity and technicity of the artisan's conception. All of them—as a direct consequence of the adoption of processual representation—transmit a sensuous, though vicarious, awareness of the labor of their subjects as skilled, intelligent, and systematic.

I proposed earlier that processual representation was not new in Latin American filmmaking at the time that the NLAC cineastes adapted its conventions to their own projects. We saw that the process genre was a dominant genre in sponsored industrial and educational cinema before the 1950s. Latin America's special contribution to the development of this genre follows from the different emphasis given to the genre's materialist and nationalist bases by the filmmakers who used it in their experimentations beginning in the late 1950s. There, leftist filmmakers used it in their valorization of a new national-popular, non-White subject potentially capable of transforming an unequal and starkly hierarchical society. These filmmakers were not advertising commodities (as in many industrial films) or classifying "first peoples" (as in many ethnographic films) or promoting a wishful vision of an emergent world power (as in many educational films). They were primarily involved in a shared effort to re-signify the low status of manual labor as a result of the legacies of slavery, forced labor, and racial ideology. In effect, they were operationalizing the populist ideologies of *mestizaje*, but they were radicalizing those projects. In their films, manual, artisanal labor would become a metaphor for political agency in the present rather than a relic from a superseded past. And the subject of this agency would be, for the first time, the indigenous- or African-descended peasant: his/her identity transformed from folkloric performer to world-making subject. In a utopian key, these filmmakers were conjuring a parallel nation, a society fit for posterity—fashioned by the intelligent labor of local peasants and local artisans. Moreover, process films in the Latin American context contributed to the genre a *revolutionary* romantic anticapitalism, one whose romanticism was reined in by

the concomitant insistence on the representation of "underdevelopment" and the basic commitment to a variant of evolutionism known as cultural materialism.[60]

Coda: *Red Persimmons*
(Ogawa Shinsuke and Peng Xiaolian, Japan, 2001)

The self-conscious, skeptical romanticism of the process genre in Latin America models one aesthetic solution to the fraught encounter among Marxism, anthropology, and developmentalism. Filmmakers in other contexts have found different solutions. But the recent instances of processual representation in slow cinema and ethnographic documentaries both within and outside of Latin America might be profitably read in relation to this tradition.

In Comparison (Harun Farocki, Austria/Germany, 2009) is an interesting recent case. The film is about the production of bricks in different parts of the world, including Austria, Burkina Faso, France, Germany, and India. It seems at first to be organized according to an evolutionary structure that begins with the simple fabrication of single mud bricks by hand in Burkina Faso and moves on to the manual fabrication of two bricks at a time and then to the mechanized fabrication of sixteen bricks at once, and so on. Simultaneously, the story of increasing complexity of method of production moves predictably across space—from Africa to India to Europe. But the film ultimately subverts the evolutionary logic in surprising and ambiguous ways. Rather than suggesting a simple and nostalgic inversion of the "modernity is bad" script by celebrating the charming sociality of artisanal mud brick fabrication in Burkina Faso in opposition to the miserable and alienated efficiency of brick fabrication in Europe, *In Comparison* finds variety and *autochthonous* innovation within each geographic space. The last episode of the film returns to a different part of Burkina Faso, where a new and novel method of brick fabrication with little resemblance to the crude method of the opening episode has been developed and is being successfully employed.

Red Persimmons is another contemporary example of an ethnographic process film that brings out other complexities of the genre's negotiation of cultural evolutionism. In this last section, as a kind of coda, I sketch some of these complexities through a reading of *Red Persimmons*.

The film was a collaboration between the Japanese New Left documentary filmmaker Ogawa Shinsuke, who directed most of the shooting in the

mid-1980s, before his death in 1992, and his student Peng Xiaolian, who finished the film in 2001. Ogawa's trajectory is almost the reverse of the Marxist NLAC filmmakers. Whereas they mostly began their careers filming mixed-race peasants in rural contexts in a romantic style and only later turned to more urban, militant activist subjects, Ogawa's early career was spent documenting the Japanese student protest movement of the 1960s. In the second part of his career, in the late 1970s and 1980s, his filmmaking cooperative turned its lens on the northern districts of Japan in *The Magino Village Story—Raising Silkworms* (1977), *"Nippon": Furuyashiki Village* (1982), and *Magino Village—A Tale/The Sundial Carved with a Thousand Years of Notches* (1986). The filmmakers spent several years living in these rural villages documenting the daily lives and the subsistence practices (e.g., rice growing and silkworm farming) of their inhabitants.

Red Persimmons is a process film about the harvesting, drying, and packaging of red persimmons in the town of Kaminoyama. This small industry was an important source of income for several agricultural villages in this region, and Ogawa films it in its waning days, as it is threatened by a labor shortage. The film is bookended by an interview Ogawa gave to the filmmaker Oshima Nagisa. Thus, Ogawa's words not only open the film but are also repeated at the end as a coda. His discourse is unmistakably derived from the salvage ethnography paradigm. Indeed, it is an almost textbook formulation: "There are thousands of villages like this in the northern districts. And one day, just like a candle waning, another village disappears. I know of many that are now ghost towns. . . . It's like a cycle of nature. Unnatural, but they do disappear. My role as a documentary filmmaker is to make a permanent record of these disappearing communities. I feel it's something I have to do." As the film suggests, the villages are threatened by urbanization as the labor-intensive, artisanal dried-persimmon-processing industry cannot find enough young workers to do the required work.

The film interlaces two narratives. The first recounts the steps in the process; the second is story about the evolution of technological devices to assist in production. In typical processual fashion, the film follows chronologically the production process from the harvesting of the persimmons to the discarding of fruit that is too small; the cutting of the stems in the shape of a "T"; the peeling by hand of a concentric circle at the top of the fruit around its stem; the peeling of the body of the fruit using a hand-cranked mechanical device; the threading of thirty-two persimmons on a rope, the fruit held in place by its stem; the hanging of the ropes in an

outdoor, roofed shelter from rafters, high off the ground, in two stories; the drying of the persimmons in the shelter for a period of approximately two weeks; the further drying of the fruit in a drying house over burning briquettes; the scrubbing of the dried hanging fruit with a brush to evenly distribute the fructose; the bundling of the ropes with thirty-two persimmons into a hanging bushel about one foot long; the sale of the dried persimmon bushels to a wholesaler; and the packaging and brand labeling of each bushel in cellophane tied at the top with a pink ribbon (see plates 6a–f). This first narrative presents both long shots that help to contextualize the activity in a distinct interior or exterior location and lengthy close-ups of the actions of laborers at work that give a sense of kinesthetic empathy, as the viewer is able to follow the skilled gestures of peelers, scrubbers, threaders, and wrappers.

Although *Red Persimmons* is straightforwardly a process film, the lyrical sequences depicting the steps in the process are interrupted not by voice-over narration recapitulating the steps (as is standard in process films) but by several carefully staged interviews with workers and village residents. The filmmaker is never present in the frame, but Ogawa's voice can be heard from offscreen asking questions of the social actors. His prompts always concern *only* the production process, its instruments, its raw materials, its genesis. "I have a question for you," Ogawa asks an older woman, who is seated on the floor peeling a persimmon using a one-foot mechanical device that rests on the ground. "You used to use a peeler driven by a chain and sprocket. Now you're using one with a sprocket but no chain."

Thus, in the film's second parallel narrative, Ogawa single-mindedly pursues the history, evolution, and functioning of two pieces of equipment used in the processing of dried persimmon: a notched knife and a peeling machine (figures 4.13a–c). The notched knife is used to peel away a concentric circle of skin around the stem of the fruit (see figure 4.13a). It was developed by Nakagawa Nakaji, whose family participated in the persimmon drying industry. According to his widow, Toshiko, Nakagawa invented the notched knife because Toshiko kept cutting her thumb with the straight-edge knife that had been the standard until her husband made and distributed notched knives to his neighbors. The machine is a peeling device that exists in several variations that the film conscientiously documents: there is the sprocket without chain version; there is the six-cog chain-and-sprocket version invented by Kaneko Fukujiro in 1931 and made from bicycle parts (see figure 4.13b); there is a variation on Kaneko's device that was tweaked by his onetime employee Sekine Magosuke; there are a

a

b

c

FIGS. 4.13a–c The notched knife (4.13a); the six-cog chain and sprocket version invented by Kaneko Fukujiro (4.13b); and Yamakawa Osami's electrical model, which uses vacuum technology (4.13c). Frame enlargements, *Red Persimmons* (Ogawa Shinsuke and Peng Xiaolian, Japan, 2001).

few different variations developed by the bicycle shop owner Konno Hajime, who added gears so the machine operator could vary the peeling speed and holes allowing one to adjust the tension of the chain so it will not fall off the gears once they start to age. Konno Hajime also developed a peeler model powered by a drill driver that dispenses with the hand crank, allows the operator to vary the speed, and adds a reverse function. There are also peelers developed by Yamakawa Osami, the son of the village's sole surviving blacksmith, which are electrical and make use of a vacuum technology to replace the traditional spike that held the fruit in place (see figure 4.13c). The film spends considerable screen time on the various devices as their inventors exhaustively detail their components, the pros and cons of the new iterations, and their salability.

There are two striking features of this parallel story. First, in this context, in which every inventor has refused the safeguards and glories of copyright, the impetus to improve the tools and machines used in the production of dried persimmon is cast not as the imposition of a creeping capitalism but as a human tinkering instinct—or, put more controversially, as the development impulse. That is, for better or worse, *Red Persimmons* treats technological development as a natural human phenomenon to ease the burden of labor and improve efficiency. When Ogawa asks the elderly Kaneko Fukujiro, who invented the first chain-and-sprocket peeling device, "You enjoy making things, do you?" Fukujiro Kaneko, beaming, replies, "Yes, I do, very much. I was always making something. . . . [My comrades in the army] used to say that I was 'machine mad.'" Yamakawa Osami, the blacksmith's son who is working on electrical peeling devices, admits that his vacuum-based device "wasn't a very efficient machine" and was not very economical. Still, he continues to work on his design. When Peng returns to the village fifteen years after Ogawa shot the footage, she notices new peeling machine models in the window of Konno Hajime's

bicycle shop. Konno eagerly invites the crew in to see what he has been working on. When asked whether his latest drill driver model is selling well, he confesses that it is not, adding, "There's more to this than just selling them. The tool must first be useful to the user." As a follow-up, he proudly reports that one of his old clients liked the new model and replaced his old one with it. The joy of invention for Kaneko, Yamakawa, and Konno is not about profit. It is about effective functioning—making things that work better. This reading is somewhat at odds with the readings of critics, including Dave Kehr in the *New York Times*, who have been amused by what they interpret as a "low-key debate between villages as to who is the inventor of an ingenious mechanism."[61] Sole inventors inhabit the litigious universe of copyright law, yet these creators seem unconcerned with asserting an individualist claim. What *Red Persimmons* is tracking is what happens to technological innovation freed from private ownership. Without any investment in the monetization of invention, a group of dispersed inventors try to improve on one another's designs. Perhaps it would be going too far to say they do so in a spirit of cooperation, but certainly they do so in a spirit of noncompetetiveness. Abé Mark Nornes has written that *Red Persimmons* "strove to discover the dawn of modernity in Yamagata's orchards."[62] This may be true, but in effect the film casts the inventor's "thrill with modernization" (Nornes's phrase) as a natural and universal thrill.[63] If modernity dawns in Yamagata's orchards in the early 1900s, it does so because—as the film suggests—modernity is inevitable. It is the logical outcome of tinkering, of the development impulse.

The second striking feature of the drama of the mechanical peeling device is that, despite the efforts at improvement, the traditional model— hand-powered, with a metal spike to stick the fruit into—is basically the best. Although some commenters have mechanically assimilated the film to a standard story in which old technology is replaced by newer, more efficient technology, that is not, in fact, what the film proposes. Kehr writes, "When Peng returns to the village, she finds that the hand-cranked peelers are being slowly replaced by an apparatus that uses a power drill to spin the fruit."[64] Nornes concurs, "Much of the film is devoted to the elaboration of more efficient methods through mechanization."[65] But part of the film's emphasis as I understand it is that the new mechanized models are not necessarily more efficient. The point of Peng's question to Konno Hajime about whether his latest drill driver is selling well is to highlight how *few* persimmon processors want to replace their old peelers with his new, drill-driver model; Konno can think of only one. Despite this, he is proud not

because of the high demand but because this one client, upon examination, preferred the new model *on the merits*. The lesson I want to draw from this is neither the one in which the new, "modern" replaces the old (how sad), nor the one in which tradition is cast as semipermanent. It is not the case that the peasants of Kaminoyama are against technology, sticking blindly and unreflectively and stupidly to the same techniques since time immemorial. If the production process in this region appears, from a certain distance, a paradigm of a traditional, "primitive" method of production, Ogawa's treatment reveals how this appearance is just that: there *have been* widely adopted technological improvements, but there have also been many failed attempts at improvement. The basic, traditional design persists because it is the most effective.

In treatments of so-called primitive modes of production, it is common to arrest tradition, to project it back into the nether reaches of time as something static, unchanging, sclerotic—something to be contrasted with the movement, innovation, and dynamism of modernity. The products of tradition—Javanese hats or woven serapes or clay bowls made without a wheel in a particular pattern—have been treated like the emanations of old and ancient races. Not only does *Red Persimmons* insist on the modest dynamism of a traditional production process, but it also insists on a relatively recent origin story. The film's opening titles report that the local dried persimmon industry has been around only since the 1900s. Asked about how persimmons came to grow in these parts, an old passerby, Sakai Sadao, floats three theories in order of decreasing romance: (1) a passing monk, kindly treated in the village, made a gift of persimmon seed; (2) a bird dropped the seed from the sky; (3) persimmon was a product of cross-fertilization. Later, the persimmon dealer Sasaki Seiichi suggests that it was her mother, Kiku, who, shortly after the sudden death of her father in a train accident in 1913, single-handedly introduced the delicacy of dried persimmon into the local economy. Her mother was a businesswoman, the widowed owner of a general store, trying to make ends meet as a fertilizer dealer. The market was volatile; prices fluctuated wildly; and wholesalers were going bankrupt. In an effort to stabilize her income, she decided to sell dried persimmon. "She thought dried persimmon would sell," Sasaki laconically reports.

What is the relevance of the dating of the industry? Despite the film's clear foregrounding of the industry's recent emergence, commenters have symptomatically had a hard time absorbing this point. In a review that is in many ways quite good as criticism, Kehr cannot resist: "*Red Persim-*

mons is ultimately about human gestures, the ritual movements that not only contain *centuries of tradition* but also reflect restless human inventiveness."[66] Even the jacket description accompanying the Icarus Films DVD contains this observation: "The film's larger subject, however, is the disappearance of Japan's traditional culture, the end of a *centuries-old* way of life." Of course, the gestures and the process presented in the film are not centuries old but only decades old. The persimmon drying industry, far from being an "ancient" tradition, is presented in the film as an "invented tradition." It is cast as a relatively recent (compared with the DuPont company, for example), ingenious, autochthonous creation—dreamed up by a desperate, enterprising petty bourgeois widow.

Despite its explicit salvage paradigm discourse, *Red Persimmons*, like the Latin American process films, exhibits a revolutionary romantic anticapitalism. Its nostalgia for the disappearing villages is an unmistakable indictment of capitalist industrialization, but the film interrupts many of the familiar tropes of ethnographic process films, from the maligning of technology to the fossilization of peasants and artisanal modes of production. In *Red Persimmons*, human technological innovation and experimentation is as natural as nature itself. Moreover, the process of improving production methods mirrors the formative process of transforming astringent persimmons into sweet dried persimmons. The people in *Red Persimmons* are treated as the intelligent makers of worlds. That the interviews hew to the particulars of dried persimmon production and eschew colorful but unrelated personal stories underlines the film's treatment of its social actors not as performers of a rural, Japanese identity or folklore, but as purveyors of verifiable knowledge of an objective world.

In one segment, an old villager, Sakai Sadao, stumbles on Ogawa and his cameraman as they are shooting the drying persimmons for a time-lapse sequence (see plate 6d). Ogawa engages Sakai in a conversation about why this outdoor drying method is used. Sakai describes four significant factors: (1) the trajectory of the sun in late fall, which dictates that the persimmons be hung such as to face south; (2) the northern and westerly winds, which do much of the work of bringing out the fruit's fructose; (3) the stark variation in temperature between cold nights and warm days; and (4) the absence of mountain mist, which is present in nearby villages. Ogawa's questions are not a pretext to get this charming and photogenic ethnographic subject talking for the sake of "local color." Rather, Ogawa prompts his subject to provide a convincing and systematic account of why the persimmons are dried the way they are dried—in open-air, two-story

drying racks oriented toward the south, and so on—and why this place produces particularly delicious dried persimmons, delicately balanced between astringency and sweetness. Taking seriously the information provided by Sakai and treating him as an expert on the matter, the camera then lends legitimacy to his testimony as it physically traces the seasonal arc of the sun from east to west. This shot permits the viewer to visually verify for herself the southern orientation of the drying shelter; given the camera's tracing of the sky, the shelter is indeed facing south. This is a modest gesture and no guarantee of an actual spatial relation. Still, the image has tried to *illustrate* Sakai's point. This may seem standard in documentary filmmaking. But in this case, the point that is being illustrated through the choice of shot is not an idiosyncratic or personal one (something related to the Sakai's description of his own life). It is an objective one. Sakai's is *expert* testimony.

As in the Latin American process films, in *Red Persimmons* the subjects engaged in this artisanal process are treated as world makers. Their status as agents rather than photogenic objects of sympathy, or victims of the world's bad ideas, is at the heart of these films' politics of representation.

THE LIMITS
OF THE GENRE

EVERY GENRE has its limits. There will be subjects that a genre is well suited to treat and ones that it is poorly suited to treat. I have argued that the process genre is ideally suited to treat movement, especially physical labor. But not all labor has a kinetic character. Much of the work involved in what has been called "immaterial labor"—that is, work that produces intangible products "such as knowledge, information, communication, a relationship, or an emotional response"[1]—is not primarily kinetic. And immaterial labor increasingly constitutes a larger proportion of the total labor performed in the world. In this last chapter, I want, first, to reflect on the historically circumscribed limits of the process genre and, second, to further test the concept of the process genre in practice. I do both through a reading of a film about a kind of immaterial labor—affective labor—and, in particular, the affective labor of the domestic servant. *Parque vía* (Enrique Rivero, Mexico, 2008), a fiction film about an older domestic servant working for a wealthy Mexican family that is preparing to force him into retirement, explores the character of such labor through its intertextual dialogue with one of my exemplars of the process genre from the introduction: *Jeanne Dielman, 23 Quai du Commerce, 1080 Bruxelles* (Chantal Akerman, France/Belgium, 1975). Reading these films together brings us full circle.

While affective labor often involves the movement of the body, the affective dimension of the work—feeling, in the case of domestic service—

involves a kind of labor that is not kinetic.[2] The work of feeling has a different relation to time and a different potential for visualization from kinetic forms of work. Because of this, feeling, and affective labor more generally, are not easily adapted to processual treatments. Yet *Parque vía* broaches the fraught character of the affective labor involved in domestic service precisely by depicting kinetic labor. It is an approach that stands out against the cycle of Latin American domestic service films of which *Parque vía* is part.

But although *Parque vía* focuses on the kinetic work of a domestic, it is not a process film. It is full of processes, but it does not present them processually. And it is not just *not* a process film; it is an *anti-process* film. It repeatedly invokes and rigorously rejects this form of representation. That raises the question, "Why?" Why would this film about domestic labor invoke, then reject, the conventions of the process genre? *Parque vía*, in my reading, explores some of the complex terrain of affective labor and work in the present moment—and it does this through its engagement with processual representation.

Parque vía and the Latin American Domestic Service Film

To understand what is interesting about *Parque vía*'s engagement with the process genre, one needs some understanding of the cultural context from which it emerges and of the body of work within which it should be situated. *Parque vía* won the Golden Leopard award at the 2008 Locarno Film Festival. It is a fiction film about Beto, the caretaker of a vacant Mexico City villa that is up for sale. The family that owns the villa vacated the house ten years earlier and left Beto, their domestic of thirty years, to maintain it until it sells. The Beto character is based on the real-life of Nolberto Coria, the actor who plays the role. Coria had long worked as a domestic for the filmmaker's extended family. The film follows Beto through his daily routine in the last weeks of his employment. During eighty-six minutes, we see Beto waking, washing, ironing, eating, cleaning, mowing the lawn, watching television; we see him receiving periodic visits from the owner of the house, from the real estate broker showing the house to prospective buyers, and from a prostitute, Lupe. We also see him making two rare excursions into the chaotic world outside the villa. When the house finally sells, Beto must vacate. But the owner of the house, whom he calls "Señora," is well aware that this change will be traumatic for him, so, in her paternalist benevolence, she has made arrangements for his future. He is set—for life.

But on the day Beto is supposed to leave the house for good, shepherded personally to his new life by his benefactor, she has a sudden heart attack in the dining room, falling to the floor. Beto checks her pulse. Concluding that she is dead, he kisses her on the lips and then beats her head in with a shovel that had been propped up in the corner of the room. The film's final scene shows Beto in jail—another paternalist institution—watching television and receiving a visit from Lupe.

Parque vía is part of a recent cycle of critically acclaimed Latin American art films about the institution of paid domestic service. While this cycle has been accompanied by other recent films about domestic service produced elsewhere, such as *The Help* (Tate Taylor, United States, 2011), I would contend that the Latin American cycle is the most sophisticated and provocative body of work about servanthood that has ever been produced. The relevant Latin American archive spans from about 1998 to 2018 and, along with *Parque vía*, includes the following documentaries and fiction films, all of which are by known auteurs or would-be auteurs: *Paulina* (Vicki Funari, Mexico/Canada/United States, 1998), *Domésticas* (Domestics [Fernando Meirelles, Nando Olival, Brazil, 2001]), *La Cienaga* (The Swamp [Lucrecia Martel, Argentina/France/Spain, 2001]), *Cama-adentro* (Live-in Maid [Jorge Gaggero, Argentina/Spain, 2004]), *Play* (Alicia Scherson, Chile, 2005), *Batalla en el cielo* (Battle in Heaven [Carlos Reygadas, Mexico, 2005]), *Santiago* (João Moreira Salles, Brazil, 2007), *Dónde están sus historias?* (Where Are Their Stories? [Nicolás Pereda, Mexico/Canada, 2007]), *Chance* (Abner Benaim, Panama, 2009), *La Nana* (The Maid [Sebastián Silva, Chile/Mexico, 2009]), *Zona Sur* (Southern Zone [Juan Carlos Valdivia, Bolivia, 2009]), *Criada* (Maid [Matías Herrera Córdoba, Argentina, 2009]), *El niño pez* (The Fish Child [Lucía Puenzo, Argentina, 2009]), *La teta asustada* (The Milk of Sorrow [Claudia Llosa, Peru, 2009]), *Babás* (Nannies [Consuelo Lins, Brazil, 2010]), *Empleadas y patrones* (Maids and Bosses [Abner Benaim, Panama/Argentina, 2010]), *Doméstica* (Domestic [Gabriel Mascaro, Brazil, 2012]), *La Paz* (Santiago Loza, Agentina/Bolivia, 2013), *El palacio* (The Palace [Nicolás Pereda, Mexico/Canada, 2013]), *Hilda* (Andres Clariond, Mexico, 2014), *Que horas ela volta?* (The Second Mother [Anna Muylaert, Brazil, 2015]), *Minotauro* (Nicolás Pereda, Mexico/Canada, 2015), *Muchachas* (Girls [Juliana Fanjul, Switzerland/Mexico, 2015]), *La novia del desierto* (The Desert Bride [Cecilia Atán and Valeria Pivato, Argentina/Chile, 2017]), *Las herederas* (The Heiresses [Marcelo Martinessi, Paraguay, 2018]), *La camarista* (The Chambermaid [Lila Avilés, Mexico/United States, 2018]), and *Roma* (Alfonso Cuarón, Mexico, 2018).[3]

This cycle comes at a time when servanthood in Latin America is being contractualized as it gets absorbed by capitalist labor relations and as the state has been pressured to formalize employment in this sector.[4] In practice this means that maids are increasingly living out rather than with families. The occupation is becoming more short-term and intermittent, and servants are working for several families rather than exclusively for one. They change jobs more frequently, and tasks are more sharply defined as a stricter division of labor has taken hold. With contractualization comes a transformation in the character of the *relationship* between domestics and their employers. Before, the paternalist features of servanthood, which included intimacy and identification, buttressed the ideological fiction that the maid is "a member of the family" or "like a daughter."[5] Increasingly, that ideological fiction is becoming untenable as domestic workers are becoming more like regular employees. The traditional material inducements for acceding to that paternalist ideology—the relative security of servant employment—likewise have become precarious.[6]

These recent historical shifts and the long-standing centrality of domestic service in Latin American life make it unsurprising that the most sophisticated, complex filmic treatments of this privileged form of affective labor have emerged from this region in the past few decades. The films of this archive distinguish themselves from a previous generation of Latin American popular culture that featured maids. Unlike the Latin American film and media of the past, these recent films are not allegorical narratives, stitching the nation together through the mechanism of marriage plots between brown maids and their white employers. Nor are these films popular melodramas featuring saintly domestics whose virtue goes unrecognized by malevolent mistresses.

Likewise, international critics have tried to compare these films to their European art film counterparts. But this comparison misses what is special about this recent cycle. The paradigmatic European art films about domestic service—take Joseph Losey's *The Servant* (United Kingdom, 1963), Luis Buñuel's *Diary of a Chambermaid* (France/Italy, 1964) or Claude Chabrol's *La cérémonie* (France, 1995)—are preoccupied with the sadism of the master-servant relationship. While the servants in these European films may be depraved—twisted by servitude—they have class-consciousness; they understand very well the realities of the master-servant power dynamic.

There is little of this in the recent Latin American cycle. On the contrary, what is fascinating about these films is their focus on the question

of the domestic's genuine affective attachment and the existence of a mutually felt, admittedly politically incorrect, intimacy between master and servant—despite everything. The subject of this cycle, then, is the relation between affective labor and servant personhood.[7] *Parque vía* is a particularly complex treatment of this relation. But before I say more about it, I want briefly to sketch the terms of the debate about the impact of servitude on servant personhood.

Personhood

Domestic service is a kind of affective labor—that is, it is a kind of "labor that produces or manipulates affects such as a feeling of ease, well-being, satisfaction, excitement, or passion."[8] We might think of affective labor as existing on a continuum. At one end is the service work of flight attendants and fast-food workers (whose job it is to deliver service with a smile). Domestic service belongs to the other end of the continuum.[9]

This other end of the continuum of affective labor—which also includes sex work, commercial surrogacy, organ sale, and care work—has been the subject of intense debate within political and legal theory. That debate has largely focused on the permissible limits of commodification. The key question has been how to think about what spheres of life, if any, should *not* be commodified.[10] The premise has been that there is an important distinction to be made between renting labor power and selling the self, even if people disagree about where to draw that line. The favorite test case for thinking about this special category of labor where one is at risk of commodifying the self (or alienating what is considered inalienable) is sex work. Adjudicating whether one is renting the body, selling a service, or selling the self requires a firm idea of what belongs to the person, what belongs to the "substance of her being" and to her personality, and what does not. Scholars such as Elizabeth Anderson defend the idea that sex work is intrinsically degrading; thus, they reject such commodification of the intimate sphere. Anderson argues that sexual acts should be understood on the model of gift exchange.[11] Because sexuality, in this view, is seen as integral to the self, selling sexuality is considered a self-estranging activity that devalues the seller, who allows her person to be used instrumentally, as it devalues sexuality as a shared human good.[12]

As with sex work (as well as commercial surrogacy and organ sale), the primary worry about domestic service is about the nature of the commodity being bought and sold.[13] It is generally thought that what is bought and

sold in traditional paid domestic service is not labor power as we conventionally understand it—that is, the capacity to work at a defined task for a contractually agreed-on period of time. The domestic worker is not merely renting out his body in an analogous way to, say, the auto factory worker who spends the workday on the assembly line repeating a narrow repertoire of bodily motions. Most would not say of the assembly line worker that she sells her personhood. Yet most scholars maintain that it is personhood—or, as one put it, "her identity as a person"[14]—that is being sold and purchased in a domestic service arrangement. This sale of personhood is at the core of the particular harmfulness of domestic service.

If in sex work it is the sale of sexuality that is considered a sale of personhood, what is the corresponding "gift" in domestic service? The often referenced personalism of domestic service is most relevant to a historically contingent form of the occupation.[15] Let us call it traditional domestic service, whose defining feature is its all-encompassing character.[16] The traditional master-servant relationship has long been understood as a "premodern relationship," a species of colonial patron-client relationship.[17] It had three basic characteristics. First, traditionally the servant "lived in"; her home was the master's home. Her privacy and thereby her freedom were delimited by the work arrangement. Second, the number of hours she worked was often unspecified; she was, in some sense, always on duty. Third, the tasks of most servants were nonspecific— they could include a variety of jobs, from cleaning and cooking to taking care of children.[18] The servant would spend a lifetime working for one family, and often her children would become servants to the family's next generation.

The domestic service represented in the cycle of films that I list at the beginning of this chapter is mostly of this traditional, live-in variety, where the servant lives in the employer's house and the labor "contract" is informal and ambiguous as far as hours and tasks are concerned. The family that employs servants has been described as a "greedy organization," one not satisfied "with claiming a segment of the time, commitment, and energy of the servant, as is the case with other occupational arrangements in the modern world, but demand[ing of] . . . full-time allegiance."[19] The "master and his family always attempt . . . greedily to absorb the *personality* of the servant."[20]

The intrusion into the servant's private sphere—both her space and her "leisure"—has serious implications. As the sociologist Lewis Coser writes:

Largely unable to shield himself from the view of the master, severely hampered in the ability to wear the protective masks with which modern men habitually protect themselves from the gaze of status superiors, structurally denied the capacity habitually to present only an appropriate facet of the self to the scrutiny of the master, the servant's self stands exposed and is largely denuded of protection. To be sure, servants may attempt to reveal only those aspects of the self that please the master, but their role-playing capacities are severely limited by their structural position.[21]

For Coser, this affects the "degree of autonomy for the individual," and it has consequences for the servant's selfhood.[22] Given the extent of isolation and surveillance, which are structural features of living-in, it has been observed that the servant manifests "a high degree of identification and affective involvement" with the master and his household; he basks "in the glories of reflected status and borrowed identity."[23] In this view, the servant who identifies with the master and his household is at risk of being self-deceived as well as estranged from her self.

These are different. She is self-deceived in this sense that, when she identifies with the master, she imagines herself a member of the family, a friend maybe, and gives the gifts that correspond to the private sphere: loyalty, trust, sympathy, love, affection, and the like. But unlike with the gift exchanges that go along with personal relationships that dictate reciprocity in-kind, the domestic can have no expectation of reciprocity in kind. While she is expected to display care, affection, loyalty—it is her job, after all—her employer is not similarly bound. His display of these "goods" is subject to his whim, and there are no risks or penalties for him if his whims lead him elsewhere.[24]

But the domestic who identifies with her master is also at risk of being self-estranged. Because constant displays of care, affection, and loyalty are required by the job, the domestic is faced with two options: she can either fake the emotion that she has to display, or she can make those emotions her own. If you fake it, as many people in the service industry do, you curse the customer/master in your heart and police your outer expression so the curse remains undetectable. Arlie Hochschild, writing on the emotional labor of flight attendants, has called this "emotive dissonance"—that is, the tension between feigned emotion (a happy, loyal attitude toward the master, say) and sincere inner feelings. But emotive dissonance is exhausting, Hochschild maintains; it puts a strain on the individual that she will try to neutralize. The individual neutralizes the strain by bringing outside

and inside closer together, either by not feigning (surface acting) or by changing what one feels (deep acting). In the second strategy, "true" feeling has been colonized, and the individual is self-estranged.[25] For Hochschild, feeling (or emotion) acts as a relay to the self, especially in a historical moment when the apprehension of a solid, stable, core self eludes us. Thus, emotion has a "signal function": it keys us to how to respond to a given event. When this signal function is distorted by commercialization, we lose touch with what our feelings tell us about ourselves.[26] In effect, to the extent that the emotional labor demanded of the domestic ends up shaping not merely her "face"—her feigned outward behavior—but her inner feelings as well, the commodity being purchased in domestic service is the personhood of the domestic, the substance of her being, her love.[27] In this case, the job has colonized her feelings; it has reached in and shaped her subjectivity. This feature of domestic service is at the heart of the commonly noted paradoxical identification of the servant with the master.

So while the European art films about domestic service explore the domain of "emotive dissonance," performance, and disguise—in other words, the terrain of insincerity—the films in the Latin American archive are largely concerned with identification and the significance of the *authenticity* of colonized feeling.

Whereas all of the Latin American films of this cycle share an underlying view of domestic service as a form of affective labor that touches on servants' personhood, they offer different representational solutions to this problem. They all attempt to shine a light on the neglected and disparaged figure of the domestic, but the different recuperative approaches reflect different understandings of what is problematic about domestic service. As one might expect, some of the films in the cycle depict the leisure lives of their subjects, suggesting that the domestic can finally be herself in her free time. Other films turn to testimonial and revel in the interview, suggesting that if only the domestic could just speak for herself we could finally see her, know her. There are only two films—*Parque vía* and *Criada*—that focus, in an observational vein, on visible, bodily movements and the various tasks entailed in domestic labor. The focus on physical labor is not a commonsense approach to recuperating the figure of the domestic and restoring her personhood (representationally, at least). Indeed, *Parque vía*'s tack is particularly striking *because* of its explicit dialogue with *Jeanne Dielman* and the way it suggestively transforms many of that film's processual elements.

Jeanne Dielman, 23 Quai du Commerce, 1080 Bruxelles

The similarities between *Parque vía* and *Jeanne Dielman* have been frequently noted in reviews. For example, one review began—matter-of-factly—by asserting that *Parque vía* is a "pocket-book *Jeanne Dielman*, with agoraphobia and master/servant irony in the place of Chantal Akerman's monumental, feminist experimentalism."[28] *Jeanne Dielman* is a three-and-a-half-hour film about three days in the life of a widowed housewife who spends her time looking after her son and earning a bit of money on the side as a prostitute working out of her own apartment. By day three, the routine that had been so scrupulously observed on the first day begins to break down. Jeanne leaves suds on a dish; she forgets to replace the lid on the dining room tureen as she habitually does; she burns the potatoes for dinner. In the penultimate sequence of the film, we see—for the first time in the film—Jeanne having sex with a client. She seems to have an orgasm (the film implies that it is the second one in two days), after which she stabs the client in the neck with scissors in a shocking climax for a film that has acclimated its audience to monitoring micro changes in behavior.

Parque vía's reference to *Jeanne Dielman* is clearly intended. Even the film's title, "Parque vía," which refers to an actual street in a formerly upscale Mexico City suburb, alludes to the subtitle of Akerman's film, "23 Quai du Commerce, 1080 Bruxelles," an actual address in Brussels. There are narrative similarities, as well. In addition to the violent ending of both films, in the figure of the domestic servant *Parque vía* synthesizes the domestic labor of the housewife and the affective labor of the sex worker into a single role. Jeanne has two roles, but they are distinct from each other: she is a housewife, and she is a sex worker. The housewife does chores, and the sex worker provides care and comfort. The domestic servant role folds together the two activities.

But perhaps the most striking feature of the dialogue between *Parque vía* and *Jeanne Dielman* is formal. Like *Jeanne Dielman*, *Parque vía* focuses on kinetic, manual labor, which takes up most of the film's screen time. The film is organized around those gestures of social reproduction. In this way, it puts itself forward as a film about labor. Like *Jeanne Dielman*, *Parque vía* adopts a rigorous approach to its treatment of that labor; the shot framing, composition, and camera movement are consistent and carefully controlled. Some shots are clear citations of the earlier film.

Against the background of this shared formalism, it is quite striking that whereas *Jeanne Dielman* makes consistent use of processual representation,

Parque vía just as consistently refuses to do so. Jeanne performs a series of tasks that are represented processually. From the iconic four-minute Wiener schnitzel sequence to the bathing sequence I discuss in the introduction to shoe-shining to bed-making to dishwashing, each process takes on the shape of a micro-action, with a beginning, a middle, and an end. Each is a kind of how-to. But this fact has not been much emphasized in the literature on the film.

When *Jeanne Dielman* came out in 1975, some prominent critics argued that it was a feminist critique of the monotony and stupefaction of the household labor that falls to women. Marsha Kinder wrote, "Jeanne is a bourgeois widow trapped in meaningless social rituals that ultimately cause her to commit a desperate, insane act."[29] And while that view has been tempered—most notably in Ivone Margulies's book *Nothing Happens*[30]—it is still largely how the film is remembered today. In her 2014 book on the representation of women's work, Anca Parvulescu, writing about Ulrich Seidl's *Import/Export* (2007), turns to *Jeanne Dielman* as a touchstone of the cinema of work. She claims that Akerman

> portrayed the dreaded routine. A fictional housewife, Jeanne, is filmed by a frontal camera that remains fixed, suggesting that no action worth following is taking place. Jeanne cooks, dusts, tidies up, serves dinner to her son, and has sex with a few male visitors. Everything unfolds in extended duration, at the same pace, and at the same level of enthusiasm. What film critics call *temps mort* is the stuff of cinema for Akerman. Viewers are forced to live the ensuing slowness, repetitiveness, and boredom as a function of spectatorship. Hard at work on tasks of spectatorship, they learn [i]n their own skin . . . how it feels to move from the kitchen to the bedroom and back to the kitchen and then back to the bedroom, each time turning the light on and off, seemingly a million times.[31]

But in emphasizing *temps mort* (dead time) and boredom and the meaninglessness of Jeanne's actions, Parvulescu and other critics who have pursued this line have missed something central to this film.

As a point of comparison, let us consider the paradigm instance of *temps mort* from *Umberto D* (Vittorio De Sica, Italy, 1952) in which the "little maid," as André Bazin called her, wakes up and sleepily goes about making coffee. In *Umberto D*, there is something unpredictable, haphazard, digressive, meandering in Maria's process of making coffee; the representation is rife with (choreographed) mistakes. For example, Maria must strike a second match, as the first time she had forgotten to turn on the

gas. Suddenly distracted, she walks to the window. Recapturing her focus, she retrieves the coffee maker from the cabinet, but on her way to fill it with water she pauses to glance at a piece of paper sitting on the table. Finally arriving at the sink, she turns on the faucet, but rather than filling the kettle directly, she splashes the ants on the wall next to her. She's thirsty; she takes a sip from the faucet. But she has sipped sloppily and water is trailing down the inside of her nightgown. She pats it down so it does not drip any further inside her gown. Now she fills the coffee kettle, etc.

Jeanne's activities are not much like Maria's at all. There is nothing in De Sica's representation that suggests a how-to; this is not an instance of generic, skilled labor. Rather, it is full of contingency. The absentminded way Maria goes about making coffee underscores the dreariness and monotony—the roteness—of what is indisputably a quotidian routine. The actions Maria undertakes are divorced from her inner life; they run on a separate track. Indeed, it is against the relentless sameness of making coffee that the prospect of having a child (she's pregnant)—even in the face of dire poverty and a future of hardship—could seem like a relief, or at least a mixed blessing. *This* sequence casts domestic labor as "meaningless social rituals"; *it* induces spectators "to live the ensuing slowness, repetitiveness, and boredom." To be clear: De Sica's representation of domestic labor is not processual. While it may have a loose narrative arc leading from entering the kitchen to grinding the coffee; it does not exhibit the tight causality characteristic of processual representation. Of course the sequence is utterly compelling (despite inducing the spectator to *feel* "dead time") in its juxtaposition of dreary social ritual and burbling inner life, but it is not absorbing in the way the sequences of domestic labor in *Jeanne Dielman* are.[32]

Although boredom has been a common lens through which *Jeanne Dielman*'s processual sequences have been viewed—both in the references to *temps mort* and in the references to minimalist films like Warhol's films *Empire* (1964) or *Sleep* (1963)[33]—some critics have also alluded to the odd effect of watching Jeanne's gestures. Margulies, who differentiates Akerman's project from both Italian Neorealism's humanism and Warholian nihilism, reports that she began her research on Chantal Akerman after she first saw *Jeanne Dielman* and "was mesmerized by the hyperreality of everyday gestures."[34] Indeed, she argues that the "rendering of the details of mundane activity is undoubtedly the key" to the film's power.[35]

The sequences of household labor in *Jeanne Dielman* have a definite formal structure. The discipline of cinematographer Babette Mangolte's framing and composition—which always places the camera perfectly parallel

or perpendicular to walls, doors, and windows—makes use of linear perspective. Rather than emphasizing the graphic qualities of the image by deploying right angles and parallel lines, Mangolte's framing produces a sense of three-dimensional space often also by using diagonals to establish a vanishing point (see figure 5.5).[36] Moreover, the filming of Jeanne's actions eschew the "synecdochal tag." Rather than cutting on action, Akerman's camera often sits on action, without cutting, until the task is complete or keeps track of actions until they are complete.[37]

Once we get the hang of it, this treatment of action establishes its own brand of expectations, suspense, and denouement. The effect is not the distantiation and boredom one might expect from my description and that is often associated with "dead time." The film engenders, throughout, the kind of spectatorial involvement typical of processual representation; watching Jeanne complete her tasks is absorbing, mesmerizing, spellbinding. Actions—washing dishes, peeling potatoes, bathing, making beds—that in another kind of film would have been peripheral, allusive, become singularly fascinating. This is an intuition that the critic Ben Singer—who compares the film to a Warholian durational experiment—will concede inadvertently when he mentions in passing the film's "surprising pleasurablity."[38]

In interviews, Akerman has emphasized the rigorousness of her rehearsals with the star actress Delphine Seyrig, who plays Jeanne Dielman. Seyrig wanted to play at hair-brushing and dishwashing, but Akerman compelled her to really brush and really wash. In other words, Akerman pressed the actress to accept that the only way to get the gesture right was to transform gesture into action: it was Seyrig, not Jeanne Dielman, doing the washing and the bed-making. As Margulies notes, "the distinction between literal gesture and a performance is canceled by the nature of the actions shown: as Jeanne peels potatoes and washes dishes, the potatoes get peeled and the dishes get clean."[39] There is no faking skill; Seyrig had to become skillful. Yet if that is what the role entailed, why did Akerman cast Seyrig, the *grand dame* of avant-garde film who was openly unpracticed in domestic tasks? Why not cast a nonprofessional actor with actual expertise in the actions under examination? Akerman has said that she "made this film to give all these actions that are typically devalued a life on film." She goes on, "I absolutely had Delphine in mind when I wrote it. I felt that the extraordinary thing was that she was not this character at all. She was quite 'the lady.' If we saw someone making beds and doing dishes whom we normally see do those things, we wouldn't really see that person, just like men are blind to their wives doing dishes. So it had to be someone we

didn't usually see do the dishes. So Delphine was perfect, because it suddenly became visible."[40]

Jeanne Dielman valorizes the wife/mother figure that works in the home by valorizing her work in two ways. First, it shows the work's systematicity, its dexterity, its economy of movement. It transforms work that is commonly devalued because considered unskilled into skilled labor. Second, it shows the work's reproductive contribution to the maintenance of life, which is established by tracking the routine over three days and suggesting the consequences of a breakdown.

For the first few hours of the film, we see Jeanne perform her domestic tasks without mistakes. Jeanne is not visibly distracted like the maid in *Umberto D*. The tasks—making the bed, bathing, cooking dinner, setting the table, clearing the table, doing the dishes, etc.—are completed with remarkable efficiency and discernible focus. The representation is processual and so the tasks have a how-to feel; they are descriptive, surely—but they are also prescriptive. The film is training our attention. When Jeanne repeats some of the same tasks on the second and third days, we become keenly aware of her departures from the protocol established earlier. A simple mistake calls out to us, as we note "She forgot to replace the lid on the tureen in the dining room" or "There are suds on that dish." This is, in part, a consequence of the use of the same camera set-ups (angle, height, distance, location) across all three days.[41] Margulies has argued that this effect owes to the structuralism of the film, which engages the spectator "in a game of 'What is wrong with this picture?'"[42] Notice that the game gets going precisely because the treatment of Jeanne's domestic tasks in the first part of the film is processual.

The seeming unity of action and concentration break down after the first orgasm, and then everything seems to progressively unravel. This is one way of putting it. But what does the unraveling entail? Because the film has shown us how Jeanne gets from one day to the next, it has, in effect, forced us to encounter the unseen work involved in the cycle of social reproduction. What would happen on Day Two if Jeanne neglected to clear and wash the dishes from Day One's dinner? What would happen if she failed to remake the bed between clients? What would it be like to have dinner in a dining room with her son, Sylvain's, unmade fold-out bed opened less than a meter from the chair where he sits to eat? Yes, there is something fastidious about Jeanne's actions, but they get her from one day to the next with a minimal amount of extraneous exertion. They make it so that the dishes don't pile up in the sink, which would in turn make

it impossible to serve dinner on plates, and so that there are clean clothes to wear to school. As anyone who does their own cleaning-up knows, the danger that attends a sink full of unwashed dishes or a basket filled to the brim with dirty underwear is not to be underestimated.

In *Jeanne Dielman* the invisible housewife (as a role) gains visibility not *despite* her household labor or apart from it, but *through* it. The character's personhood is expressed *in* her work, *not* in her leisure: she is what she does. (This is not to say that the spectator gains access to Jeanne's singular interiority.) The film valorizes domestic labor by presenting it as technique and by suggesting its *productivity* (though it produces no tangible object)—its importance. The deployment of processual representation has allowed it to do both.

But there is a risk of overstating the case. Jeanne's approach to housework is unsettling. Margulies, for example, reads the orderliness, the fastidiousness of Jeanne's execution of household tasks as a manifestation of the intolerance of ambiguity that characterizes obsessive compulsive disorder.[43] Like most processual representation, the depiction aestheticizes labor, rendering it a pleasure to watch. When Jeanne begins to make mistakes—deviating from her best practices—in the second and third days, the spectator becomes involved in a disconcerting way. We become monitors of her work, in a sense. Almost like a boss, we really want those suds washed off the dishes; we really want the lid of the tureen returned to its rightful place. The breakdown of the routine has disturbed our spectatorial satisfaction. Now we are at odds with Jeanne.

This split raises a question about the initial source of our satisfaction and of Jeanne's. *Jeanne Dielman* had lent to domestic labor all of the attributes of skilled labor, including the absorption of the worker in the work. Unlike Maria in *Umberto D*, we became absorbed in Jeanne's absorption. But what happens to us when her attention flags, when her inner life detaches from her activity? When she loses what Mihaly Csikszentmihalyi called "flow"? That is one key feature of the condition of dreary, monotonous labor. This was the case with the maid Maria, as we get an inkling that there is a world in her head that is a universe away from the kitchen her body occupies— and it becomes the case with Jeanne. Ultimately, while her domestic labor is not an accumulation of meaningless rituals—it makes life possible, after all—and while it generates its share of noninstrumental satisfactions, it still belongs to the realm of necessity.[44] This labor is surely not what Marx had in mind when he said that labor is "life's prime want." *Jeanne Dielman*, thus, also reveals domestic labor's double edge.

Empty Gestures

While *Parque vía* is organized like a process film, moving from one work activity to another, it subverts Akerman's processual treatment of work, both at the level of narrative and of style. Whereas the meaningfulness of Jeanne's daily actions becomes apparent to the spectator, who comes to appreciate their function, Beto's routine comes across as particularly useless. The activities that the film shows Beto repeating *are* actually meaningless social rituals: ironing a white collared shirt (his uniform) even though most days he sees no one; cleaning a bathtub that no one will bathe in. Some of these activities are aimed at maintaining the house's exchange value—after all, the house is on the market. Yet, Beto is not doing what a servant does—social reproduction. Both house and servant are shells of their former selves: they have retained their form, but lost their function. This loss certainly imbues the film with a powerful sense of nostalgia, which also allegorizes the changes to the institution of domestic service in Mexico as it becomes increasing contractualized.

Stylistically, Beto is *playing* at mowing, at window cleaning, at sweeping; he is gesturing at it, alluding to it. For example, the nine-second shot from which some of the film's publicity material was taken presents an extreme long shot of the villa's lawn as Beto, pushing a lawn mower, enters frame right and exits frame left (see figure 5.4). The mower makes no visible impact on the grass, as it is probably already too short to be cut down. In a similar twenty-six-second low-angle shot of one of the villa's high exterior picture windows, Beto ascends a ladder at the bottom of the frame holding the long handle of a makeshift window wiper covered by a red cloth (figure 5.1). As he reaches the window, he sets about his task: the wiper touches the center point of the window frame; with one hand Beto moves the wiper upward, but in a diagonal direction, to the top of the window's frame and then back toward the middle; he makes the shape of

FIG. 5.1 The last second before the cut to a different scene of labor. Frame enlargement, *Parque vía* (Enrique Rivero, Mexico, 2008).

a narrow, italicized capital "*N*" before jerking the wiper into the window's rightmost corner and moving down along the rightward edge, missing the bottom corner; he then wipes in a vaguely vertical motion, moving from right to left. The shot cuts before Beto reaches the center of the window. Another example is a twenty-eight-second shot of Beto's legs as he sweeps debris off interior carpeted steps; he leaves a small but visible pile on the landing. The pile of debris is in the center of the frame (figures 5.2a–b).

Rivero's approach to Beto's labor here is not processual. The activities are not presented as processes with a beginning, middle, and end. The sequences do not engender the impression of systematicity, dexterity, economy of movement—in other words, skill. There is nothing about the presentation of the activities that reveals how the activity is done or anything about the instruments used in their accomplishment. In the last example of Beto sweeping (see figures 5.2a–b), the pile of debris in the middle of the frame is a disturbance, like Jeanne's sudsy dish or Nanook's snowflakes on the ice window. But Beto does not notice.

Why invoke the process genre only to disavow it? Precisely as a way to call attention to the peculiar character of domestic service. Akerman conceived the problem of household labor as a problem of invisibility. A processual treatment is her solution: it makes household labor visible as skilled, as craft-like. This might seem a viable strategy to adopt in the representational rehabilitation of paid domestic labor, as well. After all, the problem of domestic service has also been conceived of as a question of visibility. But the invisibility of the servant extends to his or her person.

When commentators refer, facilely, to the invisibility of the servant (a common turn of phrase), what exactly do they mean? They do not mean

a b

FIGS. 5.2a–b Beto sweeping the steps (5.2a); detail of the missed debris (5.2b). Frame enlargements, *Parque vía* (Enrique Rivero, Mexico, 2008).

that the servant is not *seen*, that he is invisible the way a ghost is invisible or the way invisible ink is invisible. They mean that he is visible, present in space, but misrecognized, taken for an object rather than a human being. The servant is the classic example of what Erving Goffman called the "nonperson"—the one who is present for an interaction but occupies the role neither of audience nor of performer, "no impression need be maintained for him."[45] Glossing the view, Coser chooses his words carefully: "At a dinner party, hosts and guest interact: the servants are, as it were, part of the setting."[46] Here Coser, channeling Goffman, conjures a pictorial image, a tableau vivant. I propose that the servant's invisibility is a function of his relation to a spatial context, to a mise-en-scène. Because *Parque vía* is focused on the servant's invisibility, it will formally call attention to the spatial relation between Beto and his context rather than to action, as *Jeanne Dielman* does.

In *Jeanne Dielman*, the action had to stand out to be "visible." The film employs a few strategies to achieve this. As Akerman herself pointed out, *Jeanne Dielman* exploits the dissonance between the star aura of the actor and the mundanity of her action. It favors symmetrical compositions, with Jeanne sometimes in the center of the frame. Most shots are medium shots, which are close enough to allow the spectator to make out what is being done but not so close that we miss the movement of Jeanne's body. The film makes use of linear perspective, which pulls the spectator into the action. The takes are often long enough to capture complete actions.

Parque vía is equally formally rigorous and consistent, but it makes use of different conventions. Rather than casting a professional actor, it casts Nolberto Coria as himself (the one we "normally" see do these things). This choice results in the very unity of actor and action that *Jeanne Dielman* sought to disrupt.

Rivero's compositions call our attention to the dissonance between the man and his context, and not, as in *Jeanne Dielman*, to the microtransformations of action. This dissonance is established formally in two related ways. On the one hand, Rivero mostly eschews the medium shot that *Jeanne Dielman* favors. Had Rivero used the medium shot, he would have brought Beto's actions closer and allowed the spectator to apprehend the work of his hands. Instead, he opts for the extreme long shot, the long shot, or the extreme close-up (see, for example, figures 5.3, 5.8, 5.9a). Given the activities in which Beto is engaged, this contributes to obscuring the spectator's view of what he does. On the other hand, Rivero counters *Jeanne Dielman*'s use of linear perspective by either emphasizing the flatness of the image or by effacing the human figure in perspectival shots.

FIG. 5.3 From this distant vantage point, it is not possible to make out the particulars of shirt ironing. Frame enlargement, *Parque vía* (Enrique Rivero, Mexico, 2008).

FIG. 5.4 Beto's comparative size. Notice the size of his white shirt relative to the size of the white outdoor lamps and the size of his person relative to the bushes behind him. Frame enlargement, *Parque vía* (Enrique Rivero, Mexico, 2008).

Shot distances are about scale and proportion. When we say that a shot is a medium shot, we are accounting for the size of the subject of the shot relative to other objects in the shot. In a close-up, that subject is large relative to everything else. In a long shot or extreme long shot, that subject is smaller, closer in size to everything else in the shot. And the smaller the subject is, relative to every other object in the shot, the more ambiguous the interest of the shot becomes. Most of the shots of Beto at work are long shots or extreme long shots. Beto looks small to us, as his environment—the yard, the lights, the bushes, for example— eclipses his presence (figure 5.4). The particulars of his action become indecipherable.

The shots of Beto in action also often suspend linear perspective, rendering the image flat and two-dimensional. This is decidedly unlike in *Jeanne Dielman*. Rather than producing a linear perspective with diagonals intersecting at vanishing points that direct the spectator's gaze toward the labor being performed in the center of the frame, in *Parque vía* the compositions with Beto working often emphasize horizontal and vertical lines, establishing a grid-like pattern (see figures 5.1, 5.2a, 5.4–5.6). There are hardly any intersecting diagonals.

The effect of the graphic quality (flatness) of the image and of the long shot distances is this: despite usually being in the center of the frame (see

figures 5.4 and 5.7), Beto competes with other objects onscreen for the spectator's attention. In other words, pictorially Beto is treated as one object among others. He is presented to us as "part of the setting."

Moreover, when the film *does* employ linear perspective, the shots' diagonals converge on a vanishing point that is empty—in other words, a space that is missing a human figure (figure 5.8). This formal play with shot distance and perspective presents a striking paradox. On the one hand, the narrative of the film and many scenes put Beto, the servant, at the center. After all, he is virtually the only character in the film, and we cling to him. On the other hand, Beto is consistently effaced: he is there, but we cannot really see what he does or how he does it.

In a seemingly inverse operation, there are elements in *Parque vía* that become hyper-visible: Beto's body, for example, and his possessions. I said earlier that Rivero eschews the medium shot, favoring the long shot and the close-up. His use of the close-up in this context is worth exploring. As Beto's *action* (i.e., the particulars of what he does) recedes, Beto the man—or the "indio," as he has been symptomatically referred to on the internet—comes into focus. Consider three examples from the film.

The first is an extreme close-up of Beto's profile (figure 5.9a). It is reminiscent of the iconic prologue to Sergei Eisenstein's film *Que viva Mexico!*

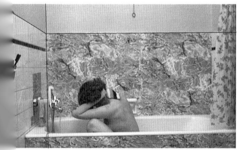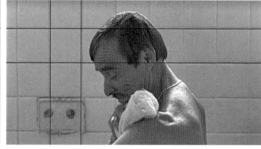

. 5.5–5.6 Compare the use of linear perspective
'eanne Dielman (5.5) with the flatness of the
ge in *Parque vía* (5.6). The image from *Jeanne*
lman features a series of diagonals converging at
man's head, while *Parque vía* features a grid of
allel horizontal and vertical lines. Frame enlarge-
its, *Jeanne Dielman, 23 Quai du Commerce,*
0 Bruxelles (Chantal Akerman, France/Belgium,
5); *Parque vía* (Enrique Rivero, Mexico, 2008).

FIG. 5.7 Beto, small but in the center of the frame. Frame enlargement, *Parque vía* (Enrique Rivero, Mexico, 2008).

FIG. 5.8 Linear perspective and the missing human figure. The diagonals converge at the center of the image, but Beto is tiny and washed out, standing on a ladder at the right of the frame. Frame enlargement, *Parque vía* (Enrique Rivero, Mexico, 2008).

(1932). In *Que viva Mexico!* the numerous shots of faces in profile serve to establish a visual analogy between Mexico's pre-Columbian past and the present of the film through the repetition of the form of an archetypal Amerindian aquiline nose—compared in stone and in the flesh (figures 5.9b–c). Of course, this formal comparison suggests a favorite trope of ethnographic representation: the timelessness of native people and cultures. Time passes, but native cultures are static, unchanging, traditional. Change, in this view, would be tantamount to extinction. This is the perspective of salvage ethnography. Moreover, in another familiar gesture from the history of visual anthropology, Beto's face is treated almost like a geological terrain (see figure 5.9a). The image gives us face-as-topography: the sweat beads on his forehead, the wrinkles, the discolored scars, the hue of brown skin against the light-beige block of color from the sidewalk. In this image, Beto's indigeneity has become hyper-visible.

In the second example, a high-angle close-up shot of Beto's feet as he weighs himself reveals a similar geography of lived experience as we confront pronounced bunions, callouses, and bulging foot veins (figure 5.10).

The third example comes from the opening of the film. In the three-and-a-half-minute opening sequence, a hand-held camera follows Beto as he traverses the horizontal and vertical span of the villa. Beto ends up

a b c

on the rooftop terrace, where his uniform has been drying. The shot lingers over a small rectangular postcard reproduction of the Virgin of Guadalupe affixed to the bottom of the terrace door (figures 5.11a–b). The incongruence of that local detail in this vast, modern, unspecific space

FIGS. 5.9a–c The ethnographic subject. Frame enlargements, *Parque vía* (Enrique Rivero, Mexico, 2008 [5.9a]); "Prologue," *Que viva Mexico!* (Sergei Eisenstein, USSR, 1932 [5.9b–c]).

(which could exist almost anywhere in the world and whose full measure we have just taken, thanks to the duration of the tracking shot) calls our attention. The incongruence follows from the juxtaposition of material (the relative durability of glass and metal versus the perishability of paper); the juxtaposition of size (the large rectangular shape of the glass door versus the small rectangular shape of the postcard); the juxtaposition of temporal frames (the modernism of the house's architectural design versus the baroqueness of the represented sixteenth-century iconic image from Mexico City's Basilica of Guadalupe and the analog character of a postcard in the internet age); the juxtaposition of the secular and the religious; of the global (modernism) and the local (the distinctly Mexican character of the Virgin of Guadalupe as a figure). This shot allegorizes Beto's out-of-placeness in this space. Beto is like the postcard. He stands in the same relation to the house's environment as the postcard stands to the terrace door: eclipsed and out of place, belonging to another universe— and to another time.

Parque vía does not restore Beto's visibility by presenting his rich leisure life or his voice or his labor. Rather, it zeroes in on invisibility as the constitutive condition of servanthood. Invisibility in this exploration is not about Beto's absence from the scene. It is about objectification and dehumanization: through the play with scale and the jarring, racialized juxtapositions, *Parque vía* suggests that Beto is an incongruent element of the mise-en-scène. Unlike Jeanne Dielman, Beto cannot take up the frame: he is either literally lost in it by becoming just one volume in an abstract graphic arrangement of objects (with varying volumes) or he is a disturbance to it by seeming to come from another world. Using this

FIG. 5.10 Worn feet, or the geography of lived experience. Frame enlargement, *Parque vía* (Enrique Rivero, Mexico, 2008).

lens, we might say that the film is about the servant's *loss* of personhood. Yet perhaps this sounds a bit banal; after all, it cannot be news that to the master the domestic is invisible. One could think that the film, in effect, presents the master's view of the domestic but in quotes—as a way to make it available for criticism and outrage. But I think the film suggests something else.

While *Parque vía* often gets talked about as employing a cool, objective style, I propose that the film's innovation is to suggest that it is itself really an example of perceptual subjectivity. The film's style enacts Beto's perspective. It thereby suggests something about the servant's interiority—not what he *thinks* (his consciousness) but how he *sees*. And how does Beto see?

Lupe, Beto's sex worker companion, trenchantly puts her finger on the symptom when she exasperatedly muses, "I don't get why living in this mansion we have to fuck in this room," referring to the servant's quarters. Beto is not like the servant described by Sartre in his introduction to Jean Genet's *The Maids*:

> In the presence of the Masters, the truth of a domestic is to be a fake domestic and to mask the *man* he is under the guise of servility; but, in their absence, the *man* does not manifest himself either, for the truth of the domestic in solitude is to play at being master. The fact is that when the Master is away on a trip, the valets smoke his cigars, wear his clothes and ape his manners. How could it be otherwise, since the Master convinces the servant that there is no other way to become a man than to be a master. . . . A valet is sometimes a man who plays at being a servant and sometimes a servant who plays at being a man.[47]

Despite the fact that Beto is in the house alone, he never really plays at being the Master.[48] Beto cannot adequately claim the house, and that is what Lupe reproaches him for: a lack of rebelliousness. Why does he be-

have (within the diegesis) *as if* he is being surveilled? Because Beto carries the servility inside. It has shaped him; it has warped him. If he could occupy the house, he could transform himself symbolically from the caretaker to the owner. He could overcome his servility. This goes to the core of the peculiarity of domestic service: the identification with one's own objectification. It is not that Beto's consciousness is false so much as that, in Hochschild's terms, his feeling is colonized. Moreover, the film has reflected formally Beto's *own* refusal to occupy the house; it has given visual expression to Beto's self-estrangement. The servant is constitutively irrecuperable. The film seems to suggest that there is no representational solution to restoring the servant's personhood.

Parque vía has sought to access and highlight the affective dimensions of paid domestic service not through testimonials, as so many other domestic service films have done, but by subverting the conventions of the process genre, a ciné-genre devoted to the representation of material labor. Rivero's anti-process approach to Beto's work insists that domestic service—by virtue of the kind of work it is—is not appropriately

FIGS. 5.11a–b Virgin of Guadalupe affixed to the rooftop terrace door (5.11a). Frame enlargement, *Parque vía* (Enrique Rivero, Mexico, 2008). Reproduction of the painting of Our Lady of Guadalupe from the shrine at the Basilica of Our Lady of Guadalupe in Mexico City (5.11b).

b

represented using a processual approach. A processual approach to Beto's household labor would have emphasized his skill and presented domestic work as craftsmanship. It would have valorized his work by aestheticizing it. It would have glorified him and established his personhood. It would have signaled, *he is what he does.* That is what processual representation itself achieves, and that is what it achieves in the first part of *Jeanne Dielman*.

There is genius in Jeanne's orderliness, in the systematic way she confronts the tasks necessary for the reproduction of life, from day to day. That such genius and skill should be limited to such tasks is the problem, and not because the tasks are unimportant or wholly unsatisfying for the person undertaking their completion. They are critical to the maintenance of life, and Jeanne's skill, the film suggests, produces a palpable satisfaction for her. But, a flourishing life must provide other—more variable and challenging—outlets. The processual approach to Jeanne's domestic labor establishes, viscerally, as a matter of kinesthetic empathy, the value of what she does in a way that talk (e.g., interviews and expert opinion) could not.

Despite the amount of screen time devoted to Beto's work, the antiprocessual treatment of it means that we do not perceive him similarly. He seems to get no satisfaction from the labor he performs. What satisfaction could there be, after all, in such absurd, useless tasks as cutting grass that does not need cutting and washing windows that are already spotless and ironing shirts that no one will see him in? But unlike in *Umberto D*, which also refuses a processual approach to the maid's morning routine, in *Parque vía* there is little indication of a parallel world in Beto's head. While Maria carries a world inside, a consolation for the deadening repetition of tasks to which she is not inclined to apply her genius, Rivero suggests the uncomfortable view that traditional domestic service is marked by the special offense of colonizing the servant's inside, leaving him bereft of such consolations. What is left to Beto except to cling to the house that has served as his prison? *Jeanne Dielman* and *Parque vía* may depict the same kind of chores, but *Parque vía*'s anti-processual treatment of labor suggests that the types of labor presented are not the same kind of labor. The one is unremunerated domestic labor, with its quotient of satisfactions, in the service of social reproduction; the other is a form of paid affective labor that shapes the subject that performs it even when the boss is out of the picture.

AT THE END OF PARQUE VÍA, Beto's feelings appear to be in disarray. The Señora has returned for one last visit to bid Beto farewell. In a medium shot she touches Beto's hand. The image cuts to a close-up of Beto's empty hand as he repeatedly opens and closes it as if reexperiencing the feeling of the Señora's touch. Moments later, the Señora is dead. Beto kisses her tenderly, one time on the mouth. He loves her. Then we see him energetically bash her head six times with a shovel. If he just wanted to land himself in the comfort of the jail (as he does when the authorities presumably mistakenly blame Beto for the Señora's death), he might have slit her throat or put a knife in her. No, he hates her. Which is the truth of his feeling? Intense love and intense hate intermingle; meanwhile, the "signal function" of emotion, as Hochschild referred to it, has been lost. This is what it is for feeling to be colonized.

There is something similar at work in *Jeanne Dielman*, for what should we make of the orgasms Jeanne experiences in the course of sex work? The film implies that they are so unsettling, so disruptive of the tenuous control Jeanne has established through her obsessively compulsive routine, that she sticks the scissors into the client's throat as a direct response. What does it mean, then, to experience pleasure in the course of sex work? "Professionalism" in sex work is widely thought to entail what Marjolein Van der Veen refers to as "boundary maintenance," which is usually thought to preclude sexual pleasure with clients.[49] If one is committed to the view that sex work is self-estranging, that it involves the sale of personhood, one might incline toward reading Jeanne's orgasm as masochistic—that is, Jeanne is taking pleasure *in* her own exploitation.[50] In other words, one might view Jeanne's orgasm in an analogous way to how I have been reading Beto's love for the Señora and for the house. One might think that this is what colonized feeling looks like in sex work.

The contemporary debates about affective labor have been precisely concentrated on the significance of its biopolitical character, on the way that it shapes subjectivities.[51] Despite the common view that traditional, live-in domestic service is a vestige of a premodern labor arrangement that is being superseded by capitalist labor relations, the terrain one must navigate in thinking about domestic service in the Global South turns out to have a lot in common with contemporary concerns about the nature of the expanding sectors of service and care work across neoliberal societies.

Given this, *Parque vía*'s seemingly nostalgic (though ambivalently so) treatment of the last days of a dying institution has contemporary

resonances, as well as implications for representing the new frontier of affective labor. How does one represent an insidious form of labor that disguises its character? How does one represent a form of labor that shapes subjects at the level of feeling to such an extent that one might not even realize when one is laboring? With affective labor, the nature of the labor process is opaque. It is not visualizable or codifiable in the reassuring way that the production of yellow crayons is. What are its tools, its machines, its raw materials? In other words, affective labor is a kind of labor that cannot be represented processually. How it should be represented is an open question—and one that must make one long nostalgically for what visibility there is in the process genre's approach to labor.

THE SPOOF
THAT PROVES
THE RULE

I was born during the Age of Machines.

A machine was a thing made up of distinguishable "parts," organized in imitation of some function of the human body. Machines were said to "work." How a machine "worked" was readily apparent to an adept, from inspection of the shape of its "parts." The physical principles by which machines "worked" were intuitively verifiable.

The cinema was the typical survival-form of the Age of Machines. Together with its subset of still photographs, it performed prizeworthy functions: it taught and reminded us (after what then seemed a bearable delay) how things looked, how things worked, how to do things . . . and of course (by example), how to feel and think.

We believed it would go on forever, but when I was a little boy, the Age of Machines ended. We should not be misled by the electric can opener: small machines proliferate now as though they were going out of style because they are doing precisely that.

Cinema is the Last Machine.

—Hollis Frampton, "For a Metahistory of Film"

IT IS OFTEN observed that genres find more traction in some historical moments than in others. It is said that film noir, for example, with its femme fatales and smooth-talking detectives, manifested an anxiety about masculinity in the post–World War II context.[1] Or the musical: its twenty-year golden age begins in the 1930s with the widespread

adoption of sound technology. While I have tried to track the process genre across a wide swath of time, there are moments in which its prominence and visibility have swelled. As I noted at the outset of this book, we are in such a moment. But if this is the case, then what accounts for the process genre's robust cultural life in the present? I am tempted to say that the process genre today marks a certain renewed anxiety, ambivalence, uncertainty about the conditions of human life in the face of significant changes to the way production is organized and managed. Ours is a period of significant technological changes; "smart" machines, deskilling, and the threat of unemployment due to increasingly efficient and expansive automation are a significant part of the story. (Contemporary debates in the West about basic income are as much about a crisis of work as anything else.) Given this, we must entertain the possibility that the resurgence and ubiquity of processual representation is a symptom, paradoxically, of the eclipse of the technologies—manual and machinic—for which it is best suited. The pleasure and fascination that processual representation elicits today may be a measure of its anachronism.

I have argued that the process genre is a genre of the expanded Machine Age, capaciously understood as beginning in the early modern period. Even when it takes craft or bodily skill as its object, the need to codify tacit knowledge for a diverse constituency arose in that period, with modernity. That such knowledge of processes, machines, and bodily skills could be made broadly intelligible to a general public has a lot to do with the *kinds* of processes, machines, and skills that were requiring representational form. The skills were physical, such as how to handle a pike; the machines were mechanical rather than electro-digital; the processes were material enough that they could be broken down into their component steps. But how does one codify—in images intelligible to the average person—the currently prevailing forms of work and the ubiquitous digital technologies of the present? How does one codify—pictorially—the kind of skill involved in affective labor or the functioning of the iPhone microchip or a complex process involving multiple steps, some of which unfold simultaneously?

The process genre is a representational consolation for a society that is too complex to be masterable. It offers up a world that can be understood, known, mastered by anyone, by everyone. Like Neil Harris's operational aesthetic, its ethos is democratic and egalitarian. A world full of stuff

whose genesis can be known and understood (even by a child), a world full of bodily skills that can practiced and learned by anybody willing to put in enough hours—that world is a world under my control. It is also a world that can be molded and transformed by one such as me.

The mastery that is entailed here is not piecemeal or partial. I have argued that the process genre projects a knowledge of the whole and that this kind of knowledge corresponds to the experience of work epitomized by the artisan or craftsman, not by the assembly line worker (even when it is the assembly line worker who is actually being depicted). Because the craftman's way of working is at the center here, the process genre also trades on the well-documented satisfactions of craftwork *for* the craftsman, often eliciting in the spectator analogous feelings of absorption and well-being. In the process genre, it is work—form-giving activity—not consumption or leisure that holds the key to meaningful human living.

In a world brimming with unfulfilling, alienating jobs; mysterious machines without gears and cranks, running on algorithms; little-understood phenomena such as credit default swaps; in a world dominated by corporate behemoths, a world whose chaos induces fear, is it any wonder that the process genre proliferates, offering compensatory fantasies to the demoralized Little Man and Woman? Whether one thinks these fantasies are indeed illusory or nostalgic, whether one disapproves of the desire to divide, name, and classify in order to appropriate the world as processual representation does, whether one prefers a politics of antiwork to a metaphysics of labor, the ubiquity of processual representation now shows that we are still compelled by its humanist and democratic values. This is not to say that processual syntax has not been used by unapologetic capitalists and sundry politically reactionary projects. It has, but the point is that it has been useful precisely because it appeals to humanist and democratic values even when it works against them. As Roland Barthes said, trying to account for the use of craft motifs in the advertising campaigns of his day, "It is not easy to be done with a civilization of the hand."[2]

THE PROLIFERATION of processual representation has been accompanied by a catalogue of spoofs. This must be a sign of the genre's saturation. In the course of this book I have discussed some parodies, such as the "The Most Unsatisfying Video in the World Ever Made," which models itself on a "hands and pans" video but, instead of showing skilled labor, shows a series of tasks phenomenally badly done: the slicing of a cake in which the

pieces are of random, awkward sizes; the cutting of a tomato with a dull knife that leaves a red, goopy mess; the peeling of an egg that leaves the egg pock-marked and falling apart (see figures 3.1a–c). Successful spoofs reveal the object of parody to be a coherent stylistic template that achieves a calculated (rather than spontaneous) effect. Mikhail Bakhtin considered parodies dialogic because they stage an encounter between two texts: the missing template that has been conjured and the parodic text with which we are directly confronted.[3] "The Most Unsatisfying Video in the World Ever Made" works as a parody; it *is* maddeningly un-satisfying precisely because we are all so well acquainted with the process genre, which routinely delivers the unacknowledged satisfactions of watching skilled actions. We have compared "The Most Unsatisfying Video in the World Ever Made" with the process genre template we carry around in our heads—perhaps without knowing it. The spoof has cleaved some distance between the spectator and the otherwise compelling object of spoofing; the satisfaction of processual representation will likely never be the same.

I conclude this book by describing and commenting on four extraordinary, mostly contemporary, spoofs of the process genre. Like "The Most Unsatisfying Video in the World Ever Made," these spoofs make use of various strategies of parody, particularly exaggeration and inversion. For example, they all exaggerate the messiness of the processes referenced, and three invert the usual priority of image over sound so that the soundtrack becomes primary. But these spoofs do something else that parodies have also been known to do: they historicize.[4] Unlike "The Most Unsatisfying Video in the World Ever Made," these spoofs locate the process genre at a temporal remove from the Present, marking its definite historical place in the flow of time. The effect of this historical plotting is threefold: in ad-dition to "constructing" a(n) (ideologized) version of the missing genre's template, the spoofs riff on the process genre's evolutionary march toward exhaustion.[5] But that is not all: the spoofs are not merely unsentimental, non-nostalgic allegories of the process genre's incongruence with the Pre-sent, of the inevitable conclusion of its lifecycle. With the distance spoofs open from the present historical moment, they subject the Present, as well, to a certain defamiliarization and critique. These parodies of pro-cessual representation, then, re-enliven the genre, in effect enlisting its dated conventions in a commentary on the new realities of work and on an alternative vision of human life.

Wonder Showzen: The Hot Dog Factory
(John Lee and Vernon Chatman, United States, 2005)

In the early 2000s, MTV's *Wonder Showzen* series, deliberately employing a dated video aesthetic, devoted itself to spoofing American educational television of the 1970s and 1980s. In one two-and-a-half-minute segment reminiscent of *Sesame Street* factory tours, a raggedy yellow puppet asks a toddler, "Do you know how hot dogs are made in a hot dog factory?" The child responds, chuckling, "No. How?" It is a textbook setup for an industrial process film, but soon after the image track cuts to the factory, it is clear that something is amiss.[6] The process is narrated not by a calm, reassuring voice like that belonging to Mister Rogers or Big Bird but by the voice-overs of a string of children, early talkers—their pronunciation is a bit off, their words are sometimes difficult to make out, and they have a funny, scatological way of putting things: "First they unroll the pig"; "I want to swim in the meat pooly [pool]"; "The meat smelled like my grandma's mouth"; "Yummy. Booger sugar"; "I got to go poopy"; "That's what my doggy does in my pants." Presented with a shot of a giant meat grinder grinding out pork, a child says, "Raining meat—just like my nightmares. . . . Flying colon." "Delicious murder," says another as the segment wraps up.

While the sequence of images, which are all archival, roughly follow the sequential process of hot dog fabrication from pig to hot dog, there are a few suggestive visual interruptions. At one point, a child says, "They showed us a chart of where the meat comes from." The voice-over is accompanied by two shots. In the first, an animated graphic of the lower half of a donkey—in imitation of familiar butchers' images of sectioned pigs—shows its hind legs and bottom separated from the rest. In the second shot, the right side of a biology textbook image of an organed human body with a graphic of a girl's head superimposed beneath the penis gets erased (figure E.1). Of course, part of the process of slaughtering animals involves the sectioning of its parts, which become "cuts" of meat. The segment suggests a visual analogy among pigs, beasts of burden, and people. Although it is standard to divorce one's thought about the "cut" of meat from the body part to which it belongs on the live animal, the sectioning of a human body or the prospect of eating donkey is anathema to our thought.

The film's audio track sometimes works as counterpoint to the image (as when an image of a slab of meat being stamped "U.S. INSPCD AND CONDEMNED" is juxtaposed with a child saying, "That's the meat that's used

FIG. E.1 The human body sectioned as if it were a cut of meat. Frame enlargement, *Wonder Showzen: The Hot Dog Factory* (John Lee and Vernon Chatman, United States, 2005).

to make hot dogs." Often, however, the script verbalizes an implicit, and distasteful, visual analogy: the meat being pushed out of the grinder and falling toward the bottom of the frame could look like rain or flying colon; the mixer folding sugar into the ground meat could look like boogers; with more liquid added and with the light hitting just so, it could look like a pool filled with meat; the fully processed meat being squirted into coils in preparation for the casing step could look like dog shit; the ropes of cased hot dogs darting down a conveyor belt toward the screen could look like bullets making their way down the chamber of a machine gun, an association suggested by the added sound effect of machine guns and screaming. Overall, the process represented looks profoundly unappetizing: the "raining" ground meat, the machinic mixing of the hot dog sludge before it is pumped into casings (figure E.2), the wieners themselves, the association with war, and so on.

In a lot of ways, this is not dissimilar to the effect of the straight meat-processing or industrial slaughter process films I discuss earlier, such as

FIG. E.2 Hot dog filling as a long coil of shit. Frame enlargement, *Wonder Showzen: The Hot Dog Factory* (John Lee and Vernon Chatman, United States, 2005).

Meat (Frederick Wiseman, United States, 1975). Meat-processing films, unlike other industrial process films, are not good advertising vehicles, as the finished commodity seems less like a wonder than an abomination. Animals are just not like unprocessed cotton. As a little boy says midway through the *Wonder Showzen* segment, "There's something wrong here." The mass production of packaged meat is wrong—even if one eats meat. In some ways, meat-processing process films already use the process genre against itself.

What changes the effect in the case of *Wonder Showzen: The Hot Dog Factory* is the audio track. The seemingly naive but visceral commentary of the children—which continually references animal nature, bodily excretions, waste, odors (e.g., poop, boogers, bad breath, dissected body parts)—makes plain the truth of the disgusting visual images, amplifying their noxious impression.

Fake Fruit Factory (Chick Strand, United States, 1986)

The title of Chick Strand's film suggests that it will be a process film. And in some ways it is. It follows the fabrication, by young Mexican women in Mexico, of life-size, painted papier-mâché fruit for the local tourist market. Structured across a single workweek (though shot over a few years), the film begins with the forming of the fruit shape, followed by its wrapping in paper, its painting, and its sealing. In the middle of the twenty-two-minute film are eight minutes devoted to a poolside picnic—something the American boss of the factory hosts for the workers every fourth Thursday. Back in the factory on Friday, the film resumes with the workers sticking labels on the fake fruit—"Made in Mexico," they say. The workers are paid

a

b

c

FIGS. E.3a–c Extreme close-ups: a face, in concentration (E.3a); cauliflower being dipped in paint (E.3b); a bather at the poolside picnic (E.3c). Frame enlargements, *Fake Fruit Factory* (Chick Strand, United States, 1986).

in cash; they board a bus; and the bus drives off into the distance.

Although it may sound like a process film from my description, it does not deploy the usual conventions. Except for one long shot, every one of the film's more than fifty shots of faces, hands, and inanimate objects is an extreme close-up (figures E.3a–c). The camera is handheld throughout, and because the lens is perpetually zoomed in, the image is especially shaky and often blurry. Perhaps the most striking innovation of the film—as in the *Wonder Showzen* example—is the soundtrack.

The audio is composed primarily of the workers' continuous commentary, broken only twice by romantic Spanish-language popular music whose basis in the image is uncertain. Otherwise, sound is direct and diegetic, though offscreen and nonsimultaneous. Early on, an extreme close-up of the profile of a young boy is accompanied by a child's voice from offscreen: "Martín! Are you going now?" The boy looks up at that very moment but does not respond. Is he even Martín? Probably not. Because there are no establishing shots, it is impossible to understand anything about the architectural context of production. What is the space like in which the process of production is taking place? Nor is it possible to connect the hands at work or the limbs in bathing suits during the poolside picnic to the many face shots of the workers. A consequence of the non-simultaneity of sound and image is the further delinking of the character from her voice. And the cacophony of offscreen voices prevents the spectator from even estimating how many people are present in the scene. The film presents one with people, deconstructed—much as process films often present objects and actions, decomposed, though primed for recomposition. Faces, voices, body parts—the building blocks of the person— are all there in *Fake Fruit Factory*, but they are in disarray. How can one put faces together with their rightful voices and bodies? But unlike a Kuleshov montage experiment that plays with the possibilities of fragmentation,

the film does not produce any wholes; it refuses to "recompose" the fragmented workers.

As for the content of the cacophony of speech, it is a stark departure from the demonstrative narration that usually accompanies process films. The voice commentary runs on a parallel track, mostly having nothing to do with the work process unfolding in the image. This might have been a perfect opportunity to inject a string of workers' complaints about the job or the *gringo* boss; after all, the film's title (*Fake Fruit Factory*) also suggests the notorious U.S.-owned United Fruit Company. Instead, the commentary's divorce from the images of work evokes the unanchored inner dialogue that accompanies activities so rote that one can perform them "without thinking," so to speak. The commentary is running but intermittent. It is cut up, but who knows whether or when one snippet recorded on, say, a Monday, butts up against another snippet recorded three-and-a-half weeks later, on a Friday. It is impossible to detect most of the sutures. (This is decidedly unlike cuts in the image, where only the rare form cut is undetectable.) The subject matter ranges from banter (To the boss: "You're very Mexican." The boss: "Me, yes. But my stomach, no.") to extended sex jokes:

> A: . . . in sex?
> B: Yes, are they good?
> C: Two, three times?
> D: Ah, Mexicans, yes. But it's the same with machismo.
> E: They are that way because they don't do anything else, sir.
> F: Not a job. No cleaning.
> G: That's why they are very strong for sex.
> H: Their minds are clear. They're not worried about anything. Well fed. Well slept. Rested.
> I: Their wives work and they sleep all day.
> J: Socorro! Expert in sex, come here![7]

In another example, the dialogue goes like this:

> A: But he makes it too small.
> B: It doesn't matter.
> C: You call that guy "little sausage"?
> D: Yeah. "Pig" would be a better name for him.[8]

But another women interjects: isn't the man actually more like beef jerky than pig? The commentary immediately turns to milk while the images

show the women dipping the fake fruit into a white liquid: "Don't you know that milk is nutritious?"; another: "That's exactly why I brought it"; another: "It's rancid"; another: "You sure drank the milk down!" The sound has been edited in such a way that the chain of topics leading from the sausage man to the beef jerky to the rancid milk evokes another set of associations: to small, sausage-like penises and foul-tasting semen. As in *Wonder Showzen: The Hot Dog Factory*, the script inclines toward the somatic.

Dough (Mika Rottenberg, United States, 2005–2006)

In the first decade of the 2000s, the artist Mika Rottenberg made a series of bizarre factory videos. *Mary's Cherries* (2004), *Tropical Breeze* (2004), *Dough* (2005–2006), *Cheese* (2008), and *Squeeze* (2010) are all short process films depicting Rube Goldberg–like processes. They exploit various commonplace conventions of processual representation while at the same time spoofing the genre. What is special in Rottenberg's spoofs is that she insistently brings the process genre into the present, experimenting with what it can do with the present status of work.

In *Dough*, four women produce vacuum-sealed globs of proofed dough. The representation begins in the usual way, with a high-angle shot of the packaged commodity. Then there is an introduction to the spaces of production at rest. Unlike in standard industrial process films, this process is organized vertically rather than horizontally in what appears to be perhaps five tiers or stories, each composed of two boxy rooms (side by side). Already the organization of the space of production—which is established early on by two diagonal tracking shots that track in a single arc across tiers and boxes—is less reminiscent of the horizontality of the factory assembly line than of the verticality of the eighteenth-century mill, the sort represented in a crosscut view in Diderot's *Encyclopédie* (see plate 2). The peregrination of the dough from sticky mass to portioned and packaged commodity is propelled by gravity; a system of manually cranked pulleys; and pedal-operated air generators (plates 7a–x). The dough begins as a giant, amorphous glob in one space. Then it makes its way to the boxy room immediately below through a hole in a drop ceiling. The dough stretches through the hole, making its way down a series of cascading platforms managed by a very large woman (about six hundred pounds), the internet star "Queen Raqui," who kneads the dough as it descends toward a hole in the floor of her room. The dough is received by another internet star, "Tall Kat," who is very tall (six foot nine) and has extraordinarily long limbs. She

pats the thick rope of dough that stretches from the hole in the ceiling of her room to the hole in her floor with her long fingers. A third woman receives the dough as it crosses the threshold of her own ceiling, guiding it to a hand-cranked conveyor belt that passes the dough to the right through a cutout in the wall, where it is received by a fourth woman, who twists the dough at intervals and then sends it back on the same conveyor belt, now moving leftward, where it is received again by the third woman, who uses the twists to demarcate where the dough needs to be severed. She assists in the severing and ensures that the proto-blob makes its way through a hole in the floor, where it lands on an elevated flat round surface. Two green hoses that almost reach the blob extend into the space from two holes in the ceiling.

The process is not finished. Each worker has two discrete jobs in the process. I have described the first job of each. Raqui's second job is to smell a bouquet of daisies, whose pollen is blown at her face by a small fan powered by a crank operated by the third woman. Raqui inhales hard. But "smelling the flowers" in this case triggers an allergic reaction that makes her cry. (This is all built into the design.) The tears fall onto her large legs, hot and sweaty from her labors, and then roll toward her toe, where they collect, eventually dripping through a hole in the floor just under Raqui's foot. The hot tears land with a sizzle on the floor of the room just below, the room with the waiting portioned blob. It turns out that the green hoses above the blob are blowing out air that is being pedaled in by a contraption Tall Kat is operating with her feet in another room above. The air plus the hot, salty tears mixed with sweat are generating the steam and salt that are proofing the dough blobs, which are then dropped through another hole. The proofing process has been, in effect, self-reproducing: what started as one unit of dough has now expanded to 1.5 units of dough. From this enlarged blob, one unit is broken off and vacuum-sealed (that is the commodity to be sold), and the 0.5 surplus is fed back into the giant, amorphous blob (which was the starting point of the process). Thus, two production cycles (which each produce 0.5 dough surplus) yield the requisite raw material (i.e., one dough unit) for a subsequent cycle (plate 8).[9]

The labor of the body takes on a new meaning in *Dough*. If wage labor involves renting one's capacity to work for a restricted period of time, the sort of capacities traditionally thought to be alienable (or available to be rented) were generally limited to physical and mental skills separate from the self and thus understood to be "external." Recent debates about sex work, surrogacy, organ sale, and affective labor hinge on the porous border between what is "internal" and what is "external." Although the actions of

limbs are typically considered "external," the womb, the sex organs, and feelings have been considered "internal" and thus too integral to the self to be alienated and commodified.[10]

Consider the expression "blood, sweat, and tears." The phrase refers to an extraordinary exertion, a high quotient of work, one that depletes the worker. It suggests the transference of my life, my vitality, my body to the task. The expression makes sense only because work generally does not literally incorporate my blood, my sweat, or my tears. *Dough* does just that, as the implicit threshold between inside and outside is cast aside. Raqui's sweat and tears have been quite literally incorporated into the final commodity. Moreover, while the process genre generally deemphasizes the particularity of human agents (think of the anonymity of the figures in Diderot's *Encyclopédie* or the missing people in Mister Rogers's crayon film or the preference for hands over faces in *Aruanda*), Rottenberg has chosen Raqui and Tall Kat for their pronounced bodily singularity, singularities that both exploit in real life to make a living. Raqui and Tall Kat lead extra-filmic lives as internet sensations. Their status points to the contemporaneity of the piece; their star texts are reminders of the shifting boundaries between "internal" and "external" as more and more of what was considered integral to the self is being traded in the market. This is the hotly debated terrain of immaterial labor.

But the piece's contemporaneity in this sense might seem incongruous with its ostentatiously analog production setup. The out-of-date feel of the piece is captured in the vertical organization of the factory, which suggests the eighteenth-century technical illustrations of machines, especially mills (see plates 1–2); the use of animal (i.e., human) power and gravity as opposed to electricity; the mechanical rather than electro-digital character of the devices that feature creaky pulleys, cranks, and gears; the choice of materials such as wood and rope rather than steel and rubber; the ad hoc, handmade character of the machines—reminiscent of Rube Goldberg's mechanical inventions—that produce a useless commodity. We are a far cry from the materials, machines, and setting of Volkswagen's Transparent Factory in *The Unstable Object*.

But what does the juxtaposition between anachronism and contemporaneity achieve? *Dough* does not merely reference the process genre, as *The Hot Dog Factory* and *Fake Fruit Factory* do. It rigorously deploys processual representation. The marvel of the piece is that the representation of the production of proofed dough is convincing. Just like Rube Goldberg's devices, the process makes sense, and the inventions, though designed to produce a commodity lacking all use value, are nonetheless ingenious and

wondrous. They *do* work. If the process could not be reconstructed as I have done, the effect would be entirely different. But what makes this ingenuity so palpable and intuitive is the analog and ad hoc character of the mechanical devices that look like something I might be able to construct with a class of third-graders. The video thereby marshals the pleasure and absorptive effects of the process genre while amplifying, literalizing—giving visual form to—the idea that "the worker," in Marx's terms, "puts his *life* into the object."[11] But what makes this conceit feel contemporary rather than like a nostalgic rehash of Marx's 1844 manuscripts is that—much like the Rube Goldberg absurdist machines of the 1910s–1930s that would soon become realities in the marketplace—real life in the Present is literalizing Marx's formulation. If I can now sell the use of my womb and the milky output of my breasts, surely soon I will be able to sell my tears, my sweat, even my sleep. Rottenberg therefore combines two insights that are usually held apart and treated as in tension: first, that labor is magic, that it has the potential of greatness; and second, that expending our life force, our labor, on quite literally disgusting commodities is perverse. In other words, commodifying ourselves—alienating us even from our tears—constitutes a new order of depravity. The use of processual representation amplifies the first insight and thus makes the second more devastating.

The Making of Forty Rectangular Pieces for a Floor Construction (Adrian Melis, Cuba, 2008)

The five-minute-and-twenty-second video by the Cuban artist Adrian Melis begins over a black screen. Ambient sound, voices, and radio music play. A stern man's voice, perhaps that of the foreman, calls out: "Come on! See about him. Julio, come here! That guy and you, all standing up there. Come here! You are wasting your time there, doing nothing." A man's voice, perhaps Julio's, replies: "Listen, dude! We've got no materials, no work, nothing. What do you want me to produce? Let's move and work. Listen, you will be . . . You are going to be the . . . I'll be the cement trombone. . . . You will be the pick and shovel. . . . And you be the one who will . . . C'mon, you start."[12] The first image appears. It is a stationary shot of the gate to a factory site in Cuba. Superimposed on its doors is the standard industrial process film title "The Making of Forty Rectangular Pieces for a Floor Construction." What follows are fifty-four shots of various machines, machine parts, instruments, tools, power switches, cords—all at rest. With the exception of eight moving shots that survey the machines, the other shots

are static, almost indistinguishable from still photographs. The factory site looks like a ruin—still; abandoned, with no people in sight; debris everywhere; the machines corroded, rusted, moldy; wild vegetation retaking the perimeter. Only the audio track is alive with movement.

For the duration of the video, an orchestra of voices—nonsimultaneous and offscreen—imitate the sounds of machines and instruments in motion. The approximately five-and-a-half-minute symphony corresponds roughly to the sounds produced by a definite *sequence* of production. For example, toward the end of the video the voices imitate the sound of an old, noisy truck—presumably the truck that will transport the finished rectangular floor pieces to their destination. The voices imitate the idling motor as if the material were being loaded onto the truck, then the sound of the truck moving. Then the sound softens and fades as if the truck has been driven out of earshot.

The shots—even though they are mostly static, neither moving much nor depicting movement—likewise correlate with the sounds and with the process. Shots 21–30 stay with one large, long cutting machine and feature close-ups of its dulled blades; its peeling, green-painted wheel cranks; its corroded pulley bands; its spent timing belt (figure E.4). We *imagine* that the use of this machine corresponds to a step in the production process as material makes its way through the machine. At the end of the video, a series of close-up static shots of power switches suggest that the machines are being turned off as the work is done. Simultaneously, the machine sounds stop, one by one.

As in *Fake Fruit Factory*, the image track and the audio track in *The Making of Forty Rectangular Pieces for a Floor Construction* tell two different stories, both bearing on the process genre. The images evoke the ruin discourse that is standard fare in visual treatments of Cuba. Cuba is "frozen in time," we are constantly told: its technology—from its cars to its factories—are

FIG. E.4 Corroded cutting machine with painted green wheel cranks. Frame enlargement, *The Making of Forty Rectangular Pieces for a Floor Construction* (Adrian Melis, Cuba, 2008).

stuck in 1959, the year the socialists came to power. Of course, the images of decayed, corroded machines and abandoned factories also suggest the Global North's aesthetic of postindustrial ruins. Whether the iconography of industrial ruins is a consequence of the shortages of materials common in Cuban state capitalism (and explicitly referenced in Melis's video when Julio answers the foreman) or of the migration of industry from the West to the East and South, the visual vocabulary preferred to represent this ruined state is much the same. And it should be said that these messy, chaotic, makeshift, weathered, disintegrating workscapes stand in stark contrast to the pristine, ordered, preplanned, shiny, newish workscapes characteristic of process films.

The corroded, decaying analog machine photographed by Melis is a perfect semantic element in that lexicon of ruin (see figure E.4) And it is one that functions to crystallize the passing of the Machine Age. The machine as it was theorized and illustrated by Franz Reuleaux in *The Kinematics of Machinery* (1875)—with its six kinematic mechanisms (the pulley chain, the crank chain, the screw chain, the ratchet chain, the wheel chain, and the cam chain) and twenty-two machine building blocks (including the screw, the wedge, the belt and pulley, the coupling, and the piston and cylinder)—the one that displayed its workings in the nineteenth and early twentieth century's world fairs, appears to be an anachronism, its analog controls superseded by digital electronics and microprocessor computer controls.[13] After all, one important difference between Reuleaux's machines and the ones that dominate the so-called Information Age is that, whereas the former were largely intuitive, the functioning of their mechanisms visible and intelligible to the average person, much of the complex technology of the present requires specialized knowledge to understand. Concentrating solely on the image track, one might think that Melis's piece allegorizes not only the end of the analog machine and of a certain approach to industrial production, but also the end of the processual representation of machines and of production processes. In other words, the new technology and the new ways of organizing production strain the process genre's capacity to represent their operations intuitively.

But if we shift focus to the audio track in Melis's video, a different perspective emerges. The orchestra of voices—which are the voices of the factory's own (pro-filmic) workers—is meant to suggest the sequential process of production: the "cement trombone" comes in and harmonizes with the wheelbarrow, then trails out as another machine sound takes over, and so on. The basic conceit here is that the workers—not the foreman—

know the production process so well that they can sonically re-create it. For them to do this, they would have, on the one hand, to be masters of the *whole* of the production process, and, on the other, to coordinate with one another as they would if the production process were organized *by* them rather than *for* them by a boss. In their symphonic rendition, they have overcome the alienated, Taylorist division of labor in the factory—but notice that they have done so without giving up a sequential organization of the work. Here the video summons an unpictured, perhaps utopian, scenario: a worker-controlled production process. And while this note, too, may strike one as standard-fare nostalgia for the promise of a fully realized (democratic) socialism that was never consolidated in Cuba, the workers' voices suggest something else entirely.

Their unmistakable Cuban way of talking, the individuation of each voice, their impressive mimicry of the machine sounds, their harmonizing of parts—the vitality of their symphony contrasts sharply with the stillness and decay of the photographed machines. If the machines belong to the refuse of history, the capacities of the workers to improvise, collaborate, coordinate, organize, intellectualize, poeticize—their capacity to reimagine production as art—these are the *human* resources of the future. Melis's spoof of the process genre does not look backward nostalgically to the Machine Age. It looks forward—expectantly—to a world arranged by the people who do the work.

AS I SUGGESTED EARLIER, spoofs conjure up their object of parody. They construct, in a sense, a *version* of the stylistic template they target. The parodied form summoned, then, is an *interpretation* of the template, with certain calculated emphases and preoccupations. From the spoofs I have just described I want to pull out a common thread that, through inversion, reveals a definite take on the process genre—and a corrective to it. All of the spoofs subvert, formally, the process genre's standardly clean aesthetic. The process genre, as I have been describing it in this book, generally works with ideal forms. It is a genre of types, of best practices, of the beautiful, of the precise, of technique, of skill, of ingenuity, of rationality. It is utopian. It is an *aesthetic* of labor. The ugly, the sloppy, the disgusting, the mistaken, the meandering, the failure, the underbelly are not native to it. But this is precisely the preferred currency of the process genre's spoofs. *Wonder Showzen*'s scatological humor and its viscerally disgusting vintage images have something in common with *Fake Fruit Factory*'s shaky handheld camera and blurry focus and its sexually focused script. *Dough*

similarly emphasizes the messiness and ad hoc character of the production process and elicits its own brand of disgust as the spectator contemplates a commodity constituted, in part, by the bodily excretions of strangers. While *The Making of Forty Rectangular Pieces for a Floor Construction* does not turn to the bodily domain of waste and sex, its images of corroding machines and a ruinous factory site are diametrically opposed to the well-oiled, sleek steel machines and ordered factories of the standard industrial process film. These spoofs answer the process genre's preference for perfected practices and perfect aesthetics with an all-around imperfect cinema. But to what end?

I propose that behind this aesthetic of sloppiness, imprecision, and viscosity—which has been gaining currency in academic and fine art circles—is the very laudable desire to smuggle back in the human dimension. The opposition between the machine and the human has often been expressed in Ruskinian terms as an opposition between the clean, the precise, the perfect and the messy, chaotic, imperfect. "Imperfection," wrote John Ruskin in *The Stones of Venice* (1851–53), "is in some sort essential to all that we know of life. It is *the sign of life in a mortal body*, that is to say, of a state of progress and change. Nothing that lives is, or can be, rigidly perfect; part of it is decaying, part nascent. . . . And in all things that live there are certain irregularities and deficiencies which are not only signs of life, but sources of beauty."[14] This Ruskinian line lives in the recent phenomenon known as "sloppy craft" or "postdisciplinary craft" in which messiness is a value "because," as one art historian put it, "life is messy."[15] Indeed, Glenn Adamson has suggested—in an ambivalent vein—that "sloppy craft" might now actually be hegemonic, for "the one thing that seems to bind the majority of contemporary art together is the lack of skill required to create it."[16]

Besides imperfection, another "sign of life in a mortal body" is its capacity for reproduction—the reproduction of the single organism from day to day and of the species from generation to generation. From this point of view, eating, shitting, and copulating and their concomitant seepiness are the stuff of life. In the spoofs I have been describing, the values of the anti-machine—imperfection and reproductive life—have predominated. Against the values of the machine, the films have insisted on animal vitality. But notice that eating, shitting, and copulating are shared across the animal kingdom. These signs of the mortal body may be decisive in differentiating animals from machines, but they do little for differentiating humans from animals. If the spoofs under discussion challenge the machinic by celebrating the animal, they also find ways to differentiate the human.

In their aesthetic commitments, all four of these spoofs suggest a certain implicit understanding of the process genre. Against its supposed (inhuman) perfectionism, they have projected an imperfect aesthetics; against its cleanliness and solidity, they have substituted waste and viscosity. By trying to defend the human against the encroachment of the machine, the spoofs have framed the problem in a definite way, and they have given a certain slant to their implicit accounts of the process genre.

Throughout this book, I have resisted such interpretations of the process genre that make its perfectionism, its constitutive aestheticism, into a sign of its antihumanism. I have resisted reducing it to an aesthetic correlate of Taylorism, thus shackling it to something like a political original sin. The process genre, rather, I would say, is at bottom a humanist genre. The human dimension does not need to be brought to it through parodic subversion; it is already there. It was Barthes who said, perceptively, of the processual plates of Diderot and d'Alembert's *Encyclopédie*, "The Encyclopedic image is human not only because man is represented in it but also because it constitutes a structure of *information*."[17] Processual representation is analytic: it divides, names, classifies, and reconstitutes. And in this way, it allows human beings to appropriate the world for themselves. "The Encyclopedia is a huge ledger of ownership," Barthes continued. "In mythic terms, possession of the world began not with Genesis but at the Flood, when man was obliged to name each kind of animal and to house it, i.e., to separate it from its next of species."[18]

What we have, then, are two alternative visions of the human. While the process genre as I have been reading it is committed to human rationality, if it works with an abstract human type, and if it casts labor as life's prime want (e.g., the essence of the human condition), the spoofs work with a different idea of the human. Their version, it should be added, like the aesthetics of imperfection, is ascendant. On the one hand, these works humanize by insisting on particularity and individuation and rejecting the logic of types. *Wonder Showzen: The Hot Dog Factory, Fake Fruit Factory,* and *The Making of Forty Rectangular Pieces for a Floor Construction* all embrace the idiosyncrasy of *each* distinct human voice with its own special frequency, intensity, and resonance and its own peculiar way of putting things. One might even say that the voice, from a certain point of view, is superior to the face as a vehicle of individuation, for it can even convey the inside out. Although voice plays no role in *Dough*, the usual anonymity in the representation of workers in process films is still challenged by Rottenberg's casting of the singular Raqui and Tall Kat. In all these pieces,

individuation, singularity, and uniqueness equate with the human. To be human is to be nonfungible.

On the other hand, the spoofs incline toward a politics of antiwork. Rather than evoke the artisan's experience of "flow," all four shorts block the absorption that generally attends processual representation. For example, Melis's film may make it possible to detect that the workers' voice symphony corresponds to a processual production process, but the spectator is still denied the satisfaction of seeing the rectangular floor pieces take shape. Who knows what the floor pieces are made of, how the machines work, or even what material they work on. The sonic and acousmatic rendition of the process is not legible without a processual image track. In *Fake Fruit Factory*, although the women seem to be producing in an artisanal way in that they *appear* to be involved in every step of the production process, the script—which is dramatically autonomous from the pictured work tasks—underscores the absence of "flow"; here mental and manual labor are completely divorced from each other. The commodities being produced are intended for the tourist market. They are quite literally folkloric handicrafts, but the film's depiction of the production process undermines the romanticism associated with such objects. Nowhere in the representation is there a hint of a metaphysics of labor. Only *Dough* comes close to delivering the usual satisfactions of processual representation as the spectator is challenged to order the steps of the process. But even in this case, the piece puns on any romantic characterization of work that would resignify toil as akin to "smelling the flowers." Smelling the flowers are precisely the terms of Raqui's alienation.

The spoofs ultimately target the logocentrism of processual representation, transforming it into a vehicle for the comedic. But they do something else. By riffing on the genre's dated, analog character, they in effect allegorize the genre's relation to the expanded Machine Age. If the process genre belongs to that world—of artisans, physical skills, and machines with "distinguishable 'parts,'" as Frampton says—and that world has faded, what is the representational form suited to the present landscape of work? The spoofs' historicizing gesture is not reassuring so much as it is disorienting. Refusing the satisfactions of processual representation, the spoofs refuse its consolations and its utopian horizons. But they offer their own provocations. Unlike contemporary process films, which are often nostalgic and poignant, these processual spoofs are vital—and nihilist. They seem to declaim, "The process genre is dead. What will the process genre become?"

NOTES

ACKNOWLEDGMENTS

1 Carlos Alberto Mattos, *Vladimir Carvalho: Pedras na lua e pelejas no planalto* (São Paulo: Imprensa Oficial, 2008), 36, my translation.

INTRODUCTION

Epigraph: Marion Foster Washburne, "A Labor Museum," *Craftsman* 6, no. 6 (September 1904): 573–74.

1 Jane Addams, "First Report of the Labor Museum at Hull House, 1901–1902," 1902, 4, accessed November 7, 2018, https://digital.janeaddams .ramapo.edu/items/show/1189.

2 For a recent popular treatment of the world of YouTube how-tos, see Kevin Allocca, *Videocracy: How YouTube Is Changing the World . . . with Double Rainbows, Singing Foxes, and Other Trends We Can't Stop Watching* (New York: Bloomsbury, 2018).

3 Robert Pirsig, *Zen and the Art of Motorcycle Maintenance: An Inquiry into Values* (New York: Harper Torch, 2006); Richard Sennett, *The Craftsman* (New Haven, CT: Yale University Press, 2008); Matthew Crawford, *Shop Class as Soulcraft: An Inquiry into the Value of Work* (New York: Penguin, 2010); Charles Jencks and Nathan Silver, *Adhocism: The Case for Improvisation* (Cambridge, MA: MIT Press, 2013); James Livingston, *No More Work: Why Full Employment Is a Bad Idea* (Chapel Hill: University of North Carolina Press, 2016). Other recent treatments of craft and work include Alain de Botton, *The Pleasures and Sorrows of Work* (New York: Pantheon, 2009); Christopher Frayling, *On Craftsmanship: Toward a New Bauhaus* (London: Oberon Books, 2011); Kathi Weeks, *The Problem with Work: Feminism,*

Marxism, Antiwork Politics, and Postwork Imaginaries (Durham, NC: Duke University Press, 2011); James Livingston, *Against Thrift: Why Consumer Culture Is Good for the Economy, the Environment, and Your Soul* (New York: Basic, 2011); David Esterly, *The Lost Carving: A Journey to the Heart of Making* (New York: Penguin, 2013); Peter Korn, *Why We Make Things and Why It Matters: The Education of a Craftsman* (Boston, MA: David Godine, 2015); Richard Ocejo, *Masters of Craft: Old Jobs in the New Urban Economy* (Princeton, NJ: Princeton University Press, 2017). There have also been recent film programs and art exhibitions devoted to work and craft. For example, in 2010 the Flaherty Seminar, curated by Dennis Lim, was devoted to the theme of "Work"; in 2014, the Oriental Institute of the University of Chicago mounted the special exhibition "Our Work: Modern Jobs— Ancient Origins"; between November 2013 and August 2015, Gallery 400 at the University of Illinois, Chicago, hosted a series of exhibitions under the title "Standard of Living: Work, Economics, Communities"; in the spring of 2016, New York City's Museum of Arts and Design ran the exhibition *In Time (The Rhythm of the Workshop)*, which included a companion film program. Then there is Antje Ehmann and Harun Farocki's ongoing project, Labour in a Single Shot, begun in 2011 and featuring more than 475 short films about work.

4 For more titles, see Martin Loiperdinger, "Early Industrial Moving Pictures in Germany," in *Films That Work: Industrial Film and the Productivity of Media*, ed. Vinzenz Hediger and Patrick Vonderau (Amsterdam: Amsterdam University Press, 2009), 65–74; also see Jennifer Lynn Peterson, "Industrial Films," in *Encyclopedia of Early Cinema*, ed. Richard Abel (London: Routledge, 2005), 320–23.

5 For more on the relation of the industrial to the process film, see Patrick Russell, "From Acorn to Oak: Industrial and Corporate Films in Britain," accessed May 3, 2018, https://www.academia.edu/16506574/From_Acorn _to_Oak_Industrial_and_Corporate_Films_in_Britain_Business_Archives _2011_.

6 Tom Gunning, "Before Documentary: Early Nonfiction Films and the 'View' Aesthetic," in *Uncharted Territory: Essays on Early Nonfiction Film*, ed. Daan Hertogs and Nico de Klerk (Amsterdam: Stichting Nederlands Filmmuseum, 1997), 9–25. Jennifer Peterson has included earlier (late 1800s) single-shot films in the category that she terms "industrial films," which, as I say, corresponds roughly with what Gunning means by "process film": see Peterson, "Industrial Films," 320–23.

7 Alison Griffiths, for example, refers in one place to "ethnographic process films" to describe the German film *Der Mauerische Töpfer* (The Moroccan Potter [1910]): see Alison Griffiths, *Wondrous Difference: Cinema, Anthropology, and Turn-of-the-Century Visual Culture* (New York: Columbia University Press, 2002). Even when the term is not reserved for production in the pre-documentary period, it is treated as a self-evident rhetorical structure. Charles Tepperman, for example, in a discussion of amateur filmmaking, refers to Grierson's *Drifters* (1929) as a process film and to the

amateur film *Ceramics* (Kenneth Bloomer and Elizabeth Sansom, 1933) as one of the more interesting process films because it recognizes "moments of visual affinity between process and camera," thereby displaying photogénie: Charles Tepperman, "Mechanical Craftsmanship: Amateurs Making Practical Films," in *Useful Cinema*, ed. Charles R. Acland and Haidee Wasson (Durham, NC: Duke University Press, 2011), 293–94. Still, the reference is made in passing. To date, the volume with most mentions of the process film (where it is treated as a rhetoric) is Hediger and Vonderau, *Films That Work*. But there also, the category is not theorized.

8 Peterson, "Industrial Films," 322.

9 Throughout this book, I use English translations of foreign language film titles unless the film is more widely recognized by its original language title.

10 See P. Adam Sitney, "The Rhetoric of Robert Bresson: From *Le Journal d'un Curé de Campagne* to *Une Femme Douce*," in *Robert Bresson*, ed. James Quandt (Toronto: Toronto International Film Festival Group, 1998). Sitney used the phrase "process sequence" in passing to refer to Robert Bresson's famous montages illustrating the craft of pickpocketing in *Pickpocket* and to the series of sequences in *A Man Escaped* devoted to documenting the protagonist's prison escape. I say more about *A Man Escaped* in chapter 2.

11 When the film won an award in Bratislava, the award certificate came with these words of praise: "For showing us how long it takes to water the long and dusty road to heaven."

12 In narrative theory, the scalar approach has been applied to the idea of "narrativity." David Herman, for example, considers narrativity a "scalar predicate" rather than a "binary predicate": something is more or less paradigmatically story-like rather than a story or not a story: David Herman, *Story Logic: Problems and Possibilities of Narrative* (Lincoln: University of Nebraska Press, 2004). This scalar methodological approach is sometimes called "classification by prototype": John Frow, *Genre*, 2d ed. (London: Routledge, 2014).

13 Later I consider process films that present the steps in a process out of sequence. This out-of-order presentation does not pose a problem for the category, because even when the steps are out of order in the plot, it is expected that the viewer will reorder them chronologically, as is done with any narrative. The spectator reconstructs the story from the information provided by the plot.

14 Ivone Margulies, *Nothing Happens: Chantal Akerman's Hyperrealist Everyday* (Durham, NC: Duke University Press, 1996), 66. Margulies uses "synecdochal tag" as a contrast to Chantal Akerman's formal treatment of domestic labor in the film *Jeanne Dielman, 23 Quai du Commerce, 1080 Bruxelles*. The idea is that a (temporal) *part* of an action stands in for the action in its temporal entirety. So, if tooth brushing takes about thirty seconds, in real time, from start to finish, it is tagged synecdochally when it takes up only ten seconds of screen time.

15 Live demonstrations have developed ways to condense time. In a live cooking demonstration, when something has to marinate or bake, the host might prepare two batches—one in front of the live audience and one ahead of time—so that, rather than waiting in real time for the process of marination or baking to finish, the cook can pull out the batch that was marinated or baked ahead of time and go on with the demonstration without pausing.

16 Hediger and Vonderau, in a short passage, have also noted similarities between industrial process films and the plates of the *Encyclopédie*: see Vinzenz Hediger and Patrick Vonderau, "Record, Rhetoric, Rationalization," in Hediger and Vonderau, *Films That Work*, 35–50.

17 Of course, we could argue about whether these are processes. What speaks for their being processes is that they have results and a repeatable, cyclical character—one gallop, one step, one rowing cycle brings the subject into position to initiate the next gallop, step, or rowing cycle.

18 See the treatment of Muybridge's placement of images in Marta Braun, *Picturing Time: The Work of Etienne-Jules Marey*, repr. ed. (Chicago: University of Chicago Press, 1995).

19 For more on media studies approaches to ASMR, see Joceline Andersen, "Now You've Got the Shiveries: Affect, Intimacy, and the ASMR Whisper Community," *Television and New Media* 16, no. 8 (December 1, 2015): 683–700; Michael Connor, "Notes on ASMR, Massumi and the Joy of Digital Painting," *Rhizome* (blog), May 8, 2013, accessed May 6, 2019, http://rhizome.org/editorial/2013/may/08/notes-asmr-massumi-and -joy-digital-painting/; Rob Gallagher, "Eliciting Euphoria Online: The Aesthetics of 'ASMR' Video Culture," *Film Criticism* 40, no. 2 (June 2016), accessed May 6, 2019, https://quod.lib.umich.edu/f/fc/13761232.0040.202 /--eliciting-euphoria-online-the-aesthetics-of-asmr-video?rgn=main;view =fulltext.

20 See, e.g., "Big Sister Does Your Makeup Roleplay (Whispered)," YouTube, May 4, 2017, https://www.youtube.com/watch?v=-6yb8IL_a4o; "Male Grooming Session: Beard Trim and Haircut," YouTube, August 5, 2013, https://www.youtube.com/watch?v=PS4VBMshLMc; "Dressing Your Wounds—A Wounded Soldier—Nurse Roleplay," YouTube, August 29, 2016, https://www.youtube.com/watch?v=Z4AI8u4rPvM.

21 There are several ASMR triggering videos that do use processual representation—in particular, those available on the Unintentional ASMR YouTube channel.

22 See Robert Bresson and J. M. G. Le Clézio, *Notes on the Cinematograph*, trans. Jonathan Griffin (New York: New York Review of Books Classics, 2016).

23 Having said this, one might wonder about parallel editing as a kind of interruption. I have in mind cutting back and forth from one process to another. Surely, parallel editing between processes is a kind of interruption that weakens the absorption of observing each distinct process. Still, it is relatively common in process films and is a different kind of inter-

ruption from one that involves experimentation, on-the-job learning, or non-processual coffee breaks.

24 There are other films about work—even factory work—that refuse processual treatments (though they are not anti-process). Michael Glawogger's *Workingman's Death* (2005) is one example. Another recent one is *Machines* (Rahul Jain, India/Germany/Finland, 2016), which films, in an observational vein, the work of people and machines in a textile factory in Gujarat, India. Still, the portrait is noticeably not processual. Jain has suggested in an interview that he had rejected early on a processual syntax: "I made 60 cuts in the editing room of the film. . . . The first one was a very linear way of how the fabric was made just because it was easy to set up like that, but it was a total disaster. It felt like an infomercial that would air at 2 a.m. in the night. From the beginning I did have the sense that I did want to leave the film open-ended because for me, I was not trying to provide any answers about what this is or how this is done." I say more about anti-process films in chapter 5. See Jean Bentley, "'Machines' Director Rahul Jain Wanted to Ask a Very Simple Question with His Film—Watch," *IndieWire*, December 8, 2017, accessed June 3, 2019, https://www.indiewire.com/2017/12/machines-documentary-rahul-jain-interview-1201898134/. Of course, the politics of non-processual treatments of labor, inside and outside the factory system, vary—as these two examples suggest.

25 For a detailed theoretical treatment of the opening of *Modern Times*, see Garrett Stewart, *Between Film and Screen: Modernism's Photo Synthesis* (Chicago: University of Chicago Press, 2000).

26 Serial representations of plant and animal life cycles (e.g., Percy Smith's *The Birth of a Flower* [1910] and Painlevé's *The Seahorse* [1934] or *The Vampire* [1945]) are ambiguously related to the process genre. For a fascinating account of the historical role of processual instructional graphics (i.e., pictorial instructions) that depicted bodily movement in the development of the serial iconography used later in embryology, see Janina Wellmann, *The Form of Becoming: Embryology and the Epistemology of Rhythm, 1760–1830*, trans. Kate Sturge (New York: Zone, 2017). Wellman traces the representational conventions used in depictions of organic development to sixteenth-century pictorial instructions in combat skills.

27 Perhaps one could conjure up a drawn or computer-generated processual sequence that tries to render these activities as chronologically unfolding processes (visualization diagrams including some process diagrams and maps attempt something like this), but it would be somewhat difficult. This suggests processual representation's natural attraction to visible movement.

28 Braun, *Picturing Time*.

29 Washburne, "A Labor Museum," 574.

30 For a synthetic art-history treatment of the role of process in art making, in art theory, and in the genre called process art, see Kim Grant, *All about Process: The Theory and Discourse of Modern Artistic Labor* (University Park: Pennsylvania State University Press, 2017).

31 What I have in mind here is not a "making of" or "behind-the-scenes" approach to *Revelations*, for that sort of approach can fit more squarely within the genre. Frederick Wiseman's *La Danse: The Paris Opera Ballet* (2009) is an interesting case in this regard because it contains processual dance sequences and moves roughly from rehearsals to performances and covers several steps in between.

32 Jamie Hook, "Love Made Visible, or Why *Rififi* Is a Perfect Film," *The Stranger*, October 21, 2000, accessed September 29, 2014, http://www.thestranger.com/seattle/love-made-visible/Content?oid=5229; Pauline Kael, *5001 Nights at the Movies* (New York: Picador, 1991), 629–30.

33 Jacques Guicharnaud and Cynthia Goldman, "Of Grisbi, Chnouf and Rififi," *Yale French Studies*, no. 17 (January 1, 1956): 11.

34 David MacDougall, *Transcultural Cinema* (Princeton, NJ: Princeton University Press, 1998), 104, emphasis added.

35 R. H. Sherard, "Jules Verne at Home: His Own Account of His Life and Work," *McClure's Magazine* 2, no. 2 (January 1894): 118.

36 Lorene Kimball Fox, Peggy Brogan, and Annie Louise Butler, *All Children Want to Learn: A Guide for Parents* (New York: Grolier Society, 1954), 87.

37 Otto Mayr, ed., *Philosophers and Machines* (New York: Science History Publications, 1976), 4.

38 Another recent and related phenomenon is the popularity of Oddly Satisfying, a subreddit established in 2013 with millions of subscribers today. Oddly Satisfying videos—which are ubiquitous on YouTube and Instagram—include several processual video clips. For a recent article on the phenomenon rooting around for the explanation for its effects, see Emily Matchar, "Finding What's 'Oddly Satisfying' on the Internet," *New York Times*, February 22, 2019, accessed June 2, 2019, https://www.nytimes.com/2019/02/22/opinion/sunday/oddly-satisfying-videos-internet.html.

39 Dayna Evans, "Why These Recipe Videos Are Taking Over Your Facebook Wall," *The Cut*, March 23, 2016, accessed May 5, 2019, https://www.thecut.com/2016/03/zen-and-the-art-of-the-buzzfeed-tasty-video.html.

40 Rita Felski, *Uses of Literature* (Malden, MA: Wiley-Blackwell, 2008), 55, emphasis added.

41 Michael Fried, *Absorption and Theatricality: Painting and Beholder in the Age of Diderot* (Chicago: University of Chicago Press, 1988), 10; Michael Fried, *Art and Objecthood: Essays and Reviews* (Chicago: University of Chicago Press, 1998).

42 John Dewey, *Art as Experience* (New York: Penguin, 2005), 3.

43 Mihaly Csikszentmihalyi, *Applications of Flow in Human Development and Education: The Collected Works of Mihaly Csikszentmihalyi* (New York: Springer, 2014), 379.

44 Tom Gunning, "The Cinema of Attractions: Early Film, Its Spectator and the Avant-Garde," *Wide Angle* 8, nos. 3–4 (1986): 63–70.

45 Janice Radway, *A Feeling for Books: The Book-of-the-Month Club, Literary Taste, and Middle-Class Desire* (Chapel Hill: University of North Carolina Press, 1997), 13.

46 Victor Nell, *Lost in a Book: The Psychology of Reading for Pleasure* (New Haven, CT: Yale University Press, 1990), 2.

47 Nell, *Lost in a Book*, 48.

48 Peter Hühn, *Eventfulness in British Fiction* (New York: De Gruyter, 2010), 2.

49 Amanda Hess, "The Hand Has Its Social Media Moment," *New York Times*, October 11, 2017, accessed May 6, 2019, https://www.nytimes.com/2017/10/11/arts/online-video-hands-buzzfeed-tasty-facebook.html.

50 I do not distinguish between "work" and "labor" but, rather, use the terms more or less interchangeably. While there are philological accounts of the historical difference between these words, the most compelling philosophical argument for such a distinction is in Hannah Arendt's *The Human Condition* and depends on the impermanence, perishability, and consumption (rather than use) of the products produced through labor as opposed to the relative stability and durability of the objects produced through work. For Arendt, human labor is little different from what nonhuman animals engage in to meet their subsistence needs. That is why she terms the human laborer an *animal laborans* and the human engaged in work a *homo faber*: see Hannah Arendt, *The Human Condition*, 2d ed. (Chicago: University of Chicago Press, 1998). But I do not ultimately find this comparison quite right; farming (labor) and pot making (work) both involve design, premeditation, organization, intention, variation, adaptability, and so on. Farming or humans' hunting is a different *kind* of activity from wolves' hunting. For critiques of Arendt's distinction between work and labor, see Mildred Bakan, "Hannah Arendt's Concepts of Labor and Work," in *Hannah Arendt: The Recovery of the Public World*, ed. Melvyn Hill (New York: St. Martin's, 1979), 49–66; Axel Honneth and Mitchell G. Ash, "Work and Instrumental Action," *New German Critique*, no. 26 (1982): 31–54; Sean Sayers, "The Concept of Labor: Marx and His Critics," *Science and Society* 71, no. 4 (2007): 431–54. For standard philological treatments of the two terms, see Hannah Arendt, "Labor, Work, Action," in *The Phenomenology Reader*, ed. Dermot Moran and Timothy Mooney (London: Routledge, 2002), 362–74; Frederick C. Gamst, "Considerations of Work," in *Meanings of Work: Considerations for the Twenty-First Century*, ed. Frederick C. Gamst (Albany: State University of New York Press, 1995), 1–45; Maurice Godelier, "Work and Its Representations: A Research Proposal," in *History Workshop Journal* 10 (1980): 164–74; Raymond Williams, *Keywords: A Vocabulary of Culture and Society*, rev. ed. (Oxford: Oxford University Press, 1985).

51 For this approach to labor, see the work of Sean Sayers, esp. Sayers, "The Concept of Labor."

52 Marcel Mauss, *Techniques, Technology, and Civilisation*, ed. Nathan Schlanger (Oxford: Berghahn, 2006), 82, 149. Mauss initially included religious rituals and artistic expressions in his definition of technique, though he would designate the difference between the use of technique in rituals and the use of technique to achieve "a mechanical, physical, or chemical effect" (98) as a matter of the intention and self-understanding of the agents. In later formulations, Mauss would explicitly exclude "those

religious or artistic techniques, whose actions are also often traditional and technical, but whose aim is always different from a purely material one and whose means, even when they overlap with a technique, always differ from it" (149). Mauss's distinction within the sphere of the "technical" aims at separating the sphere of art from technology, for to speak of artistic expression and religious ritual as technology would sow some confusion. Tim Ingold has faulted Mauss and others for imposing this artificial distinction. Ingold insists that the distinction between art and technology is relatively new, dating back to the late eighteenth century with the codification of the intellectual/manual labor divide. Ingold writes, "Where technological operations are predetermined, art is spontaneous; where the manufacture of artifacts is a process of mechanical replication, art is the creative production of novelty. These distinctions can be multiplied almost indefinitely, but they are all driven by the same logic, which is one that carves out a space for human freedom and subjectivity in a world governed by objective necessity." In contrast to this state of affairs, which is "closely tied to the rise of a peculiarly modern conception of the human subject," Ingold looks toward the classical Greek notions of *ars* (art) and *tekhne* (technology), which were very close in meaning: both meaning skill, of the sort tied to craftsmanship: see Tim Ingold, "Beyond Art and Technology: The Anthropology of Skill," in *Anthropological Perspectives on Technology*, ed. Michael Brian Schiffer (Albuquerque: University of New Mexico Press, 2001), 17–18. In fairness to Mauss, whereas he does acknowledge the unity of technique as encompassing art *and* ritual, he tries to separate out the category of technique that is *solely* concerned with practical usefulness because, like Ingold, he is interested in skill. Moreover, just because there was little distinction between art and technology in classical Greece does not mean that since then the phenomena to which art and technology refer have developed along the same path. For another critique of the separation between art and technology, see Alfred Gell, "The Technology of Enchantment and the Enchantment of Technology," in *Anthropology, Art and Aesthetics*, ed. Jeremy Coote and Anthony Shelton (Oxford: Clarendon Press, 1992), 40–63.

53 Marcel Mauss, "Techniques of the Body," in *Incorporations*, ed. Jonathan Crary and Sanford Kwinter (New York: Zone, 1992), 458.

54 Mauss, "Techniques of the Body," 464.

55 Sennett, *The Craftsman*, 9. C. Wright Mills also has this view: see C. Wright Mills, *White Collar: The American Middle Classes* (New York: Oxford University Press, 1951). See also Harold Osborne, "The Aesthetic Concept of Craftsmanship," *British Journal of Aesthetics* 17, no. 2 (1977): 138–48; David Pye, *The Nature and Art of Workmanship* (Cambridge: Cambridge University Press, 1968).

56 Guicharnaud and Goldman, "Of Grisbi, Chnouf and Rififi," 12.

57 Peter Dormer, "Craft and the Turing Test for Practical Thinking," in *The Culture of Craft*, ed. Peter Dormer (Manchester, U.K.: Manchester University Press, 1997), 139.

58 For this view, see Paul Greenhalgh, "The Progress of Captain Ludd," in Dormer, *The Culture of Craft*, 104–15.

59 Dormer, "Craft and the Turing Test for Practical Thinking," 140.

60 It is controversial to assimilate design and craft. However, they have much in common; their histories are intertwined, and their separation from each other has been relatively recent. The point here is merely that the work of a designer of machines is similar to part of the work of the craftsman in that both do the work of conception. When one admires the work of the craftsman that one has personally observed, one must be partly admiring a design, a conception, that has turned out to be effective. For more on the distinction between design and craft, see Paul Greenhalgh, "The History of Craft," in Dormer, *The Culture of Craft*, 20–52; Howard Risatti, *Theory of Craft: Function and Aesthetic Expression* (Chapel Hill: University of North Carolina Press, 2009).

61 Samuel Griswold Goodrich, *Enterprise, Industry and Art of Man: As Displayed in Fishing, Hunting, Commerce, Navigation, Mining, Agriculture and Manufactures* (Boston: Thompson, Brown and Company, 1845), 327–28.

62 There is a relevant corollary to this—namely, the commonplace treatment of bird's nest building as a kind of craft. The Brazilian filmmaker Humberto Mauro, who in the 1930s–1950s was a prolific maker of process films about industrial as well as artisanal processes, made two versions of the same film about the autochthonous red ovenbird's fabrication of an unusual covered nest. *O João de Barro* (1956) is the most accomplished and rigorously processual, depicting as one would do with biscuit fabrication the steps in the construction of the nest. The temptation to assimilate the "skill" of birds to skill in humans is also exhibited in the anthropologist Tim Ingold's essay on the anthropology of skill, in which he describes the nest-building practices of weaver birds: see Ingold, "Beyond Art and Technology."

63 Dormer, "Craft and the Turing Test for Practical Thinking," 143.

64 Roland Barthes, "The Plates of the *Encyclopedia*," in *New Critical Essays* (Evanston, IL: Northwestern University Press, 2009), 32. For a contrary treatment of the ideology of the plates of the encyclopedia, see Daniel Brewer, "The Work of the Image: The Plates of the *Encyclopédie*," in *A History of Book Illustration: 29 Points of View*, ed. Bill Katz (Metuchen, NJ: Scarecrow Press, 1994).

65 See Sennett, *The Craftsman*.

66 Ingold, "Beyond Art and Technology," 20.

67 See Gregory Bateson, *Steps to an Ecology of Mind: Collected Essays in Anthropology, Psychiatry, Evolution, and Epistemology* (Chicago: University of Chicago Press, 2000).

68 For more on kinesthetic empathy, see Dee Reynolds and Matthew Reason, eds., *Kinesthetic Empathy in Creative and Cultural Practices* (Bristol, U.K.: Intellect, 2012).

69 Ingold, "Beyond Art and Technology," 22.

70 I am using the term "identification" loosely here. For more on the range of phenomena encompassed by motor empathy, from accompaniment,

imitation, and "proximity at a distance" to fusion and projection, see Adriano D'Aloia, "Cinematic Empathy: Spectator Involvement in the Film Experience," in Reynolds and Reason, *Kinesthetic Empathy in Creative and Cultural Practices*, 91–108.

71 Kael, *5001 Nights at the Movies*, 629.

72 Guicharnaud and Goldman, "Of Grisbi, Chnouf and Rififi," 11.

73 Roger Ebert, "*Rififi* Movie Review and Film Summary (1954)," accessed October 3, 2014, http://www.rogerebert.com/reviews/great-movie-rififi-1954.

74 Roger Ebert, "*Pickpocket* Movie Review and Film Summary (1959)," accessed September 24, 2014, http://www.rogerebert.com/reviews/great-movie-pickpocket-1959.

75 Bill Nichols introduced the term "epistephilia" into his discussion of documentary realist conventions to signal that the pleasure in knowing that characterizes documentary constitutes a "distinctive" yet far from innocent "form of social engagement": Bill Nichols, *Representing Reality: Issues and Concepts in Documentary* (Bloomington: Indiana University Press, 1991), 178. The idea is that documentary nurtures this pleasure in knowing by proposing documentary itself as a source of knowledge about the real world. I use "epistephilia" here only to point out that part of the pleasure of processual representation also derives from a pleasure in knowing and a desire to know.

76 John Pannabecker has insisted on the ideological diversity of the *Encyclopédie*'s written entries and its illustrations. Some entries, such as those by Diderot and Goussier, have the tone of lectures or reports or a dialogue between businessmen, while others, such as those by Prévost, Brullé, and Watelet, take the tone of a teacher initiating a student into an unfamiliar craft: see John R. Pannabecker, "Representing Mechanical Arts in Diderot's *Encyclopédie*," *Technology and Culture* 39, no. 1 (1998): 33–73.

77 Jacques Payen, "The Plates of the Encyclopedia and the Development of Technology in the Eighteenth Century," in *Diderot Encyclopedia: The Complete Illustrations, 1762–1777*, ed. Harry N. Abrams (New York: Harry N. Abrams, 1981), xi–xxx.

78 William Reddy, "The Structure of a Cultural Crisis: Thinking about Cloth in France before and after the Revolution," in *The Social Life of Things: Commodities in Cultural Perspective*, ed. Arjun Appadurai (Cambridge: Cambridge University Press, 1986), 264. Reddy's essay provides a relevant account of the rising importance of the merchant-connoisseur in eighteenth-century France and his dependence on accurate information about production processes (presumably including image-based processual representations) for this work.

79 Barthes, "The Plates of the *Encyclopedia*," 39.

80 Barthes, "The Plates of the *Encyclopedia*."

81 Barthes, "The Plates of the *Encyclopedia*," 32.

82 Barthes, "The Plates of the *Encyclopedia*," 33. One odd feature of Barthes's taxonomy is that, while he introduces it as a tripartite classification in the first few pages of the essay, in the latter part of the essay he reverts to

a bipartite classification that corresponds better to the linguistic analogy he wishes to make. In the bipartite classification, the genetic and the tableau vivant are folded into the single category of the "vignette." In the linguistic analogy, the "vignette" occupies the "syntagmatic dimension of language"; the "anthological" image, the paradigmatic dimension: see Barthes, "The Plates of the *Encyclopedia*."

83 Smith and others researchers of the early modern period have argued that the supposed gulf between the world of craft and the world of science was overstated. Craftsman were not only keepers of traditional knowledge; they were experimenters and creators of new knowledge. In other words, the scientific revolution owes a lot to the work of artisans: see Pamela O. Long, *Artisan/Practitioners and the Rise of the New Sciences, 1400–1600* (Corvallis: Oregon State University Press, 2011); Pamela H. Smith, *The Body of the Artisan: Art and Experience in the Scientific Revolution* (Chicago: University of Chicago Press, 2006).

84 Smith, *The Body of the Artisan*.

85 Pamela Smith, "Making Things: Techniques and Books in Early Modern Europe," in *Early Modern Things: Objects and Their Histories, 1500–1800*, ed. Paula Findlen (New York: Routledge, 2012), 173–203.

86 Sennett, *The Craftsman*, 95.

87 The literature on genre is vast and diverse, and I will not survey it here. I only intend to give some indication of why I have used the notion of genre to talk about processual representation. I consider the definitions I am using basic and widely agreed on.

88 For this debate, see Rick Altman, *Film/Genre* (London: British Film Institute, 1999); Rick Altman, "Reusable Packaging: Generic Products and the Recycling Process," in *Refiguring American Film Genres: History and Theory*, ed. Nick Browne (Berkeley: University of California Press, 1998), 1–41; Tom Gunning, "'Those Drawn with a Very Fine Camel's Hair Brush': The Origins of Film Genres," IRIS-PARIS 20 (1995): 49–62.

89 Topoi usually refer to motifs, clichés, and repeated formulas contained *within* a media artifact rather than to the organizing structure of the work as a whole. In other words, if one were to treat processual representation as a topos, one might expect to find processual *moments* or *bits* in a number of media objects across time and space. And surely this is the case: there are many films that have processual segments. But the process genre designates works whose whole is shaped by processual representation: see Erkki Huhtamo, "Dismantling the Fairy Engine," in *Media Archaeology: Approaches, Applications, and Implications*, ed. Erkki Huhtamo and Jussi Parikka (Berkeley: University of California Press, 2011), 27–47. For examples of cinematic topoi from cinema studies that highlight the inappropriateness of the term for the process genre, see Alison Griffiths, "The Untrammeled Camera: A Topos of the Expedition Film," *Film History* 25, no. 1 (April 28, 2013): 95–109; Priya Jaikumar, "Haveli: A Cinematic Topos," *Positions* 25, no. 1 (February 1, 2017): 223–48. "Subgenre" might be another tempting term. But apprehending the process phenomenon as a

subgenre of the industrial or educational film or as merely a genre of early cinema is inappropriate in that, as I have tried to show, processual representation is employed in a range of genres and cannot be restricted to the period of early cinema or even to cinema as a medium. While "form"—as in literary forms such as nonfiction prose, fiction prose, poetry, drama, or fable or film forms such as documentary and experimental film—classifies according to the structure and organization of the whole, forms are agnostic in regard to subject matter and thematic content. While it is the case that most examples of the process genre are characterized by an overarching formal structure, my contention has been that they also encompass thematic concerns with technique, skill, and civilizational development. Processual representation understood as a film form comparable to documentary or experimental film or the short film is too broad and unspecific as a category designation.

90 David Duff, *Modern Genre Theory* (London: Routledge, 2014). See also Frow, *Genre*, xv.

91 Fredric Jameson, "Magical Narratives: On the Dialectical Use of Genre Criticism," in Duff, *Modern Genre Theory*, 168.

92 Jameson, "Magical Narratives," 168

93 Peter Brooks, *The Melodramatic Imagination: Balzac, Henry James, Melodrama, and the Mode of Excess* (New Haven, CT: Yale University Press, 1976), 148, xvii, vii.

94 Linda Williams, *Playing the Race Card: Melodramas of Black and White from Uncle Tom to O. J. Simpson* (Princeton, NJ: Princeton University Press, 2002).

95 For more on this distinction, see Altman, "Reusable Packaging"; Gunning, "Those Drawn with a Very Fine Camel's Hair Brush."

96 See Rick Altman, "A Semantic/Syntactic Approach to Film Genre," *Cinema Journal* 23, no. 3 (1984): 6–18. The distinction between "semantic" and "syntactic" in Altman is a bit tricky because his examples of syntactical approaches to the Western (e.g., Kitses's argument that the Western "grows out of a dialectic" between culture and nature) sound more thematic (along the lines of Jameson's understanding) than formal. Meanwhile, by "semantic" Altman means "lexical units" rather than "global meaning." Altman acknowledges that his definition of "semantic" differs from Jameson's definition in footnote 4.

97 Though it should be added that processual syntax is not the *kind* of syntactic, formal dimension that scholars of genre usually have in mind when they discuss a genre's syntactic structures.

98 It might be interesting to compare my approach to these three proximate scholarly projects that also grapple with the seductions of process in diverse cultural forms: Neil Harris's notion of the "operational aesthetic," which he first applied to P. T. Barnum's nineteenth-century amusements; Victoria Cain's "craftsmanship aesthetic," which refers to the interest Americans took in artisanal craft making between 1910 and 1945; and Ann-Sophie Lehmann's "showing making," which designates a transhis-

torical genre devoted to images of people making something. The three frameworks amount to three different efforts to demarcate and analyze a category of cultural production. While the process genre is related to these three concepts, I frame the "object" of study differently. This difference has a lot to do with my view that the process genre is best understood as a genre rather than as a mode. Harris, Cain, and Lehmann understand their respective phenomena as modes. Harris's operational aesthetic corresponds most closely to a mode in the sense that the operational aesthetic is thematically specific in this more robust sense of "generalized existential experience," but it is not formally specific—it includes how-to manuals and Barnum's nonprocessual performances. Harris's apprehension of the phenomenon looks deeply into it, exposing something more than merely semantic elements such as the presence of devices. Harris lights on a kind of spirit animating all of the operational aesthetic's expressions—namely, "a delight in observing process and examining for literal truth": Harris, *Humbug*, 79. Cain's designation, the "craftsmanship aesthetic," is also thematically specific, though in a less robust sense in that the thematic unity is defined by common semantic elements including the presence of craftsmen, workshops, and tasks. Still, the thematic unity approaches a "worldview" when Cain writes, for example, "The aesthetic celebrated the satisfactions of labor, placing human presence squarely at the center of its representation. It exalted the relationships among worker, skill, and tool. The sight of craftspeople gradually, lovingly shaping material into useful or impressive objects resonated with a public struggling with the new dynamics of scientifically managed corporations": Victoria E. M. Cain, "The Craftsmanship Aesthetic: Showing Making at the American Museum of Natural History, 1910–45," *Journal of Modern Craft* 5, no. 1 (March 1, 2012): 27. But the craftsmanship aesthetic is even less formally specific than the operational aesthetic: after all, it includes craft demonstrations as well as still photographs of American Museum of Natural History taxidermists at work. Finally, while Lehmann describes "showing making" as a genre, she treats it more as a mode. Showing making is thematically specific in the least robust sense; it is constituted by purely semantic elements—the presence of people, tools, and objects— and means many things. Meanwhile, showing making is formally nonspecific; it includes YouTube demonstrations of kneading clay, as well as flat Egyptian murals from 1400 BC and early modern portraits of artists: Ann-Sophie Lehmann, "Showing Making: On Visual Documentation and Creative Practice," *Journal of Modern Craft* 5, no. 1 (March 1, 2012): 9–23.

99 Gunning, "Those Drawn with a Very Fine Camel's Hair Brush."

100 For the debate about the significance of the emergence of digital technology for cinema's purported indexicality, see André Gaudreault and Philippe Marion, *The End of Cinema? A Medium in Crisis in the Digital Age* (New York: Columbia University Press, 2015); Tom Gunning, "What's the Point of an Index? Or, Faking Photographs," *Nordicom Review* 5, nos. 1–2 (2004): 39–49; Lev Manovich, *The Language of New Media*, rev. ed. (Cambridge,

MA: MIT Press, 2002); D. N. Rodowick, *The Virtual Life of Film* (Cambridge, MA: Harvard University Press, 2007); David Thorburn and Henry Jenkins, eds., *Rethinking Media Change: The Aesthetics of Transition* (Cambridge, MA: MIT Press, 2004). The point I am making here is a modest one: digital and analog recording (along with digital playback technology) standardly use—even if only metaphorically, not literally, as with photochemical technology—the concept of frame rate.

101 Charles Musser, *The Emergence of Cinema: The American Screen to 1907* (Berkeley: University of California Press, 1990).

102 As Haidee Wasson and Charles R. Acland understand it, "useful cinema" is "a body of films and technologies that perform tasks and serve as instruments in an ongoing struggle for aesthetic, social, and political capital": Haidee Wasson and Charles R. Acland, "Introduction: Utility and Cinema," in *Useful Cinema*, ed. Charles R. Acland and Haidee Wasson (Durham, NC: Duke University Press, 2011), 3.

CHAPTER ONE. THE PROCESS FILM IN CONTEXT

1 The picture I paint here is set in Europe and the United States, but I can imagine a parallel account of emergence, development, and diffusion focused on a different geographical context, such as Asia or the Middle East. Explorations of processual syntax outside the West could provide useful comparative cases. Along these lines, from 2014 to 2016, the Neubauer Collegium for Culture and Society at the University of Chicago sponsored the project "Knowing and Doing: Text and Labor in Asian Handwork," which organized three conferences devoted to exploring "the nature and history of . . . non-written forms of knowledge—farm work, construction, crafts, and skills that produce material objects" and thereby to expanding the sense of what constitutes a "text." The project was conceived and designed by Jacob Eyferth and Donald Harper. For more on representing craft knowledge in Asian contexts, see also Jacob Eyferth, "Craft Knowledge at the Interface of Written and Oral Cultures," *East Asian Science, Technology and Society* 4, no. 2 (June 1, 2010): 185–205.

2 Martin Loiperdinger, "Early Industrial Moving Pictures in Germany," in *Films That Work: Industrial Film and the Productivity of Media*, ed. Vinzenz Hediger and Patrick Vonderau (Amsterdam: Amsterdam University Press, 2009), 65–74.

3 Jennifer Lynn Peterson, "Industrial Films," in *Encyclopedia of Early Cinema*, ed. Richard Abel (London: Routledge, 2005), 320–23.

4 For accounts of the ambiguities of the "industrial film" as a generic label, see Frank Kessler and Eef Masson, "Layers of Cheese: Generic Overlap in Early Non-Fiction Films on Production Processes," in Hediger and Vonderau, *Films That Work*, 75–84; Vinzenz Hediger and Patrick Vonderau, "Record, Rhetoric, Rationalization," in Hediger and Vonderau, *Films That Work*, 35–50; Patrick Russell, "From Acorn to Oak: Industrial and Corporate Films in Britain," accessed May 3, 2018, https://www.academia.edu

/16506574/From_Acorn_to_Oak_Industrial_and_Corporate_Films_in
_Britain_Business_Archives_2011_.

5 Hediger and Vonderau, "Record, Rhetoric, Rationalization," 46.
6 Hediger and Vonderau, "Record, Rhetoric, Rationalization," 46.
7 Hediger and Vonderau, "Record, Rhetoric, Rationalization," 44.
8 Kessler and Masson, "Layers of Cheese," 75.
9 Devin Orgeron, Marsha Orgeron, and Dan Streible, "Introduction," in
 Learning with the Lights Off: Educational Film in the United States, ed. Devin
 Orgeron, Marsha Orgeron, and Dan Streible (New York: Oxford University
 Press, 2012), 9.
10 Elizabeth Wiatr, "Between Word, Image, and the Machine: Visual Educa-
 tion and Films of Industrial Process," *Historical Journal of Film, Radio and
 Television* 22, no. 3 (2002): 336–37.
11 Wiatr, "Between Word, Image, and the Machine," 336–37.
12 Wiatr, "Between Word, Image, and the Machine."
13 Wiatr, "Between Word, Image, and the Machine." For a case study of one
 Erpi process film, *The Wheat Farmer*, see Gregory A. Waller, "Cornering *The
 Wheat Farmer* (1938)," in Orgeron et al., *Learning with the Lights Off*, 249–70.
14 Oliver Gaycken, "The Cinema of the Future: Visions of the Medium as
 Modern Educator, 1895–1910," in Orgeron et al., *Learning with the Lights
 Off*, 67–89.
15 Wiatr, "Between Word, Image, and the Machine," 334.
16 Wiatr, "Between Word, Image, and the Machine," 334.
17 Wiatr, "Between Word, Image, and the Machine," 340.
18 Wiatr, "Between Word, Image, and the Machine."
19 For more on Pestalozzi and the object lesson, see Tom Gunning, "The
 World as Object Lesson: Cinema Audiences, Visual Culture and the
 St. Louis World's Fair, 1904," *Film History* 6, no. 4 (1994): 422–44; Paul
 Saettler, *The Evolution of American Educational Technology* (Greenwich, CT:
 Information Age, 2004).
20 Wiatr, "Between Word, Image, and the Machine," 349.
21 Wiatr, "Between Word, Image, and the Machine."
22 Lee Grieveson, "The Work of Film in the Age of Fordist Mechanization,"
 Cinema Journal 51, no. 3 (2012): 25–51.
23 Grieveson, "The Work of Film in the Age of Fordist Mechanization," 29.
24 Grieveson, "The Work of Film in the Age of Fordist Mechanization," 28.
25 Grieveson, "The Work of Film in the Age of Fordist Mechanization," 27.
26 See Lee Grieveson, "Visualizing Industrial Citizenship," in Orgeron et al.,
 Learning with the Lights Off, 107–23.
27 Michael Cowan, *Walter Ruttmann and the Cinema of Multiplicity: Avant-
 Garde–Advertising–Modernity* (Amsterdam: Amsterdam University Press,
 2016).
28 Cowan, *Walter Ruttmann and the Cinema of Multiplicity*, 138.
29 Cowan, *Walter Ruttmann and the Cinema of Multiplicity*, 158–59.
30 Alison Griffiths, *Wondrous Difference: Cinema, Anthropology, and Turn-of-
 the-Century Visual Culture* (New York: Columbia University Press, 2002).

31 There is a lot of debate about what constitutes ethnographic film. On one side are Jay Ruby and others, who would like to reserve the term for films made by—or with the significant input of—trained anthropologists: see Matthew Durington and Jay Ruby, "Ethnographic Film," in *Made to Be Seen: Historical Perspectives on Visual Anthropology*, ed. Marcus Banks and Jay Ruby (Chicago: University of Chicago Press, 2011), 190–208. On the other side are scholars such as Fatimah Tobing Rony, Bill Nichols, Trinh T. Minh-ha, and Alison Griffiths, all of whom have a broader conception that includes commercial films by nonprofessional ethnographers. For example, in *Wondrous Difference*, the term "ethnographic film" refers "principally to actuality films featuring native peoples that were produced by anthropologists, commercial, and amateur filmmakers alike": Griffiths, *Wondrous Difference*; xxix. For Rony, "ethnographic cinema" describes the "broad and variegated field of cinema which situates indigenous peoples in a displaced temporal realm": Fatimah Tobing Rony, *The Third Eye: Race, Cinema, and Ethnographic Spectacle* (Durham, NC: Duke University Press, 1996), 8.

32 For contemporary anthropological treatments of both, see the work of Tim Ingold, especially *Making: Anthropology, Archaeology, Art and Architecture* (London: Routledge, 2013). For more on cultural evolutionism, see Robert L. Carneiro, *Evolutionism in Cultural Anthropology: A Critical History* (Cambridge: Westview, 2003); Marvin Harris, *The Rise of Anthropological Theory: A History of Theories of Culture* (New York: Crowell, 1968).

33 Emilie Brigard, "The History of Ethnographic Film," in *Principles of Visual Anthropology* ed. Paul Hockings, 2d ed., (Berlin: Walter de Gruyter, 2012), 13–44.

34 There has been some disagreement about how to view the legacy of Félix-Louis Regnault and his importance for the history of ethnographic film. Griffiths argues that Regnault's "contributions to the prehistory of ethnographic cinema" represent a "dead end": Griffiths, *Wondrous Difference*, 123. Regnault's abiding interest in comparative motion studies (an interest he shared with Marey) was at odds with the interests of the few anthropologists who were using film in the early twentieth century to record ceremonial activities and material culture; these interests were more commercial—closer to the preoccupations of pioneers such as Edison than to the scientific concerns of Marey or Regnault. Rony, by contrast, maintains that "different national anthropological traditions had different theories about the use of ethnographic film, and yet the basic tenets which Regnault set forth underpinned popular and scientific notions of the genre across national boundaries": Rony, *The Third Eye*, 69.

35 Rony, *The Third Eye*, 231.

36 Cited in Jean Rouch, "The Camera and Man," in Hockings, *Principles of Visual Anthropology*, 81.

37 Félix-Louis Regnault and Dominique Lejard, "Poterie crue et origine du tour," *Bulletins de la Société d'Anthropologie de Paris* 4, no. 6 (1895): 737.

38 Regnault and Lejard, "Poterie crue et origine du tour," 737.

39 Paul A. Erickson and Liam Donat Murphy, *A History of Anthropological Theory* (Toronto: University of Toronto Press, 2013).

40 Lewis Henry Morgan and Eleanor Burke Leacock, *Ancient Society, or, Researches in the Lines of Human Progress from Savagery through Barbarism to Civilization* (Cleveland: Meridian, World Publishing, 1967), 9.

41 For an assessment of the controversy, see Eleanor Burke Leacock, "Introduction," in Morgan and Leacock, *Ancient Society*, li–lxx.

42 Morgan and Leacock, *Ancient Society*, 14.

43 R. Jon McGee and Richard Warms, *Anthropological Theory: An Introductory History*, 4th ed. (Boston: McGraw-Hill, 2007). For more on the relation of Morgan's evolutionism to cultural materialism, see Harris, *The Rise of Anthropological Theory*.

44 See Leacock, "Introduction"; Griffiths, *Wondrous Difference*.

45 Griffiths, *Wondrous Difference*.

46 Pliny Goddard, "Motion Picture Records of Indians," *American Museum Journal* 15 (April 1915): 185.

47 Goddard, "Motion Picture Records of Indians," 185.

48 Goddard, "Motion Picture Records of Indians," 186–87.

49 Goddard, "Motion Picture Records of Indians," 185.

50 Rony, *The Third Eye*. According to Taureg, the IWF's founders also frequently referred directly to Regnault: see Martin Taureg, "The Development of Standards for Scientific Films in German Ethnography," *Studies in Visual Communication* 9, no. 1 (1983): 19–29.

51 Rony, *The Third Eye*.

52 Taureg, "The Development of Standards for Scientific Films in German Ethnography," 22.

53 Peter Fuchs, "Ethnographic Film in Germany: An Introduction," *Visual Anthropology* 1, no. 3 (October 1988): 217–33.

54 For more on the relation between Kulturkreis theory and the project of the IWF, see Taureg, "The Development of Standards for Scientific Films in German Ethnography."

55 See Rolf Husmann, "Post-War Ethnographic Filmmaking in Germany: Peter Fuchs, the IWF and the Encyclopaedia Cinematographica," in *Memories of the Origins of Ethnographic Film*, ed. Beate Engelbrecht (Frankfurt: Peter Lang, 2007), 383–96; Taureg, "The Development of Standards for Scientific Films in German Ethnography."

56 Fuchs, "Ethnographic Film in Germany," 225.

57 Robert Cresswell (from the 1976 "Techniques and Cultures"), quoted in Ludovic Coupaye, "Ways of Enchanting: Chaînes Opératoires and Yam Cultivation in Nyamikum Village, Maprik, Papua New Guinea," *Journal of Material Culture* 14, no. 4 (December 1, 2009): 439.

58 Coupaye, "Ways of Enchanting." See also André Leroi-Gourhan, *Gesture and Speech* (Cambridge, MA: MIT Press, 1993).

59 Marcia-Anne Dobres, "Technology's Links and Chaînes: The Processual Unfolding of Technique and Technician," in *The Social Dynamics of Technology: Practice, Politics, and World Views*, ed. Marcia-Anne Dobres and

Christopher Hoffman (Washington, DC: Smithsonian Institution Press, 1999), 125–26.

60 Geoffrey Gowlland, "Unpacking Craft Skills: What Can Images Reveal about the Embodied Experience of Craft?," *Visual Anthropology* 28, no. 4 (August 8, 2015): 288.

61 Gowlland, "Unpacking Craft Skills," 228.

62 Gowlland, "Unpacking Craft Skills," 292.

63 Gowlland, "Unpacking Craft Skills," 291.

64 Gowlland, "Unpacking Craft Skills," 286–97.

65 For a discussion of pedagogical process views in the Keystone "600 set," see Artemis Willis, "Between Nonfiction Screen Practice and Nonfiction Peep Practice: The Keystone '600 Set' and the Geographical Mode of Representation," *Early Popular Visual Culture* 13, no. 4 (October 2, 2015): 293–312.

66 For a treatment of eighteenth-century machine demonstrations such as those that took place in the 1780s at Merlin's Mechanical Museum in London, see Richard D. Altick, *The Shows of London* (Cambridge, MA: Harvard University Press, 1978). For more on early nineteenth-century machine exhibitions, see Christine MacLeod, *Heroes of Invention: Technology, Liberalism and British Identity, 1750–1914* (Cambridge: Cambridge University Press, 2007), 214.

67 Nikolaus Pevsner, *High Victorian Design: A Study of the Exhibits of 1851* (Oxford: Architectural Press, 1951). See also MacLeod, *Heroes of Invention*.

68 Thomas Richards, *The Commodity Culture of Victorian England: Advertising and Spectacle, 1851–1914* (Stanford, CA: Stanford University Press, 1991), 30.

69 *The English Cyclopaedia: A New Dictionary of Universal Knowledge* (London: Bradbury and Evans, 1861); *Illustrated London News*, quoted in Pevsner, *High Victorian Design*.

70 Jeffrey A. Auerbach, *The Great Exhibition of 1851: A Nation on Display* (New Haven, CT: Yale University Press, 1999).

71 Henry Mayhew and George Cruikshank, *1851; or, The Adventures of Mr. and Mrs. Sandboys and Family, Who Came up to London to "Enjoy Themselves," and to See the Great Exhibition* (London: D. Bogue, 1851), 160–61, emphasis added.

72 Herbert L. Sussman, *Victorian Technology: Invention, Innovation, and the Rise of the Machine* (Santa Barbara: Praeger, 2009).

73 Sussman, *Victorian Technology*. For more on "work displays" as tourist attractions, see Dean MacCannell, *The Tourist: A New Theory of the Leisure Class* (Berkeley: University of California Press, 2013).

74 Sussman, *Victorian Technology*. For more on machine demonstrations at world expositions, see Burton Benedict, *The Anthropology of World's Fairs: San Francisco's Panama Pacific International Exposition of 1915* (Berkeley, CA: Scolar, 1983); Peter H. Hoffenberg, *An Empire on Display: English, Indian, and Australian Exhibitions from the Crystal Palace to the Great War* (Berkeley: University of California Press, 2001).

75 Auerbach, *The Great Exhibition of 1851*.

76 See Benedict, *The Anthropology of World's Fairs*; Hoffenberg, *An Empire on Display*.

77 Abigail McGowan, *Crafting the Nation in Colonial India* (New York: Palgrave Macmillan, 2009).

78 Paul Greenhalgh, *Ephemeral Vistas: The Expositions Universelles, Great Exhibitions and World's Fairs, 1851–1939* (Manchester, U.K.: Manchester University Press, 1991).

79 Greenhalgh, *Ephemeral Vistas*.

80 Greenhalgh, *Ephemeral Vistas*.

81 Benedict offers a taxonomy of four types of display of peoples: (1) "people as technicians," in which the emphasis is on a machine or technical process; (2) "people as craftsman," in which the interest is also in a technical process but the emphasis turns from the instruments of production to the handmade character of the process; (3) "people as curiosities or freaks," in which "physiological characteristic are emphasized—enormous girth, armlessness, dwarfishness, hairiness . . . [and] the physiological characteristic is a difference in ethnicity"; (4) "people as trophies," in which a "conqueror displays the conquered"; (5) "people as specimens or scientific objects." Benedict points out that different imperial powers hewed toward different kinds of people displays. Summing up, he writes, "The typical British exhibit showed a pile of raw material with a native working on it; the typical French exhibit a temple with dancers; and the typical American exhibit a school house with Native Americans being taught by whites": Benedict, *The Anthropology of World's Fairs*, 43–45, 51.

82 Benedict, *The Anthropology of World's Fairs*.

83 Benedict, *The Anthropology of World's Fairs*.

84 Hoffenberg, *An Empire on Display*, 186; see also McGowan, *Crafting the Nation in Colonial India*.

85 For an account of the shift, see McGowan, *Crafting the Nation in Colonial India*.

86 Greenhalgh, *Ephemeral Vistas*, 84, emphasis added.

87 McGowan, *Crafting the Nation in Colonial India*.

88 McGowan, *Crafting the Nation in Colonial India*.

89 McGowan, *Crafting the Nation in Colonial India*, 44.

90 Benedict, *The Anthropology of World's Fairs*; Greenhalgh, *Ephemeral Vistas*.

91 Edward N. Kaufman, "The Architectural Museum from World's Fair to Restoration Village," *Assemblage*, no. 9 (June 1989): 25.

92 Kaufman, "The Architectural Museum from World's Fair to Restoration Village," 20–39.

93 Walter Tomlinson, *The Pictorial Record of the Royal Jubilee Exhibition, Manchester, 1887*, ed. J. H. Nodal (Manchester: J. E. Cornish, 1888), 129–30, emphasis added.

94 The figure credited with creating the first living museum is the Swedish philologist Artur Hazelius, who in 1891 opened the first permanent outdoor architectural museum on a seventy-five-acre site in Stockholm.

The museum was intended to preserve traditional, rural peasant Swedish culture before it was lost to the relentless march of industrialization. Hazelius had attended or participated in international expositions since at least the 1867 Exposition Universelle in Paris. He was surely inspired by his experiences at various international expositions, and his conceit was not to display material culture but to animate the past partly through demonstrations of folk culture, including handicraft production. But the folk culture Hazelius was interested in was that of his own countrymen, whose way of life he perceived to be fast disappearing and worthy of preservation: see Kaufman, "The Architectural Museum from World's Fair to Restoration Village." For more on living museums, see Jay Anderson, *Time Machines: The World of Living History* (Nashville, TN: American Association for State and Local History, 1984); Scott Magelssen, *Living History Museums: Undoing History through Performance* (Lanham, MD: Scarecrow, 2007).

95 For a theoretical treatment of this spatiotemporal logic in anthropology, see Johannes Fabian and Matti Bunzl, *Time and the Other: How Anthropology Makes Its Object* (New York: Columbia University Press, 2014).

96 Kaufman, "The Architectural Museum from World's Fair to Restoration Village."

97 John Cotton Dana's Newark Museum is a similar case to Hull House. In the early nineteenth century, the Newark Museum also made craft demonstrations an important part of its programming. For more on craft demonstrations at the Newark Museum, see Carol G. Duncan, *A Matter of Class: John Cotton Dana, Progressive Reform, and the Newark Museum* (Pittsburgh: Periscope, 2010).

98 Jane Addams, "Labor Museum at Hull House," *The Commons*, June 30, 1900, 2, emphasis added.

99 For more on imperialist nostalgia, see Renato Rosaldo, "Imperialist Nostalgia," *Representations* 26 (1989): 107–22.

100 Quoted in Gunning, "The World as Object Lesson," 425.

101 Roland Barthes, "The Plates of the *Encyclopedia*," in *New Critical Essays*, by Roland Barthes (Evanston, IL: Northwestern University Press, 2009), 24.

102 Ernst Gombrich, "Pictorial Instructions," in *Images and Understanding*, ed. Jonathan Miller, Horace Barlow, Colin Blakemore, and Miranda Weston-Smith (Cambridge: Cambridge University Press, 1991), 42.

103 Barthes, "The Plates of the *Encyclopedia*."

104 Gombrich, "Pictorial Instructions," 37. For Gombrich, "pictorial instructions" is a broader designation that includes maps and diagrams. "Sequential narrative" is the subset of pictorial instructions that corresponds to what I am calling processual representation. I do not think Gombrich would include machine drawings within this subset. In an interesting account of the emergence of mechanization, Sigfried Giedion suggests a possible alternative origin and significance for pictorial instructions. Giedion argues that the earliest basis of mechanization rests with the idea of movement, or "changing in all its forms" (14), which, he argues, had to be grasped graphically; this was done by "repeatedly representing

the same subject at various times": Sigfried Giedion, *Mechanization Takes Command: A Contribution to Anonymous History* (Minneapolis: University of Minnesota Press, 2014), 14, 16. Giedion thus looks back to Nicolas Oresme, whom he credits with producing the first "graphical representation of movement" in the mid-1300s in a book about the shifting intensity of a quality. From Oresme's pictorial representation Giedion will trace a straight line to the work of nineteenth-century serial photographers such as Marey and Muybridge. The interesting point here is that, for Giedion, mechanization begins with a graphic representation of a process—or, as he might prefer, a graphic representation of movement.

105 Gombrich, "Pictorial Instructions."
106 Janina Wellmann, *The Form of Becoming: Embryology and the Epistemology of Rhythm, 1760–1830*, trans. Kate Sturge (New York: Zone, 2017).
107 Wellmann, *The Form of Becoming*.
108 Wellmann, *The Form of Becoming*.
109 Wellmann, *The Form of Becoming*, 168. Wellmann's account here is reminiscent of the way Giedion describes Oresme's mid-fourteenth-century graphical representation of movement. See n. 104 in this chapter.
110 Wellmann analyzes this approach in terms of rhythm, which she opposes to simple chronology. This will be an important distinction that will allow her to claim in later parts of *The Form of Becoming* that the serial iconography of these "instructional graphics" gave rise to certain pictorial practices of embryology. Wellmann's discussion raises a question about whether serial representations of biological life cycles belong to the process genre: see n. 26 in the introduction to my book. See also Wellmann, *The Form of Becoming*.
111 Wellmann, *The Form of Becoming*.
112 Following Wellmann, we might say that a difference is that in Marey, at least, the iconographic series marks an *even* unfolding of action in time rather than a *curated* unfolding of the key elements of an action.
113 Lefèvre's account here might be usefully compared with Giedion's account of the importance of graphical representation to the development of mechanization. Giedion also places special importance on the Gothic cathedral, whose "soaring verticals. . . . seem the symbols of everlasting change, of movement": Giedion, *Mechanization Takes Command*, 15.
114 Wolfgang Lefèvre, "Introduction," in *Picturing Machines 1400–1700*, ed. Wolfgang Lefèvre (Cambridge, MA: MIT Press, 2004), 1–12.
115 Pamela Smith, "Making Things: Techniques and Books in Early Modern Europe," in *Early Modern Things: Objects and Their Histories, 1500–1800*, ed. Paula Findlen (New York: Routledge, 2012), 173–203.
116 Eugene S. Ferguson, "The Mind's Eye: Nonverbal Thought in Technology," *Science* 197, no. 4306 (1977): 827–36. For an alternative account of the transformation of the style of machine drawings from flat images with multiple perspectives to a realistic appearance with a single viewpoint, see David McGee, "The Origins of Early Modern Machine Design," in *Picturing Machines 1400–1700*, ed. Wolfgang Lefèvre (Cambridge, MA: MIT Press, 2004), 53–84.

1 This segment has been remade several times. There were versions on
 Sesame Street in the 1980s, and there is a 2012 episode (#109) of *Daniel
 Tiger* titled "A Trip to the Crayon Factory."

2 "#TBT: Let Mister Rogers Show You How Crayons Are Made," *The Absolute*,
 accessed September 10, 2019, http://theabsolutemag.com/19802/videos
 /tbt-let-mr-rogers-show-you-how-crayons-are-made, emphasis added.

3 "Ever Wonder Where Yogurt Comes From?," *Saving Star*, November 8,
 2011, https://savingstar.com/blog/2011/11/ever-wonder-where-yogurt
 -comes-from (no longer available), emphasis added.

4 Whereas there are differences between these terms—especially between
 "immersion" and "absorption"—I focus on their similarities. I am not
 convinced by the arguments, such as Richard Rushton's, claiming that
 absorption is a mode "in which the spectator *goes into* the film . . . that
 is, is absorbed in or by the film," whereas in immersion, "the film comes
 out to the spectator so as to surround and envelop her/him." I do not see
 how, in practice, absorption would feel different from immersion for the
 spectator. For more on this distinction, see Richard Rushton, "Deleuz-
 ian Spectatorship," *Screen* 50, no. 1 (March 20, 2009): 45–53; Oliver Grau,
 Virtual Art: From Illusion to Immersion (Cambridge, MA: MIT Press, 2003);
 Marie-Laure Ryan, *Narrative as Virtual Reality: Immersion and Interactivity
 in Literature and Electronic Media* (Baltimore: Johns Hopkins University
 Press, 2003).

5 Roger Ebert, "*A Man Escaped* Movie Review and Film Summary (1956),"
 accessed September 29, 2014, http://www.rogerebert.com/reviews/great
 -movie-a-man-escaped-1956, emphasis added.

6 Slarek, "Men of Bronze," *Cine Outsider*, October 10, 2015, accessed May 18,
 2019, http://www.cineoutsider.com/reviews/films/h/hand_gestures
 _lffreview.html, emphasis added.

7 Jennifer Kahn, "Letter of Recommendation: 'Primitive Technology,'"
 New York Times, December 1, 2016, accessed May 18, 2019, https://www
 .nytimes.com/2016/12/01/magazine/letter-of-recommendation-primitive
 -technology.html, emphasis added.

8 See Neil Harris, *Humbug: The Art of P. T. Barnum* (Chicago: University of
 Chicago Press, 1981), 82. It should be added that Harris's term, "the op-
 erational aesthetic," might be usefully compared and contrasted to Harun
 Farocki's 2000 concept of the "operational" or "operative image." "Op-
 erational images" (such as those generated by drones or those that help
 direct remote-controlled missiles), according to Trevor Paglen, "'do' things
 in the world," rather than "simply representing things in the world": see
 Trevor Paglen, "Operational Images," *e-flux* 59 (November 2014), accessed
 June 3, 2019, https://www.e-flux.com/journal/operational-images/.
 Thomas Elsaesser puts it differently; for him, "operative images" should be
 understood as "images that function as instructions for action": Thomas
 Elsaesser and Alexander Alberro, "Farocki: A Frame for the No Longer

Visible: Thomas Elsaesser in Conversation with Alexander Alberro," *e-flux* 59 (November 2014), accessed June 3, 2019, https://www.e-flux.com/journal/59/61111/farocki-a-frame-for-the-no-longer-visible-thomas-elsaesser-in-conversation-with-alexander-alberro/. Elsaesser's account more closely implicates the process genre, though he seems to use "instructions" here loosely. Jussi Parikka is the project leader on a recently funded (by the Czech Science Foundation for 2019–2023) project—Operational Images and Visual Culture: Media Archaeological Investigations—that will investigate the multiple valances of these kinds of images. Of course, two valances relevant to the process genre are the instructional dimensions of these operative images and the role of visualization in their final forms. See also Volker Pantenburg, "Working Images: Harun Farocki and the Operational Image," in *Image Operations: Visual Media and Political Conflict*, ed. Jens Eder and Charlotte Klonk (Manchester, U.K.: Manchester University Press, 2017).

9 Harris, *Humbug*, 57.

10 Christian Metz, *Film Language: A Semiotics of the Cinema*, trans. Michael Taylor (Chicago: University of Chicago Press, 1990), 4.

11 Victor Nell, *Lost in a Book: The Psychology of Reading for Pleasure* (New Haven, CT: Yale University Press, 1990), 48.

12 Marta Braun, *Picturing Time: The Work of Etienne-Jules Marey*, repr. ed. (Chicago: University of Chicago Press, 1995), 249, emphasis added.

13 Jerome Bruner, "The Narrative Construction of Reality," *Critical Inquiry* 18, no. 1 (1991): 7.

14 Still, within narrative theory, there have been recent efforts to rethink the representation of nonhuman experience in narrative. Those efforts have concentrated on animal and on object-focused narratives; they vary to the degree that they relate these narratives to human concerns. Especially relevant in this case is the history of object narration—that is, the emergence in eighteenth-century England of talking objects, and the popularity of autobiographies of objects in the eighteenth and nineteenth centuries. It has recently been observed that these "it-narratives" or "object tales," as they have been called, were widespread and particularly popular in children's literature. Recent scholarship has pointed out the counterintuitive way that it-narratives, despite the seeming lack of eventfulness in a story about a lump of coal or a piece of flint or a grain of salt, are successful by showing that what seemed ordinary is actually extraordinary and wonderful: see David Herman, "Storyworld/Umwelt: Nonhuman Experiences in Graphic Narratives," *SubStance* 40, no. 1 (2011): 156–81. Lars Bernaerts, Marco Caracciolo, Luc Herman, and Bart Vervaeck, "The Storied Lives of Non-Human Narrators," *Narrative* 22, no. 1 (2014): 68–93. For more on it-narratives, see Mark Blackwell, *The Secret Life of Things: Animals, Objects, and It-Narratives in Eighteenth-Century England* (Lewisburg, PA: Bucknell University Press, 2007).

15 Peter Hühn, *Eventfulness in British Fiction* (New York: De Gruyter, 2010), 1–2.

16 Roger C. Schank and Robert P. Abelson, *Scripts, Plans, Goals, and Understanding: An Inquiry into Human Knowledge Structures* (Hillsdale, NJ:

Lawrence Erlbaum Associates, 1977), 41. For an account of the relation between scripts and eventfulness, see Bruner, "The Narrative Construction of Reality"; Hühn, *Eventfulness in British Fiction*.

17 Tellability is usually associated with William Labov and Joshua Waletzky's paper "Narrative Analysis: Oral Versions of Personal Experience," published in *Essays on the Verbal and Visual Arts: Proceedings of the 1966 Annual Spring Meeting of the American Ethnological Society* (Seattle: University of Washington Press, 1967). For more on "canonicity and breach," see Bruner, "The Narrative Construction of Reality."

18 See, e.g., the treatment of the recipe for pistou soup in Algirdas Julien Greimas, *La soupe au pistou, ou, La construction d'un objet de valeur* (Paris: Groupe de Recherches Sémio-linguistiques, École des Hautes Études en Sciences Sociales, Centre National de la Recherche Scientifique, 1979).

19 See David Herman, *Basic Elements of Narrative* (Chichester, U.K.: Wiley-Blackwell, 2009); David Herman, *Story Logic: Problems and Possibilities of Narrative* (Lincoln: University of Nebraska Press, 2004).

20 Gerald Prince, "Forty-One Questions on the Nature of Narrative," *Style* 34, no. 2 (June 22, 2000): 317.

21 Bruner, "The Narrative Construction of Reality," 6.

22 Marie-Laure Ryan, "Toward a Definition of Narrative," in *The Cambridge Companion to Narrative*, ed. David Herman (Cambridge: Cambridge University Press, 2007), 25, emphasis added.

23 Homer, *The Odyssey*, trans. A. S. Kline (London: Poetry in Translation, 2016), 88, emphasis added; Ryan, "Toward a Definition of Narrative," 26.

24 Ryan, "Toward a Definition of Narrative," 26.

25 Although it seems counterintuitive, Bee Wilson (writing for the *New Yorker*) has argued that a good recipe reads like a story to the avid reader of recipes who experiences a "delightful trance"—the telltale sign of the authentic story. Bee Wilson, "The Pleasures of Reading Recipes," *New Yorker*, July 26, 2013. This sense of the recipe is borne out in the mounting scholarship devoted to rehabilitating the idea that recipes are not only narratives but also often eventful ones at that. At stake in this rehabilitation has been a revalorization of discourses traditionally associated with women. For the literature on the recipe, see Anne L. Bower, ed., *Recipes for Reading: Community Cookbooks, Stories, Histories* (Amherst: University of Massachusetts Press, 1997); Laurel Forster and Janet Floyd, *The Recipe Reader: Narratives, Contexts, Traditions* (Farnham, U.K.: Ashgate, 2003); Susan J. Leonardi, "Recipes for Reading: Summer Pasta, Lobster à la Riseholme, and Key Lime Pie," *PMLA* 104, no. 3 (May 1989): 340–47.

26 Although pictorial illustration is less particular than film, still there is some particularizing. After all, the faceless figure of drawn illustration takes some form: the figure is male or female, fat or thin, tall or short, and so on.

27 I do not think that the debate about cinema's indexicality threatens this point. In any case, on this question I am compelled by the arguments made in Tom Gunning, "What's the Point of an Index? Or, Faking Photographs," *Nordicom Review* 5, nos. 1–2 (2004): 39–49.

28 This is a phrase coined by Nicholai A. Bernstein and discussed in Tim Ingold, "Beyond Art and Technology: The Anthropology of Skill," in *Anthropological Perspectives on Technology*, ed. Michael Brian Schiffer (Albuquerque: University of New Mexico Press, 2001), 21. It refers to the way that craftspeople are always adjusting their bodies to material and surrounding conditions. See Nicholai A. Bernstein, *Dexterity and Its Development*, ed. Mark L. Latash and Michael T. Turvey (New York: Routledge, 1996).

29 See Ingold, "Beyond Art and Technology."

30 See "Help with Fouette Turns | Kathryn Morgan," YouTube, February 3, 2015, accessed May 18, 2019, https://www.youtube.com/watch?v=6vopAds9808.

31 Bazin, in his short essay on *The Mystery of Picasso*, notes that this "unpredictability" constitutes a pervasive feature of the film. "Since the hand and the pencil are invisible," he writes, "nothing gives away their place but the line or the dot that appears, and, very quickly, the mind is trying more or less consciously to guess what will come next; but each time Picasso's decision completely defeats our expectation. When we think his hand is on the right, the stroke appears on the left. When we expect a stroke, we get a patch; when we look for a patch, a dot appears": André Bazin, "A Bergsonian Film: The Picasso Mystery," in *Bazin at Work: Major Essays and Reviews from the Forties and Fifties*, ed. Bert Cardullo (New York: Routledge, 1997), 212. But the unpredictability has less to do with the invisibility of pencil and hand, and more to do with the fact that we have no idea what Picasso is going to do next because neither does he.

32 Noël Carroll, "Narrative Closure," *Philosophical Studies* 135, no. 1 (2007): 2.

33 Carroll, "Narrative Closure," 4.

34 Bazin, "A Bergsonian Film," 213.

35 Carroll, "Narrative Closure," 8.

36 Bazin emphasizes the film's "unceasing suspense," thereby linking *The Mystery of Picasso* to the Clouzot's other work in the genre of the thriller. But in the case of *The Mystery of Picasso*, that suspense is at its most pure, generated not by "dramatic progression" but by the spectacle of creation. "Creation is pure waiting and uncertainty," Bazin writes. "It is 'suspense,' in that the absence or incompleteness of subject creates anticipation in the viewer": Bazin, "A Bergsonian Film," 214. Again, for Bazin, this turns out to be an uncommon way to return duration to media thought not to depend on it.

37 Bazin, "A Bergsonian Film," 212.

38 Bazin, "A Bergsonian Film," 211.

39 Rebecca Naughten, "Hand Gestures," *Eye for Film*, December 11, 2015, accessed May 19, 2019, http://www.eyeforfilm.co.uk/review/hand-gestures-2015-film-review-by-rebecca-naughten; Wendy Ide, "Hand Gestures Review—Shining Study of Sculptors in Bronze," *Guardian*, November 19, 2015; "Hand Gestures," *Dundee Contemporary Arts*, accessed June 30, 2017, http://www.dca.org.uk/whats-on/event/hand-gestures; Alex Dudok de Wit, "Hand Gestures," *Sight and Sound*, December 2015, 76.

40 This point is made in Marie-Laure Ryan, "Tellability," in *Routledge Encyclopedia of Narrative Theory*, ed. David Herman, Manfred Jahn, and Marie-Laure Ryan (London: Routledge, 2010), 589–91.

41 Ryan, "Tellability."

42 For more on the relation between eventfulness and context sensitivity, see Hühn, *Eventfulness in British Fiction*.

43 Victoria E. M. Cain, "The Craftsmanship Aesthetic: Showing Making at the American Museum of Natural History, 1910–45," *Journal of Modern Craft* 5, no. 1 (March 1, 2012): 26, 29.

44 The reception of P. T. Barnum in the southern United States provides another example of the relevance of context. Neil Harris proposes that Barnum's poor reception in the South was due to the weakness of the operational aesthetic, which in turn could be traced to a low degree of industrialization and to the low regard for labor as a result of the history of chattel slavery: see Harris, *Humbug*.

45 For a sustained reading of the repetition of everyday gestures in *Jeanne Dielman*, see Ivone Margulies, *Nothing Happens: Chantal Akerman's Hyperrealist Everyday* (Durham, NC: Duke University Press, 1996).

46 Chantal Akerman, video interview, *Jeanne Dielman, 23 Quai du Commerce, 1080 Bruxelles*, DVD (Criterion Collection, 2009).

47 In a parallel approach in literary studies, Lars Bernaerts and his colleagues have recently turned to expositional structures to account for the appeal of it-narratives. In Annie Carey's *Autobiographies of A Lump of Coal; A Grain of Salt; A Drop of Water; A Bit of Old Iron; A Piece of Flint*, they argue, the "vocabulary used to turn ordinary things into exciting and exceptional story elements prominently features words like 'strange,' 'exceptional,' 'wonderful,' and 'unsuspected.' The children are invariably taken in and seem to be listening to some detective story rather than to a scientific and educational exposé. . . . [I]t-narrators create *suspense* which elicits the children's *curiosity* and *surprise*": Bernaerts et al., "The Storied Lives of Non-Human Narrators," 84, emphasis added. It should be noted that the account claims that the children's enthrallment is produced not by anthropomorphizing objects but by an expositional structure (here, a suspense structure).

48 The following account is the one outlined in the structural affect theory developed by William F. Brewer and Edward H. Lichtenstein and in the work on expositional structures by Meir Sternberg.

49 William F. Brewer, "The Nature of Narrative Suspense and the Problem of Rereading," in *Suspense: Conceptualizations, Theoretical Analyses, and Empirical Explorations*, ed. Peter Vorderer, Hans Jurgen Wulff, and Mike Friedrichsen (New York: Routledge, 1996), 107–28.

50 Meir Sternberg, "Telling in Time (II): Chronology, Teleology, Narrativity," *Poetics Today* 13, no. 3 (1992): 531.

51 Brewer, "The Nature of Narrative Suspense and the Problem of Rereading."

52 David Bordwell, "Hitchcock, Lessing, and the Bomb under the Table," *Observations on Film Art*, November 9, 2013, accessed May 19, 2019, http://

www.davidbordwell.net/blog/2013/11/29/hitchcock-lessing-and-the-bomb
-under-the-table.

53 Brewer, "The Nature of Narrative Suspense and the Problem of
 Rereading."

54 Meir Sternberg, *Expositional Modes and Temporal Ordering in Fiction*
 (Bloomington: Indiana University Press, 1993), 65.

55 Tsvetan Todorov and Jonathan Culler, *The Poetics of Prose*, trans. Richard
 Howard (Ithaca, NY: Cornell University Press, 1978).

56 The relation between the process genre and detective stories echoes Neil
 Harris's comparison of Barnum, Poe, Greenough, and the Transcenden-
 talists. All were tapping into "the pervasiveness of the operational taste
 [aesthetic]"—that is, "the instinctive pleasure [men took] in uncovering
 process": see Harris, *Humbug*, 82.

57 Sternberg, *Expositional Modes and Temporal Ordering in Fiction*, 65.

58 For more on the history of the work display and its status as a tourist
 attraction, see Dean MacCannell, *The Tourist: A New Theory of the Leisure
 Class* (Berkeley: University of California Press, 2013).

59 This list represents some of the steps in the process depicted by the
 film. The film is missing some steps that are described on the Bosphorus
 Cymbals website, including pressing the bell, which occurs after rolling;
 tempering, which follows that; piercing the bell; and cutting around it.
 The film also seems to combine hard hammering and fine hammering into
 one step, though these are separated in the sequence by lathing.

60 The formation and testing of hypotheses goes along with curiosity and
 suspense structures. For a discussion of the role of hypotheses in filling in
 expositional gaps, see Sternberg, *Expositional Modes and Temporal Ordering
 in Fiction*. For the application of Sternberg theorization of curiosity and
 suspense hypotheses to film, see David Bordwell, *Narration in the Fiction
 Film* (Madison: University of Wisconsin Press, 1985).

61 For example, *The Great Escape* (John Sturges, United States, 1963), *Cool
 Hand Luke* (Stuart Rosenberg, United States, 1967), *Papillon* (Frank Schaff-
 ner, United Sates, 1973).

62 Brian Price, *Neither God nor Master: Robert Bresson and Radical Politics*
 (Minneapolis: University of Minnesota Press, 2011), 23.

63 Price, *Neither God nor Master*.

64 Price, *Neither God nor Master*.

65 Price, *Neither God nor Master*.

66 Buchloh, quoted in Price, *Neither God nor Master*.

67 Donald S. Skoller, "'Praxis' as a Cinematic Principle in Films by Robert
 Bresson," *Cinema Journal* 9, no. 1 (1969): 18.

68 Price, *Neither God nor Master*, 26.

CHAPTER THREE. AESTHETICIZING LABOR

1 For the explanation of why I do not distinguish between "work" and
 "labor," see n. 50 in the introduction to this book.

2 Jennifer Kahn, "Letter of Recommendation: 'Primitive Technology,'" *New York Times*, December 1, 2016, accessed May 24, 2019, https://www.nytimes.com/2016/12/01/magazine/letter-of-recommendation-primitive-technology.html. See my discussion of this review in chapter 2 as well.

3 Robert Stockhammer, "The Techno-Magician: A Fascination around 1900," in *Magic, Science, Technology, and Literature*, ed. Hans Ulrich Seeber, Jarmila Mildorf, and Martin Windisch (Berlin: Lit, 2006), 170.

4 Alfred Gell, "The Technology of Enchantment and the Enchantment of Technology," *Anthropology, Art, and Aesthetics*, ed. Jermey Coote and Anthony Shelton (Oxford: Clarendon Press, 1992), 59.

5 Gell, "The Technology of Enchantment and the Enchantment of Technology," 59.

6 Gell, "The Technology of Enchantment and the Enchantment of Technology," 58.

7 It should be added that the magical attitude not only emerges in the observation and representation of craft processes such as the one Kahn refers to on the Primitive Technology channel, where the human hand reigns; it also attends the representation of machine processes as we saw in the case of the crayon factory tour on *Mister Rogers' Neighborhood*, which has elicited several references to magic. If we apply Gell's insights to this phenomenon, the source of magic is the apprehension of the ingenuity *and* effortlessness of the machine or tool whose functioning, again, mimics an ideal technology. It is the case that we are both in awe of the efficacy and ease of machines, which function with minimal human work costs, and at a loss to imagine the "creative agency" that designed the Crayola factory's double-spout bucket or the simple, analog metal hook protruding on the conveyor belt that, by its clever placement, accomplishes the rotation of crayon boxes. Machines can look like ideal technologies on a continuum with skilled human action.

8 For recent general treatments of art and labor as well as cinema and labor, see T. J. Barringer, *Men at Work: Art and Labour in Victorian Britain* (New Haven, CT: Yale University Press, 2005); Elizabeth Cowie, "Working Images: The Representations of Documentary Film," in *Work and the Image II: Work in Modern Times: Visual Mediations and Social Processes*, ed. Valérie Mainz and Griselda Pollock (Farnham, U.K.: Ashgate., 2000), 173–92; Melissa Dabakis, *Visualizing Labor: American Sculpture* (Cambridge: Cambridge University Press, 1999); Michael Denning, "Representing Global Labor," *Social Text* 25, no. 3 (2007): 125; Valérie Mainz and Griselda Pollock, eds., *Work and the Image I: Work, Craft and Labour: Visual Representations in Changing Histories* (Farnham, U.K.: Ashgate, 2000); Ewa Mazierska, *Work in Cinema: Labor and the Human Condition* (New York: Palgrave Macmillan, 2013). See also Elena Gorfinkel and Ewa Mazierska, eds., "The Work of the Image," special issue, *Framework* 53, no. 1 (2013); Vicky Unruh, ed., "Work," special issue, *PMLA* 127, no. 4 (2012).

9 There are two notable exceptions to this emphasis on invisibility. First, Jennifer Lynn Peterson, in a consideration of recent observational docu-

mentaries about work, has argued that throughout the one-hundred-year history of cinema, "labor and industry persisted as subjects for documentaries, even if labor subjects were never a particularly mainstream theme in fiction films": Jennifer Lynn Peterson, "Workers Leaving the Factory: Witnessing Industry in the Digital Age," in *The Oxford Handbook of Sound and Image in Digital Media*, ed. Amy Herzog, Carol Vernallis, and John Richardson (Oxford: Oxford University Press, 2013), 599. Second, Ewa Mazierka cites this cliché about invisibility to disavow her own, earlier view and to refute it. Her new view is that it is not filmmakers who ignore the topic of work. Rather, it is critics and historians who have failed "to account for the different ways films represent work": Mazierska, *Work in Cinema*, 2.

10 Harun Farocki, "Workers Leaving the Factory," in *Harun Farocki: Working on the Sightlines*, ed. Thomas Elsaesser (Amsterdam: Amsterdam University Press, 2004), 238. Besides this usual complaint about the invisibility of labor as subject matter, scholars have pointed to other manifestations of invisibility, including the invisibility of the labor that goes into the production of cinema (i.e., the way in which the labor of production becomes effaced in works dedicated to suturing the spectator into the illusion and making her forget the means of filmic production). A variation on this emphasizes the invisibility of the labor of spectating, as in Jonathan Beller's argument that cinema (and other media) is like a factory in which spectators labor, not because looking is hard work (as in the old theories of active versus passive spectators), but because looking produces surplus value, as the factory does. For arguments on the invisibility of labor in cinema, see Jonathan Beller, *The Cinematic Mode of Production: Attention Economy and the Society of the Spectacle* (Hanover, NH: Dartmouth College Press, 2006); Thomas Elsaesser, ed., *Harun Farocki: Working on the Sightlines* (Amsterdam: Amsterdam University Press, 2004); Elena Gorfinkel, "Introduction," *Framework* 53, no. 1 (2013): 43–46.

11 Years after Farocki wrote this, in 2011, he and Antje Ehmann initiated a project in which they held workshops in fifteen different cities worldwide and had filmmakers in each workshop produce one- to two-minute videos, without cuts, depicting all kinds of labor, paid and unpaid, material and immaterial. Labour in a Single Shot, as the project is called, was conceived as a kind of research project aiming "to open one's eyes" to all the labor that has been unpictured—invisible and unimaginable. Some of the videos that were produced are processual. Indeed, this seems to be a discovery of the project as Ehmann and Farocki note that a single one- or two-minute shot "can already create a narrative, suspense or surprise": "Labour in a Single Shot," accessed May 24, 2019, https://www.labour-in-a -single-shot.net/en/project/concept/.

12 Jean-Louis Comolli and Annette Michelson, "Mechanical Bodies, Ever More Heavenly," *October* 83 (January 1, 1998): 30.

13 Comolli and Michelson, "Mechanical Bodies, Ever More Heavenly," 21.

14 Comolli and Michelson, "Mechanical Bodies, Ever More Heavenly."

15 Comolli and Michelson, "Mechanical Bodies, Ever More Heavenly," 22.

16 Raymond Williams, *Keywords: A Vocabulary of Culture and Society*, rev. ed. (New York: Oxford University Press, 1985), 334–35.

17 Williams, *Keywords*.

18 Marcel Mauss, "Techniques of the Body," *Economy and Society* 2, no. 1 (February 1, 1973): 76.

19 One important difference between Mauss and Gell is that while Mauss excludes rituals from his account of technique, Gell understands religious and artistic goals (including ritual) using the framework of technique: see n. 52 in the introduction to this book.

20 Alfred Gell, "Technology and Magic," *Anthropology Today* 4, no. 2 (1988): 7.

21 Gell, "Technology and Magic."

22 For a similar idea, see the Epicurious series *50 Person Prep Challenge*, which features regular people trying and failing to demonstrate basic culinary skills such as dicing an onion, juicing a lemon, or making a peanut butter and jelly sandwich. The short videos (most are under five minutes), after showing several failures, end with a satisfying demonstration of effective technique. The title of this particular video ("The Most Unsatisfying Video in the World Ever Made") probably alludes to the "Oddly Satisfying" sub-reddit which features several effective process videos culled from different social media platforms. See n. 38 in the introduction to this book.

23 Tom Ley, "I Can't Stop Watching This Video of Infuriating Fuck-Ups," *The Concourse*, accessed September 24, 2017, http://theconcourse.deadspin .com/i-cant-stop-watching-this-video-of-infuriating-fuck-ups-1793480112.

24 However, one might look at it this way: ritual, order, and process in *Jeanne Dielman* make social reproduction possible—or, put another way, they make life possible, the film suggests. Meanwhile, in *Saute ma ville*, the absence of tradition—personal and cultural—is untenable; it results in death. This sounds a bit like inversion.

25 Chantal Akerman, interview, *Jeanne Dielman, 23 Quai du Commerce, 1080 Bruxelles*, DVD (Criterion Collection, 2009).

26 Donald S. Skoller, "'Praxis' as a Cinematic Principle in Films by Robert Bresson," *Cinema Journal* 9, no. 1 (1969): 19.

27 Skoller, "'Praxis' as a Cinematic Principle in Films by Robert Bresson," 20.

28 See Amy Hayes and Steven Tipper, "Affective Responses to Everyday Actions," in *Kinesthetic Empathy in Creative and Cultural Practices*, ed. Dee Reynolds and Matthew Reason (Bristol, U.K.: Intellect, 2012), 67–86.

29 The work of Rudolf von Laban on movement has been central in the development of criteria and a vocabulary for the qualitative assessment of movements: see Rudolf von Laban, *Effort* (London: Macdonald and Evans, 1947); Rudolf von Laban, and Lisa Ullmann, *The Mastery of Movement*, 3d ed. (Boston: Plays, 1971). Flow was one of Laban's terms for describing human movement. This characteristic has also turned out to play a key role in the work of the psychologist Mihaly Csikszentmihalyi, who has made the theory of "flow" the centerpiece of his work. For Csikszentmih-

alyi, flow is "a state of optimal experience characterized by total absorption in the task at hand: a merging of action and awareness in which the individual loses track of both time and self": Mihaly Csikszentmihalyi, *Applications of Flow in Human Development and Education: The Collected Works of Mihaly Csikszentmihalyi* (New York: Springer, 2014): 379. Achieving flow, for Csikszentmihalyi, correlates directly with human happiness. Thus, he published a recently reissued national bestselling self-help book, *Flow: The Psychology of Optimal Experience* (New York: HarperPerennial, 1991), which argues for sustained fluid action as key to happiness and spiritual fulfillment.

30 Most of the experiments on which this research is based make use of video. The presence of and dependence on video is little acknowledged and not problematized in the research. Indeed, the televisual image is treated as an unmediated window onto the world of gesture.

31 Hayes and Tipper, "Affective Responses to Everyday Actions." For a treatment of motor empathy in cinema, see Adriano D'Aloia, "Cinematic Empathy: Spectator Involvement in the Film Experience," in Reynolds and Reason, *Kinesthetic Empathy in Creative and Cultural Practices*, 91–108; Albert Michotte, Georges Thinès, Alan Costall, and George Butterworth, *Michotte's Experimental Phenomenology of Perception* (Hillsdale, NJ: Lawrence Erlbaum Associates, 1991).

32 The mechanism of motor simulation is what has been called the "mirror neuron system." The idea is that—contrary to common wisdom, which might starkly distinguish the realm of perception from action—*seeing* an action and *performing* the same action depend on the activation of the same mirror neurons. Thus, mirror neurons, according to the theory, become relevant for explaining imitative behaviors in humans. For a treatment of the mirror neuron system in pictorial instructions, see Dominic McIver Lopes, "Directive Pictures," *Journal of Aesthetics and Art Criticism* 62, no. 2 (2004): 189–96. For more on mirror neurons and action, see Barbara Gail Montero, *Thought in Action: Expertise and the Conscious Mind* (Oxford: Oxford University Press, 2016).

33 For a treatment of Spencer and Bergson and the limits of their analysis, see Montero, *Thought in Action*.

34 Herbert Spencer, *Herbert Spencer, Collected Writings*, vol. 2: *Essays: Scientific, Political and Speculative* (London: Routledge, 1891), 384.

35 Spencer, *Herbert Spencer*. In the realm of architecture and craft, this view is not dissimilar to form and function arguments such as those of Horatio Greenough, who was referenced by Neil Harris in his own treatment of the operational aesthetic: see Horatio Greenough, *Form and Function: Remarks on Art, Design, and Architecture*, 4th ed. (Berkeley: University of California Press, 1962).

36 Henri Bergson, *Time and Free Will: An Essay on the Immediate Data of Consciousness* (Mansfield Centre, CT: Martino Fine Books, 2015).

37 The peculiar pleasures of watching repetitive labor that is *not* embedded in a process remains to be explored. This is the kind of pleasure about

which Comolli was likely most concerned, for the existence of this plea-sure would suggest that cinema can turn the spectator-worker against her diegetic avatar: the repetition of action that ravages the assembly line worker, body and soul, simultaneously produces delight for the specta-tor who, unreflectively, observes the plunder. But, as I explore in more depth later in this chapter, the repetitive labor characteristic of a Taylorist division of labor is not dominant in processual representation. Quite the contrary.

38 Spencer, *Herbert Spencer*, 386.

39 Peterson has made the point that industrial films "modeled a Taylorist concept": see Jennifer Lynn Peterson, "Efficiency and Abundance: Indus-trial Films and Early Educational Cinema," paper presented at the Society for Cinema and Media Studies conference, New Orleans, March 12, 2011.

40 See Jonathan Crary, *Suspensions of Perception: Attention, Spectacle, and Modern Culture*, repr. ed. (Cambridge, MA: MIT Press, 2001). For a very interesting application of Crary's concept to process films from India, see Rianne Siebenga, "Crafts and Industry in Early Films of British India: Contrasting Album and Process Films," *Early Popular Visual Culture* 12, no. 3 (2014): 342–56. Siebenga uses Crary's concept to distinguish between the early (1896–1914) album film, or the "petit métier" films depicting Indian crafts nonprocessually, and process films depicting Indian industry processually; the latter films, according to Siebenga, exhibit an "'industri-alization' of visual consumption." Her point is that the use of processual representation to depict industrial production and then the processual projection of the film (because of how the projector functions) reinforces a sense of fragmentation. The industrialization of visual consumption operates in the case of the industrial process film at the level of content (industrialization process), form (processual representation), and exhibi-tion (because of the projector). Moreover, the refusal of the processual approach in the representation of Indian craft production (in the album films) "enforces the message of the haphazardness for the Indians and organisation and method for the British": Siebenga, "Crafts and Industry in Early Films of British India," 350. For a treatment of the difference between the album film and the process film, see Jennifer Lynn Peterson, *Education in the School of Dreams: Travelogues and Early Nonfiction Film* (Durham, NC: Duke University Press, 2013), 148. The album film, accord-ing to Peterson, has a "collection structure" offering a "series of visual anecdotes" linked by "place and process" (though they are not actually processual): Peterson, *Education in the School of Dreams*, 149.

41 See Jonathan Crary, *Techniques of the Observer: On Vision and Modernity in the 19th Century*, repr. ed. (Cambridge, MA: MIT Press, 1992).

42 Quoted in Lee Grieveson, "The Work of Film in the Age of Fordist Mecha-nization," *Cinema Journal* 51, no. 3 (2012): 27.

43 William H. Sewell Jr., "Visions of Labor: Illustrations of the Mechani-cal Arts before, in, and after Diderot's *Encyclopédie*," in *Work in France: Representations, Meaning, Organization, and Practice*, ed. Steven Laurence

Kaplan and Cynthia J. Koepp (Ithaca, NY: Cornell University Press, 1986), 286.

44 This conclusion is part of a farther-reaching argument about the link between technical development and the emergence of industrial capitalism. The view is that the increased segmentation of work tasks and the division of labor did not begin with the introduction of heavy machinery. Rather, it occurred earlier, in the craft trades. This earlier introduction of a proto-capitalist work regime, according to Sewell, is on full display in the *Encyclopédie*: see Sewell, "Visions of Labor."

45 Sewell, "Visions of Labor," 277.

46 Sharon Corwin, "Picturing Efficiency: Precisionism, Scientific Management, and the Effacement of Labor," *Representations* 84, no. 1 (November 2003): 146.

47 Corwin, "Picturing Efficiency," 147.

48 Corwin, "Picturing Efficiency," 148.

49 Max Fraser, "Hands off the Machine: Workers' Hands and Revolutionary Symbolism in the Visual Culture of 1930s America," *American Art* 27, no. 2 (2013): 103–4.

50 Harry Braverman, *Labor and Monopoly Capital: The Degradation of Work in the Twentieth Century* (New York: New York University Press, 1998), 52.

51 Braverman, *Labor and Monopoly Capital*, 52.

52 Roland Barthes, "The Plates of the *Encyclopedia*," in *New Critical Essays*, by Roland Barthes (Evanston, IL: Northwestern University Press, 2009), 33.

53 Barthes, "The Plates of the *Encyclopedia*," 32.

54 John Ruskin, *The Stones of Venice* (London: Smith, Elder, 1867), 161.

55 David Pye, *The Nature and Art of Workmanship* (Cambridge: Cambridge University Press, 1968), 119.

56 Harold Osborne, "The Aesthetic Concept of Craftsmanship," *British Journal of Aesthetics* 17, no. 2 (1977): 142. For Osborne, the main problem with mass production is uniformity and standardization. For Pye, the problem is not so much standardization as a lack of "diversity."

57 Osborne, "The Aesthetic Concept of Craftsmanship," 143.

58 See Richard Sennett, *The Craftsman* (New Haven, CT: Yale University Press, 2008).

59 It is in a representation such as the one I have been describing that one might worry that watching a worker repeating an action over and over again could generate in the spectator not the desperation and boredom one would expect the worker to feel but, rather, an unsolidarious hypnotism and delight in the face of the worker's deformation. This is the kind of worry I imagine Comolli having. See also n. 37 in this chapter.

60 Thomas Richards, *The Commodity Culture of Victorian England: Advertising and Spectacle, 1851–1914* (Stanford, CA: Stanford University Press, 1991), 20.

61 Richards, *The Commodity Culture of Victorian England*, 21.

62 Richards, *The Commodity Culture of Victorian England*, 32. Gunning has suggested this reading of Richards: see Tom Gunning, "Before Documentary:

Early Nonfiction Films and the 'View' Aesthetic," in *Uncharted Territory: Essays on Early Nonfiction Film*, ed. Daan Hertogs and Nico de Klerk (Amsterdam: Stichting Nederlands Filmmuseum, 1997), 9–24.

63 For more on this example, see Patrick Russell, "Shooting the Message No. 15: ShootMedia," British Film Institute, accessed July 30, 2018, https://www.bfi.org.uk/news-opinion/news-bfi/features/shooting-message-15-shootmedia.

64 One strand in the literature resists the common view that advertising is pure deception. In contrast, this literature emphasizes that one strategy of advertising is to provide consumers with information to make rational choices. This desire for information is necessitated by the complexity of the marketplace, with its proliferation of products. Included in the information desired is how goods are produced and who produces them. Here is an implicit understanding of the role of processual representation. For a treatment of these issues, see Sut Jhally, *The Codes of Advertising: Fetishism and the Political Economy of Meaning in the Consumer Society*, rev. ed. (New York: Routledge, 1990).

65 Martin Johnson brought this film to my attention at the American Comparative Literature Association's annual meeting in 2016. Johnson's paper, "Reading the Romance of a Show: The Repetition and Erasure of Labor in Early Advertising Films," analyzed *Birth of a Hat* in relation to the emergence of process films in advertising and argued that it is an example of the concealment of labor.

66 *Birth of a Hat* is available online at the National Film Preservation Foundation, http://www.filmpreservation.org/preserved-films/screening-room/birth-of-a-hat-ca-1920.

67 The "mystery" in the title of the film contributes to this reading.

68 Jennifer Lynn Peterson has noted the way in which silent-era industrials "quite literally visualize the Marxist concept of commodity fetishism": see Peterson, "Workers Leaving the Factory."

69 Karl Marx and Ernest Mandel, *Capital, Volume 1: A Critique of Political Economy*, trans. Ben Fowkes, repr. ed. (London: Penguin Classics, 1992).

70 One might think that this condensation through editing conceals labor. Surely, it does. But this act of concealment is qualitatively different from the concealment at issue in commodity fetishism and on display in the coda to *Birth of a Hat*. The concealment implied in skipping steps in the representation of a process is done for the sake of flow, or clarity, or interest, or narrative drive. The concealment of labor as the source of value in capitalism makes it possible, so the argument goes, for the boss to profit from the worker's surplus labor often without facing resistance.

71 For a recent example, see David Frayne, *The Refusal of Work: Rethinking Post-Work Theory and Practice* (London: Zed, 2015).

72 For an account of labor as an emancipatory element in Hegel and Marx, see Axel Honneth and Mitchell G. Ash, "Work and Instrumental Action," *New German Critique*, no. 26 (1982): 31–54.

73 Kathi Weeks, *The Problem with Work: Feminism, Marxism, Antiwork Politics, and Postwork Imaginaries* (Durham, NC: Duke University Press, 2011).

The politics of antiwork have become standard in the academy. A recent example from the discipline of art history is Fraser, "Hands off the Machine." Fraser discusses the representation of hands across a range of 1930s films, such as *Master Hands* and works by Hugo Gellert, Diego Rivera, José Clemente Orozco, Russell Lee, and Philip Evergood. Fraser is focused on recuperating the revolutionary symbolism of the hand, but not for the reasons one committed to the metaphysics of labor might. Rather, what Fraser picks out in Rivera, Orozco, and Evergood, what he considers (following Kenneth Burke) the "more compelling image, a truly revolutionary symbol," is the hand (and the body) *not at work*, but at rest: Fraser, "Hands off the Machine," 107.

74 Karl Marx and Fredrick Engels, *The Economic and Philosophic Manuscripts of 1844 and the Communist Manifesto*, trans. Martin Milligan (New York: Prometheus, 1988), 76, emphasis original.

75 Erich Fromm and T. B. Bottomore, *Marx's Concept of Man* (London: Bloomsbury, 2004), 33.

76 Fromm and Bottomore, *Marx's Concept of Man*.

77 Honneth has noted the scholarly effacement of this emancipatory concept of work. "Social philosophers and social scientists since the turn of the century have gradually come to overemphasize the technical and economically functional aspects of the concept of work, thus draining it of the emancipatory significance which Hegel and Marx had claimed for it and allowing these aspects of its meaning to emigrate to the realm of cultural criticism": Honneth and Ash, "Work and Instrumental Action," 38.

78 For critiques of classical Marxism's metaphysics of labor, see Hannah Arendt, *The Human Condition*, 2d ed. (Chicago: University of Chicago Press, 1998); Jean Baudrillard, *The Mirror of Production* (New York: Telos, 1975); Dipesh Chakrabarty, *Rethinking Working-Class History* (Princeton:, NJ Princeton University Press, 2000); Moishe Postone, *Time, Labor, and Social Domination: A Reinterpretation of Marx's Critical Theory* (Cambridge: Cambridge University Press, 1993); Weeks, *The Problem with Work*.

79 For responses to this critique, see Denning, "Representing Global Labor"; Peter Hudis, "The Death of the Death of the Subject," *Historical Materialism* 12, no. 3 (2004): 147–68; Honneth and Ash, "Work and Instrumental Action."

80 Weeks, *The Problem with Work*. Hannah Arendt brings the first and second of these critiques together, offering a variation on them. She also targets classical Marxism's metaphysics of labor, homing in on what she takes to be its assimilation of labor to work. Her tack is to reintroduce a sharp distinction between the terms, already highlighted in philological accounts from several different languages. Arendt suggests that men do not distinguish themselves from animals by their way of *laboring*. Rather, they distinguish themselves by the durability and stability of the objects they fabricate through their *work*. The distinction Arendt draws between labor and work serves ultimately to identify labor with the kind of biological activity in which human beings *and* animals participate. The

distinction of labor is that we need its products to subsist, and we consume its products comparatively quickly; they are, after all, characterized by impermanence and perishability. Although labor does not distinguish humans from animals (in Arendt's view), until the modern age it was the source of happiness and well-being, as the pain and effort of labor helped us to know the pleasure of the release from pain. In the modern age, with automation, that consolation of animal life (knowing the release from the pain of toil) has been lost to us as the *animal laborans* labors on the assembly line. While work—the activity of *homo faber*, maker of tools—is, in contrast to the labor of *animal laborans*, characteristically human, it still can provide only fleeting joy as it is, at bottom, degraded by its inherent instrumentalism. For Arendt, utilitarianism is the "philosophy of *homo faber* par excellence." *Homo faber* is caught in an unending chain of means and ends; utilitarianism established utility as meaning, which really "generates meaninglessness": Arendt, *The Human Condition*, 154. "Man, in so far as he is *homo faber*, instrumentalizes, and his instrumentalization implies a degradation of all things into means, their loss of intrinsic and independent value, so that eventually not only the objects but also 'the earth in general and all forces of nature,' which clearly came into being without the help of man and have an existence independent of the human world, lose their 'value because [they] do not present the reification which comes from work'": Arendt, *The Human Condition*, 156. Reprising the Ancient's schema, Arendt proposes that the pinnacle of human life, then, the true measure of meaning is the domain of action, speech, and thought. For treatments of Arendt on work and labor, see Mildred Bakan, "Hannah Arendt's Concepts of Labor and Work," in *Hannah Arendt: The Recovery of the Public World*, ed. Melvyn Hill (New York: St. Martin's, 1979), 49–66; Honneth and Ash, "Work and Instrumental Action." This view of the inherent utilitarianism of craft (regardless of whether we talk about pre-industrial craft or industrial production) is distinct from Heidegger's view in "The Question Concerning Technology," which recuperates handcraft by treating *poiesis* as *physis*. Commenters have noted that this revises the low esteem in which the Greeks held craft: see Martin Heidegger, *The Question Concerning Technology, and Other Essays* (New York: Harper Torchbooks, 1982).

81 Weeks, *The Problem with Work*, 98.

82 Paul Lafargue, *The Right to Be Lazy and Other Studies* (Chicago: C. H. Kerr, 1907), 29.

83 James Livingston, *Against Thrift: Why Consumer Culture Is Good for the Economy, the Environment, and Your Soul* (New York: Basic, 2011). See also James Livingston, *No More Work: Why Full Employment Is a Bad Idea* (Chapel Hill: University of North Carolina Press, 2016).

84 Weeks, *The Problem with Work*, 12.

85 See, e.g., the slow cinema work of Lisandro Alonso, Lav Diaz, and Bela Tarr; the latest wave of observational cinema, including the work of Lucien Castaing-Taylor and Véréna Paravel, Sharon Lockhart, Kevin Jerome

Everson, Daniel Eisenberg, and Eugenio Polgovsky; and museum-based moving image work by Harun Farocki, Mika Rottenberg, Adrian Melis, and Sooja Kim. Something similar could be said for the recent resurgence of written treatments of craftsmanship and for the latest exhibitions and screening programs devoted to work. See n. 3 in the introduction to this book.

CHAPTER FOUR. NATION BUILDING

1 See n. 32 in chapter 1 of this book.
2 See Renato Rosaldo, "Imperialist Nostalgia," *Representations* 26 (1989): 107–22.
3 See Johannes Fabian and Matti Bunzl, *Time and the Other: How Anthropology Makes Its Object* (New York: Columbia University Press, 2014).
4 For an elaboration of this argument, see Salomé Aguilera Skvirsky, "Realism, Documentary, and the Process Genre in Early New Latin American Cinema," in *The Routledge Companion to Latin American Cinema*, ed. Marvin D'Lugo, Ana M. López, and Laura Podalsky (New York: Routledge, 2018), 119–32.
5 Julianne Burton, "Democratizing Documentary: Modes of Address in the New Latin American Cinema, 1958–1972," in *The Social Documentary in Latin America*, ed. Julianne Burton (Pittsburgh: University of Pittsburgh Press, 1990), 78.
6 This estimation is mine based on data compiled in Alicia Vega, *Itinerario del cine documental chileno, 1900–1990* (Santiago de Chile: Centro Estudios y Artes de la Comunicación, Universidad Alberto Hurtado, 2006). For an account of the album film, see Jennifer Lynn Peterson, *Education in the School of Dreams: Travelogues and Early Nonfiction Film* (Durham, NC: Duke University Press, 2013). See also n. 40 in chapter 3 of this book.
7 Vega, *Itinerario del cine documental chileno*.
8 See Claudio R. Salinas, Hans Stange Marcus, and Sergio Salinas Roco, *Historia del cine experimental en la Universidad de Chile, 1957–1973* (Santiago de Chile: Uqbar, 2008).
9 Salinas et al., *Historia del cine experimental en la Universidad de Chile*, 43. There is an interesting story to tell about Sergio Bravo's educational background. He had often said that he was more influenced by his early training in architecture than by his participation in a cine-club he started at the University of Chile in the mid-1950s (before the founding of the Centro). Bravo studied at the School of Architecture at the University of Chile in the late 1940s, following the national university reform of 1946. He studied under the direction of the Hungarian Bauhaus architect Tibor Weiner, who had arrived in Chile in 1939 and become a major force in the curricular revamping of the School of Architecture along functionalist lines (which also occurred in 1946 and 1947). For more on Weiner in Chile, see Daniel Talesnik Y., "Tibor Weiner y su role en la reforma: Una re-introducción," *De Arquitectura*, no. 14 (2006): 64–70.

10 Fernando Balmaceda del Río, *De zorros, amores y palomas: Memorias* (Santiago de Chile: El Mercurio/Aguilar, 2002), 343.

11 See Balmaceda del Río, *De zorros, amores y palomas*, 343; Diego Pino, "Fernando Balmaceda del Río," *Revista Séptimo Arte*, May 2, 2012, accessed August 31, 2015, http://www.r7a.cl/article/fernando-balmaceda -del-rio.

12 My translation.

13 All translations of the voice-over narration are mine.

14 See Vega, *Itinerario del cine documental chileno*, 230.

15 Quoted in Vega, *Itinerario del cine documental chileno,* 230. The translation is mine.

16 See Rianne Siebenga, "Crafts and Industry in Early Films of British India: Contrasting Album and Process Films," *Early Popular Visual Culture* 12, no. 3 (2014): 342–56. See also n. 40 in chapter 3 of this book.

17 For the classic text on "reactionary modernism," see Jeffrey Herf, *Reactionary Modernism: Technology, Culture, and Politics in Weimar and the Third Reich* (Cambridge: Cambridge University Press, 1986). Michael Cowan has written about reactionary modernism in relation to industrial films in the German context: see Michael Cowan, *Walter Ruttmann and the Cinema of Multiplicity: Avant-Garde–Advertising–Modernity* (Amsterdam: Amsterdam University Press, 2016).

18 Implicit in what I am saying here is a refusal of the distinction Claude Lévi-Strauss draws between the *bricoleur* (the "savage mind"), an ad hoc-ist par excellence, and the engineer (the man of science), a proper craftsman. It could be interesting to read this material through the lens of *bricolage*: see Claude Lévi-Strauss, *The Savage Mind* (Chicago: University of Chicago Press, 1966). For an analysis of Lévi-Strauss that argues against the strong distinction, see Christopher Johnson, "Bricoleur and Bricolage: From Metaphor to Universal Concept," *Paragraph* 35, no. 3 (2012): 355–72. For a classic critique of Lévi-Strauss, see Jacques Derrida, *Writing and Difference*, trans. Alan Bass, repr. ed. (Chicago: University of Chicago Press, 1978).

19 Quoted in Sheila Schvarzman, *Humberto Mauro e as imagens do Brasil* (São Paulo: Fundação Editora da UNESP, 2004), 197. All translations from this book are mine.

20 Schvarzman, *Humberto Mauro e as imagens do Brasil*.

21 Quoted in Schvarzman, *Humberto Mauro e as imagens do Brasil*, 200.

22 Schvarzman, *Humberto Mauro e as imagens do Brasil*, 220.

23 Schvarzman, *Humberto Mauro e as imagens do Brasil*.

24 Schvarzman, *Humberto Mauro e as imagens do Brasil*.

25 Schvarzman, *Humberto Mauro e as imagens do Brasil*.

26 Paulo Antonio Paranaguá, "Orígenes, evolución y problemas," in *Cine documental en América Latina* (Madrid: Catedra, 2003), 29.

27 Cowan, *Walter Ruttmann and the Cinema of Multiplicity*, 138.

28 Paranaguá, "Orígenes, evolución y problemas," 29. All translations from this book are mine. Emphasis mine as well.

29 Paranaguá, "Orígenes, evolución y problemas," 29.

30 Paranaguá, "Orígenes, evolución y problemas," 29.

31 See Paranaguá, "Orígenes, evolución y problemas."

32 Amir Labaki, *Introdução ao documentário brasileiro* (São Paulo: Francis, 2006), 41.

33 Wills Leal, *O discurso cinematográfico dos paraibanos, ou, A história do cinema da/na Paraíba* (João Pessoa, Brazil: W. Leal, 1989), 106.

34 Vladimir Carvalho, "'Vivo ainda sob a hipnose de *Aruanda*," in João de Lima Gomes, *Aruanda-Jornada Brasileira: Homenagem aos cineastas João Ramiro Mello e Rucker Vieira* (João Pessoa: Editora Universitária, 2003), 109.

35 Sarah Sarzynski, "Documenting the Social Reality of Brazil: Roberto Rossellini, the Paraíban Documentary School, and the Cinema," in *Global Neorealism: The Transnational History of a Film Style*, ed. Saverio Giovacchini and Robert Sklar (Jackson: University Press of Mississippi, 2013), 221–22.

36 Randal Johnson, "Documentary Discourses and National Identity: Humberto Mauro's Brasiliana Series and Linduarte Noronha's Aruanda," *Nuevo Texto Crítico* 11, no. 1 (1998): 194.

37 For the controversy over the film's authorship, see Jose Marinho de Oliveira, *Dos homens e das pedras: O ciclo do cinema documentário paraibano, 1959–1979* (Niterói, RJ: Editora da Universidade Federal Fluminense, 1988). Although Linduarte credited Carvalho and João Ramiro Mello as assistant directors only on *Aruanda*, both Carvalho and Ramiro Mello have publicly said that the three men cowrote the script. The script, according to Ramiro Mello, was not even remotely based on Linduarte's 1958 newspaper article about Serra do Talhado, as Linduarte Norohna has maintained. The Franco-Brazilian film critic Jean-Claude Bernadet has also said in televised interviews that Carvalho has not gotten enough credit for *Aruanda*. This authorship controversy spelled a break in the Linduarte-Carvalho friendship. The two men reconciled in 1979: Oliveira, *Dos homens e das pedras*, 75–76). Carvalho's other process films include *A Bolandeira* (1968), about the production of rapadura; *A Pedra da Riqueza* (1975), about the production of sheelite; *O País de Saõ Saruê* (1971), about the production of cotton; *Quilombo* (1975), about the production of quince marmalade; *Mutirão* (1976), about the production of textiles.

38 Carlos Alberto Mattos, *Vladimir Carvalho: Pedras na lua e pelejas no planalto* (São Paulo: Imprensa Oficial, 2008), 47, 69.

39 Mattos, *Vladimir Carvalho*, 75.

40 Mattos, *Vladimir Carvalho*, 73.

41 Vladimir Carvalho, *Cinema candango: Matéria de jornal* (Brasília: Cinememória, 2003).

42 Glauber Rocha, *Revisão crítica do cinema brasileiro* (Rio de Janeiro: Cosac Naify, 2003), 145, my translation.

43 Oliveira, *Dos homens e das pedras*, 169.

44 João de Lima Gomes and Manuel Clemente, "Linduarte e seus personagens," in Lima Gomes, *Aruanda-Jornada Brasileira*, 76.

45 Oliveira, *Dos homens e das pedras*, 169.

46 Oliveira, *Dos homens e das pedras*.

47 For this postcolonial critique of Flaherty as a "taxidermist" conjuring an unchanging indigenous man frozen in time, see Fatimah Tobing Rony, *The Third Eye: Race, Cinema, and Ethnographic Spectacle* (Durham, NC: Duke University Press, 1996). For a theoretical treatment of the denial of coevalness in anthropology, see Fabian and Bunzl, *Time and the Other*.

48 Nei Lopes, *Novo dicionário banto do Brasil: Contendo mais de 250 propostas etmológicas acolhidas pelo dicionário Houaiss* (Rio de Janeiro: Pallas, 2003), 32.

49 For a different approach to the significance of the film's title, see Elio Chaves Flores, "África e sertão da Paraíba: Luanda, Aruanda," *Cadernos Imbondeiro* 4, no. 1 (February 12, 2016): 81–101.

50 Vladimir Carvalho, "'Vivo ainda sob a hipnose de *Aruanda*,'" in Lima Gomes, *Aruanda-Jornada Brasileira*, 112.

51 Linduarte Noronha, "Aruanda é um filme autóctone," in Lima Gomes, *Aruanda-Jornada Brasileira*, 121–24.

52 Carlos Alberto Mattos, *Pedras na lua e pelejas no planalto* (São Paulo: impresaoficial, 2008), 82.

53 Carvalho, "Vivo ainda sob a hipnose de Aruanda," 95–113.

54 Michael Löwy, "The Romantic and the Marxist Critique of Modern Civilization," *Theory and Society* 16, no. 6 (1987): 894. "Romantic anticapitalism" is a phrase first coined by Georg Lukács. For a discussion of the differing strains of romanticism, see also Michael Löwy, "Marxism and Revolutionary Romanticism," *Telos* 49 (Fall 1981): 83–95. For a discussion of the term's provenance, see Michael Löwy, "Naphta or Settembrini? Lukács and Romantic Anticapitalism," *New German Critique* 42 (Autumn 1987): 17–31. For a response to Löwy's account of romantic anticapitalism and Löwy's counter-response, see the first part of G. A. Rosso and Daniel P. Watkins, *Spirits of Fire: English Romantic Writers and Contemporary Historical Methods* (Rutherford, NJ: Fairleigh Dickinson University Press, 1990).

55 Robert Sayre and Michael Löwy, "Figures of Romantic Anti-Capitalism," *New German Critique*, no. 32 (1984): 42–92.

56 There has been controversy regarding Marx's view of the abolition of the division of labor in the future society. Some scholars argue that Marx's views shift between *The German Ideology*, in which he declares the necessity of abolishing the division of labor, and *Capital*, in which even in the emancipated society of the future productive activity would be divided: it would be divided between a realm of necessity ("production for the sake of survival") and a realm of freedom ("the development of human energy which is an end in itself"), which has the realm of necessity as its basis. For more on this controversy, see Bhikhu C. Parekh, *The Concept of Socialism* (New York: Holmes and Meier, 1975); Ali Rattansi, *Marx and the Division of Labor* (London: Macmillan, 1982).

57 Löwy, "The Romantic and the Marxist Critique of Modern Civilization," 903.

58 Sayre and Löwy, "Figures of Romantic Anti-Capitalism," 90.

59 See Julianne Burton, "Film Artisans and Film Industries in Latin America, 1956–1980: Theoretical and Critical Implications of Variations in Modes of Filmic Production and Consumption," in *New Latin American Cinema, Volume 1: Theory, Practices, and Transcontinental Articulations*, ed. Michael Martin (Detroit: Wayne State University Press, 1997), 157–84.

60 For a recuperative account of the evolutionism of cultural materialism, see Marvin Harris, *The Rise of Anthropological Theory: A History of Theories of Culture* (New York: Crowell, 1968).

61 Dave Kehr, "Humanity and Nature Share a Timeless Dance on Persimmon Farms," *New York Times*, March 31, 2004, accessed May 26, 2019, http://www.nytimes.com/2004/03/31/movies/film-review-humanity-and-nature-share-a-timeless-dance-on-persimmon-farms.html.

62 Abé Mark Nornes, *Forest of Pressure: Ogawa Shinsuke and Postwar Japanese Documentary* (Minneapolis: University of Minnesota Press, 2007), 276.

63 Nornes, *Forest of Pressure*, 276.

64 Kehr, "Humanity and Nature Share a Timeless Dance on Persimmon Farms."

65 Nornes, *Forest of Pressure*, 276.

66 Kehr, "Humanity and Nature Share a Timeless Dance on Persimmon Farms."

CHAPTER FIVE. THE LIMITS OF THE GENRE

1 Michael Hardt and Antonio Negri, *Multitude: War and Democracy in the Age of Empire*, repr. ed. (New York: Penguin, 2005), 108.

2 For more on affective labor as a species of immaterial labor, see Michael Hardt, "Affective Labor," *Boundary 2* (1999): 89–100.

3 For more on the cycle, see Deborah Shaw, "Intimacy and Distance—Domestic Servants in Latin American Women's Cinema: *La Mujer sin Cabeza* and *El Niño Pez/The Fish Child*," in *Latin American Women Filmmakers: Production, Politics, Poetics*, ed. Deborah Martin and Deborah Shaw (London: I. B. Tauris, 2017), 123–48.

4 Anna Rubbo and Michael Taussig, "Up off Their Knees: Servanthood in Southwest Colombia," *Latin American Perspectives* 10, no. 4 (October 1, 1983): 5–23. For more on domestic labor organizing and legal reform, see Merike Blofield, "Feudal Enclaves and Political Reforms: Domestic Workers in Latin America," *Latin American Research Review* 44, no. 1 (2009): 158–90; Elsa M. Chaney and Mary García Castro, eds., *Muchachas No More: Household Workers in Latin America and the Caribbean* (Philadelphia: Temple University Press, 1991), pt. 4. For statistics on domestic service in Latin America, see Patricia de Santana Pinho and Elizabeth B. Silva, "Domestic Relations in Brazil: Legacies and Horizons," *Latin American Research Review* 45, no. 2 (2010): 90–113; Victor E. Tokman, "Domestic Workers in Latin America: Statistics for New Policies," Women in Informal

Employment Globalizing and Organizing (WEIGO) Working Paper (Statistics) no. 17, June 2010, accessed May 27, 2019, http://www.wiego.org/sites/default/files/publications/files/Tokman_WIEGO_WP17.pdf. For accounts of what drives rates of domestic service, see Ester Boserup, *Woman's Role in Economic Development* (New York: Earthscan, 2007); David Chaplin, "Domestic Service and Industrialization," in *Comparative Studies in Sociology*, ed. Richard F. Tomasson, vol. 1 (Greenwich, CT: Jai Press, 1978), 97–127; David M. Katzman, *Seven Days a Week: Women and Domestic Service in Industrializing America* (Urbana-Champaign: University of Illinois Press, 1981); Ruth Milkman, Ellen Reese, and Benita Roth, "The Macrosociology of Paid Domestic Labor," *Work and Occupations* 25, no. 4 (November 1, 1998): 483–510; José C. Moya, "Domestic Service in a Global Perspective: Gender, Migration, and Ethnic Niches," *Journal of Ethnic and Migration Studies* 33, no. 4 (2007): 559–79; Lakshmi Srinivas, "Master-Servant Relationship in a Cross-Cultural Perspective," *Economic and Political Weekly* 30, no. 5 (February 4, 1995): 269–78.

5 Grace Esther Young, "The Myth of Being 'Like a Daughter,'" *Latin American Perspectives* 14, no. 3 (July 1, 1987): 365–80.

6 Lewis A. Coser, "Servants: The Obsolescence of an Occupational Role," *Social Forces* 52, no. 1 (September 1, 1973): 31–40.

7 Domestic service in Latin America also offers a particularly productive site for thinking through a subject that has been hotly contested in the Global North, as well—namely, the penetration of the market into emotional life.

8 Hardt and Negri, *Multitude*, 108.

9 See, e.g., Barbara Ehrenreich and Arlie Russell Hochschild, *Global Woman: Nannies, Maids, and Sex Workers in the New Economy* (New York: Macmillan, 2003); Arlie Russell Hochschild, *The Commercialization of Intimate Life: Notes from Home and Work*, 1st ed. (Berkeley: University of California Press, 2003); Margaret Jane Radin, *Contested Commodities: The Trouble with Trade in Sex, Children, Body Parts, and Other Things* (Cambridge: Cambridge University Press, 1996); Debra Satz, *Why Some Things Should Not Be for Sale: The Moral Limits of Markets* (Oxford: Oxford University Press, 2010); Viviana A. Zelizer, *The Purchase of Intimacy* (Princeton, NJ: Princeton University Press, 2005).

10 See, e.g., Elizabeth Anderson, *Value in Ethics and Economics* (Cambridge, MA: Harvard University Press, 1995); Martha Ertman and Joan C. Williams, *Rethinking Commodification: Cases and Readings in Law and Culture* (New York: New York University Press, 2005); Martha C. Nussbaum, "'Whether from Reason or Prejudice': Taking Money for Bodily Services," *Journal of Legal Studies* 27, no. S2 (1998): 693–723; Radin, *Contested Commodities*; Satz, *Why Some Things Should Not Be for Sale*; Zelizer, *The Purchase of Intimacy*.

11 See Anderson, *Value in Ethics and Economics*.

12 See Anderson, *Value in Ethics and Economics*. It is common to both defend this view and militate *against* the criminalization of sex work and *for* legal protections for sex workers.

13 Bridget Anderson, *Doing the Dirty Work? The Global Politics of Domestic Labour* (New York: Palgrave Macmillan, 2000). Gabrielle Meagher, "Is It Wrong to Pay for Housework?," *Hypatia* 17, no. 2 (April 1, 2002): 52–66.

14 Mary García Castro, "What Is Bought and Sold in Domestic Service? The Case of Bogotá: A Critical Review," in Chaney et al., *Muchachas No More*, 122.

15 Some scholars have argued that the personalism of domestic service is not wholly mitigated by casualization and contractualization: see, e.g., Judith Rollins, *Between Women: Domestics and Their Employers* (Philadelphia: Temple University Press, 1987).

16 Coser, "Servants."

17 Emily Nett, "The Servant Class in a Developing Country: Ecuador," *Journal of Inter-American Studies* 8, no. 3 (1966): 437–52; Rubbo and Taussig, "Up off Their Knees."

18 Coser, "Servants."

19 Coser, "Servants," 32.

20 Coser, "Servants," 32.

21 Coser, "Servants," 33.

22 Coser, "Servants," 33.

23 Coser, "Servants," 36. For Coser, that identification plays an important function for the master—namely, it secures the loyalty of an employee who has special knowledge of the secrets of the master and his household, secrets that could have a negative impact on the master's reputation if exposed.

24 See Anderson, *Value in Ethics and Economics*.

25 Arlie Russell Hochschild, *The Managed Heart: Commercialization of Human Feeling* (Berkeley: University of California Press, 2012). Hochschild has been widely criticized, particularly for what is taken to be her basic allegiance to the idea of false consciousness. For a recent evaluation of those criticisms, see Paul Brook, "The Alienated Heart: Hochschild's 'Emotional Labour' Thesis and the Anticapitalist Politics of Alienation," *Capital and Class* 33, no. 2 (July 1, 2009): 7–31.

26 See Hochschild, *The Managed Heart*, 17. While Hochschild is developing her theory in relation to flight attendants in a modern wage-labor relation where airline companies are training workers to sell themselves in this way, the insight applies as well to the case of domestic service, although this may raise questions about contemporary commodification debates (i.e., Isn't there something crucially different about commodification by corporations in service industries and commodification in servant-master relations?).

27 Hochschild, *The Managed Heart*.

28 Fernando Croce, "Parque Vía," *Slant Magazine*, 2008, accessed May 27, 2019, http://www.slantmagazine.com/film/review/parque-via.

29 Marsha Kinder, "Reflections on 'Jeanne Dielman,'" *Film Quarterly* 30, no. 4 (1977): 2.

30 See Ivone Margulies, *Nothing Happens: Chantal Akerman's Hyperrealist Everyday* (Durham, NC: Duke University Press, 1996).

31 Anca Parvulescu, "Import/Export: Housework in an International Frame," *PMLA* 127, no. 4 (2012): 849.

32 For a different approach to the comparison between *Umberto D* and *Jeanne Dielman*, see Margulies, *Nothing Happens*. Margulies argues that while both are "dedramtaized cinemas," they serve different agendas. The minimal hyperrealism of *Jeanne Dielman* "undoes any idea of symbolic transcendence" or representativeness. Unlike the way that *Umberto D*'s characters stand in allegorically for types, the "literal time" in *Jeanne Dielman* (and in Warhol's expanded duration films) "robs [the representation] of the possibility of standing for something other than that concrete instance": Margulies, *Nothing Happens*, 37.

33 See, e.g., Ben Singer, "*Jeanne Dielman*: Cinematic Interrogation and 'Amplification,'" *Millennium Film Journal* 22 (1989): 56–75. Singer writes, "*Jeanne Dielman* . . . aligns itself particularly with the durational experiments of Warhol. It was Warhol who first showed in film that prolonged exposure to long periods of relatively unfaltering and thematically vacuous subject matter leads the viewer to experience duration as a 'concrete' dimension of film. In the long shots of Jeanne making coffee or kneading meatloaf or washing dishes, we are not diverted by narrative events or symbolic signification or spectacular display. . . . As a result of this excessive duration and emptiness, we are induced into feeling time. Time is perceived as a 'material' substrate of the medium": Singer, "*Jeanne Dielman*," 58. For a nuanced treatment of Akerman's relation to Warhol that rejects this basic account, see Margulies, *Nothing Happens*. Margulies writes, "In Warhol, interest is challenged on all fronts: the filmmaker is absent, the object is banal, the spectator is bored. The spectator's confrontation with his or her own physical and mental endurance delineates a cinema that has given up on the notions of truth that sustain other alternative cinema (Akerman included)": Margulies, *Nothing Happens*, 40.

34 Margulies, *Nothing Happens*, ix.

35 Margulies, *Nothing Happens*, 6.

36 The use of perspective is discussed in Singer, "*Jeanne Dielman*."

37 For more on the treatment of completed actions, see Margulies, *Nothing Happens*.

38 Singer, "*Jeanne Dielman*," 62.

39 Margulies, *Nothing Happens*, 88.

40 Chantal Akerman, interview, *Jeanne Dielman, 23 Quai du Commerce, 1080 Bruxelles*, DVD (Criterion Collection, 2009).

41 It is relevant to remember that this approach to the variation of gesture was a strategy of representation deployed by the engraver Gheyn in his serial depictions of military drills that were intended as aids to help soldiers learn the correct positioning of their bodies (see chapter 1 in this book).

42 Margulies, *Nothing Happens*, 78.

43 Margulies, *Nothing Happens*, 88–91.

44 For more on the realm of necessity as it applies to the process genre, see n. 56 in chapter 4 of this book.

45 Erving Goffman, *The Presentation of Self in Everyday Life* (Garden City, NY: Doubleday, 1959), 151.

46 Coser, "Servants," 34.

47 Jean Genet and Jean-Paul Sartre, *The Maids and Deathwatch: Two Plays*, rev. ed. (New York: Grove, 1994), 20–21.

48 There is one exception, and that is at the very end of Beto's time in the mansion when he bathes in the tub.

49 Marjolein Van der Veen, "Rethinking Commodification and Prostitution: An Effort at Peacemaking in the Battles over Prostitution," *Rethinking Marxism* 13, no. 2 (2001): 30–51.

50 Van der Veen points out that there are commentators who reject such a characterization of pleasure in sex work. "Sex radicals and prostitution rights advocates have made major efforts to depathologize forms of desire and pleasure that deviate from the 'norm' of noncommercial, monogamous heterosexuality," she writes. "Indeed, taking pleasure and desire in all its varied forms out of hidden spaces of the bedroom and closet, sex workers and their advocates are striving to open up new spaces for experimentation, for the innovation of new desires and pleasures, and for greater self-exploration": Van der Veen, "Rethinking Commodification and Prostitution," 37. This line of argument finds little use for the concept of commodification. Presumably, these commentators would also reject the efforts to delineate permissible and impermissible areas of life that may be commodified.

51 See Michael Hardt and Antonio Negri, *Empire* (Cambridge, MA: Harvard University Press, 2001).

EPILOGUE

Epigraph: Hollis Frampton, "For a Metahistory of Film: Commonplace Notes and Hypotheses," *ArtForum* 10, no. 1 (1971): 34–35.

1 It should be acknowledged that film noir as a genre category is one that was labeled *retrospectively*, by critics. For an account of the retrospective emergence of the category, see James Naremore, *More than Night: Film Noir in Its Contexts*, updated and expanded ed. (Berkeley: University of California Press, 2008).

2 Roland Barthes, "The Plates of the *Encyclopedia*," in *New Critical Essays*, by Roland Barthes, trans. Richard Howard (Evanston, IL: Northwestern University Press, 2009), 29.

3 See Mikhail M. Bakhtin, *The Dialogic Imagination: Four Essays* (Austin: University of Texas Press, 2010).

4 For this view, see Linda Hutcheon, *A Theory of Parody: The Teachings of Twentieth-Century Art Forms* (New York: Methuen, 1985); Gary Saul Morson, *The Boundaries of Genre: Dostoevsky's* Diary of a Writer *and the Traditions of Literary Utopia* (Evanston, IL: Northwestern University Press, 1988).

5 Several theorists have treated the question of the lifecycle of genres from the Russian formalists Boris Eichenbaum, Viktor Shklovsky, and Yuri Tynyanov to John Cawelti, Henry Focillon, and Thomas Schatz. For an overview, see Simon Dentith, *Parody* (London: Routledge, 2002). See also John Cawelti, "*Chinatown* and Generic Transformation in Recent American Films," in *Film Genre Reader III*, ed. Barry Keith Grant (Austin: University of Texas Press, 1986), 243–61; Henri Focillon, *The Life of Forms in Art* (New York: Zone, 1948); Thomas Schatz, *Hollywood Genres: Formulas, Filmmaking, and the Studio System* (New York: McGraw-Hill, 1981).

6 There is a small catalogue of early films spoofing processual sausage production, including the Lumière brothers' *The Mechanical Butcher* (1895), Biograph's *Sausage Machine* (1897), George Albert Smith's *Making Sausages* (1897), and Edwin S. Porter's *Fun in a Butcher Shop* (1901) and *Dog Factory* (1904). For a treatment of these early "hot dog" films through an animal studies lens, see Pao-chen Tang, "Of Dogs and Hot Dogs: Distractions in Early Cinema," *Early Popular Visual Culture* 15, no. 1 (2017): 44–58.

7 As I said earlier, because we do not see people talking, it is impossible to know who says what or even how many people are participating in the conversation. Here each letter of the dialogue is meant *only* to suggest that there has been a change in the speaker from the previous letter. My guess is that fewer than ten people (i.e., A–J) are participating in the conversation. What matters for my purposes is what is said and that it is a conversation between at least two people.

8 These four letters (i.e., A–D) may not represent different people. I cannot tell for certain from the voices whether they belong to distinct people. Each letter is meant only to indicate that there has been a change in the speaker from the previous letter.

9 There is certainly more that could be said about the self-generating (perhaps living) character of the dough. Rather than being used up in the production process, the raw material of this production process is self-reproducing. There is, of course, an analogy to be made here with human labor, which also "replenishes" itself—both from day to day and from generation to generation.

10 For a comprehensive treatment of these debates about commodification, see Margaret Jane Radin, *Contested Commodities: The Trouble with Trade in Sex, Children, Body Parts, and Other Things* (Cambridge: Cambridge University Press, 1996).

11 Karl Marx and Fredrick Engels, *The Economic and Philosophic Manuscripts of 1844 and the Communist Manifesto*, trans. Martin Milligan (Amherst, NY: Prometheus, 1988), my emphasis.

12 My use of ellipses here is meant to mark the moments in the audio that are indecipherable—presumably intentionally—rather than moments I have intentionally elided.

13 See Franz Reuleaux and Eugene S. Ferguson, *The Kinematics of Machinery: Outlines of a Theory of Machines* (Mineola, NY: Dover, 1963). See also Francis C. Moon, *The Machines of Leonardo da Vinci and Franz Reuleaux:*

Kinematics of Machines from the Renaissance to the 20th Century (Dordrecht, the Netherlands: Springer Science and Business Media, 2007).

14 John Ruskin, *The Stones of Venice* (London: Smith, Elder, 1867), 171, my emphasis.

15 Gloria Hickey, "Why Is Sloppy and Postdiscplinary Craft Significant and What Are Its Historical Precedents?," in *Sloppy Craft: Postdiciplinarity and the Crafts*, ed. Elaine Cheasley Paterson and Susan Surette (London: Bloomsbury Academic, 2015), 115.

16 Glenn Adamson, "When Craft Gets Sloppy," in Paterson and Surette, *Sloppy Craft*, 199.

17 Barthes, "The Plates of the *Encyclopedia*," 29.

18 Barthes, "The Plates of the *Encyclopedia*," 27.

BIBLIOGRAPHY

Acland, Charles R., and Haidee Wasson, eds. *Useful Cinema*. Durham, NC: Duke University Press, 2011.

Adamson, Glenn. "When Craft Gets Sloppy." In *Sloppy Craft: Postdisciplinarity and the Crafts*, ed. Elaine Cheasley Paterson and Susan Surette, 197–200. London: Bloomsbury Academic, 2015.

Addams, Jane. "First Report of the Labor Museum at Hull House, Chicago, 1901–1902," 1902. Accessed November 7, 2018, https://digital.janeaddams .ramapo.edu/items/show/1189.

Addams, Jane. "Labor Museum at Hull House." The Commons, June 30, 1900.

Allocca, Kevin. *Videocracy: How YouTube Is Changing the World . . . with Double Rainbows, Singing Foxes, and Other Trends We Can't Stop Watching*. New York: Bloomsbury, 2018.

Altick, Richard D. *The Shows of London*. Cambridge, MA: Harvard University Press, 1978.

Altman, Rick. *Film/Genre*. London: British Film Institute, 1999.

Altman, Rick. "Reusable Packaging: Generic Products and the Recycling Process." In *Refiguring American Film Genres: History and Theory*, ed. Nick Browne, 1–41. Berkeley: University of California Press, 1998.

Altman, Rick. "A Semantic/Syntactic Approach to Film Genre." *Cinema Journal* 23, no. 3 (1984): 6–18.

Anderson, Bridget. *Doing the Dirty Work? The Global Politics of Domestic Labour*. New York: Palgrave Macmillan, 2000.

Anderson, Elizabeth. *Value in Ethics and Economics*. Cambridge, MA: Harvard University Press, 1995.

Anderson, Jay. *Time Machines: The World of Living History*. Nashville, TN: American Association for State and Local History, 1984.

Andersen, Joceline. "Now You've Got the Shiveries: Affect, Intimacy, and the ASMR Whisper Community." *Television and New Media* 16, no. 8 (December 1, 2015): 683–700.

Arendt, Hannah. *The Human Condition*, 2d ed. Chicago: University of Chicago Press, 1998.

Arendt, Hannah. "Labor, Work, Action." In *The Phenomenology Reader*, ed. Dermot Moran and Timothy Mooney, 362–74. London: Routledge, 2002.

Auerbach, Jeffrey A. *The Great Exhibition of 1851: A Nation on Display*. New Haven, CT: Yale University Press, 1999.

Bakan, Mildred. "Hannah Arendt's Concepts of Labor and Work." In *Hannah Arendt: The Recovery of the Public World*, ed. Melvyn Hill, 49–66. New York: St. Martin's, 1979.

Bakhtin, Mikhail M. *The Dialogic Imagination: Four Essays*. Austin: University of Texas Press, 2010.

Balmaceda del Río, Fernando. *De zorros, amores y palomas: Memorias*. Santiago de Chile: El Mercurio/Aguilar, 2002.

Barringer, T. J. *Men at Work: Art and Labour in Victorian Britain*. New Haven, CT: Yale University Press, 2005.

Barthes, Roland. "The Plates of the *Encyclopedia*." In *New Critical Essays*, by Roland Barthes, trans. Richard Howard, 23–40. Evanston, IL: Northwestern University Press, 2009.

Bateson, Gregory. *Steps to an Ecology of Mind: Collected Essays in Anthropology, Psychiatry, Evolution, and Epistemology*. Chicago: University of Chicago Press, 2000.

Baudrillard, Jean. *The Mirror of Production*. New York: Telos, 1975.

Bazin, André. "A Bergsonian Film: *The Picasso Mystery*." In *Bazin at Work: Major Essays and Reviews from the Forties and Fifties*, ed. Bert Cardullo, 211–20. New York: Routledge, 1997.

Beller, Jonathan. *The Cinematic Mode of Production: Attention Economy and the Society of the Spectacle*. Hanover, NH: Dartmouth College Press, 2006.

Benedict, Burton. *The Anthropology of World's Fairs: San Francisco's Panama Pacific International Exposition of 1915*. Berkeley, CA: Scolar, 1983.

Bentley, Jean. "'Machines' Director Rahul Jain Wanted to Ask a Very Simple Question with His Film—Watch." *IndieWire*, December 8, 2017. Accessed June 3, 2019. https://www.indiewire.com/2017/12/machines-documentary -rahul-jain-interview-1201898134/.

Bergson, Henri. *Time and Free Will: An Essay on the Immediate Data of Consciousness*. Mansfield Centre, CT: Martino Fine Books, 2015.

Bernaerts, Lars, Marco Caracciolo, Luc Herman, and Bart Vervaeck. "The Storied Lives of Non-Human Narrators." *Narrative* 22, no. 1 (2014): 68–93.

Bernstein, Nicholai A. *Dexterity and Its Development*, ed. Mark L. Latash and Michael T. Turvey. London: Psychology Press, 2015.

Blackwell, Mark. *The Secret Life of Things: Animals, Objects, and It-Narratives in Eighteenth-Century England*. Lewisburg, PA: Bucknell University Press, 2007.

Blofield, Merike. "Feudal Enclaves and Political Reforms: Domestic Workers in Latin America." *Latin American Research Review* 44, no. 1 (2009): 158–90.

Bordwell, David. *Narration in the Fiction Film*. Madison: University of Wisconsin Press, 1985.

Boserup, Ester. *Woman's Role in Economic Development*. New York: Earthscan, 2007.

Botton, Alain de. *The Pleasures and Sorrows of Work*. New York: Vintage International, 2010.

Bower, Anne L., ed. *Recipes for Reading: Community Cookbooks, Stories, Histories*. Amherst: University of Massachusetts Press, 1997.

Braun, Marta. *Picturing Time: The Work of Etienne-Jules Marey*, repr. ed. Chicago: University of Chicago Press, 1995.

Braverman, Harry. *Labor and Monopoly Capital: The Degradation of Work in the Twentieth Century*. New York: New York University Press, 1998.

Bresson, Robert, and J. M. G. Le Clézio. *Notes on the Cinematograph*, trans. Jonathan Griffin. New York: New York Review of Books Classics, 2016.

Brewer, Daniel. "The Work of the Image: The Plates of the *Encyclopédie*." In *A History of Book Illustration: 29 Points of View*, ed. Bill Katz. Metuchen, NJ: Scarecrow Press, 1994.

Brewer, William F.. "The Nature of Narrative Suspense and the Problem of Rereading." In *Suspense: Conceptualizations, Theoretical Analyses, and Empirical Explorations*, ed. Peter Vorderer, Hans Jurgen Wulff, and Mike Friedrichsen, 107–28. New York: Routledge, 1996.

Brigard, Emilie. "The History of Ethnographic Film." In *Principles of Visual Anthropology*, ed. Paul Hockings, 2d ed., 13–44. Berlin: Walter de Gruyter, 2012.

Brook, Paul. "The Alienated Heart: Hochschild's 'Emotional Labour' Thesis and the Anticapitalist Politics of Alienation." *Capital and Class* 33, no. 2 (July 1, 2009): 7–31.

Brooks, Peter. *The Melodramatic Imagination: Balzac, Henry James, Melodrama, and the Mode of Excess*. New Haven, CT: Yale University Press, 1976.

Bruner, Jerome. "The Narrative Construction of Reality." *Critical Inquiry* 18, no. 1 (1991): 1–21.

Burton, Julianne. "Democratizing Documentary: Modes of Address in the New Latin American Cinema, 1958–1972." In *The Social Documentary in Latin America*, ed. Julianne Burton, 49–86. Pittsburgh: University of Pittsburgh Press, 1990.

Burton, Julianne. "Film Artisans and Film Industries in Latin America, 1956–1980: Theoretical and Critical Implications of Variations in Modes of Filmic Production and Consumption." In *New Latin American Cinema, Volume 1: Theory, Practices, and Transcontinental Articulations*, ed. Michael Martin, 157–84. Detroit: Wayne State University Press, 1997.

Cain, Victoria E. M. "The Craftsmanship Aesthetic: Showing Making at the American Museum of Natural History, 1910–45." *Journal of Modern Craft* 5, no. 1 (March 1, 2012): 25–50.

Carneiro, Robert L. *Evolutionism in Cultural Anthropology: A Critical History*. Cambridge: Westview, 2003.

Carroll, Noël. "Narrative Closure." *Philosophical Studies* 135, no. 1 (2007): 1–15.

Carvalho, Vladimir. *Cinema candango: Matéria de jornal*. Brasília: Cinememória, 2003.

Carvalho, Vladimir. "Vivo ainda sob a hipnose de Aruanda." In *Aruanda-Jornada Brasileira: Homenagem aos cineastas João Ramiro Mello e Rucker Vieira*, ed. João Lima Gomes, 95–114. João Pessoa, Brazil: Universidade Federal da Paraíba/Editora Universitária, 2003.

Castro, Mary García. "What Is Bought and Sold in Domestic Service? The Case of Bogotá: A Critical Review." In *Muchachas No More: Household Workers in Latin America and the Caribbean*, ed. Elsa M. Chaney and Mary García Castro, 118–30. Philadelphia: Temple University Press, 1989.

Cawelti, John. "*Chinatown* and Generic Transformation in Recent American Films." In *Film Genre Reader III*, ed. Barry Keith Grant, 243–61. Austin: University of Texas Press, 1986.

Chakrabarty, Dipesh. *Rethinking Working-Class History*. Princeton, NJ: Princeton University Press, 2000.

Chaney, Elsa M., and Mary García Castro, eds. *Muchachas No More: Household Workers in Latin America and the Caribbean*. Philadelphia: Temple University Press, 1991.

Chaplin, David. "Domestic Service and Industrialization." In *Comparative Studies in Sociology*, ed. Richard F. Tomasson, vol. 1, 97–127. Greenwich, CT: Jai, 1978.

Comolli, Jean-Louis, and Annette Michelson. "Mechanical Bodies, Ever More Heavenly." *October* 83 (January 1, 1998): 19–24.

Corwin, Sharon. "Picturing Efficiency: Precisionism, Scientific Management, and the Effacement of Labor." *Representations* 84, no. 1 (November 2003): 139–65.

Coser, Lewis A. "Servants: The Obsolescence of an Occupational Role." *Social Forces* 52, no. 1 (September 1, 1973): 31–40.

Coupaye, Ludovic. "Ways of Enchanting: Chaînes Opératoires and Yam Cultivation in Nyamikum Village, Maprik, Papua New Guinea." *Journal of Material Culture* 14, no. 4 (December 1, 2009): 433–58.

Cowan, Michael. *Walter Ruttmann and the Cinema of Multiplicity: Avant-Garde–Advertising–Modernity*. Amsterdam: Amsterdam University Press, 2016.

Cowie, Elizabeth. "Working Images: The Representations of Documentary Film." In *Work and the Image II: Work in Modern Times: Visual Mediations and Social Processes*, ed. Valérie Mainz and Griselda Pollock, 173–92. Farnham, U.K.: Ashgate, 2000.

Crary, Jonathan. *Suspensions of Perception: Attention, Spectacle, and Modern Culture*, repr. ed. Cambridge, MA: MIT Press, 2001.

Crary, Jonathan. *Techniques of the Observer: On Vision and Modernity in the 19th Century*, repr. ed. Cambridge, MA: MIT Press, 1992.

Crawford, Matthew. *Shop Class as Soulcraft: An Inquiry into the Value of Work*. New York: Penguin, 2010.

Csikszentmihalyi, Mihaly. *Applications of Flow in Human Development and Education: The Collected Works of Mihaly Csikszentmihalyi*. New York: Springer, 2014.

Csikszentmihalyi, Mihaly. *Flow: The Psychology of Optimal Experience*. New York: Harper Perennial, 2008.

Dabakis, Melissa. *Visualizing Labor: American Sculpture*. Cambridge: Cambridge University Press, 1999.

D'Aloia, Adriano. "Cinematic Empathy: Spectator Involvement in the Film Experience." In *Kinesthetic Empathy in Creative and Cultural Practices*, ed. Dee Reynolds and Matthew Reason, 91–108. Bristol, U.K.: Intellect, 2012.

Denning, Michael. "Representing Global Labor." *Social Text* 25, no. 3 (2007): 125.

Dentith, Simon. *Parody*. London: Routledge, 2002.

Derrida, Jacques. *Writing and Difference*, trans. Alan Bass, repr. ed. Chicago: University of Chicago Press, 1978.

Dewey, John. *Art as Experience*. New York: Penguin, 2005.

de Wit, Alex Dudok. "Hand Gestures." *Sight and Sound*, December 2015, 76.

Dobres, Marcia-Anne. "Technology's Links and Chaînes: The Processual Unfolding of Technique and Technician." In *The Social Dynamics of Technology: Practice, Politics, and World Views*, ed. Marcia-Anne Dobres and Christopher Hoffman, 124–46. Washington, DC: Smithsonian Institution Press, 1999.

Dormer, Peter. "Craft and the Turing Test for Practical Thinking." In *The Culture of Craft*, ed. Peter Dormer, 137–57. Manchester, U.K.: Manchester University Press, 1997.

Duff, David. *Modern Genre Theory*. London: Routledge, 2014.

Duncan, Carol G. *A Matter of Class: John Cotton Dana, Progressive Reform, and the Newark Museum*. Pittsburgh: Periscope, 2010.

Durington, Matthew, and Jay Ruby. "Ethnographic Film." In *Made to Be Seen: Historical Perspectives on Visual Anthropology*, ed. Marcus Banks and Jay Ruby, 190–208. Chicago: University of Chicago Press, 2011.

Ehrenreich, Barbara, and Arlie Russell Hochschild. *Global Woman: Nannies, Maids, and Sex Workers in the New Economy*. New York: Macmillan, 2003.

Elsaesser, Thomas, ed. *Harun Farocki: Working on the Sightlines*. Amsterdam: Amsterdam University Press, 2004.

Elsaesser, Thomas, and Alexander Alberro. "Farocki: A Frame for the No Longer Visible: Thomas Elsaesser in Conversation with Alexander Alberro." *e-flux* 59 (November 2014). Accessed June 3, 2019. https://www.e-flux .com/journal/59/61111/farocki-a-frame-for-the-no-longer-visible-thomas -elsaesser-in-conversation-with-alexander-alberro/.

The English Cyclopaedia: A New Dictionary of Universal Knowledge. London: Bradbury and Evans, 1861.

Erickson, Paul A., and Liam Donat Murphy. *A History of Anthropological Theory*. Toronto: University of Toronto Press, 2013.

Ertman, Martha, and Joan C. Williams. *Rethinking Commodification: Cases and Readings in Law and Culture*. New York: New York University Press, 2005.

Esterly, David. *The Lost Carving: A Journey to the Heart of Making*. New York: Penguin, 2013.

Evans, Dayna. "Why These Recipe Videos Are Taking Over Your Facebook Wall." *The Cut*, March 23, 2016. Accessed May 5, 2019. https://www.thecut.com /2016/03/zen-and-the-art-of-the-buzzfeed-tasty-video.html.

Eyferth, Jacob. "Craft Knowledge at the Interface of Written and Oral Cultures." *East Asian Science, Technology and Society* 4, no. 2 (June 1, 2010): 185–205.

Fabian, Johannes, and Matti Bunzl. *Time and the Other: How Anthropology Makes Its Object*. New York: Columbia University Press, 2014.

Farocki, Harun. "Workers Leaving the Factory." In *Harun Farocki: Working on the Sightlines*, ed. Thomas Elsaesser, 237–44. Amsterdam: Amsterdam University Press, 2004.

Felski, Rita. *Uses of Literature*. Malden, MA: Wiley-Blackwell, 2008.

Ferguson, Eugene S. "The Mind's Eye: Nonverbal Thought in Technology." *Science* 197, no. 4306 (1977): 827–36.

Flores, Elio Chaves. "África e sertão da Paraíba: Luanda, Aruanda." *Cadernos Imbondeiro* 4, no. 1 (February 12, 2016): 81–101.

Focillon, Henri. *The Life of Forms in Art*. New York: Zone, 1948.

Forster, Laurel, and Janet Floyd. *The Recipe Reader: Narratives, Contexts, Traditions*. Farnham, U.K.: Ashgate, 2003.

Fox, Lorene Kimball, Peggy Brogan, and Annie Louise Butler. *All Children Want to Learn: A Guide for Parents*. New York: Grolier Society, 1954.

Frampton, Hollis. "For a Metahistory of Film: Commonplace Notes and Hypotheses." *ArtForum* 10, no. 1 (1971): 32–35.

Fraser, Max. "Hands off the Machine: Workers' Hands and Revolutionary Symbolism in the Visual Culture of 1930s America." *American Art* 27, no. 2 (2013): 94–117.

Frayling, Christopher. *On Craftsmanship: Toward a New Bauhaus*. London: Oberon, 2011.

Frayne, David. *The Refusal of Work: Rethinking Post-work Theory and Practice*. London: Zed, 2015.

Fried, Michael. *Absorption and Theatricality: Painting and Beholder in the Age of Diderot*. Chicago: University of Chicago Press, 1988.

Fried, Michael. *Art and Objecthood: Essays and Reviews*. Chicago: University of Chicago Press, 1998.

Fromm, Erich, and T. B. Bottomore. *Marx's Concept of Man*. London: Bloomsbury, 2004.

Frow, John. *Genre*, 2d ed. London: Routledge, 2014.

Fuchs, Peter. "Ethnographic Film in Germany: An Introduction." *Visual Anthropology* 1, no. 3 (October 1988): 217–33.

Gallagher, Rob. "Eliciting Euphoria Online: The Aesthetics of 'ASMR' Video Culture." *Film Criticism* 40, no. 2 (June 2016). Accessed May 6, 2019. https://quod.lib.umich.edu/f/fc/13761232.0040.202/--eliciting-euphoria-online-the-aesthetics-of-asmr-video?rgn=main;view=fulltext.

Gamst, Frederick C. "Considerations of Work." In *Meanings of Work: Considerations for the Twenty-First Century*, ed. Frederick C. Gamst, 1–45. Albany: State University of New York Press, 1995.

Gaudreault, André, and Philippe Marion. *The End of Cinema? A Medium in Crisis in the Digital Age*. New York: Columbia University Press, 2015.

Gaycken, Oliver. "The Cinema of the Future: Visions of the Medium as Modern Educator, 1895–1910." In *Learning with the Lights Off: Educational Film in the United States*, ed. Devin Orgeron, Marsha Orgeron, and Dan Streible, 67–89. New York: Oxford University Press, 2012.

Gell, Alfred. "Technology and Magic." *Anthropology Today* 4, no. 2 (1988): 6–9.

Gell, Alfred. "The Technology of Enchantment and the Enchantment of Technology." In *Anthropology, Art, and Aesthetics*, ed. Jeremy Coote and Anthony Shelton, 40–63. Oxford: Clarendon Press, 1992.

Genet, Jean, and Jean-Paul Sartre. *The Maids and Deathwatch: Two Plays*, rev. ed. New York: Grove, 1994.

Giedion, Sigfried. *Mechanization Takes Command: A Contribution to Anonymous History*. Minneapolis: University of Minnesota Press, 2014.

Goddard, Pliny. "Motion Picture Records of Indians." *American Museum Journal* 15 (April 1915): 185–88.

Godelier, Maurice. "Work and Its Representations: A Research Proposal." *History Workshop Journal* 10 (1980): 164–74.

Goffman, Erving. *The Presentation of Self in Everyday Life*. Garden City, NY: Anchor, 1959.

Gombrich, Ernst. "Pictorial Instructions." In *Images and Understanding*, ed. Jonathan Miller, Horace Barlow, Colin Blakemore, and Miranda Weston-Smith. Cambridge: Cambridge University Press, 1991.

Goodrich, Samuel Griswold. *Enterprise, Industry and Art of Man: As Displayed in Fishing, Hunting, Commerce, Navigation, Mining, Agriculture and Manufactures*. Boston: Thompson, Brown and Company, 1845.

Gorfinkel, Elena. "Introduction." *Framework* 53, no. 1 (2013): 43–46.

Gorfinkel, Elena, and Ewa Mazierska, eds. "The Work of the Image." Special issue, *Framework* 53, no. 1 (2013).

Gowlland, Geoffrey. "Unpacking Craft Skills: What Can Images Reveal about the Embodied Experience of Craft?" *Visual Anthropology* 28, no. 4 (August 8, 2015): 286–97.

Grant, Kim. *All about Process: The Theory and Discourse of Modern Artistic Labor*. University Park: Pennsylvania State University Press, 2017.

Grau, Oliver. *Virtual Art: From Illusion to Immersion*. Cambridge, MA: MIT Press, 2003.

Greenhalgh, Paul. *Ephemeral Vistas: The Expositions Universelles, Great Exhibitions and World's Fairs, 1851–1939*. Manchester, U.K.: Manchester University Press, 1991.

Greenhalgh, Paul. "The History of Craft." In *The Culture of Craft*, ed. Peter Dormer, 20–52. Manchester, U.K.: Manchester University Press, 1997.

Greenhalgh, Paul. "The Progress of Captain Ludd." In *The Culture of Craft*, ed. Peter Dormer, 104–15. Manchester, U.K.: Manchester University Press, 1997.

Greenough, Horatio. *Form and Function: Remarks on Art, Design, and Architecture*, 4th ed. Berkeley: University of California Press, 1962.

Greimas, Algirdas Julien. *La soupe au pistou, ou, La construction d'un objet de valeur*. Paris: Groupe de Recherches Sémio-linguistiques, École des Hautes Études en Sciences Sociales, Centre National de la Recherche Scientifique, 1979.

Grieveson, Lee. "Visualizing Industrial Citizenship." In *Learning with the Lights Off: Educational Film in the United States*, ed. Devin Orgeron, Marsha Orgeron, and Dan Streible, 107–23. New York: Oxford University Press, 2012.

Grieveson, Lee. "The Work of Film in the Age of Fordist Mechanization." *Cinema Journal* 51, no. 3 (2012): 25–51.

Griffiths, Alison. "The Untrammeled Camera: A Topos of the Expedition Film." *Film History* 25, no. 1 (April 28, 2013): 95–109.

Griffiths, Alison. *Wondrous Difference: Cinema, Anthropology, and Turn-of-the-Century Visual Culture.* New York: Columbia University Press, 2002.

Guicharnaud, Jacques, and Cynthia Goldman. "Of Grisbi, Chnouf and Rififi." *Yale French Studies*, no. 17 (January 1, 1956): 6–13.

Gunning, Tom. "Before Documentary: Early Nonfiction Films and the 'View' Aesthetic." In *Uncharted Territory: Essays on Early Nonfiction Film*, ed. Daan Hertogs and Nico de Klerk, 9–25. Amsterdam: Stichting Nederlands Filmmuseum, 1997.

Gunning, Tom. "The Cinema of Attractions: Early Film, Its Spectator and the Avant-Garde." *Wide Angle* 8, nos. 3–4 (1986): 63–70.

Gunning, Tom. "'Those Drawn with a Very Fine Camel's Hair Brush': The Origins of Film Genres." *IRIS-PARIS* 20 (1995): 49–62.

Gunning, Tom. "What's the Point of an Index? Or, Faking Photographs." *Nordicom Review* 5, nos. 1–2 (2004): 39–49.

Gunning, Tom. "The World as Object Lesson: Cinema Audiences, Visual Culture and the St. Louis World's Fair, 1904." *Film History* 6, no. 4 (1994): 422–44.

"Hand Gestures." *Dundee Contemporary Arts.* Accessed June 30, 2017. http://www.dca.org.uk/whats-on/event/hand-gestures.

Hardt, Michael. "Affective Labor." *Boundary 2* 26, no. 2 (1999): 89–100.

Hardt, Michael, and Antonio Negri. *Empire.* Cambridge, MA: Harvard University Press, 2001.

Hardt, Michael, and Antonio Negri. *Multitude: War and Democracy in the Age of Empire*, repr. ed. New York: Penguin, 2005.

Harris, Marvin. *The Rise of Anthropological Theory: A History of Theories of Culture.* New York: Crowell, 1968.

Harris, Neil. *Humbug: The Art of P. T. Barnum.* Chicago: University of Chicago Press, 1981.

Hayes, Amy, and Steven Tipper. "Affective Responses to Everyday Actions." In *Kinesthetic Empathy in Creative and Cultural Practices*, ed. Dee Reynolds and Matthew Reason, 67–86. Bristol, U.K.: Intellect, 2012.

Hediger, Vinzenz, and Patrick Vonderau, eds. *Films That Work: Industrial Film and the Productivity of Media.* Amsterdam: Amsterdam University Press, 2009.

Hediger, Vinzenz, and Patrick Vonderau. "Record, Rhetoric, Rationalization." In *Films That Work: Industrial Film and the Productivity of Media*, ed. Vinzenz Hediger and Patrick Vonderau, 35–50. Amsterdam: Amsterdam University Press, 2009.

Heidegger, Martin. *The Question Concerning Technology, and Other Essays.* New York: Harper Torchbooks, 1982.

Herf, Jeffrey. *Reactionary Modernism: Technology, Culture, and Politics in Weimar and the Third Reich.* Cambridge: Cambridge University Press, 1986.

Herman, David. *Basic Elements of Narrative.* Chichester, U.K.: Wiley-Blackwell, 2009.

Herman, David. *Story Logic: Problems and Possibilities of Narrative*. Lincoln: University of Nebraska Press, 2004.

Herman, David. "Storyworld/Umwelt: Nonhuman Experiences in Graphic Narratives." *SubStance* 40, no. 1 (2011): 156–81.

Hickey, Gloria. "Why Is Sloppy and Postdisciplinary Craft Significant and What Are Its Historical Precedents?" In *Sloppy Craft: Postdisciplinarity and the Crafts*, ed. Elaine Cheasley Paterson and Susan Surette, 109–24. London: Bloomsbury Academic, 2015.

Hochschild, Arlie Russell. *The Commercialization of Intimate Life: Notes from Home and Work*. Berkeley: University of California Press, 2003.

Hochschild, Arlie Russell. *The Managed Heart: Commercialization of Human Feeling*. Berkeley: University of California Press, 2012.

Hoffenberg, Peter H. *An Empire on Display: English, Indian, and Australian Exhibitions from the Crystal Palace to the Great War*. Berkeley: University of California Press, 2001.

Homer. *The Odyssey*, trans. A. S. Kline. London: Poetry in Translation, 2016.

Honneth, Axel, and Mitchell G. Ash. "Work and Instrumental Action." *New German Critique*, no. 26 (1982): 31–54.

Hudis, Peter. "The Death of the Death of the Subject." *Historical Materialism* 12, no. 3 (2004): 147–68.

Hühn, Peter. *Eventfulness in British Fiction*. New York: De Gruyter, 2010.

Huhtamo, Erkki. "Dismantling the Fairy Engine." In *Media Archaeology: Approaches, Applications, and Implications*, ed. Erkki Huhtamo and Jussi Parikka, 27–47. Berkeley: University of California Press, 2011.

Husmann, Rolf. "Post-War Ethnographic Filmmaking in Germany: Peter Fuchs, the IWF and the Encyclopaedia Cinematographica." In *Memories of the Origins of Ethnographic Film*, ed. Beate Engelbrecht, 383–96. Frankfurt: Peter Lang, 2007.

Hutcheon, Linda. *A Theory of Parody: The Teachings of Twentieth-Century Art Forms*. New York: Methuen, 1985.

Ide, Wendy. "Hand Gestures Review—Shining Study of Sculptors in Bronze." *Guardian*, November 19, 2015.

Ingold, Tim. "Beyond Art and Technology: The Anthropology of Skill." In *Anthropological Perspectives on Technology*, ed. Michael Brian Schiffer, 17–31. Albuquerque: University of New Mexico Press, 2001.

Ingold, Tim. *Making: Anthropology, Archaeology, Art and Architecture*. London: Routledge, 2013.

Jaikumar, Priya. "Haveli: A Cinematic Topos." *Positions* 25, no. 1 (February 1, 2017): 223–48.

Jameson, Fredric. "Magical Narratives: On the Dialectical Use of Genre Criticism." In *Modern Genre Theory*, ed. David Duff, 167–92. London: Routledge, 2000.

Jencks, Charles, and Nathan Silver. *Adhocism: The Case for Improvisation*. Cambridge, MA: MIT Press, 2013.

Jhally, Sut. *The Codes of Advertising: Fetishism and the Political Economy of Meaning in the Consumer Society*, rev. ed. New York: Routledge, 1990.

Johnson, Christopher. "Bricoleur and Bricolage: From Metaphor to Universal Concept." *Paragraph* 35, no. 3 (2012): 355–72.

Johnson, Martin. "Reading the Romance of a Show: The Repetition and Erasure of Labor in Early Advertising Films." Paper presented at the annual meeting of the American Comparative Literature Association, Harvard University, March 17–20, 2016.

Johnson, Randal. "Documentary Discourses and National Identity: Humberto Mauro's Brasiliana Series and Linduarte Noronha's Aruanda." *Nuevo Texto Crítico* 11, no. 1 (1998): 193–206.

Kael, Pauline. *5001 Nights at the Movies*. New York: Picador, 1991.

Katzman, David M. *Seven Days a Week: Women and Domestic Service in Industrializing America*. Urbana-Champaign: University of Illinois Press, 1981.

Kaufman, Edward N. "The Architectural Museum from World's Fair to Restoration Village." *Assemblage*, no. 9 (June 1989): 21–39.

Kessler, Frank, and Eef Masson. "Layers of Cheese: Generic Overlap in Early Non-Fiction Films on Production Processes." In *Films That Work: Industrial Film and the Productivity of Media*, ed. Vinzenz Hediger and Patrick Vonderau, 75–84. Amsterdam: Amsterdam University Press, 2009.

Kinder, Marsha. "Reflections on *Jeanne Dielman*." *Film Quarterly* 30, no. 4 (1977): 2–8.

Korn, Peter. *Why We Make Things and Why It Matters: The Education of a Craftsman*. Boston, MA: David Godine, 2015.

Labaki, Amir. *Introdução ao documentário brasileiro*. São Paulo: Francis, 2006.

Laban, Rudolf von. *Effort*. London: Macdonald and Evans, 1947.

Laban, Rudolf von, and Lisa Ullmann. *The Mastery of Movement*, 3d ed. Boston: Plays, 1971.

Labov, William, and Joshua Waletzky. "Narrative Analysis: Oral Versions of Personal Experience." In *Essays on the Verbal and Visual Arts: Proceedings of the 1966 Annual Spring Meeting of the American Ethnological Society*. Seattle: University of Washington Press, 1967.

Lafargue, Paul. *The Right to Be Lazy and Other Studies*. Chicago: C. H. Kerr, 1907.

Leacock, Eleanor Burke. "Introduction." In *Ancient Society; or, Researches in the Lines of Human Progress from Savagery through Barbarism to Civilization*, ed. Henry Lewis Morgan and Eleanor Burke Leacock, li–lxx. Cleveland: Meridian, World Publishing, 1963.

Leal, Wills. *O discurso cinematográfico dos paraibanos, ou, A história do cinema da/na Paraíba*. João Pessoa, Brazil: W. Leal, 1989.

Lefèvre, Wolfgang. "Introduction." In *Picturing Machines 1400–1700*, ed. Wolfgang Lefèvre, 1–12. Cambridge, MA: MIT Press, 2004.

Lehmann, Ann-Sophie. "Showing Making: On Visual Documentation and Creative Practice." *Journal of Modern Craft* 5, no. 1 (March 1, 2012): 9–23.

Leonardi, Susan J. "Recipes for Reading: Summer Pasta, Lobster à la Riseholme, and Key Lime Pie." *PMLA* 104, no. 3 (1989): 340–47.

Leroi-Gourhan, André. *Gesture and Speech*. Cambridge, MA: MIT Press, 1993.

Lévi-Strauss, Claude. *The Savage Mind*. Chicago: University of Chicago Press, 1966.

Lima Gomes, João de. *Aruanda-Jornada Brasileira: Homenagem aos cineastas João Ramiro Mello e Rucker Vieira*. João Pessoa, Brazil: Universidade Federal da Paraíba/Editora Universitária, 2003.

Lima Gomes, João de, and Manuel Clemente. "Linduarte e seus personagens." In *Aruanda-Jornada Brasileira: Homenagem aos cineastas João Ramiro Melloe Rucker Vieira*, ed. João de Lima Gomes, 65–78. João Pessoa, Brazil: Universidade Federal da Paraíba/Editora Universitária, 2003.

Livingston, James. *Against Thrift: Why Consumer Culture Is Good for the Economy, the Environment, and Your Soul*. New York: Basic, 2011.

Livingston, James. *No More Work: Why Full Employment Is a Bad Idea*. Chapel Hill: University of North Carolina Press, 2016.

Loiperdinger, Martin. "Early Industrial Moving Pictures in Germany." In *Films That Work: Industrial Film and the Productivity of Media*, ed. Vinzenz Hediger and Patrick Vonderau, 65–74. Amsterdam: Amsterdam University Press, 2009.

Long, Pamela O. *Artisan/Practitioners and the Rise of the New Sciences, 1400–1600*. Corvallis: Oregon State University Press, 2011.

Lopes, Dominic McIver. "Directive Pictures." *Journal of Aesthetics and Art Criticism* 62, no. 2 (2004): 189–96.

Lopes, Nei. *Novo dicionário banto do Brasil: Contendo mais de 250 propostas etmológicas acolhidas pelo dicionário Houaiss*. Rio de Janeiro: Pallas, 2003.

Löwy, Michael. "Marxism and Revolutionary Romanticism." *Telos* 49 (Fall 1981): 83–95.

Löwy, Michael. "Naphta or Settembrini? Lukács and Romantic Anticapitalism." *New German Critique* 42 (1987): 17–31.

Löwy, Michael. "The Romantic and the Marxist Critique of Modern Civilization." *Theory and Society* 16, no. 6 (1987): 891–904.

MacCannell, Dean. *The Tourist: A New Theory of the Leisure Class*. Berkeley: University of California Press, 2013.

MacDougall, David. *Transcultural Cinema*. Princeton, NJ: Princeton University Press, 1998.

MacLeod, Christine. *Heroes of Invention: Technology, Liberalism and British Identity, 1750–1914*. Cambridge: Cambridge University Press, 2007.

Magelssen, Scott. *Living History Museums: Undoing History through Performance*. Lanham, MD: Scarecrow, 2007.

Mainz, Valérie, and Griselda Pollock, eds. *Work and the Image I: Work, Craft and Labour: Visual Representations in Changing Histories*. Farnham, U.K.: Ashgate, 2000.

Manovich, Lev. *The Language of New Media*, rev. ed. Cambridge, MA: MIT Press, 2002.

Margulies, Ivone. *Nothing Happens: Chantal Akerman's Hyperrealist Everyday*. Durham, NC: Duke University Press, 1996.

Marx, Karl, and Fredrick Engels. *The Economic and Philosophic Manuscripts of 1844 and the Communist Manifesto*, trans. Martin Milligan. Amherst, NY: Prometheus, 1988.

Marx, Karl, and Ernest Mandel. *Capital, Volume 1: A Critique of Political Economy*, trans. Ben Fowkes, repr. ed. London: Penguin Classics, 1992.

Matchar, Emily. "Finding What's 'Oddly Satisfying' on the Internet." *New York Times*, February 22, 2019. Accessed June 2, 2019. https://www.nytimes.com /2019/02/22/opinion/sunday/oddly-satisfying-videos-internet.html.

Mattos, Carlos Alberto. *Vladimir Carvalho: Pedras na lua e pelejas no planalto.* São Paulo: Impresa Oficial, 2008.

Mauss, Marcel. "Techniques of the Body." *Economy and Society* 2, no. 1 (February 1, 1973): 70–88.

Mauss, Marcel. "Techniques of the Body." In *Incorporations*, ed. Jonathan Crary and Sanford Kwinter, 454–77. New York: Zone, 1992.

Mauss, Marcel. *Techniques, Technology, and Civilisation*, ed. Nathan Schlanger. Oxford: Berghahn, 2006.

Mayhew, Henry, and George Cruikshank. *1851; or, The Adventures of Mr. and Mrs. Sandboys and Family, Who Came up to London to "Enjoy Themselves," and to See the Great Exhibition.* London: D. Bogue, 1851.

Mayr, Otto, ed. *Philosophers and Machines.* New York: Science History Publications, 1976.

Mazierska, Ewa. *Work in Cinema: Labor and the Human Condition.* New York: Palgrave Macmillan, 2013.

McGee, David. "The Origins of Early Modern Machine Design." In *Picturing Machines, 1400–1700*, 53–84. Cambridge, MA: MIT Press, 2004.

McGee, R. Jon, and Richard Warms. *Anthropological Theory: An Introductory History*, 4th ed. Boston: McGraw-Hill, 2007.

McGowan, Abigail. *Crafting the Nation in Colonial India.* New York: Palgrave Macmillan, 2009.

Meagher, Gabrielle. "Is It Wrong to Pay for Housework?" *Hypatia* 17, no. 2 (April 1, 2002): 52–66.

Metz, Christian. *Film Language: A Semiotics of the Cinema*, trans. Michael Taylor. Chicago: University of Chicago Press, 1990.

Michotte, Albert, Georges Thinès, Alan Costall, and George Butterworth. *Michotte's Experimental Phenomenology of Perception.* Hillsdale, NJ: Lawrence Erlbaum Associates, 1991.

Milkman, Ruth, Ellen Reese, and Benita Roth. "The Macrosociology of Paid Domestic Labor." *Work and Occupations* 25, no. 4 (November 1, 1998): 483–510.

Mills, C. Wright. *White Collar: The American Middle Classes.* New York: Oxford University Press, 1951.

Montero, Barbara Gail. *Thought in Action: Expertise and the Conscious Mind.* Oxford: Oxford University Press, 2016.

Moon, Francis C. *The Machines of Leonardo da Vinci and Franz Reuleaux: Kinematics of Machines from the Renaissance to the 20th Century.* Dordrecht, the Netherlands: Springer Science and Business Media, 2007.

Morgan, Lewis Henry, and Eleanor Burke Leacock, eds. *Ancient Society, or, Researches in the Lines of Human Progress from Savagery through Barbarism to Civilization.* Cleveland: Meridian, World Publishing, 1967.

Morson, Gary Saul. *The Boundaries of Genre: Dostoevsky's* Diary of a Writer *and the Traditions of Literary Utopia.* Evanston, IL: Northwestern University Press, 1988.

Moya, José C. "Domestic Service in a Global Perspective: Gender, Migration, and Ethnic Niches." *Journal of Ethnic and Migration Studies* 33, no. 4 (2007): 559–79.

Musser, Charles. *The Emergence of Cinema: The American Screen to 1907*. Berkeley: University of California Press, 1990.

Muybridge, Eadweard. *Animal Locomotion: An Electro-Photographic Investigation of Consecutive Phases of Animal Movements, 1872–1885*. Philadelphia: University of Pennsylvania Press, 1887.

Naremore, James. *More than Night: Film Noir in Its Contexts*. Updated and expanded ed. Berkeley: University of California Press, 2008.

Naughten, Rebecca. "Hand Gestures." *Eye for Film*, December 11, 2015. Accessed May 19, 2019. http://www.eyeforfilm.co.uk/review/hand-gestures-2015-film-review-by-rebecca-naughten.

Nell, Victor. *Lost in a Book: The Psychology of Reading for Pleasure*. New Haven, CT: Yale University Press, 1990.

Nett, Emily. "The Servant Class in a Developing Country: Ecuador." *Journal of Inter-American Studies* 8, no. 3 (1966): 437–52.

Nichols, Bill. *Representing Reality: Issues and Concepts in Documentary*. Bloomington: Indiana University Press, 1991.

Nornes, Abé Mark. *Forest of Pressure: Ogawa Shinsuke and Postwar Japanese Documentary*. Minneapolis: University of Minnesota Press, 2007.

Noronha, Linduarte. "Aruanda é um filme autóctone." In *Aruanda-Jornada Brasileira: Homenagem aos cineastas João Ramiro Mello e Rucker Vieira*, ed. João de Lima Gomes, 121–24. João Pessoa, Brazil: Universidade Federal da Paraíba/Editora Universitária, 2003.

Nussbaum, Martha C. "'Whether from Reason or Prejudice': Taking Money for Bodily Services." *Journal of Legal Studies* 27, no. S2 (1998): 693–723.

Ocejo, Richard. *Master of Craft: Old Jobs in the New Urban Economy*. Princeton, NJ: Princeton University Press, 2017.

Oliveira, Jose Marinho de. *Dos homens e das pedras: O ciclo do cinema documentário paraibano, 1959–1979*. Niterói, RJ: Editora da Universidade Federal Fluminense, 1988.

Orgeron, Devin, Marsha Orgeron, and Dan Streible. "Introduction." In *Learning with the Lights Off: Educational Film in the United States*, ed. Devin Orgeron, Marsha Orgeron, and Dan Streible, 3–14. New York: Oxford University Press, 2012.

Osborne, Harold. "The Aesthetic Concept of Craftsmanship." *British Journal of Aesthetics* 17, no. 2 (1977): 138–48.

Paglen, Trevor. "Operational Images." *e-flux* 59 (November 2014). Accessed June 3, 2019. https://www.e-flux.com/journal/operational-images/.

Pannabecker, John R. "Representing Mechanical Arts in Diderot's *Encyclopédie*." *Technology and Culture* 39, no. 1 (1998): 33–73.

Pantenburg, Volker. "Working Images: Harun Farocki and the Operational Image." In *Image Operations: Visual Media and Political Conflict*, ed. Jens Eder and Charlotte Klonk. Manchester, U.K.: Manchester University Press, 2017.

Paranaguá, Paulo Antonio. "Orígenes, evolución y problemas." In *Cine documental en América Latina*. Madrid: Catedra, 2003.

Parekh, Bhikhu C. *The Concept of Socialism*. New York: Holmes and Meier, 1975.

Parvulescu, Anca. "Import/Export: Housework in an International Frame." *PMLA* 127, no. 4 (2012): 845–62.

Payen, Jacques. "The Plates of the Encyclopedia and the Development of Technology in the Eighteenth Century." In *Diderot Encyclopedia: The Complete Illustrations, 1762–1777*, ed. Harry N. Abrams, xi–xxx. New York: Harry Abrams, 1981.

Peterson, Jennifer Lynn. *Education in the School of Dreams: Travelogues and Early Nonfiction Film*. Durham, NC: Duke University Press, 2013.

Peterson, Jennifer Lynn. "Efficiency and Abundance: Industrial Films and Early Educational Cinema." Paper presented at the Society for Cinema and Media Studies conference, New Orleans, March 12, 2011.

Peterson, Jennifer Lynn. "Industrial Films." In *Encyclopedia of Early Cinema*, ed. Richard Abel, 320–23. London: Routledge, 2005.

Peterson, Jennifer Lynn. "Workers Leaving the Factory: Witnessing Industry in the Digital Age." In *The Oxford Handbook of Sound and Image in Digital Media*, ed. Amy Herzog, Carol Vernallis, and John Richardson, 598–622. Oxford: Oxford University Press, 2013.

Pevsner, Nikolaus. *High Victorian Design: A Study of the Exhibits of 1851*. Oxford: Architectural Press, 1951.

Pirsig, Robert. *Zen and the Art of Motorcycle Maintenance: An Inquiry into Values*. New York: Perennial Classics, 2006.

Postone, Moishe. *Time, Labor, and Social Domination: A Reinterpretation of Marx's Critical Theory*. Cambridge: Cambridge University Press, 1993.

Price, Brian. *Neither God nor Master: Robert Bresson and Radical Politics*. Minneapolis: University of Minnesota Press, 2011.

Prince, Gerald. "Forty-One Questions on the Nature of Narrative." *Style* 34, no. 2 (June 22, 2000): 317–18.

Pye, David. *The Nature and Art of Workmanship*. Cambridge: Cambridge University Press, 1968.

Radin, Margaret Jane. *Contested Commodities: The Trouble with Trade in Sex, Children, Body Parts, and Other Things*. Cambridge: Cambridge University Press, 1996.

Radway, Janice. *A Feeling for Books: The Book-of-the-Month Club, Literary Taste, and Middle-Class Desire*. Chapel Hill: University of North Carolina Press, 1997.

Rattansi, Ali. *Marx and the Division of Labor*. London: Macmillan, 1982.

Reddy, William. "The Structure of a Cultural Crisis: Thinking about Cloth in France before and after the Revolution." In *The Social Life of Things: Commodities in Cultural Perspective*, ed. Arjun Appadurai, 261–84. Cambridge: Cambridge University Press, 1986.

Regnault, Félix-Louis, and Dominique Lejard. "Poterie crue et origine du tour." *Bulletins de la Société d'Anthropologie de Paris* 4, no. 6 (1895): 734–39.

Reuleaux, Franz, and Eugene S. Ferguson. *The Kinematics of Machinery: Outlines of a Theory of Machines*. Mineola, NY: Dover, 2012.

Reynolds, Dee, and Matthew Reason, eds. *Kinesthetic Empathy in Creative and Cultural Practices*. Bristol, U.K.: Intellect, 2012.

Richards, Thomas. *The Commodity Culture of Victorian England: Advertising and Spectacle, 1851–1914*. Stanford, CA: Stanford University Press, 1991.

Risatti, Howard. *Theory of Craft: Function and Aesthetic Expression*. Chapel Hill: University of North Carolina Press, 2009.

Rocha, Glauber. *Revisão crítica do cinema brasileiro*. Rio de Janeiro: Cosac Naify, 2003.

Rodowick, D. N. *The Virtual Life of Film*. Cambridge, MA: Harvard University Press, 2007.

Rollins, Judith. *Between Women: Domestics and Their Employers*. Philadelphia: Temple University Press, 1987.

Rony, Fatimah Tobing. *The Third Eye: Race, Cinema, and Ethnographic Spectacle*. Durham, NC: Duke University Press, 1996.

Rosaldo, Renato. "Imperialist Nostalgia." *Representations* 26 (1989): 107–22.

Rosso, G. A., and Daniel P. Watkins. *Spirits of Fire: English Romantic Writers and Contemporary Historical Methods*. Rutherford NJ: Fairleigh Dickinson University Press, 1990.

Rouch, Jean. "The Camera and Man." In *Principles of Visual Anthropology*, ed. Paul Hockings, 2d ed., 79–98. Berlin: Walter de Gruyter, 2012.

Rubbo, Anna, and Michael Taussig. "Up off Their Knees: Servanthood in Southwest Colombia." *Latin American Perspectives* 10, no. 4 (October 1, 1983): 5–23.

Rushton, Richard. "Deleuzian Spectatorship." *Screen* 50, no. 1 (March 20, 2009): 45–53.

Ruskin, John. *The Stones of Venice*. London: Smith, Elder, 1867.

Russell, Patrick. "From Acorn to Oak: Industrial and Corporate Films in Britain." Accessed May 3, 2018. https://www.academia.edu/16506574/From_Acorn _to_Oak_Industrial_and_Corporate_Films_in_Britain_Business_Archives _2011_.

Ryan, Marie-Laure. *Narrative as Virtual Reality: Immersion and Interactivity in Literature and Electronic Media*. Baltimore: Johns Hopkins University Press, 2003.

Ryan, Marie-Laure. "Tellability." In *Routledge Encyclopedia of Narrative Theory*, ed. David Herman, Manfred John, and Marie-Laure Ryan, 589–91. London: Routledge, 2010.

Ryan, Marie-Laure. "Toward a Definition of Narrative." In *The Cambridge Companion to Narrative*, ed. David Herman, 22–35. Cambridge: Cambridge University Press, 2007.

Saettler, Paul. *The Evolution of American Educational Technology*. Greenwich, CT: Information Age, 2004.

Salinas Muñoz, Claudio R., Hans Stange Marcus, and Sergio Salinas Roco. *Historia del cine experimental en la Universidad de Chile, 1957–1973*. Santiago de Chile: Uqbar, 2008.

Santana Pinho, Patricia de, and Elizabeth B. Silva. "Domestic Relations in Brazil: Legacies and Horizons." *Latin American Research Review* 45, no. 2 (2010): 90–113.

Sarzynski, Sarah. "Documenting the Social Reality of Brazil: Roberto Rossellini, the Paraíban Documentary School, and the Cinema." In *Global Neorealism: The Transnational History of a Film Style*, ed. Saverio Giovacchini and Robert Sklar, 209–25. Jackson: University Press of Mississippi, 2012.

Satz, Debra. *Why Some Things Should Not Be for Sale: The Moral Limits of Markets.* Oxford: Oxford University Press, 2010.

Sayers, Sean. "The Concept of Labor: Marx and His Critics." *Science and Society* 71, no. 4 (2007): 431–54.

Sayre, Robert, and Michael Löwy. "Figures of Romantic Anti-Capitalism." *New German Critique*, no. 32 (1984): 42–92.

Schank, Roger C., and Robert P. Abelson. *Scripts, Plans, Goals, and Understanding: An Inquiry into Human Knowledge Structures.* Hillsdale, NJ: Lawrence Erlbaum Associates, 1977.

Schatz, Thomas. *Hollywood Genres: Formulas, Filmmaking, and the Studio System.* New York: McGraw-Hill, 1981.

Schvarzman, Sheila. *Humberto Mauro e as imagens do Brasil.* São Paulo: Fundação Editora da UNESP, 2004.

Sennett, Richard. *The Craftsman.* New Haven, CT: Yale University Press, 2008.

Sewell, William H., Jr. "Visions of Labor: Illustrations of the Mechanical Arts before, in, and after Diderot's *Encyclopédie*." In *Work in France: Representations, Meaning, Organization, and Practice*, ed. Steven Laurence Kaplan and Cynthia J. Koepp, 258–86. Ithaca, NY: Cornell University Press, 1986.

Shaw, Deborah. "Intimacy and Distance—Domestic Servants in Latin American Women's Cinema: *La Mujer Sin Cabeza* and *El Niño Pez/The Fish Child*." In *Latin American Women Filmmakers: Production, Politics, Poetics*, ed. Deborah Martin and Deborah Shaw, 123–48. London: I. B. Tauris, 2017.

Siebenga, Rianne. "Crafts and Industry in Early Films of British India: Contrasting Album and Process Films." *Early Popular Visual Culture* 12, no. 3 (2014): 342–56.

Singer, Ben. "*Jeanne Dielman*: Cinematic Interrogation and 'Amplification.'" *Millennium Film Journal* 22 (1989): 56–75.

Sitney, P. Adam. "The Rhetoric of Robert Bresson: From *Le Journal d'un Curé de Campagne* to *Une Femme Douce*." In *Robert Bresson*, ed. James Quandt, 117–44. Toronto: Toronto International Film Festival Group, 1998.

Skoller, Donald S. "'Praxis' as a Cinematic Principle in Films by Robert Bresson." *Cinema Journal* 9, no. 1 (1969): 13–22.

Skvirsky, Salomé Aguilera. "Realism, Documentary, and the Process Genre in Early New Latin American Cinema." In *The Routledge Companion to Latin American Cinema*, ed. Marvin D'Lugo, Ana M. López, Laura Podalsky, 119–32. New York: Routledge, 2018.

Smith, Pamela H. *The Body of the Artisan: Art and Experience in the Scientific Revolution.* Chicago: University of Chicago Press, 2006.

Smith, Pamela. "Making Things: Techniques and Books in Early Modern Europe." In *Early Modern Things: Objects and Their Histories, 1500–1800*, ed. Paula Findlen, 173–203. New York: Routledge, 2012.

Spencer, Herbert. *Herbert Spencer, Collected Writings*. Vol. 2: *Essays: Scientific, Political and Speculative*. London: Routledge, 1891.

Srinivas, Lakshmi. "Master-Servant Relationship in a Cross-Cultural Perspective." *Economic and Political Weekly* 30, no. 5 (February 4, 1995): 269–78.

Sternberg, Meir. *Expositional Modes and Temporal Ordering in Fiction*. Bloomington: Indiana University Press, 1993.

Sternberg, Meir. "Telling in Time (II): Chronology, Teleology, Narrativity." *Poetics Today* 13, no. 3 (1992): 463–541.

Stewart, Garrett. *Between Film and Screen: Modernism's Photo Synthesis*. Chicago: University of Chicago Press, 2000.

Stockhammer, Robert. "The Techno-Magician: A Fascination around 1900." In *Magic, Science, Technology, and Literature*, ed. Hans Ulrich Seeber, Jarmila Mildorf, and Martin Windisch, 167–78. Berlin: Lit, 2006.

Sussman, Herbert L. *Victorian Technology: Invention, Innovation, and the Rise of the Machine*. Santa Barbara: Praeger, 2009.

Talesnik Y., Daniel. "Tibor Weiner y su role en la reforma: Una re-introducción." *De Arquitectura*, no. 14 (2006): 64–70.

Tang, Pao-chen. "Of Dogs and Hot Dogs: Distractions in Early Cinema." *Early Popular Visual Culture* 15, no. 1 (2017): 44–58.

Taureg, Martin. "The Development of Standards for Scientific Films in German Ethnography." *Studies in Visual Communication* 9, no. 1 (1983): 19–29.

Tepperman, Charles. "Mechanical Craftsmanship: Amateurs Making Practical Films." In *Useful Cinema*, ed. Charles R. Acland and Haidee Wasson, 293–94. Durham, NC: Duke University Press, 2011.

Thorburn, David, and Henry Jenkins, eds. *Rethinking Media Change: The Aesthetics of Transition*. Cambridge, MA: MIT Press, 2004.

Todorov, Tsvetan, and Jonathan Culler. *The Poetics of Prose*, trans. Richard Howard. Ithaca, NY: Cornell University Press, 1978.

Tokman, Victor E. "Domestic Workers in Latin America: Statistics for New Policies." Women in Informal Employment Globalizing and Organizing (WEIGO) Working Paper (Statistics) no. 17, June 2010. Accessed May 27, 2019. http://www.wiego.org/sites/default/files/publications/files/Tokman_WIEGO_WP17.pdf.

Tomlinson, Walter. *The Pictorial Record of the Royal Jubilee Exhibition, Manchester, 1887*, ed. J. H. Nodal. Manchester, U.K.: J. E. Cornish, 1888.

Unruh, Vicky, ed. "Work." Special issue, *PMLA* 127, no. 4 (2012).

Van der Veen, Marjolein. "Rethinking Commodification and Prostitution: An Effort at Peacemaking in the Battles over Prostitution." *Rethinking Marxism* 13, no. 2 (2001): 30–51.

Vega, Alicia. *Itinerario del cine documental chileno, 1900–1990*. Santiago de Chile: Centro Estudios y Artes de la Comunicación, Universidad Alberto Hurtado, 2006.

Washburne, Marion Foster. "A Labor Museum." *The Craftsman*, September 1904.

Waller, Gregory A. "Cornering *The Wheat Farmer* (1938)." In *Learning with the Lights Off: Educational Film in the United States*, ed. Devin Orgeron, Marsha Orgeron, and Dan Streible, 249–70. New York: Oxford University Press, 2012.

Weeks, Kathi. *The Problem with Work: Feminism, Marxism, Antiwork Politics, and Postwork Imaginaries*. Durham, NC: Duke University Press, 2011.

Wellmann, Janina. *The Form of Becoming: Embryology and the Epistemology of Rhythm, 1760–1830*, trans. Kate Sturge. New York: Zone, 2017.

Wiatr, Elizabeth. "Between Word, Image, and the Machine: Visual Education and Films of Industrial Process." *Historical Journal of Film, Radio and Television* 22, no. 3 (2002): 333–51.

Williams, Linda. *Playing the Race Card: Melodramas of Black and White from Uncle Tom to O. J. Simpson*. Princeton, NJ: Princeton University Press, 2002.

Williams, Raymond. *Keywords: A Vocabulary of Culture and Society*, rev. ed. New York: Oxford University Press, 1985.

Willis, Artemis. "Between Nonfiction Screen Practice and Nonfiction Peep Practice: The Keystone '600 Set' and the Geographical Mode of Representation." *Early Popular Visual Culture* 13, no. 4 (October 2, 2015): 293–312.

Young, Grace Esther. "The Myth of Being 'Like a Daughter.'" *Latin American Perspectives* 14, no. 3 (July 1, 1987): 365–80.

Zelizer, Viviana A. *The Purchase of Intimacy*. Princeton, NJ: Princeton University Press, 2005.

INDEX

defamiliarization: and absorptiveness, 39; in *A Man Escaped*, 114; and material consciousness, 39–40; in *Mimbre*, 159–62; and repurposing, 114–15; in spoofs, 222; and technological innovation, 114–15, 162, 276n18

design: versus craft, 37, 125, 126–27, 247n60; of machines, 118

detective stories, 98–99, 264n47, 265n56

developmentalism, 40, 108, 147–49, 163, 164, 172, 175, 180–82, 188, 189, 271n44. *See also* evolutionism; romantic anticapitalism

Dewey, John, 31

Día de organillos, 150, 153, 164

Diderot, Denis. See *Encyclopédie ou Dictionnaire raisonné des sciences, des arts et des métiers*

Di Lauro, Jorge, 152–53

disenchantment, 117–18

Dobres, Marcia-Anne, 63

domestic service: as affective labor, 197, 199–200, 217–18; contemporary debates on, 217; emotive dissonance in, 199–200; Latin American, 196, 280n7; Lewis Coser on, 198–99, 209, 281n23; in *The Maids*, 214; personhood as commodity, 197–200; servants, 198–99, 209; traditional, 198–99

domestic service films, 195–97, 200. See also *Parque vía*

Dough: overview of, 228–29; anachronism versus contemporaneity in, 230; antiwork politics of, 237; clean aesthetics, subverting, 234–35; the human in, 236–37; and labor debates, 229–30; processual representation in, 231–32; Raqui and Tall Kat in, 228–30, 236; self-reproduction in, 229, 284n9

Drifters, 6, 147, 240n7

Duff, David, 46

Eastman Classroom Films, 54–55

Ebert, Roger, 41, 78

educational film: definitions of, 54–55; early producers of, 54–55; and Ford Motor Company, 56–57; history of, 55; industrial film overlap, 55–56; and nationalism, 57–58; and the "object lesson," 56; and process film overlap, 5, 42, 52, 54–58; state-produced, 57–58; and visualization, 55–56

Ehmann, Antje, 239n3, 267n11

Encyclopaedia Cinematographica, 62–63, 146–47

Encyclopedia Britannica Films, 55

Encyclopédie ou Dictionnaire raisonné des sciences, des arts et des métiers, plates: overview of, 42–43, 72; anthological versus genetic images, 72–73; audience for, 42; Barthes on, 38, 42–43, 72, 133, 236, 248n82; as dehumanizing, 130–32; duration in, 20, 21; Ernst Gombrich on, 72; ideological diversity in, 248n76; and pictorial instructions, 72, 73; and process genre, 3, 51; as proto-Taylorist, 130–31; representations of machine and instruments, 42, 73, 228; and world exhibitions, 72, 137

Engels, Friedrich, 60–61

epistephilia, 42, 248n75

Erpi Classroom Films, 54–55

ethnographic film: overview of, 58–59, 146–49; *chaîne opératoire*, 63–65; coevalness, denial of, in, 148, 149, 175, 184, 212–13, 254n31; criteria debate, 254n31; Encyclopaedia Cinematographica, 62–63; and Félix-Louis Regnault, 59–61, 146, 254n34; and German anthropology, 61–62; material culture in, 59–62; movement in, 59, 62; nationalist, 148; and Pliny Goddard, 61–62. See also *Aruanda*; exhibitions; *In Comparison*; *Nanook of the North*; *Red Persimmons*

Evans, Dayna, 30

Hochschild, Arlie, 199–200, 281nn25–26
"How People Make Crayons." *See* Crayola crayon factory film
"How People Make Things" films, 95
how-tos: versus art creation, 26–28; early modern, 4, 75; emergence of, 44; examples of, 44; *The Great Art of Light and Shadow*, 48; manuals, 3, 4, 41–42, 44, 65, 73, 75, 83, 250n98; physical actions, emphasis on, 45; process films as, 85, 117; and processual representation, 17, 42, 84; repeatability of, 24. *See also* pictorial instructions
Hühn, Peter, 32, 83. *See also* "process narration"
Hull House, Chicago, 2, 71, 95. *See also* Addams, Jane
humanism, 38, 142–43, 183, 221, 236

imperialist nostalgia, 72, 148
In Comparison, 185. *See also* Farocki, Harun
industrial films: overview of, 53–54; *Birth of a Hat: The Art and Mystery of Making Fur Felt Hats*, 137–39; Brazilian, 167; Chilean, 151–52, 154; and commodity fetishism, 136–41; concealment of labor in, 136; as dehumanizing, 132; educational film overlap, 55–58; eventfulness in, 94–95; factory films, 24–25, 243n24; ideology of, 56; and labor theory of value, 136–41; *Mannesmann*, 58, 147, 167; *Master Hands*, 132, 147; meat processing, 224–25; nationalism in, 57–58, 120, 148, 153–54, 167; parallel editing in, 105, 106, 135–36; versus process films, 5–6, 36, 54, 240n6; *Rhapsody in Steel*, 132. *See also* advertising; industrial production; *Tejidos Chilenos*; *Unstable Object, The*
industrial production, 4, 5, 24, 36–38, 54, 56–57, 94, 129–30, 152, 135–36,

146, 167, 233, 270n40. *See also* artisanal production; industrial films; Mauro, Humberto; *Tejidos Chilenos*
industrial slaughter films, 140–41, 224
Ingold, Tim, 40, 245n52, 247n62
Institut für den Wissenschaftlichen Film (IWF), 61–62, 147, 255n50
Instituto Nacional de Cinema Educativo (INCE), 165–67, 169–71
instructional graphics, 74, 243n26, 259n110. *See also* Wellmann, Janina; pictorial instructions
instruments, 15, 23, 38–41, 43, 44, 47, 114, 121, 147, 257n81. *See also* material consciousness; technique
it-narratives, 261n14, 264n47
Ivens, Joris, 153

Jameson, Fredric, 46–47
Jardin d'Acclimatation, 68
Jeanne Dielman, 23 Quai du Commerce, 1080 Bruxelles: overview of, 12–14, 16, 201; absorptiveness and tellability of, 96–97, 204; Akerman on, 204–5; craftsmanship in, 35–36; Delphine Seyrig's acting in, 204–5; eventfulness in, 96–97; formal structure of, 203–4, 209; kinesthetic empathy in, 216; labor in, 32–33, 205–6; long takes in, 18; material consciousness in, 39–40; movement in, 205, 209; orgasms, Jeanne's, 201, 205, 217; versus *Parque vía*, 201–2, 207, 209–10, 211, 216; performance in, 23–24; as process film, 202, 205, 216; reception of, 202; versus *Saute ma ville*, 124–25, 268n24; versus *Umberto D*, 202–3, 206, 216, 282n32; unraveling of routine in, 205–6; as valorizing domestic labor, 205–6, 208; and Warhol's films, 203–4, 282n33
João de Barro, O, 170, 247n62. *See also* Mauro, Humberto

Johnson, Martin, 272n65
Joy of Painting, The, 26, 89

Kael, Pauline, 28, 41
Kahn, Jennifer, 79, 116–17
Kaufman, Edward, 70
Kaulen, Patricio, 152
Kehr, David, 189–91
Kessler, Frank, 54
Kinematics of Machinery, The, 233
kinesthetic empathy, 40, 110–11,
 127–28, 187, 216, 269n30. *See also*
 grace; movement
Kircher, Athanasius, 48
knowledge, 41–44, 248n75
Kramerenco, Naúm, 152

Labaki, Amir, 169
Laban, Rudolf von, 268n29
labor: aestheticization of, 118–20, 234;
 affective, 193–94, 197, 217–18; and
 capitalism, 143; in cinema, 118–19,
 266n9, 267nn10–11; under com-
 munism, 142–43; concealing and
 revealing, 133; craftsmanship, 34–38;
 definition and examples, 32–33;
 immaterial, 193; versus leisure, 119,
 221; and magic, 117–18, 139, 266n7;
 paid versus unpaid, 119; precision in,
 133–34; repetitive, viewing of, 128,
 269n37; represented as skillful, 33–34,
 118, 221; segmentation of, 130, 133;
 sex work, 197–98, 217, 283n50; and
 technique, 33–34, 125; as toil, 119–21;
 wage, 119; versus work, 245n50,
 273n80. *See also* Barthes, Roland;
 domestic service; Comolli, Jean-
 Louis; Gell, Alfred; Ruskin, John;
 Sewell, William; Taylorism
labor, metaphysics of: overview of, 47,
 120–21, 141–45, 221, 237, 273n80.
 See also antiwork politics
Labour in a Single Shot, 239n3, 267n11
Lafargue, Paul, 143

Lajard, Dominique, 60
Láminas de Almahue, 153, 164
Latin American cinema, 148, 184–85,
 195–97. *See also* New Latin American
 Cinema (NLAC)
Latin American domestic service indus-
 try, 196, 280n7
Lefèvre, Wolfgang, 75
Lehmann, Ann-Sophie, 250n98. *See also*
 showing making
Leroi-Gourhan, André, 63. See also
 chaîne opératoire
Ley, Tom, 122–23
living museums, 70, 76, 257n94
Livingston, James, 5, 144
Löwy, Michael, 181, 183, 278n54. *See also*
 romantic anticapitalism

machines: and absorption, 29–30, 78,
 80, 266n7; and craftsmanship, 37,
 134, 247n60; demonstrations of,
 65–68, 71, 256n66, 257n81; design
 of, 37, 247n60, 266n7; and Franz
 Reuleaux, 233; humans, opposition
 to, 235; and labor, 118, 120; and the
 Machine Age, 95, 119–20, 233, 234;
 and machine drawings, 72–73, 75,
 258n104, 259n116; in *The Making of
 Forty Rectangular Pieces for a Floor
 Construction*, 231–34; in *Peek Frean*,
 36–37; and pictorial instructions,
 43, 72, 75, 76, 258n104; and preci-
 sion, 37, 134, 235–37; and processual
 representation, 33, 36–37, 102; in *Red
 Persimmons*, 187–90; in *Tejidos Chile-
 nos*, 154–58; visibility of, 67. *See also*
 industrial films; industrial produc-
 tion; Rube Goldberg–like machines;
 technology; *Unstable Object, The*
 Machines, 243n24
magic, 30, 32, 37, 77, 81, 100, 116–19,
 127, 133, 138–39, 140, 144, 170, 231,
 266n7. *See also* Gell, Alfred; grace;
 movement

psychological identification, 32, 80, 81, 82, 110; and the recipe, 81–85, 93, 262n25; scalar theory of, 241n12; tellability, 83, 94, 96–97, 262n17. *See also* eventfulness; expositional structures

nationalism: in educational film, 56–58, 148; in industrial film, 56–58, 120, 148, 153–54, 167; in *Mannesmann*, 58, 147, 167; in NLAC process films, 148–49, 154, 180, 184; process genre's association with, 119–20, 147–48; in processual representation, 52, 148. *See also* educational film; industrial films

nationality, 147, 148. *See also* ethnographic film; *Mimbre*

Nell, Victor, 32, 81

New Latin American Cinema (NLAC): overview of, 148–49; *Araya*, 150–51; *Arraial do Cabo*, 150–51; and artisanal film production, 183; in Brazil, 165–85; *Ceramiqueros de Traslasierra*, 150–51; in Chile, 151–65; *Chircales*, 150; craftsmanship and labor in, 184; *Faena*, 150; Fernando Birri, 150; films of, 6, 149; Griersonian influence on, 149–50; historical contexts of, 151; historiography of, 149–51; indigenous subjects in, 156–57; Italian influences on, 149–50; Julio García Espinosa and, 150; *El mégano*, 150; national contexts of, 151; process films of, 148–51; *Tire dié*, 177, 180; Tomás Gutiérrez Alea and, 150; underdevelopment in, 149–50, 157, 169–70. *See also* Brazilian process films; Chilean process films; Cinema Novo

Nichols, Bill, 248n75

Nornes, Abé Mark, 189

object tales. *See* it-narratives

Oddly Satisfying videos, 244n38

Ogawa Shinsuke, 185–88, 190–91. *See also* Red Persimmons

operational aesthetic, 47, 79–80, 220, 250n98, 260n8, 264n44, 265n56, 269n35. *See also* craftsmanship aesthetic; showing making

operational images, 260n8

Osborne, Harold, 133–34

Pannabecker, John, 248n76

parallel editing, 105, 106, 135, 242n23

Parkinsonismo y cirugía, 153. *See also* Bravo, Sergio

Park Lanes, 7, 102, 105

parodies. *See* spoofs

Parque vía: and affective labor, 93; as anti-process film, 194, 202, 208–9, 215–16; close-ups, use of, in, 211–13, 214; colonization of feeling in, 214–15, 217; and ethnographic gaze, 211–14; versus *Jeanne Dielman*, 201–2, 207, 209–10, 211, 216; linear perspective, use of, in, 210–11, 212; Nolberto Coria in, 194, 209; perceptual subjectivity in, 214–15; personhood as commodity in, 214–16; and *Que viva Mexico!*, 211–12; and servant invisibility, 208–9, 211, 213–14; shot composition of, 209–12; spatial relations in, 209–13

Parvulescu, Anca, 202

pattern books, 73–74

Peek Frean. See *Visit to Peek Frean and Co.'s Biscuit Works, A*

Peng, Xiaolian, 185–86, 188–89

Pestalozzi, Johann Heinrich, 56. *See also* educational film

Peterson, Jennifer Lynn, 5–6, 240n6, 266n9, 270nn39–40, 272n68

Petrowitsch, Pablo, 152–53

Pickpocket, 10, 12, 16, 29, 32, 33, 35, 39, 41, 241n10

pictorial instructions, 3, 4, 27, 44, 48, 72; combat manuals, 73–74, 75; Ernst Gombrich on, 72–73, 258n104; machine drawings, 75; for movement,

Rube Goldberg–like machines, 24, 228, 230, 231
Rushton, Richard, 260n4
Ruskin, John, 37, 133–34, 235. *See also* craftsmanship
Ruttmann, Walter, 58, 147. See also *Mannesmann*
Ryan, Marie-Laure, 83–84. *See also* process narration; tellability

Saute ma ville, 123–26, 268n24
Sayre, Robert, 181
Schvarzman, Sheila, 166. *See also* Mauro, Humberto
Sennett, Richard, 34, 38–39, 44, 134
serial iconography. *See* Wellmann, Janina; pictorial instructions
Serra, Richard, 112
Sewell, William, 130–33, 271n44
Seyrig, Delphine, 23–24, 204–5
showing making, 47, 250n98
Siebenga, Rianne, 156–57, 270n40
Singer, Ben, 204, 282n33
Skiff, Frederick, 72
skill, 17, 23, 24, 25, 33–34, 40–41, 85, 118, 125, 127–29, 133–35, 168, 204–8, 216, 220–22, 234–37. *See also* craftsmanship; technique
Skoller, Donald, 112, 126
sloppy craft, 234–35. *See also* craftsmanship
Smith, Pamela, 43, 75, 249n83
spectators: artisans, similarities to, 36; contexts of, 93–97; identifying with practitioners, 41; of industrial films, 136. *See also* absorption
Spencer, Herbert, 128–29
spoofs: of aestheticization of labor, 122–24, 268n22; aesthetics of, 234–36; antiwork politics of, 237; as dialogic, 222; functions of, 222; as historicizing, 237; the human in, 235–37; *The Making of Forty Rectangular Pieces for a Floor Construction*, 231–37; Mika

Rottenberg's, 228–31; "The Most Unsatisfying Video in the World Ever Made," 122–24, 126, 221–22, 268n22; and objects of parody, 234; process genre understanding, 236; proliferation of, 221; of sausage production, 284n6; *Wonder Showzen: The Hot Dog Factory*, 223–25, 234. See also *Dough*; *Fake Fruit Factory*
Sternberg, Meir, 98, 264n48. *See also* expositional structures; narrative
"Story of a Pioneering Sock, The," 137
Straet, Jan van der, 131
surprise: expositional structure, 97–98, 108; in *A Man Escaped*, 109, 113; in *The Mystery of Picasso*, 88–89; in narrative, 83; in *The Unstable Object*, 104, 106, 108
suspense: expositional structure, 28, 89, 98, 101–2, 104, 105, 107–8, 263n36, 264n47, 265n60, 267n11. See also *Man Escaped, A*; *Park Lanes*; *Unstable Object, The*
Sussman, Herbert, 67
synecdochal tag, 18, 204, 241n14

Taureg, Martin, 62
Taylorism, 36, 52, 119–20, 129–30, 132–34, 135–36, 142, 234, 236
technical processes, 36–38
technique: Alfred Gell on, 121–22, 268n19; of the body, 33–34; definitions of, 33–34, 121–22; and instruments, 38; and labor, 125; Marcel Mauss on, 33–34, 121, 245n52, 268n19; and material, 38–39; visibility of, 63. *See also* craftsmanship; skill
technique, representing: allegory, 125–26; causality, 126; conventions for, 125; criteria for, 125; and dehumanization debates, 134–35; lack of, 122–25, 268n22; motor fluency and dexterity, 127–29; offscreen planning, 126–27. *See also* grace; movement; sloppy craft

technology, 29–30, 36–38, 40, 57, 60, 61, 67, 69, 75, 115, 117–18, 130, 147, 148, 156–57, 162–64, 182, 188–91, 220, 245n52, 266n7, 274n80. *See also* developmentalism; instruments; machines; romantic anticapitalism

Tejidos Chilenos, 154–57, 161–62, 164

tellability, 83, 94, 96–97, 262n17. *See also* eventfulness

temps mort (dead time), 202–4

Tire dié, 177, 180

Tomlinson, Walter, 70

tools. *See* instruments; machines

topos, 45, 249n89

Trilla, 6, 150, 153, 164. *See also* Bravo, Sergio

Umberto D, 202–3, 206, 216, 282n32

underdevelopment, 149, 150, 157, 169, 170, 172, 185. *See also* developmentalism; evolutionism

Unstable Object, The, 102–8, 135, 230

Urban, Charles, 55

useful cinema, 49, 52, 54, 146, 252n102. *See also* educational film; ethnographic film; industrial films

Van der Veen, Marjolein, 217, 283n50

Velador, El, 14–15, 16, 18, 22, 23, 29, 33, 35, 39, 97

Verne, Jules, 29

Visit to Peek Frean and Co.'s Biscuit Works, A, 5, 7–8, 16, 32, 33, 36, 37, 38, 99

visual anthropology, 146, 212. *See also* ethnographic film

Vitali, Velasco, 90–93. See also *Hand Gestures*

Vonderau, Patrick, 53, 242n16

Washburne, Marion Foster, 1–2, 4, 26

Wasson, Haidee, 252n102

Weeks, Kathi, 143–44

Wellmann, Janina, 73–74, 243n26, 259nn109–10

Wiatr, Elizabeth, 55–56, 64

Williams, Linda, 46

Williams, Raymond, 119

Wiseman, Frederick, 3, 140–41, 224–25, 244n31

Wolf, Gotthard, 62

Wonder Showzen: The Hot Dog Factory, 223–25, 228, 230, 234, 236

work. *See* labor

World Fairs. *See* exhibitions

WunderTütenFabrik, 122–23. *See also* "Most Unsatisfying Video in the World Ever Made, The"